A Potter's Companion

*1. **Ronald Larsen:** Basket, stoneware, 10" high, 7" diameter, 1988.*

A Potter's Companion

Imagination, Originality, and Craft

compiled and edited by Ronald Larsen

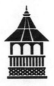

Park Street Press
Rochester, Vermont

Park Street Press
One Park Street
Rochester, Vermont 05767

LIBRARY OF CONGRESS CATALOGING-IN PUBLICATION DATA

A Potter's companion : imagination, originality, and craft / edited and compiled by Ronald Larsen.
 p. cm.
 Includes index.
 ISBN 0-89281-445-4
 1. Pottery—Literary collections. 2. Pottery. I. Larsen, Ronald, 1937–
PN6071.P58P68 1992
808.8'0355—dc20

92–18904
CIP

Printed and bound in the United States

10 9 8 7 6 5 4 3 2

Park Street Press is a division of Inner Traditions International
Distributed to the book trade in Canada by Publishers Group West (PGW), Toronto, Ontario
Distributed to the book trade in the United Kingdom by Deep Books, London
Distributed to the book trade in Australia by Millennium Books, Newtown, N. S. W.
Distributed to the book trade in New Zealand by Tandem Press, Auckland
Distributed to the book trade in South Africa by Alternative Books, Randburg

Text Design by Virginia L. Scott

Text Sources

Acknowledgment is made for permission to print, or to excerpt from, the works indicated here. The list includes all literary permissions and courtesy acknowledgments, arranged in alphabetical order by author.

Rob Barnard: excerpt from "Potters of the Blue Ridge Mountains" in *Studio Potter* Vol. 13 No. 2 (1985). Reprinted by permission of *Studio Potter* and Rob Barnard.
Gregory Benford: "Time Shards," Copyright © 1979 by Gregory Benford and reprinted by permission.
Charles Fergus Binns: quotation from "The Craft of Pottery" in *The Craftsman* Vol. 9 (1906).
Cynthia Bringle: "What Is a Pot," Copyright © 1965 by Cynthia Bringle. Printed by Permission of Cynthia Bringle.
Everette Busbee: "Making Music Versus Merely Playing the Piano" in *Ceramics Monthly Magazine* Vol. 36 No. 5 (1988). Reprinted by permission of *Ceramics Monthly* and Everette Busbee (Edited).
Alan Caiger-Smith: excerpt from "Alan Caiger-Smith" in *Potters on Pottery* by Elisabeth Cameron and Philippa Lewis. Copyright © 1976 by Carter Nash Cameron Limited. Reprinted by permission of St. Martin's Press.
Michael Cardew: "Why Make Pots in the Last Quarter of the 20th Century?" in *Studio Potter* Vol. 7 No. 1 (1978). Reprinted by permission of *Studio Potter* and Seth Cardew. Excerpt from *Pioneer Pottery* by Michael Cardew, copyright © 1969 by Michael Cardew. Reprinted by permission of St. Martin's Press and Seth Cardew. Excerpt from "Potters and Amateur Potters" in *Ceramics Monthly Magazine* Vol. 27 No. 2 (1979). Reprinted by permission of *Ceramics Monthly* and Seth Cardew. Excerpt from *A Pioneer Potter* by Michael Cardew, copyright © Seth Cardew 1988. Reprinted by permission of Seth Cardew. Excerpt from "Michael Cardew: An Interview on His 80th Birthday" in *Crafts* No. 50 (1981). Reprinted by permission of Seth Cardew.

John Chappell: "R.S.V.P." in *Pottery Quarterly* Vol. 1 No. 4 (1954) and "Clay" in *Pottery Quarterly* Vol. 4 No. 15 (1957). Reprinted by permission of *Pottery Quarterly*.

Geoffrey Chaucer: first line from the poem "The Parlement of Foules" in *The Complete Works of Geoffrey Chaucer*, Vol. 1, edited by Rev. Walter. W. Skeat, Oxford University Press, 1926.

Chuang Tzu: "The Need to Win" in *The Way of Chuang Tzu* by Thomas Merton, copyright © 1965 by the Abbey of Gethsemani. Reprinted by permission of New Directions Publishing Corporation.

Charles Counts: poems "What Magic" and "Fragments" from *Common Clay*, copyright © 1971 by Charles Counts and Charles W. Haddox, Jr. Reprinted by permission of Charles Counts.

Harry Davis: "An Historical Review of Art, Commerce and Craftmanship" in *Studio Potter* Vol. 6 No. 1 (1977) and "Potters, Zombies and Others" in *Ceramics Monthly Magazine* Vol. 33 No. 7 (1985). Reprinted by permission of *Studio Potter, Ceramics Monthly,* and May Davis.

George Demetrios: "The Potter's Hands" from *When Greek Meets Greek* by George Demetrios. Copyright © 1947 by George Demetrios. Reprinted by permission of Houghton Mifflin Company. All rights reserved.

Mike Dodd: "In Defence of Tradition . . . because of the heart, in spite of the head" in *Pottery Quarterly* Vol. 11 No. 41 (1964). Reprinted by permission of Mike Dodd (Edited).

Angela Fina: two anecdotes, copyright © 1991 by Angela Fina and printed by permission.

Reginald Dunderdale Forbes: "The Song of Jethro the Potter" in *The Craftsman* Vol. 22 (1912).

Robert Francis: "Museum Vase," reprinted from *Robert Francis: Collected Poems, 1936–1976* (Amherst: University of Massachusetts Press, 1976), copyright © 1965 by Robert Francis.

John Green: "The Potmaker" in *New Zealand Potter* Vol. 22 No. 2 (1980). Reprinted by permission of New Zealand Potter Publications.

Edgar J. Goodspeed: "All These Rely on Their Hands" from Ecclesiasticus 38 in *The Apocrypha: An American Translation*, copyright © 1938 by Edgar J. Goodspeed. Reprinted by permission of The University of Chicago Press.

Donald Hall: excerpt from "Lean Proseball" in *Fathers Playing Catch with Sons*, copyright © 1985 by Donald Hall. Published by North Point Press and reprinted by permission.

Shoji Hamada: excerpts from "Hamada" by Yoshiko Uchida, *Craft Horizons* Vol. 16 No. 4 (1956). Reprinted by permission of *Craft Horizons* (American Craft). Excerpts from *Hamada, Potter* by Bernard Leach. Copyright © 1957 by Kodansha International Ltd. Reprinted by permission. All rights reserved.

Lafcadio Hearn: "The Tale of the Porcelain-God" from *Leaves from the Diary of an Impressionist, Creole Sketches, and Some Chinese Ghosts* by Lafcadio Hearn. Copyright © 1911 and 1922 by Houghton Mifflin Company (Edited).

Wayne Higby: "Harmonizing Imagination and Logic" in *Useful Pottery*, Pyramid Arts Center, Rochester, N.Y., 1985. Reprinted by permssion of Wayne Higby.

Jamake Highwater: "Illusions of Originality," copyright © 1991 The Native Land Foundation. Printed by permission of the The Native Land Foundation.

Robin Hopper: excerpt from *Functional Pottery* by Robin Hopper, copyright © 1986 by Robin Hopper. Reprinted by permission of Chilton Book Company, Radnor, Pa.

Geoffrey Household: "The Greeks Had No Word For It" from *The Europe That Was* by Geoffrey Household. Copyright © 1979 by Geoffrey Household. Reprinted by permission of Ilona Household.

Ogata Kenzan: poem "Those who seek fame and profit" by Ogata Kenzan (translation Bernard Leach) from *Kenzan and His Tradition* by Bernard Leach. Copyright © 1966 by Bernard Leach. Reprinted by permission of Faber & Faber, Ltd. and David Leach.

Lao Tzu: Book I, Chapter XI of the Tao Te Ching from *The Way and Its Power* by Arthur Waley, copyright © 1958 by Grove Press, Inc. and reprinted by permission.

Ronald Larsen: "A Pot in Sonata Form," copyright © 1991 by Ronald Larsen, and printed by permission.

Bernard Leach: "The Potter's Challenge" from *The Potter's Challenge* by Bernard Leach. Copyright © 1975 by Bernard Leach. Used by permission of the publisher, Dutton, an imprint of New American Library, a division of Penguin Books USA, Inc. Excerpts from *A Potter's Book* by Bernard Leach, copyright © 1940 by Bernard Leach. Reprinted by permission of Faber & Faber, Ltd. Excerpt from *A Potter's Portfolio* by Bernard Leach, copyright © 1951 by Percy Lund Humphries and Co., Ltd. Reprinted by permission of Lund Humphries Publishers, Ltd. and David Leach.

Jenny Lind: excerpt from *The Studio Potter: A Question of Quality*, Sun Valley Center for the Arts, 1979. Reprinted by permission of Sun Valley Center for the Arts.

Warren MacKenzie: "Criticism in Ceramic Art" in *Studio Potter* Vol. 9 No. 1 (1980). Reprinted by permission of Studio Potter and Warren MacKenzie. Excerpt from *Minnesota Pottery: A Potter's View*, University Gallery, University of Minnesota, 1981. Reprinted by permission of University of Minnesota and Warren MacKenzie.

Washington Matthews: excerpt from "Navaho Myths, Prayers and Songs with Texts and Translations," *University of California Publications in American Archaeology and Ethnology* Vol. 5 No. 2 (1907). Reprinted by permission of University of California Press.

William Morris: excerpts from "The Lesser Arts of Life" in *Collected Works of William Morris*, Vol. XXII, Longmans Green and Company, London, 1914.

Lewis Mumford: excerpt from *Art and Technics*, Columbia University Press, 1951.

Frank Owen: "Pale Pink Porcelain" from *The Porcelain Magician* by Frank Owen. Copyright © 1948 by Frank Owen.

Octavio Paz: "Use and Contemplation" in *In Praise of Hands: Contemporary Crafts of the World*, by Octavio Paz and the World Crafts Council. Copyright © 1974 by the World Crafts Council. Reprinted by permission of Little, Brown and Company, in association with The New York Graphic Society.

David Pye: excerpts from *The Nature and Aesthetics of Design*, Van Nostrand Reinhold, 1978. Excerpts and "Design Proposes, Workmanship Disposes" and "The Workman of Risk and the Workmanship of Certainty" from *The Nature and Art of Workmanship*, copyright © 1968 by Cambridge University Press. Reprinted by permission of Cambridge University Press.

Philip Rawson: excerpts from *Ceramics*, copyright © 1984 by the University of Pennsylvania Press. Reprinted by permission of the University of Pennsylvania Press.

Herbert Read: excerpts from *The Meaning of Art*. Reprinted by permission of Pitman Publishing Corporation.

John Reeve: excerpt from *The Craftsman's Way: Canadian Expressions* by Hart Massey and John Flanders, copyright © 1981 The Massey Foundation. Reprinted by permission of Hart Massey.

Daniel Rhodes: "Legends of Ahimsa" from *Studio Potter* Vol. 3 No. 2 (1974/75). Reprinted by permission of *Studio Potter* and the Rhodes family. "Pottery & The Person" from *Pottery Form*, published by Chilton Book Co. Copyright © 1976 by Clay Space, Inc., and reprinted by permission of Chilton Book Co., Radnor, Pa., and the Rhodes family.

M. C. Richards: excerpt from *Centering* by M. C. Richards. Copyright © 1964 by M. C. Richards. Reprinted by permission of University Press of New England.

John Ruskin: quotation from "The Relation of Art to Morals" in *Lectures on Art*, Garland Publishing, Inc., New York 1978.

Owen S. Rye and Ahmed Din: Reprinted by permission of the Smithsonian Institution Press from "Sohni and Mahinwal: A Gujrati Potter's Legend" by Owen S. Rye and Ahmed Din in *Contributions to Anthropology*, Number 21. Copyright © Smithsonian Institution, Washington, D.C., 1976, pp. 194–195.

Charles Augustin Sainte-Beuve: Quoted in *The Invisible Core: A Potter's Life and Thoughts*, by Marguerite Wildenhain, Pacific Books, Publishers, 1973.

David Shaner: quotations from *Ceramics Monthly Magazine* Vol. 27 No. 10 (1979) and Vol. 38 No. 4 (1990). Reprinted by permission of *Ceramics Monthly* and David Shaner.

Michael Simon: excerpt from "Old and New Pots" in *Ceramics Monthly Magazine* Vol. 31 No. 6 (1983). Reprinted by permission of *Ceramics Monthly* and Michael Simon.

Barbara Skinner: "A Reply" in *Pottery Quarterly* Vol. 2 No. 5 (1955). Reprinted by permission of *Pottery Quarterly*.

Gary Snyder: "The Firing" in *The Back Country*. Copyright © 1964 by Gary Snyder. Reprinted by permission of New Directions Publishing Corporation. World rights.

A. L. Solon: "The Potter's Visitors" in *The Potter* Vol. 1 No. 3 (1917).

Joe Spano: "A Journey Shared" in *Studio Potter* Vol. 13 No. 2 (1985). Reprinted by permission of *Studio Potter* and Joe Spano.

Wallace Stevens: "Anecdote of the Jar" from *The Collected Poems of Wallace Stevens*. Copyright © 1923 and renewed 1951 by Wallace Stevens. Reprinted by permission of Alfred A. Knopf, Inc.

Barry Targan: "Ceramics and The State of Art" in *Bennington Review* No. 1 (April 1978, edited). "The Clay War" in *American Review* 18 (September 1973). Copyright © 1973 by Bantam Books, Inc. Reprinted by permission of Barry Targan.

Terry Tempest Williams: excerpt from *Coyote's Canyon*, text copyright © 1981 by Terry Tempest Williams,

photographs copyright © 1981 by John Telford. Reprinted by permission of Gibbs Smith, Publisher.

Byron Temple: quotation in *Ceramics Monthly* Vol. 33 No. 3 (1985). Reprinted by permission of *Ceramics Monthly* and Byron Temple.

Mike Thiedeman: excerpt from "Conversations with Indiana Potters" in *Studio Potter* Vol. 19 No. 2 (1991). Reprinted by permission of *Studio Potter* and Mike Thiedeman.

Henry David Thoreau: excerpt from the entry for August 5, 1851 in *The Journal of Henry D. Thoreau*, edited by Bradford Torrey and Francis H. Allen, Houghton Mifflin Co., Boston, 1906.

John Updike: "From the Journal of a Leper" from *Problems and Other Stories* by John Updike. Copyright © 1976 by John Updike. Reprinted by permission of Alfred A. Knopf, Inc.

Jack Vance: "The Potters of Firsk" in *Lost Moons*, copyright © 1982 by Jack Vance. Reprinted by permission of Ralph M. Vicinanza, Ltd.

Janwillem van de Wetering: "The New Disciple" from *The Sergeant's Cat and Other Stories* by Janwillem van de Wetering. Copyright © 1987 by Janwillem van de Wetering. Reprinted by permission of Pantheon Books, a division of Random House, Inc.

Aart van der Leeuw: "De Pottenbakker" in *Pottery Quarterly* Vol. 7 No. 28 (1962). Reprinted by permission of *Pottery Quarterly*.

Frans Wildenhain: excerpt from *Frans Wildenhain*, Memorial Art Gallery, University of Rochester, Rochester, N.Y., 1984. Reprinted by permission.

Marguerite Wildenhain: "A Potter's Philosophy" in *Ceramic Review* No. 70 (1981), copyright © 1981 by *Ceramic Review* and reprinted by permission. Excerpt from *Pottery: Form and Expression* (rev. ed. 1962), copyright © 1959 by Marguerite Wildenhain. Reprinted by permission of Pacific Books, Publishers.

Penelope Williams-Yaqub: "The Last Firing," copyright © 1990 by Penelope Williams-Yaqub. Printed by permission of Penelope Williams-Yaqub.

David Winkley: excerpt from "Confessions of an English Potter" in *Studio Potter* Vol. 10 No. 2 (1982). Reprinted by permission of *Studio Potter* and David Winkley.

Soetsu Yanagi: Excerpts from *The Unknown Craftsman*. Copyright © 1972 by Kodansha International Ltd. Reprinted by permission. All rights reserved. "Mystery of Beauty" from *Craft Horizons* Vol. 27 No. 3 (1967). Reprinted by permission of *Craft Horizons (American Craft)*.

Illustration Sources

1–29, 42, and 43: The sources for the pot images are given in their captions.

30 and 31: These woodcuts are from the 1815 edition of the *Ching-te-chen T'ao lu* in the Wason Collection on East Asia of the Cornell University Library. They are based on an original set of watercolor paintings depicting porcelain manufacture in the Chinese city of Ching-te-chen, and may date from the seventeenth century or earlier. The original set of watercolors has never been found. Further discussion of the *Ching-te-chen T'ao lu* and its woodcuts can be found in *Ching-te chen: Views of a Porcelain City* by Robert Tichane, The New York State Institute for Glaze Research, 1983.

32, 33, 38, and 39: These illustrations derive from Cipriano Piccolpasso's manuscript *The Three Books of the Potter's Art (I Tre Libri dell'Arte del Vasaio)* written in 1557 but never published in book form in the author's lifetime. The manuscript is now in the possession of The Victoria and Albert Museum, London. Six facsimile versions of the original manuscript have been published over the years; three in Italian (1857, 1879, and 1976), one in French (1860), and two in English (1934 and 1980). The first English facsimile was done by Bernard Rackham and Albert van de Put and published by The Victoria and Albert Museum, and the second was published by Scolar Press, London, with translation and introduction by Ronald Lightbown and Alan Caiger-Smith.

34: This depiction of a Greek kiln is from a Corinthian pot called a pinax. It is taken from *The Techniques of Painted Attic Pottery* by Joseph Veach Noble, Watson-Guptill Publications, 1965.

35 and 36: These two illustrations are portions of a scroll commissioned by Edward S. Morse in 1882 and executed by Kono Bairei (1844–95). The painting, in its entirety, depicts all the stages in the production of pottery at the workshop of the Kyoto potter Rokubei. The scroll is in the collection of the Peabody Museum, Salem, Mass.

37: This drawing is taken from Bernard Leach's *A Potter's Book*, 1940, and is reprinted by permission of Faber & Faber, Ltd.

40: This woodcut appears in *The Pirotechnia (De la pirotechnia)* by Vannoccio Biringuccio, and first published in 1540 shortly after his death. It is primarily a book on metallurgy, but contains a short chapter on pottery. It has been published, in whole or in part, in quite a number of editions and versions, as well as excerpted in many works. The major versions include six in Italian (1540, 1550, 1558/59, 1559, 1678, and 1914), four in French (1556, 1572, 1627, and 1856), one in German (1925), and four in English (1555, 1560, 1941, and 1942). The first complete translation into English is the 1942 edition by Cyril Stanley Smith and Martha Teach Gnudi, published under the auspices of The American Institute of Mining and Metallurgical Engineers.

41: This woodcut, by Jost Amman, appears in *The Book of Trades (Eygentliche Beschreibung Aller Stände auff Erden*—popularly known as the *Ständebuch)*, first published in 1568 in Frankfurt. The work contains 114 woodcuts by Amman depicting various professions, trades, and crafts of the time, ranging from pope to fool. Each woodcut is accompanied by a descriptive verse written by Hans Sachs, the same Sachs of Wagner's *Die Meistersinger*. A Latin version of the book was also published in 1568, and an expanded edition with 132 woodcuts in both German and Latin was published in 1574. A facsimile edition, with an introduction by Benjamin Rifkin, is available from Dover Publications, 1973.

Photo Credits

Deborah Bedwell—15; The Brooklyn Museum—18; Garth Clark—6 and 7; Harry and May Davis—8; Steven Diehl and Vici Zaremba—1 and 10; Angela Fina—5; Ron Forth—28; Courtney Frisse—2, 4, 19, 20, and 25; Kodansha International—43; Peter Lee—3, 11, 16, 17, and 29; Roger Lee—21 and 42; Thomas Liden—22; Robert Lorenz—24; Steve Myers—9; Fran Ortiz—12; The Royal Ontario Museum—23; Mark Sexton—35 and 36; Al Surratt—13 and 14; Robert Tobey—27; U.S. Dept. of the Interior, Indian Arts and Crafts Board—26.

2. Unknown Potter: Pennsylvania Slipware Plate, earthenware, ½" high, 10" diameter, late 18th century. Courtesy of Everson Museum of Art, Syracuse; gift of Mrs. William J. Davison, 1941.

*For Nils Erik, with thanks and the hope
that he thrive and flourish*

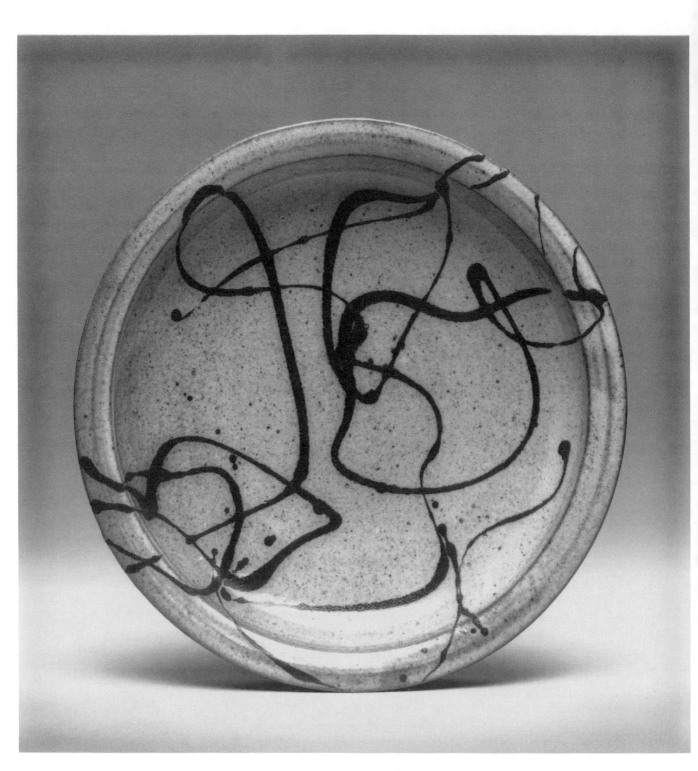

3. Warren MacKenzie: *Platter, stoneware, 2½" high, 14" diameter, 1989.*
Courtesy of Warren MacKenzie.

Contents

Illustrations

Foreword

Warren MacKenzie

When Ron Larsen first mentioned the idea of a collection of writings on pottery to be gathered into a book, I had some doubts. All of these pieces were already available to anyone who wanted them. One only had to look in the books and magazines at the library or on his or her own shelves. However, I did say that I would like to see what he had collected, and when I sat down with the rough draft of the present book, I was amazed at the number and variety of writings Ron had found. They were far more extensive and wide ranging than what I had available in my own library. As the project developed, the selection of articles, paragraphs, poems, and stories grew and changed, and I realized that this book, if it were ever printed, would be the sort of book that many potters would enjoy. It could be read and reread, kept on the desk to browse through at odd hours, or kept by the bed to provide a suitable closing after a day of work in the studio.

The pieces vary from serious essays about our craft, poems and stories, fiction and fact to one-line observations that speak sharply about a single idea. As I read through the selections I am often struck by some of these single ideas, and I close the manuscript and think about what I have read. The fascinating thing to me is that the writers are often unknown, at least to me. Maybe the sentences come from a graduate thesis, maybe from an obscure article in a magazine, or possibly even from writing that was not centered upon the craft of pottery. Thank goodness Ron has had the sense not to include any of those dreary arguments about art vs. craft. This book is for those who are convinced about what they do and who want to read writings by others who are similarly oriented.

Although I have had the manuscript in my possession several times for extended periods, I have never read all of the selections. This is not a book to be read from front to back, but rather a book to dip into at random for refreshment of the spirit, for a laugh, for reflection, or in some cases for a challenge to ideas held dear. Each time I have opened it there has been a surprise and something to engage my interest. Where Ron got all of the entries is a puzzle, but it is our good fortune that he had the inspiration and the tenacity to gather these bits and pieces from all over the world and bring them to our attention.

Enjoy it.

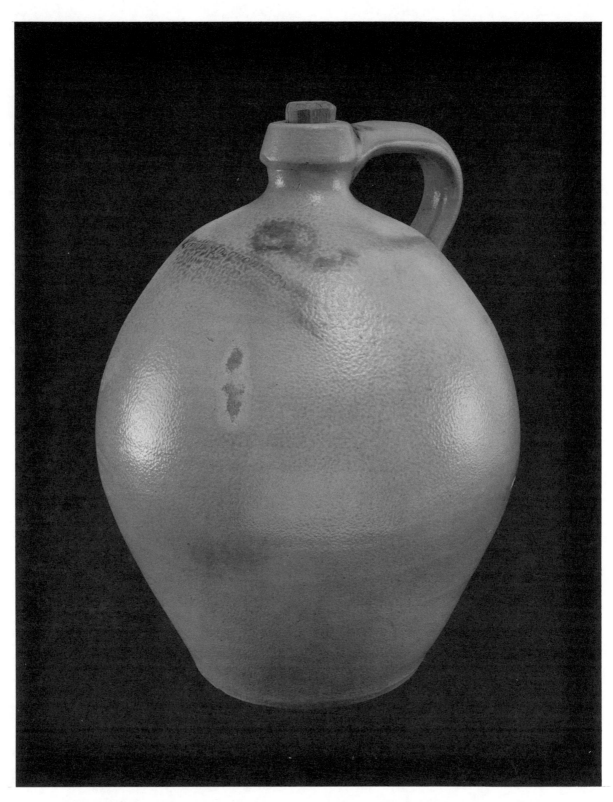

4. Unknown Potter: *Saltglaze Jug, stoneware, 13" high, 9½" diameter, circa 1845,*
Thomas D. Chollar Pottery, Cortland, N.Y. Courtesy of Everson Museum of Art, Syracuse;
gift of Mr. & Mrs. Victor Cole, 1981.

Preface

And so too with the potter:
his proper work is making pots.
Michael Cardew

Over the last thirty to forty years, a great deal of time and effort has been expended to raise the level of aesthetic appreciation of crafts as an art form. Although this entrance of crafts into the arena of fine art undoubtedly has its salutary effects for those working with clay, it also has had some noticeable negative aspects. The kudos and plaudits, the awards, grants, and exhibitions go mainly to the makers of nonutilitarian clay work. The renaissance of functional pots that emerged in the mid-twentieth century—exemplified by the work and writings of Leach, Hamada, Cardew, and their successors—is in danger of being submerged by the clamor and cacophony of the art scene. When the price tag on a nonfunctioning teapot is set at four or five times that on a functioning one, the maker of utilitarian ware begins to feel rather marginal, and the modest art of producing fine functional pots becomes in many minds a questionable one.

In recent years this questioning has become even more acute with the trend toward factory techniques in the production of utilitarian pots and the challenge this presents to the viability of the independent small-scale studio potter who primarily employs traditional handcraft methods.

It is hoped that this malaise may be somewhat ameliorated by the compilation of writings on functional pottery presented here. It is offered as a partial antidote to the pressure for "art pots" and as a celebration of "straight pots" and handwork; to serve as a reference tool, a solace, an inspiration, and an amusement; and as a goad to provoke thought and a place to search for answers and assurance. Although the selections were made by a potter with potters in mind, it is hoped that the general enthusiast of pots, potting, and craft may find them of interest as well.

The collection is divided into two sections. The first, "Rhymes & Reasons," consists of essays concerned with the history, aesthetics, and philosophy of utilitarian pottery, although many of the sentiments expressed apply equally to functional craft as a whole. Each essay is followed by a number of shorter related observations from various sources, punctuated with a poem, and illustrated with pot photos relevant to the text. The authors of the selections are primarily potters and critics, but voices from other disciplines are heard as well, ranging from poets, philosophers, and social critics to an actor, a woodworker, a Native American author and critic, and a Nobel laureate. In most cases, if an essay is by or about a

particular potter, the photo accompanying the essay is of that potter's work. Otherwise, the pot images have been chosen to complement or elucidate the content of the essay and observations.

The second section, "Tales & Fables," is made up of short stories and fantasies dealing with pots and potters. Not all of these selections are of undying literary value, although many have considerable artistic merit. Some were chosen for historical context, some for irony, some for a smile, and all for a good read. They are interspersed with a variety of historical illustrations concerning the potter's craft.

Naturally, the choices in both sections are idiosyncratic and eclectic, reflecting the peculiar interests and resonances of the editor's mind.

The reader who is sensitive to the issue of gender neutral language will readily observe that many of the essays, observations, and even poems are heavy with masculine pronouns. It should be kept in mind that this book is an anthology and, as such, the latitude for editorial change is severely limited. Moreover, roughly two-thirds of the items listed in the text sources were written in the 1970s or earlier when generic use of the masculine pronoun was still widely accepted. As irritating as this usage may be, it is hoped the attention of the reader will focus on what the material conveys concerning pots, potting, and craft. It is, after all, with this in mind that the selections in this anthology were chosen.

Every editor must face two major difficulties when compiling an anthology: deciding what to include, and deciding when research and reorganization have ceased to be efficacious and have deteriorated into mere tinkering. After six or seven versions over three years, I took heart from a remark made by Michael Cardew in an interview on his eightieth birthday and ceased tinkering. He said, "I just try to do the best I can, but I don't worry unduly if I make a botch shot. I think, 'Well, there it is: fumble, bumble, I made a mistake. Well, there it is.'" Well, fumble, bumble, here it is—botch shot or not.

During the making of this book many people have contributed in one way or another, sometimes, I suspect, unwittingly. Thanks are due to Dick Aerni, Dana Appleton-Reitman, Debbie Bedwell, Marvin Bjurlin, Steve Branfman, Anne Burnham, Carla Castelanni, Garth Clark, Louise Allison Cort, May Davis, Bob DeGraaff, Mike Dodd, Norm Hessert, Wayne Higby, Steven Hill, Hanna Hopp, Barbara Knutson, Dick Lang, Bert and Ellen Lowry, John Rexine, Jim Sankowski, Mark Shapiro, Tran Turner, Gerry Williams, Cornelia Wright, and Christine Zerbinis.

I am especially grateful to Angela Fina, William Hunt, and Warren MacKenzie for their frequent advice, assistance, and encouragement; to Darlene and Don Leonard, who converted my hodge-podge pasteup into a presentable manuscript; to the interlibrary loan staff at the Owen D. Young Library of St. Lawrence University for their patience and expertise; to editor Lee Wood for her ever able and cheerful presence during the production of the book; to editor Jeanie Levitan for yeoman work on the design of the book; and to Joan Larsen, for her expert editorial and bibliographic assistance, as well as her insights and support.

Finally, and perhaps most important, my thanks to all those who have taken the time and effort to ruminate and write about pots, potting, and craft or who have found a source of literary inspiration in them. Certainly not every such author is represented in these pages, but without them all, this book would not exist.

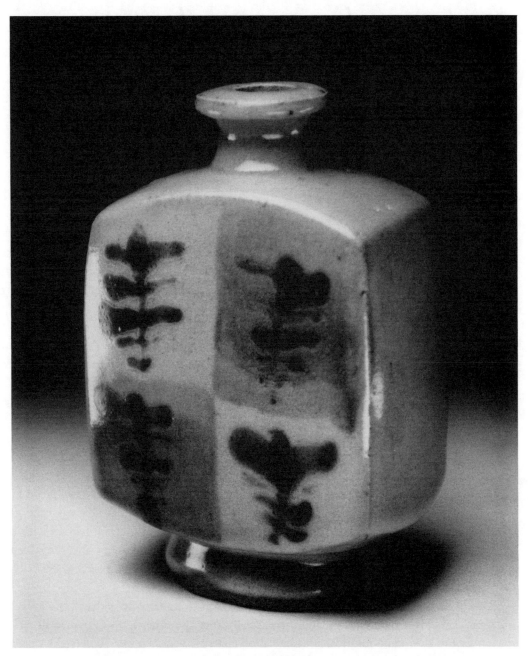

5. Bernard Leach: *Bottle, stoneware, 7½" high, 5" wide, 2¾" deep, 1960s.*
Courtesy of Angela Fina.

Rhymes & Reasons

Why Make Pots in the Last Quarter of the 20th Century?

Michael Cardew

I feel a lot of sympathy for the lecturer who recently told a large gathering that if all craft potters and their works were to disappear overnight from the face of the earth, the world at large would not notice that anything had happened. Some of the potters present were indignant about this, but you have to admit that he had a point; many potters do seem to have lost their sense of proportion and with it, their sense of humour.

The reason I proposed the rather heavy title for my remarks is that I hoped it might help me to understand "what pottery is about." But before I get into that, I ought to explain (though you have probably discovered the fact for yourselves already) that I find modern pottery—much of modern pottery—very difficult to understand. There are two reasons for this—both fairly simple ones.

The first is that I happen to come into pottery, not from any training in art but from studying philosophy at the university. I had to try philosophy because I had already discovered that I had no talent for drawing or painting or music; I was not what is called "artistically gifted" in any particular field. So I hoped I might be able to make the grade in this "word thing" called philosophy. But I soon discovered that I could not make the grade in this "word thing" either, so I had to become a potter. I know several potters who came to pottery by a similarly circuitous route. When somebody asks you the unanswerable question, "What made you take to pottery?" the only possible answer, if you are honest, is "I was no good at anything else."

The other reason I find modern pottery hard to understand is that I was away in West Africa for over twenty years, and there, for most of the time, I was occupied in tackling and trying to overcome formidable technical obstacles. It was a country where the potters were not troubled by our "problems." Their tradition had not been interrupted in the way ours was, and they made pots quite naturally, simply because they were needed. Now those were the years, 1942 to 1965, during which the craft pottery movement in Europe and America was growing at a very surprising rate. When I, from time to time, surfaced again on the Western scene and was confronted with this proliferation of strange-looking objects, I was taken by surprise. I viewed all these developments in the perspective of African common sense and realised that these objects were being made as a response to a highly specialised situation—for a small audience who were still interested in, and seemed to value very highly, something which to me had become like the last squeezings from lemons which I had discarded two or three decades ago. It was surprising to come back and find that what

appeared to be just the same "lemons" were still being hopefully squeezed, but with the aid of new and evermore sophisticated techniques.

So my account of "What pottery is about" starts from the primitive, basic level of assuming that pots are made because people want to use them and to have them to be "nice." By "nice," I mean convenient, well designed, good to look at and to handle and to live with, not too much more expensive than those produced by the "factory system," and above all, alive (whatever we mean by that).

Several years ago I was talking to a group of student potters in Eugene, Oregon, who asked me, "Why are Hamada pots so expensive? We were told that he started his pottery at Mashiko because it was a village where good, simple, useful unpretentious pottery was being made for the use of ordinary poor people. Yet this 'poor man's friend' (as we supposed) sells his pots now for astronomical sums!"

The only answer I had at that time was to invoke the mechanism of the law of supply and demand. I said it was simply a case of when the supply is static and the demand is increasing, the price has to go up. Hamada knew that even if he continued to sell his pots very cheaply, dealers would still charge high prices for them; not being a born fool, he avoided that trap.

But that is not the only point. Much more interestingly, the motives of those who bought or wanted to buy Hamada's pots were not (or not often) commercial or materialistic. People desired his pots mostly *because they liked them.* Hamada's pots had something about them which made them extremely desirable, and they had it more unfailingly than most other pots.

The interesting (and rather disturbing) thing about the collectors' motivation is that they only wanted pots by a particular potter, not the pots of the potter's pupils or imitators. Constable said, "Imitators always make the defects of the original more conspicuous," and yet pupils, not only in pottery but in other arts as well, normally begin by imitating. Some never get very far beyond that. But occasionally—I would say quite often—a "great master" will have pupils who are in the process of becoming something much more than mere imitators. They begin as "school of A," and for a time they may honestly believe that they are trying to be as like "A" as possible. But a stage usually comes when they themselves are obliged to recognise that their work *now* is not very like that of "A." And when that begins to happen, you would expect that the people who bought "A's" pots will want pots by his pupil "B" as well. If and when and wherever that is happening, the state of the potter's art is healthy. Up to now it has not been happening very often; but perhaps there are signs that it will be happening more often in the future.

But it will be happening only if the conditions are such that it *can* happen. The new talent will only emerge from where it has lain hidden if the climate and conditions are propitious. These depend partly on what sort of artist "A" is: on whether his/her life and practice and approach to the craft are such that others are moved to work in the same way. Then the consequence of "A's" attitude and way of working will be that the numbers of good potters will be increasing, and if you cannot get pots from "A," you will be able to get other pots by potters who are just as good in their way as "A" is (or was) in his.

When that begins to happen, the whole scene will be changing: there will be plenty of good potters and a healthy demand for their work instead of, *as now,* a few (very few)

potters who are overestimated, overpaid and "overlionised" and after them, a crowd of imitators all trying to keep up with them or to outfreak them.

I feel in fact that the exaggerated demand and high prices paid for the work of just a few potters is a sign that the potter's art is not well. That, incidentally, is why we have to have Art Schools. I call them "art hospitals," built for the ailing by those who (we hope) are themselves in good health. But if the instructors tell their pupils that they should always be looking consciously for some new way to assert their individuality and originality—instead of encouraging them to cultivate the common ground of a human *consensus* and allow true originality (which is inside all of us) to flower naturally without being forced—then I begin to lose faith in the "doctors" who man these "hospitals."

But if learners, instead of being fed such doctrines at their art schools, were encouraged to set themselves to work in a more normal way and to follow those among the already established potters whose work they like and admire (and thus allow their own sense of form and style to develop in an unforced way), I believe the numbers of good potters would soon increase and that there would not be so much of this present tendency to elevate established ceramics artists to pedestals which isolate them from the rest of us. Perhaps somebody will try to persuade me that this is merely a utopian dream. "Don't you see," they will say, "that 'true talent' is something which very rarely occurs on this earth, and that works of true talent will inevitably be much sought after by those who appreciate them and can recognise them, and therefore these pots will always be extremely expensive?"

But wait a minute! It is not true that the world's fund of talent—talent of all kinds, including a talent for pottery—is a static thing. There have been times of great fertility when talent of every kind was abundant, inexhaustible, springing up everywhere; and other times when there appeared to be a dearth of it. What causes the apparent dearth (because it *is* only apparent)? Evidently, Nature herself has her seasons of plenty and seasons of dearth, and the arts are like that too. Every particular art has its times of growth and fertility, and its times of sterility. But I believe the underground reservoir of talent is always there and is unaffected by "seasonal" fluctuations, that most people have a potential talent of some kind, but that nobody can get it out until they have the opportunities, and the incentive, to cultivate it in an appropriate way.

If we look at the potter's art today, we see that we certainly have the opportunities. For instance, there are the great advances which have been made over the past fifty years in all branches of ceramic technology. Thus we have now at our disposal much better refractory products than we ever had in the past, and this gives us better kilns and better kiln furniture. We have better fuels and better ways of firing kilns, better (or potentially better) materials for making clay-bodies and glazes. We even have a few potters' wheels which are better than the old ones. We also have, if we take the trouble to study it, a much more scientific understanding of what goes on when pots are being made; when we mix clay and water together; when our pots are drying; when we fire them at high or low temperatures.

But the most striking opportunity of all is provided by the social environment in which we live, where there are millions of people like ourselves—cultivated middle-class people—who for the first time in human history are able to exercise "consumer choice." Only a mere thirty (or less) generations ago our ancestors were still struggling in a state of "primary poverty" in which, as Thomas Gray said of the forefather buried in the Country Churchyard:

Chill Penury repressed their noble
Rage
And froze the genial current of the
Soul.

I realize that of all these millions of prosperous people today, fewer than one percent are going to like the kind of pots that you and I make; but even that small proportion will be more than enough to keep us busy, and if our pots are good we shall find that our admirers are continually increasing.

The opportunities are evidently there. Needed are the incentive and the example. I maintain that the place where these are to be found is in the craftsman's workshop—it was the place in the past, and it still can be. It will be a workshop operated by a potter who has had enough tenacity to cultivate his or her talent to a stage where it is able to flow naturally into and out of his work. But such a potter needs assistants or pupils, since you can't run a pottery of reasonable size without helpers. The pupil (being a free agent) will go to that workshop rather than another because he is attracted to the pots that are made there; and if he is a beginner, he will want to learn to make pots which are something like the pots made in that workshop. But from the moment the pupil begins working in the shop, individual differences of touch will appear in his work. Some of these may be due to a simple deficiency of skill, which is no problem at all since he is repairing the deficiency all the time. In some cases the difference might be due to a misunderstanding, or a real divergence of aims. That simply means that the pupil has come to the wrong workshop by mistake and has not yet found the right one for himself. Or (and this is what normally happens) the pupil will be making the same kind of pots as the master, but the pots will be slightly, subtly, indescribably, different. And this difference is the bud; the growing point which keeps the traditional forms alive.

This is a great part of the reason, I think, a potter needs to work in a workshop of two or three or more people, rather than in a one-man studio. This growing point, where the pupil's work begins to show departures or divergences from the master's, is the great test for the master's integrity as an artist. He has to watch carefully, to keep his perceptions open and alive, and to have enough faith in the universality of pottery forms to see which divergences contain the true germ of life in them. He must not assume that divergence in itself poses a threat to his own hard-won standards. He must be able to see that this is not something the pupil has put into his forms "on purpose," just to prove to himself that he is "different." It is something he can't help doing but does in spite of himself, unconsciously.

But if the master potter, thinking to protect his own standards from slipping, nips off those buds and tries to make the pupil's work conform to his own orthodoxy and his own strict view of how the shape should be (as has often happened in the past), he will be betraying the tradition. This is what has given tradition a bad name among us. If it happens, it means that the master potter has accepted the same fallacy as the well-meaning people who used to maintain that good potters ought to be designing "artistic prototypes for mass production." He will in fact be trying to "make love by proxy," as William Staite Murray said in the 1930s. The master potter is not going to live forever, and trying to make love by proxy is not going to be any help toward survival. If he confines his effort to making his own masterpieces, that is only one part of his function—perhaps one half of it. If he makes

masterpieces, that's fine—for him and for us. But if he aims only at making his own master-pieces, there will be a constantly increasing risk that they will be stillborn. The other half of his function, and perhaps the more significant, is to work in such a way that he will leave good potters behind him, because that is the true tradition—a handing-on of something which (like life itself) is self-renewing because it is continually being fertilised by human effort and human love.

If we can make good pots, we shall find that the numbers of people who want to use them will increase continually. People have been looking for that element of "life" in the things they use—something they can't find in ordinary stores. Quite often I hear these would-be users of "living" pots saying that when they visit a gallery or a craft exhibition they see there many interesting and clever things, but (sadly) very few items that they could really use. For example, they may have wished to buy some ordinary plates or bowls or cups to use at home, but there were hardly any good ones to be found. This makes me think that we who call ourselves modern potters are missing a great opportunity. Our potential patrons or customers are looking for pots which are alive but at the same time useful and well made, and their admirable, natural, healthy appetite remains unsatisfied. "The hungry sheep look up and are not fed."

I can't help thinking, that part of the reason is that the schools and academies have been telling potters and would-be potters that this kind of work is dull and insignificant. "You had better avoid it," they seem to be saying, "and concentrate instead on making something original." I too am very fond of the idea of originality, but when the professors use the term in that way, I think they are limiting themselves and seriously misleading their students.

I note that all over the Western world there is a spectacular explosion of all kinds of fine-art ceramics—ceramics as sculpture, as satire, as social or political comment, as meta-physical or surrealist statements. Don't assume that I am against all that; I had better not be, since these or similar movements and works have always been an essential part of the ceramics scene in all countries and in all ages. I just think it is rather odd that we seem to have reached a stage where it is the "plain potters" who are expected to explain and justify themselves. I would have thought that the onus of explanation (if there is any) lay with the fantasy ceramists.

Perhaps we are the victims of, or the slaves of, a dualisitic kind of thinking which takes the form "*either* you make mere utility ware, *or else* you are a ceramic artist creating things not meant for use at all." The potters of West Africa are not tied down in that way. They move with perfect ease and no sense of incongruity from pottery which is religious, ritual or ceremonial sculpture, through many varieties of fun ceramics—toys, dolls, wedding presents, ceramic jokes—to the pots and pans of everyday life; these pots and pans, which account for about nine-tenths of their production, are (in terms of life and humanity) among the most beautiful and significant ceramic creations I have seen. They are quite common and, techni-cally speaking, they are primitive and rudimentary—so soft-fired that they only just qualify as unglazed ceramic work. The people who make them don't overestimate them; if they had glass cases, these things would not be what they would put into them. Yet I am sure that they would never deny that their pots are also, in a perfectly good sense, sacred works. That is why they give them so much loving care when they are making and decorating them.

Today, just because of the accidental (and perhaps transitory) circumstance that clay

plates, bowls, pots, pans, pitchers, jugs, and so on are all supplanted by mass-produced alternatives, are we to be told that it is "nonsense" to make those plates, bowls, and other items by hand? People want them and ask for them—for that reason alone it makes sense for us to produce them. The alternative materials available—glass, plastics, paper—are convenient and even necessary in some contexts and situations, yet the effect they have on me is to make me more determined than ever to make and use clay ones.

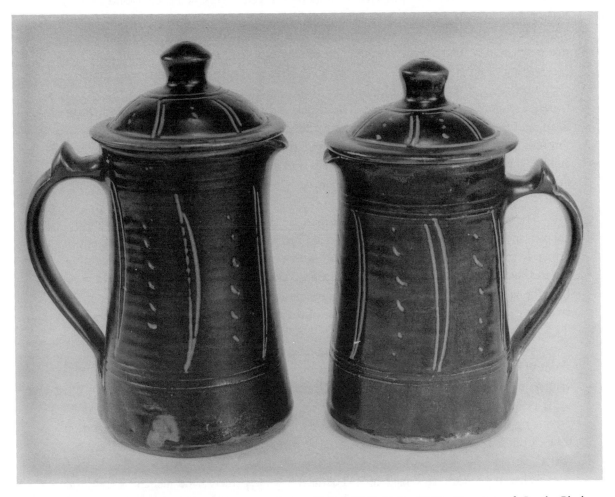

6. *Michael Cardew: Hot Water Jugs, stoneware, 6" and 5½" high, 1962. Courtesy of Garth Clark.*

My imaginary Professor of Art may still tell me that this is just absurd. There are (alas!) so many sides from which he can try to quench and extinguish my "noble rage" and genial enthusiasm. But if he says that my work will be unreal, irrelevant, out of touch with modern life; or that I am pandering to a sentimental passion of middle-class people for all those things which in museums are collectively known as "Bygones," that I am just a camp-follower of the commercial trade in "Recent-Antiques," providing reproductions and facsimiles for the trade; if moreover he says, and this is his strongest point because there is sometimes a terrible truth in it, that the old things were "real" and they make my work look contrived and artificial—if my imaginary Professor talks to me like this (as he often

does, in my imagination), I have an answer ready at last. I say to him: "You, with your pig's-trough interpretations of human motives, think that those old-time craftsmen only made jugs, pitchers, pans, jars, plates and the rest because there was a compelling economic necessity for them. Nobody denies the economic necessity; the potters of those times were ordinary human craftsmen who knew all about economic necessities, perhaps more than you do yourself, my dear Professor. But they were good craftsmen as well as economists; and nearly all of them, even those of small or underdeveloped talents, achieved a kind of greatness because though they may have been "serfs" in terms of wealth, they were free agents where their sense of form was concerned, and they responded to it instinctively and with that magnanimity which is always there in ordinary working people—a magnanimity latent and waiting to be given a chance to show itself. Yes, of course the pots made in those conditions are real and convincing; but the main reason that they are is not that they were merely a response to economic need. The reason is that those potters were concentrating on form, and in their effort to achieve expressive functional forms *they became a channel*— through them a universal genius was making its statement. That is why we respond immediately to their pots. They refresh us with a renewed sense of reality and act as a tonic after the self-conscious posturing of the make-believe world in which we have been enclosed too long."

The true successors of those old craftsmen are the modern potters who now, in the happier and more relaxed context of today, are making the same response to form, not primarily from an economic or commercial motive but chiefly because "absolute form" inspires them to work in the same way. They are liberated from dualistic habits of thinking. Like the village potters of West Africa they see no difference between their own work— creating living forms for daily use—and that of the free ceramic sculptor, who makes forms for a non-utilitarian purpose.

All our anxious discussions and argumentations about function and functionalism, about the changing needs of different periods or generations—all those questions like: "Is it valid to make functional pots in the age of Continuous Technological Revolution?" "What is the purpose or *raison d'être* of ceramic creation?" "Should we be making utensils, or producing surrealist fantasies?" All these debates are unnecessary, wasting our time and the time of our friends and contemporaries. Pottery is about one thing only: **the majesty of form.**

What makes form so "majestic"? The universe we perceive and feel and know (the *only* universe we can know) is form—whether felt, heard, tasted, smelled, seen, or created by thought. Form is the only shape in which we can live. It predates all our mental categories and includes them as contributors or attributes of its power. Whatever you express, in any medium, you do it in, by, and through form. Form says more than any discourse or process of reasoning, and it says it more neatly—that is the true meaning of the saying: "The style is the man."

And this is what a potter is doing, well or less well, according to his talent, his perseverance, his skill, his capacity for work, his capacity for pleasure, his power of concentrating the whole of himself on what he is making. All arts use form, but pottery tends to be almost all form—the shape is about ninety percent of the whole pot. This is the reason I continue to believe that making pots in the last quarter of the twentieth century is just as valid, and just as necessary, as it ever was in the past.

Shards

A good potter cannot treat his raw materials merely as a means of production; he treats them as they deserve to be treated, with love. He cannot make things merely as utensils; he makes them as they have the right to be, as things with life of their own. When a potter not only knows his job but delights in it, when technique and inspiration become identified, the glow of life will begin to appear in his pots. Nobody can say in rational terms exactly what this glowing consists of, or how the inanimate can be capable of transmitting life from the maker to the user, but it is a fact of common experience (if not describable in terms of common-sense). This aspect of pottery is not always discernible to a first inspection; but provided it is in daily use it will gradually become visible, just as a good character comes to be appreciated only through continued acquaintance. Its presence will fill the gaps between sips of tea or coffee at those moments when the mind, not yet focused on activity, is still in an open and receptive state; and it will minister quietly to the background of consciousness with a friendly warmth, even perhaps on some occasions with a kind of consolation.

This quality is the surest criterion of good pottery, whether the art that made it was conscious or unconscious. If pottery which is made for everyday uses of the home passes this test, it is art; and this is the field of expression which properly belongs to the potter. If he insists that because he is an artist he must make things for contemplation only, and refuses to supply the needs of daily life, he deprives himself of a main channel for his art, and denies himself the use of its richest medium.

Michael Cardew

Learning to make pots is like learning to write. When as children we were being taught to write, they didn't tell us the great thing to aim at was to make the writing "express our personality"; personality is something too big and too mysterious to be treated that way. They taught us skill, or craftsmanship, that is, to make our writing legible. But while you are learning to write legibly, your handwriting becomes

yours and only yours. Legibility is not going to rob it of its personality; on the contrary, it makes it possible for your personality to flower and be seen; your handwriting is you and nobody else can imitate it exactly.

The best way to impart character and personality to pots is to turn your attention to other matters; to make them with as much concentration as you are capable of, to enlarge your skill over as wide a range as possible, to get to know your materials by living with them, trying to understand them, and finding out little by little—not with your head but with your body—how they want to be treated; in fact, to treat them with proper respect as we would a friend. Then, nothing can stop your personality from appearing in your pots. They will be as individual and unmistakable as your handwriting. But the handwriting has to be legible; if it isn't, the message—the meaning—will not be communicated.

The hands make the head clever.

Michael Cardew

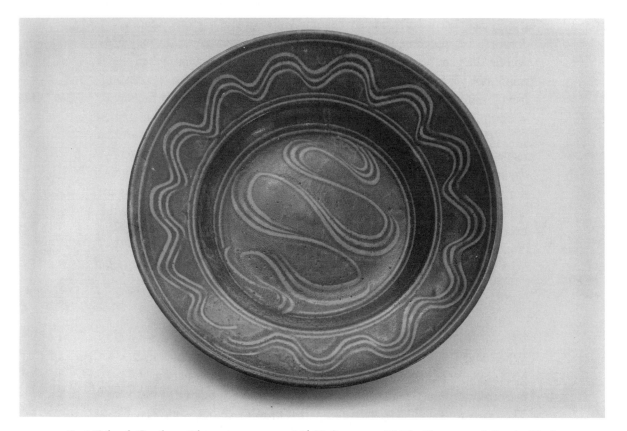

7. Michael Cardew: *Platter, stoneware, 13½" diameter, 1958. Courtesy of Garth Clark.*

The Last Firing

Michael Cardew: 1901–1983

Penelope Williams-Yaqub

Michael Cardew
Kicks the flywheel
Spins the earth,
Centers.
Gnarled fingers swiftly
Form cone and crater
Moving upwards
Vessel evolving,
Slowing
As he comes
To the rim of his life.

Leather hard,
He pulls, forms
The handle.
Dry to his cheek
He fires first
To golden bisque.
Swiftly
Dips, swirls, spins
Back into the earth
Dolomite, kaolin and zinc
Back into the fire element
To rise permanent, glaze glorious.

A life
Centered in clay
Until
The last firing.

Potters, Zombies and Others

Harry Davis

If one wanted to make a study of the minor follies and conceits of society, one could do worse than start with the potters of the 20th century. That pathetic piece of advice, to would-be "artist-potters" not to have anything to do with function, would make a good starting point. This could be followed by the more recent confession of another potter who explained that he had given up making functional pots because it was turning him into a zombie.

If there is something to be extracted from remarks of this sort, it has surely to do with the psychological condition and status ambitions of the people who make them. It obviously also has something to do with the background and training they underwent as young potters. Whatever the explanation, the policies have paid off, as is well and truly endorsed by the role now being played by the world of art auctioneers. Does anyone need further proof of the superiority of artist-potters over any other sort of potter? True, it took quite a while to work up to this point, but the price tag as the guide to excellence has been established over a long period. At first the level rested on the nerve of the potter who ventured to market his pots in a Bond Street gallery. More recently the work of artist-potters now dead has become of interest in the world of real-estate investors. Sale by auction now puts their work alongside that of dead painters. This is a new and probably irreversible twist.

All this poses problems for living potters, for let it not be forgotten that there is still a case for ignoring the seductions of auctioneers and collectors and following the road taken by potters for thousands of years. This road invites the making of simple pots for mundane use that incorporate a function and a meaningful decorative role. In other words, the stamp of some degree of human concern and warmth in their making: something the industrially mass-produced alternative conspicuously fails to provide. The world of pottery users is still crying out for pots of vitality and moderate price, to be lived with on a humble domestic plane. But this is a tougher proposition, calling firstly for a type of training that teaching institutions are simply unable to offer. It calls for an attitude to economic independence which needs a lot of determination to achieve, and a withdrawal from the suburban ethos of "studios." It calls for self-discipline and a capacity to resist the seductions of those who recruit staff for teaching institutions. One cannot do both: be a teacher in the formal class-room sense; and a potter of substance in the creative and economic sense. For those installed on the teaching staff of a college, it takes a rare stamina to pull out and re-establish them-selves as makers of pots for a living. It also takes another sort of stamina and some vision to

do this without subsiding into a routine of stagnant repetition. This hazard has to be avoided whatever the stage in a potter's life. In fact, the opposite is essential, for without it no development is possible, and it requires more than a little dedication to prevent practical and commercial considerations from swamping all others. To escape this challenge by shirking all repetitions is no answer.

The idea that the way to learn to be a potter is to be apprenticed in a potter's place of work went out a long time ago, though in remote parts of Africa and South America one may still see a little girl learning to make pots from her mother—but that is another category. Now the accepted route, if not the only route, is via a school of art or a technical institute where the chances are that the teaching staff has no experience of what it takes to earn a living making sound pots at prices that do not exclude them from the work-a-day world of domestic life. In all probability they came straight from another teaching institution of the same kind, staffed in the same way. There are now many successive generations of this sort of teacher. This is what I mean by the limiting factors associated with the training of potters. This alone explains a great deal about the jaundiced view many hold about the making of pots for use, for tedium is accentuated when skill is minimal.

How did all this come about? Historically it is fairly clear. When the challenge of reviving handcraft pottery first presented itself, there probably did not exist in all Europe a potter with integrated creative talents and skills such as lived in China or Ecuador three millennia ago—or for that matter may still be found in some isolated communities in Africa or Latin America. By that time potters in Europe were proletarian wage earners specialized in narrow categories. A thrower was such a person. The revitalizing of the craft had to come via educated and probably through traveled people of privilege. It was a middle class intelligentsia that conceived the idea because their privileges had enabled them to get a glimpse of the diversity of fine work that so many potters had achieved in so many places, mostly unknown to each other. But when they tried to put the idea into effect, they had either to employ a thrower or "mug up" what they could for themselves. Some did find traditional potters willing to teach them some of their skills, but a conditioning factor in all this was that they came to the situation as adults with the outlook of "artists." They were self-conscious and well beyond the appropriate age when a young person could be expected to knuckle under and acquire the skills properly and fully. There were also certain other influences emanating from Japan which, in seeking to achieve what was regarded as vitality, managed to introduce an odd cult of unskill. The outcome of all this was that the revival was launched on a practical level that was bound to make repetition distasteful and to make it extremely difficult to earn a living without indulging in extravagant pricing, which in turn meant reliance on an affluent and elitist clientele. Fragmentation of the movement was an inevitable consequence.

Faculty members in science departments are admonished to "publish or perish." Research is expected as a matter of course and as long as results are published, all is well. Something similar happens in the world of art teaching institutions, only the admonishment is to exhibit instead of to publish, and so the regular appearance of the "Solo Exhibition" becomes an essential part of the example set before the young in teaching institutions. Right—if that is how it is, so be it, but why all the ranting about the other side of the coin where potters make, and have made for millennia, simple functional pots for people to use and live with? Why the warning implying dire consequences for an "artist-potter" who

ventures into that humble field? Why the fear of being—or being thought to be—a zombie as the price of being a persistent maker of useful pots? Why the shades of denigration associated with the classifying adjective in "production potter"? What else have potters always done but produce pots? Why not just stick with the title potter and leave the qualifying adjective "artist" to those who feel insecure without it? It is surely significant that none of this fragmentation arose to trouble all those generations of potters in simple societies who made pots for eating and cooking and ceremonializing. They were unaffected by differences of mood arising on the one hand out of the making of countless stew pots, all vital in their own small way, and on the other hand, the making of more spectacular pieces with quite different functions. Functions they all had, be it as a burial urn or a stew pot, yet the potter was one and the same person—usually a woman. Where did we all go wrong in our little macho conceits, or is this also a consequence of the trauma called specialism?

We are in no doubt today about the immensity of the body of knowledge and the impossibility of any one person being able to encompass all of it. The last universal person, it is sometimes said, was Leonardo da Vinci, but the fact that we can no longer encompass all knowledge in one grand sweep of wisdom is no reason for not striving to encompass what we can, whether in terms of skills acquired, levels of sensitivity achieved, or sheer intellectual grasp of scientific technicalities. Not to strive has a stunting effect, whereas efforts to realize one's potential mean personal growth and maturity. Aldous Huxley and Lewis Mumford are two outstanding examples of people in our day who resisted the temptations of narrow specialism. The breadth of their understanding and wisdom has been a real inspiration to many.

In his famous Santa Barbara lectures (1969), Aldous Huxley refers to his grandfather, T. H. Huxley, as having struggled in vain in the last century to broaden the basis of studies at the University of London—to integrate education, in other words. The Santa Barbara lectures are a fine testimony to Aldous Huxley's efforts to achieve the blend of wisdom and intellect that he did. Lewis Mumford identifies himself with a similar opposition to narrow specialism and refers to himself in several of his writings as a generalist.

That universities have capitulated in favor of fragmentation and specialism to the extent that they have, I find sad and hard to understand. But much more difficult to understand is why this capitulation should have taken such a hold among potters. The handcraft pottery revival was in essence an attempt to recapture the ethos of a simpler world—a simpler technology more easily integrated and capable of being understood by an individual potter. Why has it allowed itself to succumb to fragmentation along with so much else in our society? It could be a mixture of complacency and a yielding to a line of least resistance presented by the plethora of vendors of expertise and materials. Or is it one, or several, of the social vices tempting potters in directions that yield more kudos for less effort? The circumstances of the founding of the movement were essentially middle class, and it is perhaps not surprising that it has come to be dominated by the values of that class. Born though it was on a wave of protest, that element in its makeup was soon stifled.

A noble effort was once made within a closely knit community to outlaw some of the more flagrantly fragmenting social habits. That was the Dominican order, which framed its rules so that people's physical, spiritual and intellectual attributes might remain in step with each other. This meant dividing the working day, that is, the waking hours, into three: the manual, the meditative, and the intellectual, with each accorded equal importance and

respect. This splendid concept leaves no place for the snobs who look down their noses at manual workers—no place for that urbane arrogance that equated immaculate clothes and unsoiled hands with proof of nobility. It has no place either for that sad misconception that craftspeople and artists are necessarily two distinct sorts. It was a frontal attack on many perverse social values, but it was also something that clearly required a discipline. Given the voluntary acceptance of discipline implicit in the idea of a monastic order, it could obviously work and be an inspiration as well. But outside such an order all hangs on self-discipline, and that is the rub. Very few people are capable of cultivating it. Nevertheless, this notion of a way of life has a relevance to potters. My personal experience has been an almost accidental drift into similar divisions of time: not punctuating the day with any fixed program, but nevertheless ranging back and forth over these three kinds of activity.

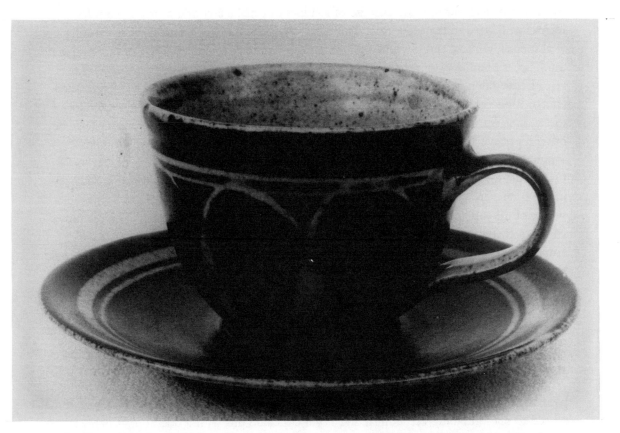

8. Harry Davis: Breakfast Cup and Saucer, stoneware, 1960s. Courtesy of May Davis.

To interpret this concept in terms of a potter's world implies a combination of adequate skill, some degree of sensitivity and also a willingness to think, but above all it implies a readiness to apply them all to mundane things as well as to the more exalted. It implies a wish to make pots for mundane purposes, yet imparting positive qualities to them in spite of their prosaic role and shunning the attitude expressed by the curator of a public gallery who said, "They don't want to make pots; they want to make Art." So the first category would be covered by this willingness to make mundane things and lots of them in a generous and

positive spirit. That would be the manual fraction in the rule. The second category implies a more relaxed mood in which imaginative elements and nonpractical ideas are given play, as in experimenting with form and relating decorative embellishment to it. This is a mood of hunches and feelings and not much conscious thought. Stretching the meaning of words a little, this would correspond to the spiritual and meditative part of the rule. The last section of the rule covers the intellectual, which implies a willingness to grapple with the science side of it all: the geological, the chemical, the physical and the mechanical. It also implies what is perhaps the most important field for thought, some introverted speculation about motives. Why make this and not that, and for whom, with an occasional glance at the balance sheet so that the overall implementation does not become dangerously unrealistic.

The total reflects in my opinion a diversity that makes for an integrated person: a potter with integrity. It includes something once defined by Eric Gill as re-creation. Such an oscillation of activities and the exercise of faculties can make any one of the three rules a recreation relative to the other two. The word recreation implies a process of re-creating vital mental, spiritual and physical energies, which, contrary to current ways of working and thinking, is possible within the day's work, as well as outside it.

I have often heard comments, even from fellow potters, which reveal the fragmented effects of poorly integrated attitudes. A recurring example, made no doubt by a member of the zombie-fearing fraternity, was usually prompted by the sight of piles of dinner plates or other repetitive work. The comment usually took the form of a question which went something like this: "Don't you find it soul destroying to do repetition work of this sort?" One could imagine that same question being asked of the monk digging irrigation ditches in the monastery grounds. The obvious answer in both cases would be: "That is not the whole of the job. The plates are wanted and needed," or in the other case: "The ditches are needed and must be dug." In my situation I would probably also add that as a self-employed person, I could switch to something else when I had had enough and that I could also think about why I was doing it. Not so in the case of a man in a glass factory of whom I once asked a question: "What is that material you are shoveling?" To which he answered: "I am not paid to know anything, I am only paid to shovel the bloody stuff." If monotony damages souls that was surely an example, for he was not free to do something else when he felt inclined; nor was thinking his strong point, or he might have realized the damage he was doing to himself.

Some years ago I concluded an essay called "Art, Commerce and Craftsmanship" (see page 98) by saying that potters should have the courage to be potters. There still seems to be a need to say something very similar and I will conclude this with a question. When are the potters going to get the sculptors out of their hair . . . or when are some sculptors going to stop pretending to be potters? Sculptors have been traditionally content to be known by that simple title. They do not seem to have felt the need to qualify their activities with prefixes indicating that they work in stone or wood or bronze or even terra cotta. So why, may one ask, this insistence on *ceramic* sculpture? When a potter's conference involving some 750 participants is reported as being dominated by nonpotters with sculptural pretentions, it is time for such nonpotters to tag on to the world of sculptors pure and simple, taking those afflicted with zombiephobia along with them. Potters could then settle down to being potters.

Shards

Shapes which are repeated begin to mature without undergoing any obvious changes. The form evolves by itself, and if you compare two pots made to the same measurement at an interval of about five years you find that the shape has become more agreeable simply by being often made. The same with brush strokes. You may trace back one of your own designs done a few years before, something you have systematically made a dozen times a year, and it has developed, even though you were not trying to change it, or indeed aware of the change as it occurred. I think this secret evolution is an important part of any work which involves repetition. It is a feature of some of the best peasant pottery.

I would say there is a difference between inattentive repetition, which leads eventually to something pretty vacant and facile, and repetition done with attention, which is really a growing thing, giving rise to the process of maturing that you only see long afterwards. Very often, people talk about repetition as if it meant doing exactly the same thing again and again; it really means going through the same kinds of motion repeatedly, without doing precisely the same thing. It struck me particularly because I was so bad to begin with that there was plenty of room for improvement, but it is something that happens even with really skilled people. There is a case for non-repeat work, too, and that has its own reasoning and philosophy. There is simply something about repetition which a lot of people under-estimate.

Alan Caiger-Smith

I said earlier that for the domestic potter trying to stay fresh, the problem of inner survival is perhaps more difficult than paying the bills. It's not something I think about often; in fact, I don't really think about it at all. Rather it's something that I am aware of, because personal fulfillment is why most of us are potters. God knows we're not in it for the money, but it's all too easy to get bogged down by the everyday problems of making a living.

Creative development isn't a constantly growing experience. It comes in fits and starts. I find that there are often long periods of just coasting along, doing the day-to-day tasks. Then suddenly I throw a shape, or take a pot from the kiln, and I know that pot represents a growth point. Then for a time after, the work seems to take on a new impetus. Somewhere in his writing Robert Frost describes this much better than I can. "The exciting movement in nature is not progress, advance, but expansion and contraction, the opening and shutting of the eye, the hand, the heart, the mind. . . . We throw our arms wide in a gesture of religion to the universe, we close them around a person. We explore and adventure for a while and then draw in to consolidate our gains."

You can't force new ideas for shapes or decorations to come. I find it's sometimes better to approach problems obliquely, stalk them from behind, or just wait for the moment and then seize it. Some of the best ideas seem to grow organically out of doing the job. For me, it is the repetition of throwing or decorating which helps bring this about. Self-consciousness and repetition can't easily exist side by side, so a relaxed state of mind is very receptive to new ideas—like an empty vessel waiting to be filled.

David Winkley

Traditional pottery has largely been replaced in our modern, technologically oriented society by mass-produced objects. One would be mistaken in concluding, however, that handmade pottery is no longer relevant. Pottery has proved to be remarkably tenacious. It seems that function, the aspect of pottery that would appear to make it redundant in twentieth-century America, has been the very feature that has enabled it not only to survive, but to flourish.

It is not enough, though, for a piece of pottery to be merely functional—Dixie cups, for example, perform admirably. Pottery, to be viable, must be able to bring elements which raise that function to an aesthetic experience. This ability is essentially what separates contemporary pottery of substance from the Dixie cup.

Rob Barnard

The Song of Jethro the Potter

Reginald Dunderdale Forbes

Jethro the potter am I,
Lord of no ancient line,
Yet at my breath the clay
Glows with the spark divine.
Though at my bidding, men
Bend not the servile knee,
Yet in my hands dead earth
Takes on eternity.
Mounted on prancing steeds,
Kings pass me by, none guess
How soon shall pomp and name
Suffer forgetfulness;
While I, all ragged clad,
Shaping with fingers deft
Urns for the dust of those
Time has of life bereft,
Whistle my life away,
Kingdoms and kings forgot,
Sure that while time endures
My art shall perish not.

Harmonizing Imagination and Logic

Wayne Higby

The dichotomous nature of functional pottery is one of its most fascinating features. In fact, the successful bridging of the division between practical problem-solving and individual expression becomes a central creative challenge for the potter. How the potter sees a way to fuse these seemingly opposite concerns defines the quality of his or her perception and artistic ingenuity.

Limits are essential to the creative process because they trigger reaction and focus energy. The greater the limitations the more vigorous the challenge. Functional pottery puts many restrictions on expression. It takes a highly sensitive, inventive, and patient individual to turn these constraints into poetry. The teapot must pour. It must be well balanced at a comfortable scale. Its handle must provide security in lifting, and its lid shouldn't fall into the cup as the tea flows from its spout. Simply stated, the teapot must "work" or be relegated to the shelf. One sure test of quality for a functional pot is whether or not it *can* be used. However, whether a pot is used is also inextricably connected to the pleasure it gives in the process of functioning. Paper plates work but provide little except convenience.

Human desire seems torn between a quest for pragmatic solutions to problems and a longing for pleasurable release. The art of the potter addresses this conflict by proving that it need not exist. More than a mere balancing act, the fine useful pot is an example of creative vision that transcends constraint by turning specific limitations into moments of artistic expression.

Uniqueness of decoration and clever manipulation of material and process can provide a potter with a signature style. But the important statements within the realm of the useful pot are made by potters who have firm control of their egos and are willing to face squarely the problems of creating for use. The good useful pots are those that reveal artistic individuality and sensitivity, particularly at the points where the pot must function. The way the lid lifts or handle responds to the hand are dynamic factors critically related to the quality of a useful pot. This clearly suggests that functional pottery is one of those rare forms of art that gives pleasure not only through visual-cerebral connections, but through physical-sensual ones as well.

Unlike architecture and the products of the artistic problem-solving activities of design, handmade pottery provides a person-to-person intimacy. The hand of the artist reaches through the object to touch the hand of the user, creating a bond of friendship, caring, and aesthetic gratification that nurtures human life and fortifies it against indifference. Harmonizing the dual forces of imagination and logic lies at the center of all artistic labor. The utilitarian pot is one of humanity's most enduring examples of how this duality is reconciled to achieve objects of intelligence and beauty.

Shards

Pottery is at once the simplest and the most difficult of all the arts.

Herbert Read

It is also important to remember that, although pottery is made to be used, this fact in no wise simplifies the problem of artistic expression; there can be no fulness or complete realization of utility without beauty, refinement and charm, for the simple reason that their absence must in the long run be intolerable to both maker and consumer. We desire not only food but also the enjoyment and zest of eating. The continued production of utilities without delight in making and using is bound to produce only boredom and to end in sterility.

Bernard Leach

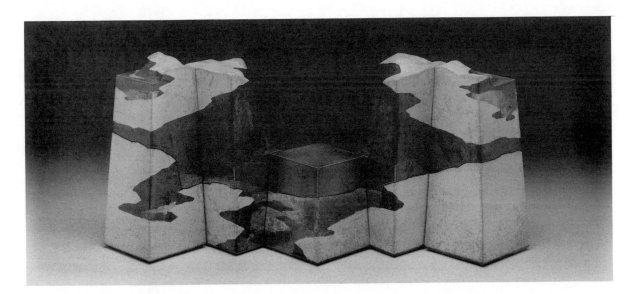

9. Wayne Higby: *Landscape Container (five lidded boxes), "Symmetrical Gap," earthenware, 14¼" high, 33⅝" wide, 9" deep, 1988. Courtesy of Wayne Higby.*

Museum Vase

Robert Francis

It contains nothing.
We ask it
To contain nothing.

Having transcended use
It is endlessly
Content to be.

Still it broods
On old burdens—
Wheat, oil, wine.

A Pot in Sonata Form

Ronald Larsen

The scene is a summer evening in 1807 at the rented lodgings in Heilegenstadt, near Vienna, of the Late Classical musician, composer, and social rebel Ludwig van Beethoven. He is pacing restlessly, evidently distraught, wrestling with the composition of his fifth symphony. "Ach, I just can't do it. All these set musical structures for the symphony; first movements in sonata form—exposition, development, recapitulation, the double return to the main key and theme for the recapitulation, a scherzo or minuet, all those rules of counterpoint! How can anyone hope to be expressive, to say anything meaningful hedged about with all these formal constraints?"

What is wrong with this scene? It is difficult indeed to imagine that Beethoven, who raised the symphony to perhaps its ultimate level of perfection and expressiveness and did it almost completely within the confines of the formal Classical structures inherited from Mozart and Haydn, would rail against the boundaries and restraints of musical form. His triumph and accomplishment, as is true for essentially all significant classical music, is that of *expression within constraint*. To be a musician and composer is to accept these constraints and to work through them and, at times, transcend them. The formal structures are never cited to excuse a failure of expression.

Now change the scene. A potter's studio emerges, the shelves filled with utilitarian ware in various stages of completion. The potter sits forlornly at the wheel contemplating the bowl just thrown. "Cripes, I can't handle this. All these functional forms and structures over and over—foot, belly, lip. What can one say with another mug? Where is the expression in a bowl? And all those teapots must balance well, pour well. How can one hope to communicate anything with all the constraints intrinsic to utilitarian pots?" A plaint that is all too familiar to most makers of functional pottery.

There is a basic parallel, I think, between the challenge of communication within the confines of classical musical form and the expressive content of functional pottery. Don't misunderstand; producing a coffee mug is not the equivalent of writing a symphony. Such hubris does not survive well in a potter's workshop. But the analogy remains.

Anyone who chooses and accepts the role of maker of utilitarian clay ware is faced with the necessity of producing pots that work and work as well as possible within the limits of the maker's skills and aesthetic decisions. Mugs should be pleasurable to the lip, pitchers should be liftable, storage jar lids should fit, flower vases should hold water, a spoon in a soup bowl should not sound like fingernails on a blackboard. These and many more

functional qualities have to be attended to, but in no way do they limit the ability of the potter to communicate. With all the choices of forming and firing methods, clay, glaze, shape, pattern, and color, the possibilities for expression are essentially limitless. A bowl, for example, can easily be friendly or aloof, crude or elegant, loud or quiet, without in any way compromising its usefulness. A potter's lack of skills, knowledge, or insight may limit what can be said within the constraints of useful pots, but those constraints in themselves are not the reason for a lack of communication.

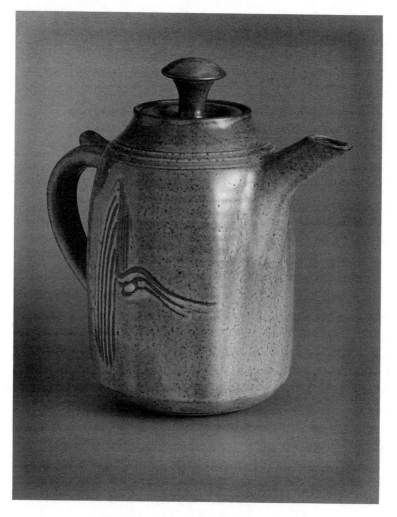

Clearly some pottery forms are more appropriate to conveying certain feelings than others. Vases are often more suited to formal aesthetic statements, mugs to more intimate ones of pleasurable use, just as the scope and magnitude of a symphony may express a weightier message than the intimate string quartet. But functional forms allow for a full range of expression.

Thus, just as Vivaldi did not carp about the expressive limits of the concerto, J. S. Bach did not complain about the rules of counterpoint when employing fugal form, and Haydn never felt unable to communicate in his one hundred and eight symphonies, the makers of utilitarian pots need not fret over the expressive constraints of their work, for the

10. Ronald Larsen: *Coffee Pot, stoneware, 8½" high, 4½" wide, 8½" deep, 1988.*

constraints are, in the main, illusory. The classical musician communicates the spectrum of human feelings and thoughts within the familiar confines of musical form, and the potter can be similarly expressive within the constraints of functional form.

If it helps, the next time just think of making a pot in sonata form.

shards

Domestic ware has plenty of opportunities for self-expression, but it's a poor vehicle for self-indulgence.

David Winkley

When any useful thing is designed the shape of it is in no way imposed on the designer, or determined by any influence outside of him, or entailed. His freedom in choosing the shape is a limited freedom, it is true, but there are no limitations so close as to relieve him or the maker of responsibility for the appearance of what they have done. The ability of our devices to "work" and get results depends much less exactly on their shape than we are apt to think. The limitations arise only in small part from the physical nature of the world, but in a very large measure from considerations of economy and of style. Both are matters purely of choice. All the works of man look as they do from his choice, and not from necessity.

David Pye

For me, making any shape whatever is a continual and progressive revelation of a form which is taking shape through my own hands. The more you enter into a long campaign of exploring the inner character of even a simple form, the more completely and excitingly it reveals itself with each new realization on the wheel. This is what my life is: for me this is what it means to be a potter.

Michael Cardew

R.S.V.P.

John Chappell

Should I write a poem on a pot
or not?
Should I try to make them understand
my clay through words
or is there some other way?
How can I tell them
that it is not I that make the pot,
it is the clay that through my fingers shapes my dreams
and brings up all my hours to the pointer's sway?
And if the ever flowing circles of my deeds
become eccentric now and then
and seated with a wobble I grow away from society,
it is the clay that keeps my sanity.
But all these words will never make any argument.
It is the teapot, cup and saucer, plate and jug
on which my efforts should be spent.
Should I write a poem on a pot?
Should I write a poem or should I not
or should I
pot?

Criticism in Ceramic Art

Warren MacKenzie

In talking about criticism or aesthetic discussion of pottery, I am concerned that it must reflect both the simplest direct experience of the objects being assessed and at the same time attempt to understand a series of relationships which can plumb the depths of the culture itself. Looking at criticism, for this talk, I am speaking of pots: containers, vessels, utilitarian ware made for use in the home but made with the possibility of communication and expression which at its best can equal any of the other arts and in its worst can be as useful and as expressive as a plastic milk carton. I want to concentrate on the *direct experience*, which I feel is one of the most important aspects of pottery communication and one which exists more powerfully in pottery than in any other creative work. Each pot is a unique experience or combination of experiences. It is also a point in time given visible form, which for all its uniqueness, is partly the result of much that has gone before. To say that we are all the sum of our knowledge—past, present, and projected future—is to belabor the obvious, but we are at the same time, each of us, someone or something which has never existed before and will never exist in exactly this form again. No matter how many billions of people live on the earth, each is similar to all of the others but each is also unique in form and thought. Pottery is like this in that despite the differences of the cultures which have produced them, all pots relate back to a primal need of man, the physical feeding of the body. Fired clay has of course been used to make a wide variety of objects including toys and playthings, building brick and tile, writing tablets and religious objects. In our time we would have to add the accouterments of the scientific world with electrical components, insulations, and fantastically sophisticated medical tools and equipment. Even though pottery may be based on some of these technological advances, if it is good pottery it always eludes the tyranny of its technology. As Philip Rawson says: ". . . instead, the resources are deployed and improvements sought ultimately for the sake of living needs: the manufacturing processes and investigations serve a purpose which lies not within their own terms of reference, but within the life of the human beings who are the pots."

However, for my discussion of criticism I would like to talk about those ceramic works which have as their basic reason for existence the containment of food or drink. This relationship with food endows utilitarian pots with special symbolic qualities.

In our time, with its proliferation of books and museums, there is an unfortunate tendency to believe we can understand a work of art uprooted from its culture and preserved behind glass or on the printed page. This belief has led directly to a basic difficulty in

criticism—the thought that abstract relationships of form and arrangement are the sum total of pottery expression. Critics are less likely to address other arts in this manner, but when faced with a utilitarian container the talk immediately descends to form, glaze, technique, and decoration. In adopting this approach the critic ignores a basic fact—that when a pot goes into a museum it is partially dead. An autopsy of the body will not result in an understanding of the force which once animated even the humblest of utilitarian vessels. Thus it is difficult, if not impossible, for a critic to assess the qualities of a pot intended for use that can only be seen in an exhibition context. A significant part of its statements is made to the user through those contacts which can only occur when this piece is part of our daily life. Putting a cup to the mouth or experiencing the interior of a soup bowl with the sweep of a spoon are things which a critic cannot do (at least with a pot on exhibit). To miss these is to miss a great part of the communication between the maker and yourself. To eliminate the tactile sense, the surface texture, balance, and weight is to eliminate many of the major elements available to the potter in making his or her statement.

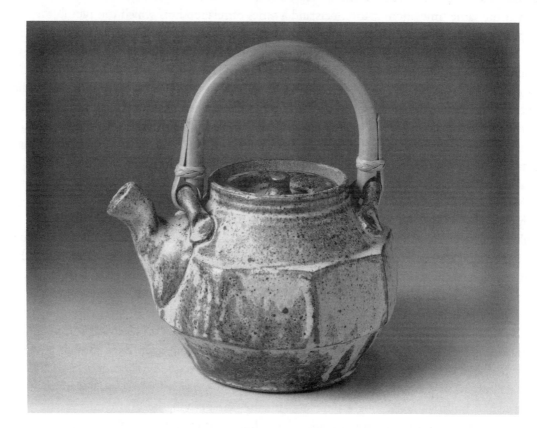

11. Warren MacKenzie: *Tea Pot, stoneware, 8" high, 6½" wide, 7½" deep, 1988. Courtesy of Warren MacKenzie.*

I have a small Hagi ware bowl that was given to me by a friend many years ago. It is a simple piece. Any competent potter could make something like it. Similar pots were probably made by the thousands by unknown potters and used as eating bowls for soup or rice served as part of a meal in a Japanese home. I owned the pot for many years before I used it

to eat from. It was only as I used it more and more that I could really relate to it as a utilitarian piece and in some way understand the qualities that were in it. Over the years I have come to regard it as one of the best pieces of pottery that I own.

I have never tried to duplicate this piece. That would be stupid. But I have found it valuable as a gauge to measure the achievement of my own work. When I feel I have some pots that are above the general run of my production I will often bring them to the house and put the Hagi piece among them. Only a few times have I felt that my work has approached the quality of this pot and those that did were pots that were made without striving for artistry of effect or uniqueness of form and decoration. Instead they were pots that had transcended my own ego or personality. Through this a pot had been made that was far more important than anything I as an individual might achieve. I don't mean to subscribe to the myth of the idiot thrower who without thinking makes thousands of pots and hopes that out of the lot some few might be good. All of my life, experience, ideas and goals are embodied in all of the pots made, but in a few there is something that defies analysis and yet which can be recognized by others if they will open themselves to the experience.

These intangibles which are so difficult to discern when looking at a piece of pottery in a gallery setting are the things that make the difference between a piece of good craftsmanship and a great work. It is the difference between a dead body and a living person. All of the external forms may be the same and either well or poorly arranged. However, that quality of life, which none of us would have difficulty in recognizing in a human being, is absent. If we are to have criticism of utilitarian pottery this problem which I feel is central to understanding must be addressed. In closing I would like to quote again from Philip Rawson:

> As we live our lives we accumulate a fund of memory traces based on our sensory experience. These remain in our minds charged, it seems, with vestiges of the emotions which accompanied the original experiences. The overwhelming majority of these experiences belong within the realms of sensuous life, and may never reach the sphere of word formation or what are usually regarded as concepts at all. And yet they probably provide the essential continuum from which evolves everyone's sense of the world and consistent reality, everyone's understanding of what it means to exist, and are even the ultimate "compost" from which scientific abstractions spring. It is in the realm of these submerged memory traces that creative art moves, bringing them into the orbit of everyday life and making them available to the experience of others by formalizing and projecting them on to elements of the familiar world which can receive and transmit them. From the artist's side the projection is done by his activity in shaping and forming. From the spectator's side it must be done by active "reading" of the artist's forms. (Rawson, *Ceramics,* 1984)

Shards

A good pot may well have even more structure to offer to the attentive hand than to the sense of sight . . . for a potter produces his forms by placing his hands and fingers in particular positions to make clay shapes. And when we are able to find these positions with our own fingers a pot can spring to life in an extraordinary fashion.

Philip Rawson

What level of experience do we achieve by running a hand over a Formica counter, gripping the rim of a stainless steel mixing bowl, or touching the door of a refrigerator? Even materials that have an intrinsic tactile surface, such as wood, are rendered neutral by being permeated with plastic and isolated from our tactile sensors. As a result, we are deprived of one of the basic senses with which potters must concern themselves, since the forms and surfaces they create are made by the pressure and grip of their hands on the clay. In some standardized and repetitive ceramics, these gestures become stereotyped and meaningless, but in a sensitively made pot this contact between maker and material can become a direct and moving experience that may be shared by users of the pot. Not only the forms which reveal themselves, but also the weight of the pot, the texture of the materials, and surface gesture provide an open door to understanding. First, however, we must overcome the inhibitions of our Western acculturation that cause us to feel knowledge by touch is immature, primitive, and even illegal. Among many other peoples, the hand is a live instrument of experience, used in daily life to hold, lift, grip, and explore. As a tool for living, it becomes a tool for knowing.

Warren MacKenzie

A Reply

Barbara Skinner

You want to write a poem on a pot?
Why not?

But wind with words the line and form,
And round the rhythm with a phrase,
Curve the lip to syllables of sound:
This is creation for the mind and ear
Not hand and eye.
Let the teapot and the cream jug break:
Forsake
These fragile creatures of the brain.
Deep from the damp earth's dungeons
Dig your clay,
Spin it
And from the magic spirals let it rise,
A springing, slender line, sensitive, ageless.
Fire it, hold it petrified in stone
Safe beyond time.

The form, the rhythm and the phrase
Are yours
And you have got,
A poem
And a pot.

A Potter's Philosophy

Marguerite Wildenhain

Most of us have been given by nature the average capacities that make a normal human being: counting on the kindness of nature we take that almost for granted. A feeling heart and an adequate brain to cope with the daily requirements of life we generally are graciously given; also all our senses, to see, to hear, to smell, to feel, to be able to walk, to stand, to move our limbs and so on. We rarely think about all that and barely are we grateful.

But a few of us sometimes get more than average gifts: perhaps it is a beautiful voice or an ear to play an instrument, or legs to dance with, or hands specially apt to make things, and eyes to see what most cannot see. All that too we take for granted, I believe, and do not reflect on the obligation that special gift puts on us.

Let me be specific. Potters are craftworkers; that is, they use their hands to make objects for everyday use that need to have form and design as an integral part of their being. To be able to do this potters need a certain ability, not only of the hands (as most might think) but especially a capacity to *see* what is formful, beautiful, characteristic and so on. Beyond this capacity they also need to be able to *convey* what is seen and felt into inert material, and somehow mysteriously make it come to life.

To see is very difficult; to see, not like a camera, but with a feeling heart, with a bright brain, with more than average sensitivities, what everybody also could see, if they knew how to look! The first thing a fledgling potter needs to learn is to see. It is a long and often trying process and often exasperatingly difficult and demanding in patience and perserverance. To be able to see, namely, that the *outside* of a thing is also the expression and the character of the *inside*, of the life itself of that thing, for that one needs training day by day, year by year. It does not come easily, but it is the main test of the artist-craftworker which we would all like to be. The technique of the pottery craft itself, though often very difficult, is like child's play compared to the demands made on your eyes, your mind, your whole sensitivities. You never can learn enough; but life in this development of all your senses becomes very exciting, and it will require the dedication of your total being and of all your capacities, even those that you do not know you possess.

If you want to be a potter, it is this total development of all your abilities and sensibilities that is required, and *that* is difficult to learn. Obviously it takes quite a special gift just to be *moved*, let us say, by the most ordinary sights of life; for example, by the proportions of a leaf, or by the rhythm of its veins or by the variety of its forms inside the given pattern of

that leaf, and then be able to convey this emotional experience in your materials with a few lines or colours.

There is no limit to what has to be looked at: any stone on the edge of a river or on the beach has a very special lesson on sculptural form: a sponge with its fuzzy holes in contrast to a piece of hard lava with holes will also make you look intensely and perhaps for hours at what makes the two forms and materials so different in character, though on first look they seem to be more or less alike. Mountains with their different rock formations convey different expressions and feelings, trees all have different forms, different ways of growing, different leaves and fruit, and so they convey different feelings to us. And so on.

But why do craft potters need to go through all these difficult steps for their development? Because first of all, craft potters who are any good have to have hearts and be moved by what is alive *first*, then they have to learn to see form and content as a *unity*, how the one cannot be there without the other, since the form is an expression of what is behind it, namely, a living soul.

When potters make pots the forms must not only be adequate to the uses and purposes they were meant to serve, but must also convey an idea of the feelings of the potter, just as if they were making a figure or a bird. And all this has to come from their own experience of life. If they cannot manage to transfer their deepest being and feelings into the "being" of the pot, the main thing is missed, and it will not have life. So the pot just remains a technical something on a lowly piece of clay around a hole. Let us abhor making these.

Abstract sculptural form, *that* is what a good pot should be first, but it also needs to have a living warmth and a tension of its lines, so that its proportions and masses will *move* a person who can see. This is the point that is the most difficult to reach, and that will never be reached if we have not learned to see. Any design as a decoration, must be well drawn, well placed, and the lines must *live*, must have tension and rhythm, must fit just on that one special pot and must accentuate that which you want the form to say. It will also work from all sides, not just from the front, because the pot is a sculpture and has to be seen all round and from all angles and must remain convincingly alive and beautiful. Just as we have to be able to read to get the contents of a good book it is essential to learn to see.

It is painful to state that in our times many have never learned to see, and yet such people make pots or sculpture or whatever else they choose. That these items are ugly, badly made, insipid and totally devoid of life, does not seem to bother the makers. Actually they are worse than just ugly, they are false and dishonest products for they are not naive or simple because the maker is just *that*: naive and simple, they are plainly ugly and falsely simple because the potter was neither well trained, nor skillful, nor sensitive, nor gifted, nor educated, but in no way naive and honest and simple. For if a person has learned to develop some of the more intelligent aspects of creative life, that would have been a defence against falling for anything that is just "new" or "up to date." They would have learned to put enthusiasm into whatever is well-made, honest, and in a real way personal, not in a "trick."

How have we come to that state of affairs? Twelve years of basic education at school and at least four more in colleges . . . and we have not learned to be truthful; nor have we learned from former generations and other cultures what *they* have done that is of permanent value, and so would have received a sense of proportion as to our own achievements. Most of the students are so alienated from their society, even from their families or their background, that they can only think of, and get pleasure out of the affirmation of their ego,

their pleasures, tastes, likes and dislikes and so on. What they don't care for is "out." There is little attempt to understand what other cultures and times have produced that maybe could also be an inspiration. And how rarely in the field of the crafts is anyone ever asked to work on a project that would require more than a short effort, that would need constant application over a long period? Nobody is forced to follow through, to perhaps its painful end, what was perhaps a good beginning (though in itself ONLY just that, a beginning), nobody needs to battle with the materials, the techniques, the feelings, the honesty of expression . . . and so through these continuous efforts develop what is really in them and what makes the result their work. Few even have ever had a critical appraisal of their work.

All those painful experiments, trials and errors would soon make you find out who you are, what abilities may be yours, which one you do *not* have, how or whether you can respond to the world around you, or to your own dreams. Sometimes, and more often than not, this is a painful voyage of discovery, but only through efforts and pains does one grow anyway. Is it not just that which develops the individual? To face oneself is the beginning of all wisdom and to *evade* the issue is cowardly.

And this is how we come back to the issue of learning (to see). Let us frankly admit that we know little, that we need and want to learn as much as we can as thoroughly and well as possible, that we will muster all our abilities to develop whatever there is in us (sometimes to your surprise more than you thought!) so that possibly we could have something valid to say, after all. But, more than anything else, let us acknowledge first as a principle and as the most important maxim of our life, that every gift we were given is a deep and lasting obligation that we will find rewarding to fulfil to the last days of our life.

You are familiar with most of the basic techniques of pottery; throwing on the wheel, making handles, lids, and spouts and so on, and know about slipping, decorating, glazing, packing kilns and firing. These are basic skills that we need to control so that we can use them in whatever way we choose to work.

But all this is not enough to produce a really good pot. No techniques alone, however elaborate or difficult, can ever make a really excellent piece of pottery. Nor is the opposite, an elementary or simple technique, a reason to regard a pot as inferior to a more difficult-to-achieve one. We have all seen many pots with technically skillful glazes and decoration that have left us absolutely cold, while on the other hand, pots made by American Indians or by prehistoric people in China or by potters of the ancient civilisation of Suza (4000 to 3000 B.C.) have excited us and moved us to tears, perhaps. Why does that happen, you may ask, and I would answer, "Because techniques alone are dead." They are an abstraction of knowledge, but they do not come from the heart and the soul, nor from the depth of the character of the potter; they do not produce all those inner qualities that are absolutely essential to any expression in the field of art. What those excellent but primitive pots mentioned above had outside of their techniques was "life," namely: they were the expression of human beings who not only knew their craft (as they all did formerly) but also felt and saw and could articulate their feelings in their materials and with their forms. They knew how to use those simple techniques like they used their hands and feet, quite spontaneously, without inhibitions and each in their own special way. They said something with their work that all could understand at that time, but which also would be understood in the future because what was said was eternally valid.

We may wonder why those perhaps more simple women and men could achieve what most of us cannot. To me it is no mystery; they were not only competent potters, they were also dedicated and inspired and there was no dichotomy between their life and their work. They made pots for daily need, but *also*, for beauty and in dedication to their religious belief, to nature, to the gods, to Woman and Man. It was all *one*, and it was LIFE.

Let us see how we can perhaps get back some of that dedication, wholeness, and devotion to our work that they had to theirs. First we have to learn the craft, not dilettantically (as so much is nowadays), but quite thoroughly. It is our alphabet and we cannot say anything at all if we do not master that, but we also need to know the syntax of our potters' language. Let me explain: all pots are made of several parts, even the simplest has a foot, a belly, a rim or a neck. Like the parts of a sentence they have to relate well and say clearly what you mean to say. Many pots have far more attributes, they may be complex in their own form and in relation to others, especially if they are part of a large unit, table-ware for example, where every pot must relate with every other one and with the whole, in form, in character and feeling. We must build a coherent unity that is well thought out, well made and convincing. But even all this knowledge is not enough, though essential. Ultimately it is what the potter says about the work that matters: is it just a joke that amuses for a very short time, as all jokes do, but gets extremely boring on repeat and in additional imitations, or it is some "modern" trick that will be imitated by everybody tomorrow and become obsolete next week? Or is what they say with the pots deeply moving, having a beauty quite its own and thus of permanent value because it is truly and intensely the work of an inspired, dedicated, and gifted person?

This is the issue and thus also the problem of the potter. How does one get to that state of mind and knowledge and feeling and devotion so that the pot becomes, it seems, the natural result of all those qualities? Let us try to find out.

How do we go about conceiving pots? Where do those imaginary pots come from and how do they get from the initial image in our mind to become the work of our hands? Perhaps one could say they originate from the collective vision of all pots that in some mysterious way have accumulated during our lifetime in the depth of your soul. They are not only those that you have seen, but all that you have imagined or can imagine in the future, that lie untapped in your subconscious and that will surge into life when you pull them out of that strata and actually start making them in clay. All this does not happen consciously, of course, but out of the depth of your inner reserve comes up an exciting multitude of different objects that stand before your inner eye in quite specific forms, sizes, materials, characters, expression and purpose, out of which you will choose when you actually start making a form in clay.

How does one choose the ones to make? There are these points to consider: the choice of material and technique and the attention one has to give to the basic facts of objective use, thus the competent solution of all technical problems. This is an absolute necessity, and the better the potter is, the more different and excellent solutions to problems will be found, in fact these sometimes tough problems will be faced with enthusiasm because they increase imaginative and formative abilities.

Once these technical though important problems have been resolved the far more sensitive and difficult question has to be considered, of what I would like to call the "inner

life" of the pot: namely the relation of lines to sculptural form, of details to the total mass, of vertical to horizontal planes, of more or less active curves to lazy and relaxed ones, and all those separate items to the total character of the form that you are making and trying to bring to *life*. Later there is also the choice of decoration (if any) and of the glaze so that both accentuate the expression of what the whole pot says.

Every glaze has a certain character; its thickness or thinness, its transparency or opacity, its lightness or darkness, shininess or mattness; all need to be considered so that the decoration and the glaze fit like a skin. And there is also, last but not least, the controlled knowledge of the firing, and when all is done as best you can there are still many imponderables that no potter can control, because "we all play with fire" and the fire-god is fickle.

For professional potters who make their daily living from pottery, one of the most difficult problems is how to invent new and alive forms: that is the move from an honest and competent *plain* potter to one who is *creative, inspired* and *imaginative*. That is the test of your life as a potter.

All the technical questions and also those of skill and dexterity and imagination still do not touch the really vital point, namely, how does one make a pot, or a line, or a form or design, come to life? How can one make a pot breathe, have tensions and character, expression and life? How can a piece of lowly clay become an object of beauty that will move us deeply and that will retain that quality for all times and be a stirring experience for all sensitive people, now and in the future? It is not difficult to understand that such an intangible quality that does not depend on materials or techniques, or even on skill and labour, is not easily attainable, for one cannot command it at will. You may try as best you can and LIFE will still elude you, and the vital spark will not come to that pot you are making and not ignite its life.

These are rare moments, and the artists accept this gift with deep gratitude and a tremendous sense of obligation, knowing that they cannot command such happening at will. It is rather a matter of human openness to a certain spiritual extasis that comes upon the potter when deeply moved and completely forgetful of self in work. In a mysterious synthesis they become the pots to which they have tried to give life, and at the same time, the pot becomes the essence, the soul of what the potter is, what the potter feels, thinks, knows and believes. In this unconscious interchange, all the former experiences of the potter that have been lying, so to say, in an unused but alive pool of images and forms, seem to come to the fore through the intermediary of vision, talent and the depth and intensity of feeling. But this is a process as far from "self-expression" as possible. For it is not *you* but the *pot* that has come to life, that has "expressed" itself. In a strange way you are only the medium through which the actual life of that pot is created; in a mysterious union, not quite under your control, there is a fusion of materials and feelings, of techniques and heart and emotions, of will and humility, of pride and thankfulness, a union of both the pot and yourself.

Shards

The question is not what you look at, but what you see.

Henry David Thoreau

A number of years ago at an exibition of Bernard Leach pots, which was the first time I ever saw that many of them, I happened to be standing next to Warren MacKenzie in front of a very large jug with an iron black glaze. I just didn't get it and asked Warren what it was that made this a good pot. He said: "For heaven's sake just *look* at it!"

Shoji Hamada was asked once to critique student pots at Black Mountain College. After looking silently at them for a long time, he said: "These *look* like good pots . . . but they're not."

Angela Fina

A pot is an odd article to appreciate. A potter's statements are conveyed by suggestion and innuendo. Often the first sight of a pot will be quite different from the following in two weeks, three years. The appreciation of a pot demands not so much a thoughtful analysis, but a kind of everyday, sensual response. I depend on time to make the judgment. It will. Time will root out the pot's foolishness, its ill proportion, its discomfort—whatever there is bad or good about it.

Michael Simon

Without using there is no complete seeing, for nothing so emphasizes the beauty of things as their right application.

Soetsu Yanagi

I am willing to accept less than the best, but never to strive for less than the best. To do otherwise is like taking aim without setting your sights on the bull's eye.

There are no rules. There are only opportunities.

David Shaner

Genuine work is never easy. The effort is the reward, and success which costs nothing is worth exactly what it cost.

Charles Fergus Binns

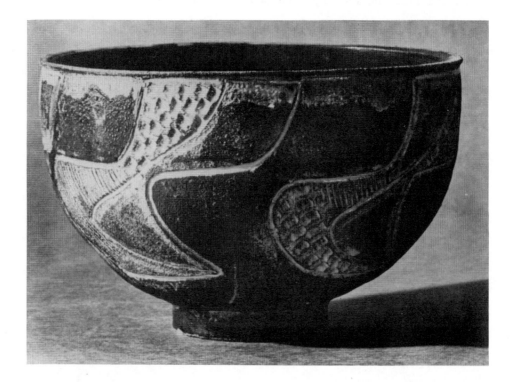

12. Marguerite Wildenhain: Carved Bowl, stoneware, 1970s. From The Invisible Core: A Potter's Life and Thoughts, *by Marguerite Wildenhain, 1973, Pacific Books, Publishers, Palo Alto, CA.*

What Magic

Charles Counts

What magic is there in it?
What force
 what mystery
to be caught in the centrifugal power
that the turning WHEEL
has when it takes
COMMON CLAY
and shapes it into FORM.
Simple act . . . (or so it appears:
 the taking of clay
 and making of a pitcher).
 A vessel of service for MAN and TIME and SPACE.
Seeing it done by a master is
 indeed magic.
So seemingly effortless
 like a dance,
 and out of the process
 comes a real object.
I was inspired . . . turned . . . by
 the reality of this work.
 Somehow
a "calling" had come to me
 and I was changed.

Design Proposes, Workmanship Disposes

David Pye

In the years since 1945 there has been an enormous intensification of interest in Design. The word is everywhere. But there has been no corresponding interest in workmanship. Indeed there has been a decrease of interest in it. Just as the achievements of modern invention have popularly been attributed to scientists instead of to the engineers who have so often been responsible for them, so the qualities and attractions which our environment gets from its workmanship are almost invariably attributed to design.

This has not happened because the distinction between workmanship and design is a mere matter of terminology or pedantry. The distinction both in the mind of the designer and of the workman is clear. Design is what, for practical purposes, can be conveyed in words and by drawing: workmanship is what, for practical purposes, cannot. In practice the designer hopes the workmanship will be good, but the workman decides whether it shall be good or not. On the workman's decision depends a great part of the quality of our environment.

Gross defects of workmanship the designer can, of course, point out and have corrected, much as a conductor can at least insist on his orchestra playing the right notes in the right order. But no conductor can make a bad orchestra play well; or, rather, it would take him years to do it; and no designer can make bad workmen produce good workmanship. The analogy between workmanship and musical performance is in fact rather close. The quality of the concert does *not* depend wholly on the score, and the quality of our environment does *not* depend on its design. The score and the design are merely the first of the essentials, and they can be nullified by the performers or the workmen.

Our environment in its visible aspect owes far more to workmanship than we realize. There is in the man-made world a whole domain of quality which is not the result of design and owes little to the designer. On the contrary, indeed, the designer is deep in its debt, for every card in his hand was put there originally by the workman. No architect could specify ashlar until a mason had perfected it and shown him that it could be done. Designers have only been able to exist by exploiting what workmen have evolved or invented.

This domain of quality is usually talked of and thought of in terms of material. We talk as though the material of itself conferred the quality. Only to name precious materials like marble, silver, ivory, ebony, is to evoke a picture of thrones and treasures. It does not evoke a picture of grey boulders on a dusty hill or logs of ebony as they really are—wet

dirty lumps all shakes and splinters! Material in the raw is nothing much. Only worked material has quality, and pieces of worked material are made to show their quality by men, or put together so that together they show a quality which singly they had not. 'Good material' is a myth. English walnut is not good material. Most of the tree is leaf-mould and firewood. It is only because of workman-like felling and converting and drying and selection and machining and setting out and cutting and fitting and assembly and finishing—particularly finishing—that a very small proportion of the tree comes to be thought of as good material; not because a designer has specified English walnut. Many people seeing a hundred pounds worth of it in a London timberyard would mistake it for rubbish, and in fact a good half of it would be: would have to be.

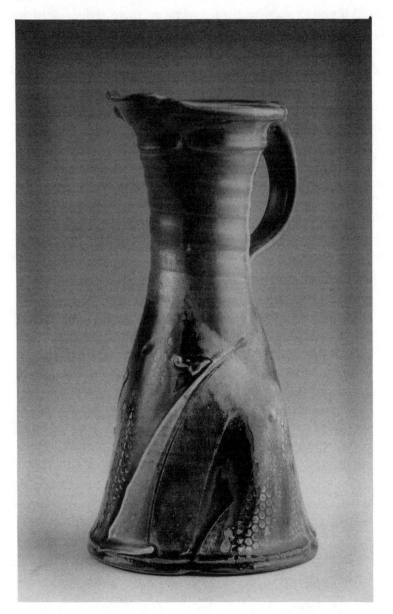

13. Steven Hill: Pitcher, stoneware, 15" high, 7" deep, 1984.
Courtesy of Steven Hill.

So it is with all other materials. In speaking of good material we are paying an unconscious tribute to the enormous strength of the traditions of workmanship still shaping the world even now (and still largely unwritten). We talk as though good material were found instead of being made. It is good only because workmanship has made it so. Good workmanship will make something better out of pinchbeck than bad will out of gold. *Corruptio optimi pessima!* Some materials promise far more than others but only the workman can bring out what they promise.

In this domain of quality our environment is deteriorating. What threatens it most is not bad workmanship. Much workmanship outside of mass-production is appallingly bad and getting worse, to be sure, and things are seen in new buildings which make one's hair rise. But at least it is easy to see what the remedies are, there, if difficult to apply them. Moreover, it is not the main danger, because it is outside the field of mass-production, and the greater part of all manufacture now is mass-production; in which, although there is some bad workmanship, much is excellent. Much of it has never been surpassed and some never equalled. The deterioration comes not because of bad workmanship in mass-production but because the range of qualities which mass-production is capable of just now is so dismally restricted; because each is so uniform and because nearly all lack depth, subtlety, overtones, variegation, diversity, or whatever you choose to call that which distinguishes the workmanship of a Stradivarius violin, or something much rougher like a modern ring-net boat. The workmanship of a motor-car is something to marvel at, but a street full of parked cars is jejune and depressing; as if the same short tune of clear unmodulated notes were being endlessly repeated. A harbour full of fishing-boats is another matter.

Why do we accept this as inevitable? We made it so and we can unmake it. Unless workmanship comes to be understood and appreciated for the art it is, our environment will lose much of the quality it still retains.

Shards

You understand that our ground is that not only is it possible to make the matters needful to our daily life works of art, but that there is something wrong in the civilization that does not do this: if our houses, our clothes, our household furniture and utensils are not works of art, they are either wretched makeshifts or, what is worse, degrading shams of better things.

First. Your vessel must be of a convenient shape for its purpose. Second. Its shape must show to the greatest advantage the plastic and easily-worked nature of clay; the lines of its contour must flow easily; but you must be on the look-out to check the weakness and languidness that comes from striving after over-elegance. Third. All the surface must show the hand of the potter, and not be finished with a baser tool. Fourth. Smoothness and high finish of surface, though a quality not to be despised, is to be sought after as a means for gaining some special effect, and not as an end for its own sake. Fifth. The commoner the material the rougher the ornament, but by no means the scantier; on the contrary, a pot of fine materials may be more slightly ornamented, both because all the parts of the ornamentation will be minuter, and also because it will in general be considered more carefully. Sixth. As in the making of the pot, so in its surface ornament, the hand of the workman must be always visible in it; it must glorify the necessary tools and necessary pigment: swift and decided execution is necessary to it; whatever delicacy there may be in it must be won in the teeth of the difficulties that will result from this; and because of these difficulties the delicacy will be more exquisite and delightful than in easier arts where, so to say, the execution can wait for more laborious patience. These, I say, seem to me the principles that guided the potter's art in the days when it was progressive: it began to cease to be so in civilized countries somewhat late in that period of blight which was introduced by the so-called Renaissance.

William Morris

Anecdote of the Jar

Wallace Stevens

I placed a jar in Tennessee,
And round it was, upon a hill.
It made the slovenly wilderness
Surround that hill.

The wilderness rose up to it,
And sprawled around, no longer wild.
The jar was round upon the ground
and tall and of a port in air.

It took dominion everywhere.
The jar was gray and bare.
It did not give of bird or bush,
Like nothing else in Tennessee.

The Workmanship of Risk and the Workmanship of Certainty

David Pye

Workmanship of the better sort is called, in an honorific way, craftsmanship. Nobody, however, is prepared to say where craftsmanship ends and ordinary manufacture begins. It is impossible to find a generally satisfactory definition for it in face of all the strange shibboleths and prejudices about it which are acrimoniously maintained. It is a word to start an argument with.

There are people who say they would like to see the last of craftsmanship because, as they conceive of it, it is essentially backward-looking and opposed to the new technology which the world must now depend on. For these people craftsmanship is at best an affair of hobbies in garden sheds; just as for them art is an affair of things in galleries. There are many people who see craftsmanship as the source of a valuable ingredient of civilization. There are also people who tend to believe that craftsmanship has a deep spiritual value of a somewhat mystical kind.

If I must ascribe a meaning to the word craftsmanship, I shall say as a first approximation that it means simply workmanship using any kind of technique or apparatus, in which the quality of the result is not predetermined, but depends on the judgement, dexterity and care which the maker exercises as he works. The essential idea is that the quality of the result is continually at risk during the process of making; and so I shall call this kind of workmanship "The workmanship of risk": an uncouth phrase, but at least descriptive.

It may be mentioned in passing that in workmanship the care counts for more than the judgement and dexterity; though care may well become habitual and unconscious.

With the workmanship of risk we may contrast the workmanship of certainty, always to be found in quantity production, and found in its pure state in full automation. In workmanship of this sort the quality of the result is exactly predetermined before a single saleable thing is made. In less developed forms of it the result of each operation done during production is predetermined.

The workmanship of certainty has been in occasional use in undeveloped and embryonic forms since the Middle Ages and I should suppose from much earlier times, but all the works of men which have been most admired since the beginning of history have been made by the workmanship of risk, the last three or four generations only excepted. The techniques to which the workmanship of certainty can be economically applied are not nearly so diverse as those used by the workmanship of risk. It is certain that when the workmanship of certainty remakes our whole environment, as it is bound now to do, it will also change the visible quality of it.

The most typical and familiar example of the workmanship of risk is writing with a pen, and of the workmanship of certainty, modern printing. The first thing to be observed about printing, or any other representative example of the workmanship of certainty, is that it originally involves more of judgement, dexterity, and care than writing does, not less: for the type had to be carved out of metal by hand in the first instance before any could be cast; and the compositor of all people has to work carefully; and so on. But all this judgement, dexterity and care has been concentrated and stored up before the actual printing starts. Once it does start, the stored-up capital is drawn on and the newspapers come pouring out in an absolutely predetermined form with no possibility of variation between them, by virtue of the exacting work put in beforehand in making and preparing the plant which does the work; and making not only the plant but the tools, patterns, prototypes and jigs which enabled the plant to be built, and all of which had to be made by the workmanship of risk.

Typewriting represents an intermediate form of workmanship, that of limited risk. You can spoil the page in innumerable ways, but the N's will never look like U's, and however ugly the typing, it will almost necessarily be legible. All workmen using the workmanship of risk are constantly devising ways to limit the risk by using such things as jigs and templates. If you want to draw a straight line with your pen, you do not go at it freehand, but use a ruler, that is to say, a jig. There is still a risk of blots and kinks, but less risk. You could even do your writing with a stencil, a more exacting jig, but it would be slow.

Speed in production is usually the purpose of the workmanship of certainty but it is not always. Machine tools, which, once set up, perform one operation, such for instance as cutting a slot in an absolutely predetermined form, are often used simply for the sake of accuracy, and not at all to save time or labour. Thus in the course of doing a job by the workmanship of risk a workman will be working freehand with a hand tool at one moment and will resort to a machine tool a few minutes later.

In fact the workmanship of risk in most trades is hardly ever seen, and has hardly ever been known, in a pure form, considering the ancient use of templates, jigs, machines and other shape-determining systems, which reduce risk. Yet in principle the distinction between the two different kinds of workmanship is clear and turns on the question: "Is the result predetermined and unalterable once production begins?"

Bolts can be made by an automatic machine which when fed with blanks repeatedly performs a set sequence of operations and turns out hundreds of finished bolts without anyone even having to look at it. In full automation much the same can be said of more complex products, substituting the words "automated factory" for "automatic machine." But the workmanship of certainty is still often applied in a less developed form where the product is made by a planned sequence of operations, each of which has to be started and stopped by the operative, but with the result of each one predetermined and outside his control. There are also hybrid forms of production where some of the operations have predetermined results and some are performed by the workmanship of risk. The craft-based industries, so called, work like this.

Yet it is not difficult to decide which category any given piece of work falls into. An operative, applying the workmanship of certainty, cannot spoil the job. A workman using the workmanship of risk assisted by no matter what machine-tools and jigs, can do so at almost any minute. That is the essential difference. The risk is real.

But there is much more in workmanship than not spoiling the job, just as there is more in music than playing the right notes.

There is something about the workmanship of risk, or its results; or something associated with it; which has been long and widely valued. What is it, and how can it be continued?

It is obvious that the workmanship of risk is not always or necessarily valuable. In many contexts it is an utter waste of time. It can produce things of the worst imaginable quality. It is often expensive. From time to time it had doubtless been practised effectively by people of the utmost depravity.

It is equally obvious that not all of it is in jeopardy: for the whole range of modern technics is based on it. Nothing can be made in quantity unless tools, jigs, and prototypes, both of the product and the plant to produce it, have been made first and made singly.

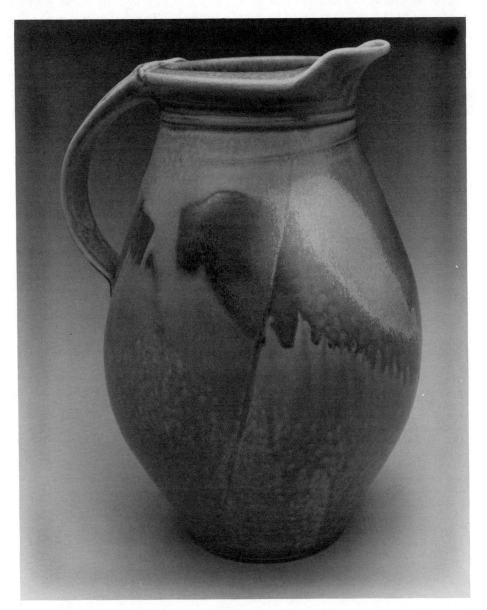

14. Steven Hill: *Pitcher, stoneware, 11" high, 9" deep, 1990. Courtesy of Steven Hill.*

It is fairly certain that the workmanship of risk will seldom or never again be used for producing things in quantity as distinct from making the apparatus for doing so; the apparatus which predetermines the quality of the product. But it is just as certain that a few things will continue to be specially made simply because people will continue to demand individuality in their possessions and will not be content with standardization everywhere. The danger is not that the workmanship of risk will die out altogether but rather that, from want of theory, and thence lack of standards, its possibilities will be neglected and inferior forms of it will be taken for granted and accepted.

There was once a time when the workmanship of certainty, in the form colloquially called "mass-production," generally made things of worse quality than the best that could be done by the workmanship of risk—colloquially called "hand-made." That is far from true now. The workmanship of a standard bolt or nut, or a glass or polythene bottle, a tobacco-tin or an electric-light bulb, is as good as it could possibly be. The workmanship of risk has no exclusive prerogative of quality. What it has exclusively is an immensely various range of qualities, without which at its command the art of design becomes arid and impoverished.

A fair measure of the aesthetic richness, delicacy and subtlety of the workmanship of risk, as against that of certainty, is given by comparing the contents of, say, the British Museum with those of a good department store. Nearly everything in the Museum has been made by the workmanship of risk, most things in the store by the workmanship of certainty. Yet if the two were compared in respect of the ingenuity and variety of the devices represented in them the Museum would seem infantile. At the present moment we are more fond of the ingenuity than the qualities. But without losing the ingenuity we could, in places, still have the qualities if we really wanted them.

Shards

The very expansion of the machine during the last few centuries has taught mankind a lesson that was otherwise, perhaps, too obvious to be learned: the value of the singular, the unique, the precious, the deeply personal. There are certain occasions in life when the aristocratic principle must balance the democratic one, when the personalism of art, fully entered into, must counteract the impersonalism, and therefore the superficiality, of technics. We do no one any service, with our reproductive processes, if we limitedlessly water the wine in order to have enough to give every member of the community a drop of it, under the illusion that he is draining an honest glass. Unless we can turn the water itself into wine, so that everyone may partake of the real thing, there is in fact no miracle, and nothing worth celebrating in the marriage of art and technics.

Lewis Mumford

No machine can compare with a man's hands. Machinery gives speed, power, complete uniformity, and precision, but it cannot give creativity, adaptability, freedom, heterogeneity. These the machine is incapable of, hence the superiority of the hand, which no amount of rationalism can negate. Man prefers the creative and the free to the fixed and the standardized.

Soetsu Yanagi

Fragments

Charles Counts

We know the past by pieces
 by sherds
 broken pieces of pottery found
 beneath the earth's crust
 having once been a part, expressing totality.
Now still a part more and less so
 speaking history to us
 being form in fragment.
What can we name it . . .
 when a way of life still exists
 and itself is a fragment
 being part of the past and
 projecting tenaciously into our time?
Patterns of existence . . . what for?
 this life-way discovered and reported is not a
 hard-fact fragment
 it is a real existence
 flowing
 continuously in today from yesterday
 making tomorrow.
In our totality of today we can see it only
 as a fragment and learn some truth
 in its form. Paradoxically in looking
 we atrophy it making it hard and fast.
But this must be transcended for today was
 yesterday and our living
 will see tomorrow.
Potters are water-carriers of history's truths.

Making Music Versus Merely Playing the Piano

Everette Busbee

Two or three hundred pianists can play the piano
better than I, but few can make music as well

Artur Rubinstein

The young reporter submitted a story saying, "When
the judge sentenced the defendant, she fell prostitute on the
floor." His editor informed him he must learn to distin-
guish between a woman who has fallen and one who has
merely lost her balance.

Anonymous

Craftsmanship. For those of us in clay, a warm, comfortable word, and
for many, a word seeming to have grown from the earth like a great mountain, and as
unquestionable. But just as the tongue keeps returning to where the filling is missing, I have
often had the haunting feeling that the word craftsmanship somehow better suits the build-
ing trades, whose rigidly defined goals demand such accuracy and economy that the indi-
vidual touch is rarely perceptible, always inconsequential. The word seems oddly out of
place in contemporary American ceramics, where constraints are rare and the individual
touch is everywhere—is everything. Potters, once as necessary as carpenters and masons,
now produce pitchers as unnecessary as a painting on a wall, and perhaps as unconcerned
with accuracy and economy. Yet we tenaciously retain a word denying this, even though
any newly obsolete but still powerful word banging around in our thoughts can confuse
goals and misdirect energy. This may partially explain our field's notorious love affair with
technique.

A rule of thumb I use to determine if a juried exhibition is worth seeing: If the word
"craftsmanship" appears even once in the juror's statement, the exhibition will be
unexciting, and if "craftsmanship" is preceded by "the necessity of good," no glaze in the
show could match the depth of the one that would form over my eyes.

Modern ceramics has a history of questioning emphasis on craftsmanship. Shoji
Hamada, in his late fifties, said that every potter in Tamba had more skill than he, but added
as a so what, "skill is cheap." His fellow countryman, Rosanjin, called soulless craftsmanship
a "reckless tool," and insisted that pottery was not an art of technical expertise, but was
"dependent solely upon the beauty of the mind."

Over a decade ago John Mason included all of ceramics when he noted the trend

toward a "fastidious technical execution of craft in an effort to attain professional status," leading to sacrifice of "inner experience in favor of results," producing "a ceramic form empty in content and lacking in vitality, as demonstrated by the examples seen in our stores, exhibitions and architectural commissions." This bare-knuckles criticism is well summarized by Baudelaire's famous comment in his review of the 1900 Paris Salon: "The painting is getting better and better, and I find it a lamentable thing."

The definition of "craftsmanship" centers on "skill," which according to the dictionary is "the ability to do something well." This "something" done well can refer equally to the activities of a nation's most skilled peace negotiator or a dictator's most skilled elicitor of confessions. So choosing "something" to do is ultimately more important than the doing. Words, supposedly the servant of thought, can become its tyrant. Deep in our hearts we know "craftsmanship" has something to do with "well finished." Couple this with the possibly genetically dominant view that possession of ample craftsmanship is qualification for beatification, and we may be off and running toward the goal of technical perfection, without once having questioned it—thought control at its best. The real question is not "Is my craftmanship good enough?" It is "What do I want my work to be?"

Craftsmanship as the pursuit of technical perfection—such an easy, well-lit route. There is the story of the man under a street light who, when asked what he was doing, replied he was looking for something he lost over there. When asked why he was searching here rather than over there where he lost it, he replied that the light was much better here. Under the light we will always be comfortable, and will probably find something sooner or later. But not what we are looking for. For the real goal, the music rather than the piano playing, we must search in darkness. Yet this term, "search," implying something already exists, is misleading. We do not search, we choose—from infinite possibilities—making something out of nothing. We choose to work meticulously, we choose to work roughly. All very simple—until we introduce the concept of craftsmanship. All of a sudden there is the implication that those unworthy of accolades for craftsmanship, if suddenly blessed with better coordination, would, after thanking providence for a second chance, assiduously perfect their skills and join the ranks of the truly talented.

Some other fields have an admirable, richer use of "well crafted" as "well composed, designed, or thought out," as in: *The Art of the Fugue, The Turn of the Screw* and the model Paulina Porizkova are well crafted." An ingenious attempt in ceramics to rehabilitate—or to neutralize—the word "craftsmanship" has been redefining it as "the ability to do what you want to do," as Ken Ferguson and Warren MacKenzie have done. This leads irrefutably to the unsatifying conclusion that a potter with George Ohr's abilities, who has an unfulfilled desire to throw twice as tall and twice as thin, is a lousy craftsperson. This logic can be avoided by assuming a reasonable desire. But it then follows that every trained professional has the ability to do what he or she reasonably wants to do, or can—after sufficient offerings to the god of the shard pile—acquire that ability. That is, for every professional craftsmanship is a given, and as such, is devoid of critical value. John Mason gave me a variation of the "ability to do what you want" theme: Craftsmanship in itself is meaningless; it is merely something that allows you, with a certain directness and economy, to get the job done, to get your ideas across. Notice that with a substitution of "a hard rubber rib" for "craftsmanship," the sentence still makes sense. Craftsmanship is a tool, not a message, and again has no critical value. This definition may also refer to the aesthetic economy of using the largest

brush or the fewest brush strokes to get the job done, but this would be a craftsmanship of boldness, not technical perfection.

When we really get down to it, if we exclude our early fumblings, a failure in clay is due to a failed idea, not motor ineptness. Is there a single potter who makes gorgeous but technically inept pitchers? How many thousands make vice versa? And think of the hordes of students sitting at a wheel, staring blankly at a passable, even fresh, 8-inch cylinder, wondering what to do next, and who, if asked if they are limited by idea, eye, or technical abilities, would moan, "Technical abilities." And so, as if one more weight loss book is purchased in the vain hope it will lead to slimness without dieting, they search out one more technique in the vain hope it will produce excellence without thinking.

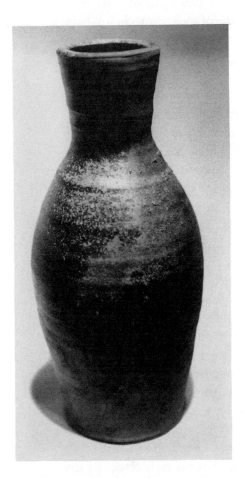

15. Everette Busbee: *Anagama Vase, stoneware, 17" high, 6" diameter, 1987–88. Courtesy of Baltimore Clayworks.*

The love of technique in ceramics reflects our wider culture's love of technique over idea. High-tech constructions light television and movie screens, stimulating little more than optic nerves. A radio segment attributes the recent cocaine-related death of a ballet star in part to pressure induced by the growing demand in ballet for great physical feats at the expense of the art. A critic says creative writing courses are producing technically brilliant writers with little emotional depth. While the battle cry of the sixties was "Make love, not war," I had thought the eighties were caught by the question, "Would you care for a croissant?" Perhaps our times are caught even better by the whine, "Do you like my technique?"

"Virtuosity" in ceramics is problematic, and is applied too freely. A virtuoso in classical music interprets someone else's ideas, generally playing works so well-known only the performance is evaluated. The word "virtuoso" is used far less in jazz, where the musical ideas of an improvised composition normally take precedence over instrument playing. In clay (as in jazz), we provide both idea and realization. In addition, musical-virtuosity-as-dazzling-skill implies raw speed, often accompanied by boldness, even cockiness. The young Segovia, asked his aesthetic reason for playing a certain movement at such great velocity, replied, "Because I can." The analogue in clay is Peter Voulkos, who once responded to the question of whether he could throw one of his 75-pound platters in two minutes: "What should I do with the time left over?" Or George Ohr, the self-proclaimed "world's greatest potter," who churned out wareboards of demanding pieces as if they were mugs. This virtuosity, like that allowing the "Minute Waltz" to be played in 45 seconds, augments rather than pillages

our supply of time, encouraging rather than inhibiting experiment and thought. What often passes for virtuosity in ceramics is really grueling, time-devouring detail work. It is like a Turkestani working five years full time to weave a rug: the result may be beautiful, but it hardly speaks of virtuosity.

Question emphasis on technique as we may, the reality we deal with, whether we revel in it or consider it a necessary evil, is that ceramics is one of the most technical fields in the arts, fine or coarse. Developing technique is a necessity, a survival tactic, but this doesn't justify our tendency to fixate on technical matters. At a symposium, John Mason was asked the formula for his clay body. He snapped back, "There's no magic in materials." Such a question may at times need asking, but like dental flossing, it best be done in private.

Admittedly, technique and idea blur. An idea necessitates a technique, which may inspire another idea, a leapfrogging process of artistic growth. And, after all, ideas can only be expressed through technique. In one respect a Mozart symphony is a string of compositional techniques. But here ideas were in charge, not a technique gone wild, as was the case with the palindrome, an accepted poetry form a few centuries ago in India, which reads the same backward and forward as in "Poor Dan is in a Droop." Its value was determined largely by length, which was often several pages. Technically brilliant but shallow of meaning and poetic language, existing today as nothing more than historical oddities, these palindromes illustrate how, as our abilities increase, a growing technique momentum—like a sort of lobotomized Attila the Hun—can lay waste to most ideas in its path. And as an anorexic's plunge toward a perceived perfect body weight overshoots a reasonable goal and produces a physical and spiritual impoverishment indistinguishable from that of a famine victim, the quest in ceramics for perfection of finish can lead to an art that rivals the aesthetic and humanistic impoverishment of much of American mass production.

The mind and emotions, more interesting than skill, can produce a pitcher, smooth and elegant or rough and stalwart, that adds to the total of human knowledge. That is what we are about, not a pitcher so ingratiating of curve and surface, so devoid of visual interest, uncertainty, and anything that could possibly cause even a hint of angst, that it is perfect for serving a wine of similar character—say a white zinfandel—while listening to Barry Manilow. And what is true for the pitcher, with its functional constraints, is obviously true for the vessel and for sculpture, where constraints are minimal to nonexistent.

We can feel a camaraderie because of our shared experience of working in clay, and can appreciate proficiency, elegance and elan in the craft of making. An admiration for others and pride in ourselves glows warmly in us all, unless we forget why we came to clay in the first place. This warm glow would not be cooled by our dismissing the world of gratuitous refinement as well as the word supplying its philosophical underpinnings—the slippery and baggage-laden "craftsmanship."

Shards

Technique alone has no depth of meaning: as in poetry, where the most perfect technique in rhyme and verse, without a valuable thought and emotion behind it, would not make a poem of any significance, so too with pottery.

Marguerite Wildenhain

Thorough discipline gives the skills needed to enable freedom of expression so that one is not bound up with the "how-to," and can concern oneself with the "why-to." It is like the musician who practices endless scales and arpeggios, without which he cannot make music. If we are to "make music" in our clay works, an understanding of form, details, and variations is our equivalent of the musician's scales and arpeggios. Without them our compositions are amorphous and limp.

Robin Hopper

Technique and skills must be absorbed and wrapped up and put away to become such an integral part of yourself that they will be revealed in your work without your thought.

Shoji Hamada

It is more important to read poetry than books about pottery . . . such manuals are helpful for technical data but they do not provide the essence, the elixir of life beyond God and the wind.

Frans Wildenhain

De Pottenbakker

Aart van der Leeuw
(Trans: Henk van Amstel)

The master says give to the bowl the shape of a loaf of bread
Why use a fine goblet, as a simple vessel cupped in the hollow
 of the hand will equally quench the thirst
Allow as only ornament for your jar the generous curving of a
 smooth belly
Heavy is the burden of life, earnest; the good things of life
 go always with the blood and sweat of men
Take care that formed in a sober shape the simplest bowl
 receives those bitter fruits,
But when I sit working at my window and in the frames of the
 window pane fields and sky delight me by their mighty
 picture, the daisies sparkling in the meadow, swallows
 dashing swift arabesques from cloud to cloud, the
 butterflies unfolding the mystic marvels of their patterns
 etched diamond against sapphire;
Then my finger trembles while the wheel is turning and the
 shining liquid pours over the lump of clay—Unconsciously
 I press the soft clay into calyxes like the flowers of the
 meadow and thin and slender swells aloft the neck like a
 bird flying upward whistling in the sky. In the sprightly
 whirls I musingly make, hover butterflies in silent talk,
 while finally under my fine pencil I steal the blue shade
 of the sky.
Only when the finished pot stands before me in all its
 refinement
 —Alas, then I think of the master and his advice.

The Potter's Challenge

Bernard Leach

Two girls once came to visit me in St. Ives.

They were interested in pottery but they did not know very much about it, and I decided that I would talk to them very straight: "You are interested in pottery; do you know what that means? Do you know that to have the whole world's pottery to look at is like having the whole world's food to eat? Can you digest it? Can you find a way of judging what is a good pot, whether it is made in twelfth-century China, in Persia, or Greece, in Europe or by American Indians? How can you come to say with conviction to other people (and yourself), 'That is a good pot'? Are you prepared for that? It means a whole life's work and it means that you must care about it tremendously."

They went away, rather thoughtful.

Where should the legions of would-be potters begin? They have to find their standard by beginning to know what is good in pots. They must start to be able to see what is good in each other's work, or at least some signs of it. They must learn to recognize all the bad things being done: pots that imitate the primitive; pots that do not imitate the primitive that are still worse; pots that are wretched imitations of unfelt Grecian shapes 2,500 years or more after the first good one was made; pots that are bad because there is no heart at all in the work, only thinking process.

For the person who cannot devote a whole life, even thirty hours a week, to pottery, perhaps only three, there is a place to begin. He should start looking at *good* pots; find someone who has written a book on pots, or someone who has arranged a good exhibition of them in a museum. He should touch and examine pots made by a good potter. He should stay away from theories.

If, on any day, I walked into my pottery and pointed to a board full of newly thrown jugs and asked each man in the shop to pick out the best and worst, nearly always everyone gave much the same answer. It was not done by any measurement; the answer came intuitively.

There are hundreds of thousands of people studying pottery today. Some are seriously pursuing ceramics in art school, many are taking it up on weekends as a new activity. How

many of them will achieve any type of recognition in this pursuit? How many names will be known a century hence? If considered from this point of view, if that type of success is the objective, then the task is frightening, overpowering. By this, I am not trying to discourage the new potter. I am trying to do the opposite: to open an understanding of what pottery can be and has been in man's history, as a way of using time richly and naturally.

The only satisfactory answer to this dilemma I ever found came out of my own experience. I was sixteen and the youngest pupil at the Slade, which was considered the best school for art students in England. I suddenly realized that the question asked of a student in my time, an individualist's time, was, "Does he have the makings of an artist?" In the same way that a poet or composer is judged, did one have that quality we recognize when we say of a man that he is a genius? And, if the answer was "No, I am not," what was the hope? Was there any use? Was there even a point in trying? Surely there must be. What is the excellence we recognize in oak furniture, in wrought ironwork, in an edifice like Chartres, in medieval pottery? These things were not made by men of genius; they were made by Tom, Dick and Harry, who were sometimes very good stonecutters, joiners, potters, blacksmiths, and so on. It was a communal contribution and it provides a precedent. It tells us today that there must be a way by which the ordinarily gifted or not gifted man can do something with his life that is worthwhile. That is what is required, and we have to find out just how in our day and age to go about this. It is not easy, because our time is quite a different time from that which produced those simpler minds in the medieval centuries. They were not readers, they did not have the whole world in their living room. They were people who carried out the right way of doing work, in the way a farming family does from generation to generation.

We are not that kind of person today. We are individualists and we have developed what we call artists. What does this mean? It means that the crafts have been placed alongside, or in the same position as, the fine arts and that the number of people who get through will be very few. We are no longer peasants, but does this mean that we must all aspire to one-man exhibitions at the best galleries? I do not believe that is the end in view. We are searching for a balanced form of self-expression, and potting is one of the few activities today in which a person can use his natural faculties of head, heart and hand in balance. If a potter is making utensils for use—simple bowls, pitchers, mugs and plates—he is doing two things at the same time: he is making ware that may give pleasure in use, which provides one form of satisfaction to the maker, and he is traveling in the never-ending search for perfection of form, which gives a different gratification. As these two activities come together and the potter is at one with the clay, the pot will have *life* in it.

In the pots of the world that we consider the best—Korean of the Yi dynasty and Chinese Sung—this quality of life comes out of what was essentially *repeat work*. These rice and soup bowls that we admire were made by the thousands. In the Leach Pottery, where we usually have several student potters, I have always said that by making a lot of similar pots by hand (of a shape you like), an expansion of the true spirit at the expense of the lesser ego is bound to take place. There are two parts to each of us: the surface man who is concerned with pose and position, who thinks what he has been taught to think; and the real man who responds to nature and seeks life in his work.

How then does repeat work fall into the scheme of the young potter today? They are so keen on a one-of-a-kind, they want so much to be artists, that the acceptance of work

for life's sake has been lost. The potter today hopes he will produce something analogous to the *Mona Lisa*. Someone interested in music is usually happy to be a fiddler, but the potter wants to be composer, first violin, and conductor. In Japan, beauty has always been related to humility, and the best potters are some of the most humble who do not need to display themselves by a shelf of pots all of contrived differences in shape and color. Repeat work is like making good bread. That is what it is, and although one is doing repeat work it is not really deadly repetition; nothing is ever quite the same; never, cannot be. That is where the pleasure lies.

In making pots one of the great pleasures I have had is in using a good clay to pull a handle. Pulling is done by taking a slightly hardish lump of clay with a wet hand constantly dipped in water to keep it lubricated. Take that lump of clay and form it by the thumb pressing it inside and the hollow of your hand on the outside until it looks like you are milking the teat of a cow. You put pressure down the edge on one side, then you do it on the other side until it has the desired thickness and ribbing, so that the handle will be nice to use, nice to pour with. You get pleasure in the making, there is pleasure to you in using, pleasure to your friends, pleasure in the work. That is the kind of pleasure I have had, and I think perhaps the greatest. I am fairly good at making a handle and I have taught many potteries of Japan how to make a handle of the pulled kind, which they never had in their past. The pleasure comes in keeping the same width to hold comfortably when pouring. How the jug balances best, not only empty but full of liquid, is determined by the handle and its line, which should swing through to the spout or lip. The handle should be strong in attachment so that it carries the weight. Its base should come off the side like the branch of a beech tree. I like to see where the angle is, not just the slick S-curve. Every curve has a bone in it, just as every arm has a bone in it, and to make it a sweet line of single or double curve is not giving enough appreciation of construction and materials. Usually it is well to have an inch or more coming straight off an extra ridge along the top of the jug. That is the natural jumping off place. It should be half the width of the average hand for a full-size jug, and it should stay far enough away from the pitcher so that your knuckles won't be burned. Yet the handle must not stick out like an airplane wing. It must be comfortable to hold. It can convey beauty, and provide use and pleasure in combination.

Now a young potter may say that as a machine can turn out repeated things item for item what is the purpose of trying to do the same thing by hand? The answer is that aside from the rhythm and method of work that develop within the potter, there are a surprising number of people who want to enjoy a pitcher when they use it, and they cannot get that kind of joy when the man who produced it did not really make it, did not have any joy making it. How is the joy to get into factory-made work? We need that joy. It serves a starved heart both in the maker and user. We need to find a way for all people in this world to get this extra bonus. There must be an element of choice and the play of imagination. Think of the hours women have spent with knitting needles and in cooking good home-made food. In such they found pleasure and satisfaction as well as work. Repetition for a hand potter is of a like nature.

We turn out people for the desk and they may have become very good at their jobs, and enjoy their occupation, but the more mechanical it is the more rebellion we are going to have in this world. This is not to say that we have to banish the machine, that it is the embodiment of the devil. It is not. It is essential to our life, but the machine is always on

the cool side of man. It is the difference between machine-made silver spoons and the ones that have been hammered by hand. I think it is the precise quality of the machine, the nonhuman quality, that is driving hundreds of thousands of people back to clay. They want to enjoy themselves. They want to use and stretch their imaginations. They want to give expression to their feelings about life. They find clay to be a silent language, and in that language they are comparatively free to speak from the heart. But when it comes to repeating a shape, I am sure that someone has told them (or they think) if they do repeat work they are demonstrating a lack of imagination. It is not the case. Anybody who has learned to like cooking has found that there is pleasure in the repeat, a rhythmic pleasure in which you are at home, one, with the rhythm.

My great friend, Shoji Hamada, has been using the "same" design for the past thirty years. It is a stem-leaf motif that was originally based on a growth of sugar cane he saw that had been blown askew by a typhoon. When asked why he always repeats himself his answer is: "It is not repeat. It is never the same twice, all different. Even if I tried to repeat, the pigment, brush, my arm and the thought would be different." When we look at Hamada's pots we see the truth of this. We recognize the same motif, but each application has fresh vitality and is appropriate to the pot it decorates.

We cannot expect to be forever on tiptoe. We cannot all be like a star of the films. No, there are stars born, but there will never be many. We do not need to be a star to make beauty. What are the ingredients of beauty? Sincerity is one—sincerity to one's own true nature. To make a thing as well as it is possible to make it is close to admiration of life itself. It is man's necessity and at the moment of perfection there should be no gap between the maker and the object.

Signature—how important is signature? Is it important at all? Isn't signature a sign of our modern problem? When Hamada left the pottery in England in 1923 he left behind his pottery seal and thereafter neither sealed nor signed any of the pots which he made. Many people have asked him why he did this. I have talked the matter over with him at various times and he made it clear that he did not wish to put an accent on his own personality. Neither did he want people to buy the pot merely because of his name. This was an act of modesty as a protest against over-individualism which is sweeping the world of art today as never before. Both he and Kawai Kanjiro have practiced this restraint all their lives. He said to me it was not a matter of whether a pot was signed or not signed but really the integrity of the act. I think there is a fine humility in this attitude of his. In my own case I signed or sealed as a rule not only the place, SI (St. Ives), but also my own initials, BL, on work which I had made with my own hands. This was in order to distinguish between work done by me, my sons and my grandsons, all working independently, a total of five Leaches producing pots.

We are still left with the question of whether an unknown craftsman deserves to be put on a level with the best artist. My answer is yes, provided that humility and life are given expression, and in that respect I agree with Yanagi who says, "In my heaven of beauty there is a round table without top or bottom at which all are equal." He is saying that they are equal because they have produced beauty whether they are conscious of it or not. By making this argument I do not suggest that we can go back to a period of anonymity, for we cannot. The known craftsman cannot become unknown; there are different qualities attached to each. Nor do I believe the simple countryman will be able to stand up

against the impact of the modern industrial world, its individualism, and its corruption of basic values. Everywhere he has proved to be doomed for lack of wide enough understanding. The work, the doing, the activity for its own sake is no longer the actual goal. Our salvation lies in preserving humility in a world of widening and changing demand.

There is a recent book [Ronald Blyth, *Akenfield*, Dell Publishing Co., New York 1969] about the village of Akenfield in England, in which the author tells of the old farmers who could look at a field where ten people had ploughed and tell you the name of the man who had done each furrow. In it could be felt the character of that ploughman. In a similar way I have been told of Indian markets in South America where they sell rope and can tell you, just by looking at it, who made each particular piece. There is a great difference between such innate character and what is an attempt at a "personal" statement.

It is no different from the pot being the signature for Hamada. Those farmers in Akenfield were asked why they took such care to make furrows so precise—the precision would not yield more beans—and they answered that it wasn't because they were paid more, it was because it was their work and they did it as best they could. It belonged to them, it was them. "It was his signature," writes Blyth about the farmer, "not only on the field but on life."

I used to be able to tell which person made the pots in my pottery—the standard ware of cups and bowls and plates. There were eight or ten people working and sometimes I would go around and see some of their work on a shelf and I would say to myself the character of the person who made that is coming through. That is what I want to see. It is a very important thing; the beginning of a man's own statement without his self-conscious, aggressive, leaping ambition. It is the real thing coming through. But in this modern world we have become too intellectual and have lost so much of that naive quality.

By "naive" I am speaking of the quality of Korean people above all, in the good sense of the word, and that is why I love their pots best. We are no longer naive people.

On the top of my desk I keep two bowls. One is almost the last pot I made and the other is a Korean pot made for rice. My piece is fancy by comparison, and its market value is about seventy-five dollars. The Korean pot probably costs less than a penny although perhaps now worth as much as mine partly because of rarity, and I say that the Korean pot is better. True, mine is quite pretty, and I do not think it is bad, but the Korean one was born; mine has been made. What are we going to do with our "making"? We have to get back to a simpler form of life, a life of man on this planet where he is not so pleased with the petard that threatens to blow him up. People are ashamed today to kneel down, but what I am asking is for people to kneel down before life, essence; be humble. When I compare the Korean pot with mine I say that the Korean pot is better: it has warmth. That warmth is there because there is no ego; we do not feel any egotism on the part of the maker. Today, we have something in us which is a desire for individual recognition. We strive for this recognition by trying to achieve perfection, and we deceive ourselves into calling the result heaven. We want whatever we do to be unique. The difference between the farmer who took pride in his furrow and a modern artist today is that the latter is probably trying to show off. Perfection can be a fetish. The Scandinavian crafts, in a way, became a victim of this. Their potters are engineers. They are called "engineer artists," not just "artists." They were given apparent freedom, but were conquered because they were ruled by calculus and the processes of industrial production, and their style was cramped.

The result is not sufficient. The glazes are marvelous, but they lack warmth and they are a show-off of technique.

Technique has come to stand between a person's natural intuition and his job. In America technique rules. When I visited Alfred University with all its apparatus, every kind of kiln, in all of this did I see one live pot? No! Technique can be an emasculating thing. It is putting the cart before the horse. When Hamada first came to England with me he had completed a long university study of pottery and he felt he needed to get away from too many formulas. They stood between him and beauty, between him and life. Last year he said: "We don't need teachers or technical knowledge; if we have clay and wheel, clay and wheel will teach us." If someone wants to play the violin, we may expect awful sounds at first, but when the student is caught by music for its own sake then technique will follow, as shadow follows light. It is as Blake says; do not pursue skills, technique will follow the idea. The idea will find technique, it is included in the real gift. In America there is all that technique, and the problem is to decide what to do with it. Technique can be a good thing but not by itself. It is back to front again; technique before idea. The schools are filled with too much technique; they have pendulums and metronomes to make sure that everybody stays in time with the music instead of letting the natural rhythm come. And there are erasers on all the pencils so that in a drawing class deviations may be corrected and the thing perfected, instead of saying; no erasures; put your last penny on the line. Try to draw.

Rather than working for something to grow out of a tree, educators are driving nails into boards. They try to measure the immeasurable and they do harm. We must strive for the encouragement of intuition, of idea. Somewhere it is there in everyone and it must be allowed to develop. A flower can emerge. Take away the fertilizer and you can get an original wild flower. Take me back to my own nature and I am free.

The interesting thing about the Oriental perception of pots (or other crafts) is their unconcern with natural flaws and irregularities. There is a certain amount of irregularity, but there is also a difference between the acceptance of the natural irregularities and sloppiness. *Nonchalance* is a good word to describe the way the Koreans and other craftsmen of the East approach their work. There is a great freedom, and nonchalance and care are both present. It is all dependent on the spirit in which the work is done. If it is done from sloppiness of an individual, it is sloppy. If it is not quite true because the maker was in a hurry or was not feeling quite right and yet it is done with love, then the work may be tolerable. One can even be clumsy, and yet beautiful in clumsiness. But how can we distinguish between a person who is beautiful in his clumsiness and sheer clumsiness? It depends, really, on whether the man and the work are in the scheme of nature. The clumsiness in the art school is not the clumsiness of nature; it is the sloppiness of the inside of a mind. It is laziness. But there is a difference between laziness and the work of one who is under pressure, perhaps from his wife because the children are hungry.

Because of the very smoothness of perfection we yearn for imperfection. Imperfection —irregularity—is a necessity. We are ourselves imperfect; our noses are crooked, one eye is nearer the bridge of the nose than the other, and so on right through the whole body. Trees are asymmetrical and irregular; the sand and rocks on a beach are also. In all of nature there is this asymmetry; not too much, but a degree of it, and it provides the sense of vitality of life. We note the beauty of a slate or thatched roof. We do this because of the variation and irregularity of the material. For the same reason we are bored by asphalt and aluminum

siding. It may be very convenient, but dull repetition is adverse to nature. How intimate and strange is this matter of beauty! Whether it is in smell, or the taste of food, or in touch, or in what we see. We often pretend to ourselves that we are happy when there is no irregularity, but we have killed the joy in making because we have become the slave of the machine. Here we come to one of the key elements of beauty. It is liberation of the free spirit of man in *work*. It is a big word, work, and it covers our principal occupation on this globe. Of the world's pots I would choose the Koreans above all. The last thing in the world those people would think is that they were artists or craftsmen. They were people doing work as well as they knew how and getting as much satisfaction as a man could. In their pots this is revealed through an innocence, a nonchalance, a closeness to nature which shows itself, and not the man.

The real question for today is how does the man involved with the machine make a joy out of his work? He cannot. It is unfortunate that only a few people do the kind of work that they want to do. There are very few people who leave school, in fact, even knowing what talents they possess naturally. Nor do they have the chance to use the talents with which they were born. This is a tragedy, because it would make life happier for most people if they did have a chance of finding this satisfaction, of doing their thing, just as the ploughman could get the satisfaction out of making a straight furrow. I know this from the use of my own body during the last eighty-seven years. We must remember that until two hundred years ago everything was made by hand or tool. Whether potter or weaver, each filled his day doing a job, largely repeat work, in which the work itself was the personal expression and the satisfaction. But the reality of today, where more people are employed in jobs that have neither natural materials nor any fulfilling passion, is that they are going to have to find these outlets elsewhere. You work like this all week, can you then begin to live on Saturday and Sunday? I do not know, but perhaps that is why people are turning to such activities as pottery. We have our own brand of slavery. It is not the heart's work. Potters who are potting all their lives do not need holidays. We get great satisfaction out of trying to get a good pot. It is impossible, however, to go back millennia; we have to take things where they are. We have to take the situation that there are millions of people working Monday through Friday at jobs at which they are bored. They cannot escape that by becoming full-time potters or farmers, so they go to a pottery school on Saturday morning with its two hundred wheels (crossing the Golden Gate Bridge I saw one at work once—whole families in superficial bliss but the results unblessed). The object is to encourage them to perceive standards.

How do we set our standards? It is difficult because the traditional craftsman was nearer to life than the man with the machine, and I think the man with the machine potentially knows it. We have what we call classic standards in some subjects, such as literature and music. What is a classic standard in music? I suppose it is a consensus of informed opinion over a long passage of time, of what gives the greatest pleasure. In pottery there has not been a similar evolution of taste. It is my conviction, however, that there have been several places and times in which a great quantity of good pottery was made, and from these centers we can draw a consensus. There is a common thread between these civilizations of good pots and it is based on what the Oriental calls *thusness*, even though some of these civilizations were not of the East.

Thusness is a peculiar word. The eternity of the spirit. How the East is expressed by

rather strange words! Thusness indicates to the Japanese mind the unspoiled nature of the child, or the Korean way of life, or the primitive way of life. Naivety, the condition before the expulsion from the Garden of Eden, before the recognition of the difference between beauty and ugliness, discord and harmony—as in the composition of music. Once we have eaten of the tree of knowledge of good and evil, we cannot any more go back to an earlier stage; we have to go forward. We have to learn to put the thinking apparatus, our intellectual box of tricks, into proper relationship with the intuitive part of our mind. When they are properly related to each other we can still live in a world of thusness or, let us say, wholeness. We are seeking the nonrelative in the relative world. This enters the field of philosophy. What is absolute and what is relative? The Orient accuses the West of becoming more and more rational, individual, mechanical. They say that their philosophy, Buddhism, is nondual, similar to that state in the Garden of Eden. Thusness is what everybody can contribute to life in his own way by being himself, by being as he was made. The Oriental does not talk about God, he talks about thusness, including you as you really are; your true nature whether a person or a bird, even a stone. It is a tremendously important concept and it gives us a fresh way of thinking of beauty.

What is the evolution of this thought? It matured in Japan following the development of a sense of value and belief about the meaning of life through Buddhism and, behind that, Hinduism. This thought traveled gradually across China, through Korea, and finally reached Japan in the seventh century. It was a long journey but Japan was its end until we Westerners came upon the scene. Because of that strip of water between the Japanese islands and the mainland there was enough peace and isolation to allow time for meditation and the creation of a body of thought that can be centralized in the one word, Zen. It is nonrational thinking, intuitional, imaginative; and the real adepts of Zen have always decided for the people what is valuable in life. Thus they established this inner world of quiet spirit from which the standards of centuries were set. Tea masters developed ways of understanding beauty in pottery, in calligraphy, even in the rocks in their gardens, which are to them the symbols of eternity. They enjoyed these things for the sake of beauty in the unobserved commonplace. Thus, although the tea masters and Zen represent a specialized way of looking at the world, of seeing beauty, the substance of their experience can be reached by anyone. There is a latent search for this hidden in us all. We want to enjoy these sensations called truth and beauty and sincerity. Behind all insincerities, uglinesses and untruth, occasionally something reaches us; it might be a bird on a tree, or a stone, or shells on the beach, flowers, butterflies, the beauty of women and children. *We can also find this type of beauty in the things that people make when the making is done purely in a celebration of life.* It hits one by surprise, and although not accustomed to these standards evolved by Orientals, nevertheless, the moment is understood by people. There is a universality in this appreciation and this experience—*life.*

I write of beauty, and truth and thusness. I think the final word I would use as a criterion of value in the world of art, if I were reduced to a single word, would be the presence of *life.* Life in me, life in the work of my hands, life coming toward birth. Sometimes a teacher will see it being born in a student's eyes and there is great joy in that moment. How wonderful it is! It is a force that goes beyond all arts or artists. It is the ultimate standard and it is attainable.

Shards

Aesthetically a pot may be analysed for its abstract content or as a humanistic expression; subjectively or objectively; for its relationships of pure form or for its manner or hand-writing and suggestion of source of emotional content. It may be coolly intellectual, or warmly emotional, or any combination of such opposite tendencies. Whatever school it belongs to, however, the shape and pattern must, I believe, conform to inner principles of growth which can be felt even if they cannot be easily fathomed by intellectual analysis. Every movement hangs like frozen music in delicate but precise tension. Volumes, open spaces and outlines are parts of a living whole; they are thoughts, controlled forces in counterpoise of rhythm. A single intuitive pressure on the spinning wet clay and the whole pot comes to life; a false touch and the expression is lost. Of twenty similar pots on a board, all made to weight and measure in the same number of minutes, only one may have that life. A potter on his wheel is doing two things at the same time: he is making hollow wares to stand upon a level surface for the common usage of the home, and he is exploring space. His endeavor is determined in one respect by use, but in other ways by a never-ending search for perfection of form. Between the subtle opposition and interplay of centrifugal and gravitational force, between straight and curve (ultimately of sphere and cylinder, the hints of which can be seen between the foot and lip of every pot), are hidden all the potter's experience of beauty. Under his hands the clay responds to emotion and thought from a long past, to his own intuition of the lovely and the true, accurately recording the stages of his own inward development. The pot is the man: his virtues and his vices are shown therein—no disguise is possible.

Bernard Leach

Beauty is not on the surface, but rather comes from within the form.

David Shaner

Thus one of the prime reasons why ceramics is such an interesting art is that it fills the gap which now yawns between art and life as most people understand their relationship. To explain the meaning of ceramics can be, in a sense, to explore the historical roots of art as such. For whereas other arts, painting, and sculpture in particular, have come for centuries to resemble cut flowers, separated from the living plant which produced them, in the case of ceramics we are everywhere brought face to face with the root. This appears in the primal interweaving of matter, human action, and symbol that each pot represents. Inert clay, from the earth, is made into something which is directly and intimately related to active craft, to the processes of human survival, and to social and spiritual factors in the life of man, all at once. None of the elements is lost; all are reflected in some sort of balance in each successful work.

Philip Rawson

. . . that beauty is not found in the excessive, but in what is lean and spare and subtle.

Terry Tempest Williams

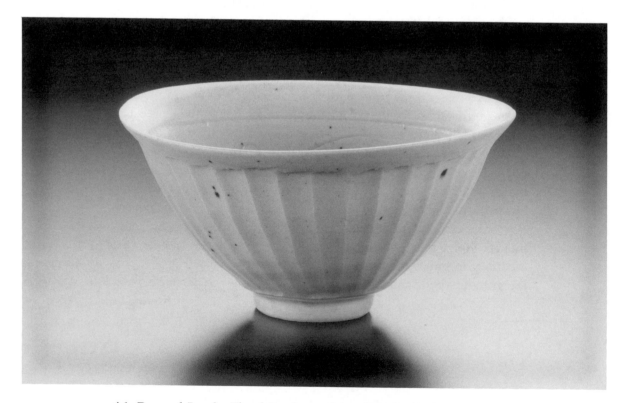

16. Bernard Leach: *Fluted Bowl, porcelain, 4" high, 8" diameter, 1958. Courtesy of Warren and Nancy MacKenzie.*

Clay

John Chappell

For clay takes men
And teaches them
The craft, the skills
The knowledges
The life within
The force beneath,
The power of
The parent earth.
Where power is
Is in the clay
And all we do
Is snatch a little
Of the glory

Ceramics and The State of Art

Barry Targan

On January 5, 1978, Shoji Hamada, 83, died at his home in Mashiko, Japan. This passing was not noted in the obituaries of the *New York Times*. It was not observed in *Newsweek's* "Transitions," nor in *Time's* "Milestones." On the day and in the week after his death, few in the United States knew of it. Shoji Hamada was, however, the most renowned and revered potter of the twentieth century, a figure equal in achievement to a Balanchine, say, or a Lowell, or a Stravinsky: one of those whose imagination illuminated and extended the possibilities of an art form. Hamada was also a figure comparable in certain ways to Pablo Casals in the sense that he was as great an aesthetic moral force as he was an unparalleled creator, remembered as much for what he said and did and taught as for what he made.

For those who know his history, the basic facts are familiar. At twenty-four, Hamada, a young university-trained technical potter, met Bernard Leach on Leach's visit in 1918 to Japan. Through Leach, the Japanophile, Hamada was encouraged in his desire to be a studio potter, and was redirected into the pottery of his own country, particularly to the pottery of the nearly moribund *mingei* tradition, the tradition of folk pottery. In 1920 he traveled with Leach to England and together they established Leach's pottery at St. Ives in Cornwall. After three years working with Leach, he returned to Japan to Mashiko where the clay is less good, more problematic, but where the *mingei* tradition burned slightly stronger than elsewhere. And there he stayed for fifty years, building his kilns, developing his ash glazes and engobes from the oxides ground out of the pebbles in the streams near his house, refining his life and his art into the single search for the essence of *balance*, the discovery of the point where effort disappears and the tea pot sits commonly on the table, binding volume and mass, color and shape and ornamentation, into simple and ordinary use.

But for those who do not know his history his impact upon their lives is no less "known." Simply, no other artist was more responsible for the dominant direction that major pottery in this century has taken, for without question it is the *mingei* tradition (even the name was created by Hamada) that we mainly encounter in the racks and piles and rows of mugs and soup bowls, and planters displayed at craft fairs, in craft galleries and shops, and increasingly in museums. There is, of course, much more, enormously more, to our experience with pottery now than this one functional idea and style, but it is with this idea and style that twentieth century pottery was reborn. And so for most of us—and there are many of us now—the Japanese folk tradition is what we initially understand as pottery: the vessel

that indicates the fire it was born in, the random iron spotting drawn out of the clay by the carbon of the reduction flames, the varying tones and sudden breaks where the glaze has thickened or thinned, the blush of deeper light where pots have reflected heat off of each other. The presence of the human hand. The felicitous "accident." And although we encounter many other styles—funk, minimal, pop and on and on, it is still a fair assertion that the *mingei* is the nearly inevitable first stage in the development of all serious potters, the phylogeny of the craft and art indicating its ontogeny. Voulkos, Mason, Arneson, Takaezu, Autio, La Verdiere, Baily, Ferguson, Price—each began as disciples to Hamada's traditional folk impetus. And so today do all still begin wherever else they may go or end.

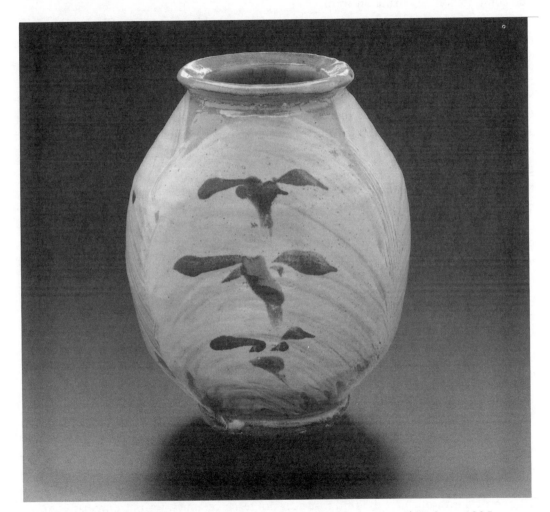

17. Shoji Hamada: Vase, stoneware, 8¾" high, 7½" wide, 6½" deep, 1935. Courtesy of Warren and Nancy MacKenzie.

Then here is a fine irony indeed. An officially designated Living Treasure of Japan (but of course of all the world) dies, but unlike the deaths of Casals or Picasso or Stravinsky or Lowell, where the entire culture stood quietly in homage and bereavement and true loss, an equal artist passes with little more significant note than brief statements in *Ceramics Monthly*

and *Craft Horizons* (though I imagine greater eulogies will come). The irony, however, is instructive, and it is an irony that Hamada would have enjoyed. For all his fame, the enshrinement of his studio, the ceaseless pilgrimages to Mashiko, his wealth (a major piece by Hamada could command as much as $25,000), he sought—demanded as a principle in his life and work—anonymity, the submergence of the artist's personality in larger values and statements. Hamada did not sign his work.

Which brings us to the larger paradox facing all of handcrafted pottery, which is implied in the silence greeting Hamada's death: the unwillingness of the "proper arts" (artists? critics? scholars?) to allow pottery—traditional or contemporary—its equal place and due consideration as a major art form.

But quickly, this is not to say that pottery has not achieved a place of high cultural regard and significance. It clearly has. And thus the paradox of pottery's rejection as a proper art is compounded at many points, for pottery has experienced an enormous receptivity by a large and eager public even as it has also generated a specially knowledgeable, particularly well-informed smaller audience. Pottery, very much like ballet, has its *cognoscenti*, its connoisseurs, its theorists, its arguments and debates (acrimonious and otherwise)—surely signs of its arrival. Nor is it excessive to say that in twenty-five years hand-crafted pottery has become a popular art experience in the same sense (if not size) that movies and recorded music are popular art experiences, experiences, whatever else, primarily of a broad and democratizing nature, for pottery has swept, cometlike, through our society, from the ubiquitous stoneware coffee mug to be found on anyone's kitchen table to dinner settings at the White House.

Another dimension to the paradox is that today both in the exploration of new possibilities and in the more effective achievement of traditional visions, pottery has further than any other art form utilized contemporary science and engineering. Space-age insulation material developed from the lithium derivates in rocket nose cones, exotic salts, used in glazes, thixotropic clay, gas physics and engineering, delicate instrumentation to measure and control firings, the transportation of special materials from *anywhere*, the availability of power for firings unimaginable in the past—all of this and more that describes so much of the contemporary technological experience, perhaps the central experience of our time, is indirectly expressed in nearly all pottery produced in the country today, but it is, too, often directly expressed, *announced and proclaimed*, in the amazing scope and daring of the innovative contemporary ceramics that have moved so far beyond traditional boundaries.

Further, pottery now has high visibility in the numerous college-sponsored crafts shows and in the important regional competitions which bring work to attention and reward. State councils on the arts consider pottery and grant it generous support. Craft galleries and shops abound and prosper. And hardly an art department (or evening continuing education program) exists throughout the land that does not teach ceramics, for not only has pottery been noticed, purchased, honored, supported by the state, it has also become a participatory activity for many with lesser ambitions than the artist; it is heavy with its counterparts to the Sunday painter.

Still, it falls just short of Art (say some). And it goes without saying that *no* potter who makes purely functional ware or who works in the functional mode is ever considered to be an artist in the fullest sense.

One could go on drawing attention to the discriminations large and small: that juries of general art shows, regionals, special competitions do not include potters as judges; that in

college art departments the craft teachers are quietly (and not so quietly) second class citizens, never quite legitimate; that the prices that *objets d'art* can claim dwarf the prices of any comparable ceramic shapes (in this country). And no volume of art history such as those used in college courses includes a serious consideration of ceramics much after the Grecian urn.

But the ultimate demonstration of the art world's refusal to accept pottery as a legitimate art form occurs in the recent superb show, *The State of Art*, held in the New York State Museum in Albany. The show spanned three centuries of art in New York State, from the anonymous limners of the pre-colonial period through the splendid Hudson River school work of Church and Thomas Cole and Bierstadt to the new 3-D day-glo jangle of Frank Stella—but no twentieth century pottery *at all* was included. An innocuous pile of orange styrofoam, a simple-minded bank of tinted fluorescent tubes, even a huge, totally black painting—but no pottery, no ceramic statement in the entire show at all except for a few eighteenth century crocks and jugs mixed in with the Shaker furniture.

No. In our retrospectives, in our journals, in our anthologies of art, in our major museums, pottery is nearly totally excluded. It is doubtful that it is even considered before being rejected. It is merely not regarded.

Why?

Why, for all the public acceptance of pottery in all and any of its often complex contemporary manifestations—from the dinner table to massive architectural murals—is it still refused perfect acceptance by those most entrusted with informing social taste and understanding? Why, for instance, have the Kramers and Greenbergs and Steinbergs never taken pottery seriously enough to examine it deeply?

The failure even to look at pottery cannot be accepted as a circular judgment before the fact: one need not look at what is not to be found. Alas, we seem here in our best critics' indifference to be confronted (at worst) by a thoughtless prejudice and an unworthy bias, or (at best—and more likely) by a simple inattention to an important cultural and visual contemporary development.

Still, even such inattention must have its schooling, be rooted in certain implicit if not stated assumptions about the nature of art. An examination, or at least a steady hard look, at some of those assumptions is in order.

1. Art cannot be useful.

This is a strong art-for-art-sake prejudice that gets entangled in our time with such an idea, say, as that which has governed the liberal arts concept of education for so long, the idea that a liberal arts education is not or should not be directly useful or directly applicable to anything except possibly the teaching of itself. There is an old-fashioned kind of elitism in all this that dies hard. But I do not want to get into an argument with that idea here; I only want to offer the following observation as far as *use* affects *seeing*.

I submit that it is impossible to demonstrate that there are inherent limitations in the shape and surface treatment of functional (or functional related) forms which prevent the same visual excitation that occurs in non-useful shapes and surfaces. The manipulation of line, color, volume, mass, texture are not properties peculiar to a substance or a technique or a genre. And this concentration on the elements of *vision* is *particularly* true to the ruling Formalist perspectives on Art. It is entirely inappropriate to the critical thought of our time to reject traditional pieces (or non-traditional ceramics *certainly*) because of what they *are*.

Such an attitude would be nearly a retrograde corollary to the attitude which rejects a painting because it does not look *like something*.

It is elementary to contemporary aesthetic thought at this moment in the twentieth century that the subject of a painting is the *painting itself* and not the object depicted (should there even be one). How then can a ceramic vessel or object not be considered similarly, for the visual *process* and not for what it may (or may not even) do?

2. Art cannot be accidental, but the best pottery is often a result of uncontrolled events—"luck"—in the kiln.

Much of what is most exciting in reduction-fired pottery is the result of elements and forces that are not totally predictable. But such results are not accidents in the usual sense, for ordinary accidents are unexpected events, *unprepared* for and unwelcomed. The ceramic artist, however, goes through a highly determined process in order to prepare for, *heighten the possibilities of,* certain kinds of events that can occur in the kiln. Such artists put themselves in the way of such accidents. It is this ability to induce certain kinds of events that often marks the superior artist. The nature of the glaze, the method of glaze application, the placement of ware in the kiln, the time and pattern of the firing of the kiln, knowledge of the characteristics of a specific kiln (for *all* kilns, even of the same design and dimensions, fire differently)—all of this is part of the arrangements necessary for the "accidents." Besides, after a sufficient application of technical knowledge and skill, any ceramic artist can come extremely close to recreating predictable results. It is not so mysterious after all.

But even more to the point is this: it is not the production but the selection that finally engages the aesthetic sensibility at its highest. It is the choice that the artist makes of what will be acceptable to the artist that determines the "art" of a piece just as a painter will paint and then scrub out or cover over a canvas. In the final accepting, even more than the doing, is art made.

3. Art is exclusive.

Here I think we come close to an unhappy condition that plagues all the visual arts, or those visual arts fixed in an *ownable object*.

I think that one reason for the rejection of pottery as a proper art form is that it is *fundamentally available*. Unlike the one painting or the one pile of styrofoam or the one bank of fluorescent lights or the one Rembrandt or the one Henry Moore, which can be owned by one person, a piece of pottery *feels to be* ownerless, uncontrollable, less an artifact for one than a *commodity* for all. There are, of course, numerous one-of-a-kind pieces in pottery, and even a series of production pieces has its important variations, but the overall feeling is of pottery's basic tradition, its deep rootedness in a common, a *communal* use.

Such a feeling is counter to the dominant motivation of an acquisitive society, where power and self-esteem are often measured solely by what can be uniquely possessed: what I can own but you cannot, what my class can own but not yours. Pottery unnervingly and threateningly undercuts that attitude and thus cannot be easily accepted by the great museums, which depend heavily for their existence upon the very assumptions of exclusivity that pottery confutes.

In this respect pottery is comparable to graphic arts, another art form that has undergone a great common introduction in the past twenty-five years. Graphic art, like pottery, is much less expensive (usually) than painting, less "valuable" than a painting (because there is more than one), more mobile than paintings in a mobile society. And the production of

graphics is more directly participated in than anything else in art except pottery and possibly photography—itself a form of graphic art. Graphic art, like pottery, makes great use of contemporary technological developments. And graphics, of course, are far more widely available than painting, less exclusive, less owned. But, like pottery, for all its enthusiastic public acceptance (and, indeed, serious consideration as a major art form), graphic art is yet held just a notch below the major forms. Graphic art, however, has the advantage of a long tradition of serious acceptance and has always been associated in some degree or other with the great painters, many of whom dabbled—or worked at—graphics.

But there is just too much *craft* in graphics, too much of the artisan's specialized skill for it to escape its lessening. And nearly anyone can own a work of graphic art—old or new, and for that sweeping availability it cannot be wholly forgiven. Like pottery, it is cursed by its commonality.

What will happen?

Pottery's enriching acceptance into our visual and tactile experience of life will go on as it is going on, and that experience will inevitably grow, for it is an attractive experience and there appears to be no reason why it should lessen. Increased attention will be forced to it and, at last, it will be allowed a subniche in the approved halls. The line to be crossed, after all, is not a very real one. It is just an arbitrary line established by the hegemonic opinions of our leading art critics, nearly all of whom are New York based. (And therefore bound?)

But I doubt that pottery will ever be entirely accepted by critics and scholars and "proper" artists as being on a creative par with other art forms. At least not in foreseeable time. That, however, is no great matter. Presently the United States is the undisputed world leader in the ceramic arts; that is, this country's ceramic artists are producing the work, developing the techniques, constructing the imaginative possibilites to which other artists everywhere look. And the audience of this "national" performance is growing apace. The overall condition of pottery is too vital and happy for all of those involved in it to be concerned with "proper" approval. What I see, then, is a condition in which pottery will not ask for nor compete with "art" for acceptance. In parallel with "art," it will be appreciated, enjoyed, seriously considered, establishing in its own image its own unchallengeable validity.

shards

If one is observing a pot or any good article, one must be aware that "taste" is only a partial viewing, while perceiving the "feeling" of an article is seeing the whole. The person who is preoccupied with good taste will respond to the details and incidentals of the object he is viewing, but is too close to see the whole object properly. The person who is concerned with feeling stands aside and allows the work to make its natural impact on him.

The same distinction also applies to the craftsman doing his work; he can consciously create tasteful things but he cannot deliberately create things with feeling. Real feeling seems to hover impartially; it is something inherent in the nature of a work. The piece achieves its beauty irrespective of the conscious aims of the maker. Usually the craftsman sets out to produce a particular effect and is pleased or displeased with the final result, depending on how near the work comes to his original intention. In fact, the essence of the true quality of the work lies somewhere else, and his conscious efforts to achieve this quality make little difference.

Good taste is a formula, and almost anyone can develop the ability to have good taste or to create good taste. But it is not so with feeling, it cannot be purchased like a new coat. Therefore, criticism or appreciation by people who deal essentially in taste is of little real value to the craftsman, whereas any genuine criticism of a work's feeling gives the maker cause for serious thought.

I said I was not interested in making or creating something novel or refined or acceptable from the standpoint of the usual idea of beauty, but that I was aiming at making correct and healthy things, pottery that is practical and not forced, that responds to the nature of the materials. I did not want to make something outwardly beautiful, but to begin from the inside; health and correctness were more important to me.

Shoji Hamada

Those Who Seek Fame and Profit

Ogata Kenzan
(Trans: Bernard Leach)

Those who seek fame and profit
Little know the peace of the hills.
Morning and evening the clear air blows,
Between heaven and earth my life exists,
My lungs expand, my body functions at ease,
If I think of other places, nowhere attracts,
If I think of this place, nowhere distracts.
The moon waxes full, the pure winds blow.

Mystery of Beauty

Soetsu Yanagi

In South Korea stands the village Ampo, a lonely hamlet, remote from towns. To visit this village was a hope I had long cherished, for I had seen many examples of beautiful turnery (wood turning) made by the villagers. Nearly all Korean woodwork, especially turnery, suffers some deformity in its shape. But this slight crookedness always gives us a certain peculiar asymmetrical beauty, an indescribable charm that entices us into a sense of beauty that is free and unrestricted. From what source and by what means Korean craftsmen obtain such natural asymmetrical beauty had long been a question for me.

In Japan we find also a great deal of turned works. Some are extremely good, made so precisely that they are almost perfect in shape. But their symmetrical perfection lacks the quality of unrestricted beauty. In turning there is an accepted rule that the wood used should be thoroughly dried; otherwise cracks will almost certainly appear. In Japan the wood is air dried for at least two or three years. This is common sense. In modern factories, of course, the drying is done quickly in kilns. In any case, all turnery should be produced from well dried wood.

Fortunately, I was favored with a rare visit to that Korean village where those beautiful turned goods are made. I was excited by the opportunity of seeing these Korean craftsmen at work because I thought that I might grasp the mysterious beauty of their products.

When I arrived after a long, hard trip, I noticed at once beside their workshops many big blocks of pine ready to be lathed. To my great astonishment all of them were sap green and by no means ready for use. Imagine my surprise when a workman set one of these blocks in a lathe and began to turn it. The pine was so green that turning it produced a spray redolent of the scent of resin. This use of green wood perplexed me greatly, for it defies a basic rule of turnery. I asked the artisan, "Why do you use such green wood? Cracks will appear pretty soon." "What does it matter?" was the calm answer. I was amazed by this Zen-monk-like response. I felt sweat on my forehead. Yet I dared to ask him, "How can we use something that leaks?" "Just mend it," was his simple answer.

I was amazed to discover that these artisans mend their turnery so artistically and ingeniously that a cracked piece seems better than a perfect one. Consequently they do not care whether it is cracked or not. Our common sense is of no use to Koreans at all. They live in a world of "thusness," not of "must or must not." Their way of making things is so natural that man-made rules are meaningless to them. They are attached neither to the perfect piece nor to the imperfect. So it was that at this moment when I received the artisan's unexpected answer I came to understand for the first time the mystery of the

asymmetrical nature of Korean turnery. Because Korean artisans use green wood, their wares inevitably deform while drying. Therefore, the asymmetry is but a natural outcome of their state of mind, not the result of conscious choice. In short, their minds are free from any attachment to symmetry or asymmetry. The deformity of their work is the result of nonchalance, freedom from restriction. This explains why Japanese turnery looks hard and cold in comparison with Korean. We are attached to perfection; we want to make the perfect piece. But what is human perfection after all?

In modern art, as everyone knows, the beauty of deformity is very often emphasized, insisted upon. But how different is Korean deformity. The former is produced deliberately, the latter naturally. Korean work is merely the natural result of the artisan's state of mind, which is free from dualistic man-made rules. He makes his asymmetrical turnery not because he regards the asymmetrical form beautiful or the symmetrical ugly but because, as he works, he is perfectly unaware of such polarities. He is quite free from conflict between the beautiful and the ugly. Here lies buried the mystery of the endless beauty of the Korean artisan's work. He simply makes what he makes, without pretension.

It is very interesting to consider that the aim of the strenuous spiritual efforts of Zen monks is focused always on grasping "thusness" which is not yet separated into right and wrong, good and evil. The following story recorded in a book by a Zen monk will perhaps illustrate what I want to make clear.

Once there were three people who took a walk in the country. They chanced to see a man standing on a hill. One of the three said, "I think he must be up there looking for stray cattle." "No," the second said, "I believe he is trying to find a lost friend." But the third said, "No, he is simply enjoying the summer breeze." Unable to reach an agreement, they climbed the hill and asked the man: "Are you looking for stray cattle?" "No," he replied. "Are you looking for a friend?" "No," again. "Are you enjoying the breeze?" "No," yet again. "Then why are you standing here on the hill?" "I am just standing," was the answer. The Zen monk who recorded this story was interested in the state of mind of just being or "thusness" which is not yet confined by any preconception.

One who has had the chance to visit a Korean potter's shed may notice that the wheel used for throwing pots is never exactly true. Sometimes it is so crudely mounted that it is not even horizontal. The asymmetrical nature of Korean pots results in part, therefore, from the uneven movement of the wheel. But we must understand that Koreans do not make such wheels because they like unevenness and dislike evenness. Rather, they simply construct their wheels in a happy-go-lucky way. This unevenness, then, is but a natural outcome of the untrammeled state of their minds. They live just as circumstances permit, without any conception of artificiality. Of course, if the wheel is canted too much, they may correct it to some extent, but even then it will not be precise. They are scarcely troubled by accuracy or inaccuracy, for in their world these qualities are not yet differentiated. This state of mind is the source from which flows the beauty of Korean pots.

Why did our tea-masters, men of keen eyes, prefer Korean pots to all others? The asymmetrical beauty, free from all pretension, was immensely attractive to their aesthetic eyes. They so ardently loved to gaze upon those Korean pots that they finally tried to analyze the beauty expressed in them. They enumerated ten virtues as the elements of which their beauty consisted. It is quite remarkable that the eyes of our tea-masters penetrated so deeply into the beauty of these pots.

Paradoxically, however, their very analysis initiated the history of an erroneous attitude which has poisoned nearly all the latter tea-potters in Japan. They imagined that they could make good pots by isolating the indispensable elements of beauty which characterized Korean tea utensils. But what was the result? In spite of their careful craftsmanship and passionate love of beauty, their analytical self-consciousness has never been able to produce pots as beautiful as the original Korean ware. Why? The reason is obvious: they did not understand that the Korean pots were not the result of intellectual analysis but of a natural and spontaneous condition of the mind. If our tea-masters had told the Korean potters about the ten virtues, the Koreans would not have known what to say.

The Koreans simply made pots, while the Japanese proceeded from thought to action. We have made nice things, but they are different. We proceed upon a conscious differentiation of the beautiful and the ugly, while the Korean's work is done before such differentiation takes place. Which is better? I do not say that the analytical approach is useless, but if we are confined by analysis, we cannot be assured of producing pots of indescribable beauty. Why is it that self-conscious potters cannot make beautiful pots with ease? Because it is extremely hard for them to make things in that state of mind described by Buddhists as "thusness."

Once there was a Buddhist devotee named Genza. Though an illiterate peasant, he was actually an enlightened man. He had a friend named Naoji. Attaining together the age of nearly ninety years, both fell ill and took to bed. Naoji, realizing that the end was at hand, began to be anxious about his death, for he wanted to die peacefully. So he sent his niece to his friend Genza to inquire how one may die with a peaceful mind. Genza replied simply, "Just die." A week later, it is said, both of them died peacefully.

His answer is magnificent. If anyone can just die, what problem remains? Death is powerless to trouble a man if he can just die. But it is difficult for most men to die in peace, for they do not want to die or they think they should not die yet or they fear the unknown or pity themselves. Some even commit suicide. All troubles, anxieties, agonies come from attachment to life and from ignorance of the meaning of death. If we can escape the dualistic conception of life and death, we can just live and we can just die at any moment and in any place without anxiety. This state of mind is called "Buddhahood attained" or "Enlightenment."

All beautiful crafts are nothing more than the expression of attained Buddhahood. Enlightenment means liberation from all duality. If we want to make a truly beautiful object, we must before all else reach this state of mind which is free. In comparison to this radical condition, degree of skill, depth of knowledge, even the quality of materials are secondary considerations. This is the utter simple truth implicit in every Santo or Retablo painted by those Mexican devotees of the humble mind.

Of course it is far better to have good training, knowledge, and well chosen materials, but the one absolutely indispensable thing is the attainment of that state of mind which is free from all dualistic fetters. If this one condition is lacking, all skill, knowlege and materials will be wasted.

Shards

It is the uniformity of perfection that kills.

Bernard Leach

The best work happens while I am looking the other way. . . .

Mike Thiedeman

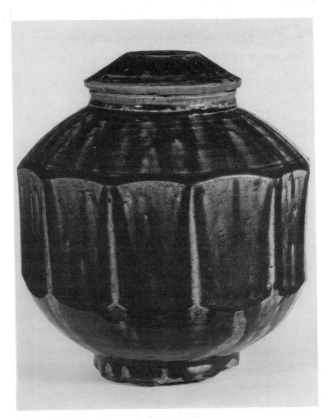

18. Unknown Potter: *Honey Jar with Lid, stoneware, 8¼" high, 7¾" diameter, 19th century, Yi dynasty, Korea. Courtesy of The Brooklyn Museum; gift of Robert S. Anderson.*

On Nothing

Lao Tzu
(Trans: Arthur Waley)

We put thirty spokes together and call it a wheel;
But it is on the space where there is nothing that the
usefulness of the wheel depends.
We turn clay to make a vessel;
But it is on the space where there is nothing that the
usefulness of the vessel depends.
We pierce doors and windows to make a house;
And it is on these spaces where there is nothing that the
usefulness of the house depends.
Therefore just as we take advantage of what is, we should
recognize the usefulness of what is not.

Illusions of Originality

Jamake Highwater

Many people are not aware of how works of art are made. They have been coaxed by public falsity into a clumsy notion that novels, sonatas, paintings, poems, films, and dramas are the products of a pervasive originality. Yet the history of art makes it very clear that originality has played a very small part in the lives and works of most important artists. So it is difficult to imagine why so many sophisticated people still insist that innovation and novelty are prime requirements of masterful arts.

We need to make a distinction between originality and individuality. And that distinction will necessarily invoke a contrast between the way art is conceptualized by the West and by numerous primal societies. "Originality" betrays an ego that identifies *itself* as the ultimate source of inspiration and art, whereas "individuality" in art identifies with a tribal tradition.

Of course the public is not alone in seeing artists as supreme egoists. Many renowned artists have themselves been devoted to self-aggrandizement, thrusting upon the public a curiously contradictory view of the creative personality as both egocentric and mystical. But the fact remains that the creation of art is a largely unconscious activity—almost to the point of being anonymous. "Who speaks to me with my own voice?" (Dufrenné). From ourselves comes a stranger called art.

The West is disinclined to accept the impersonal nature of artistic inspiration. It continues to envision art as the final proof of free-will and creative self-determinacy in Faustian man. Primal people, to the contrary, have rejected the entire premise of originality and have tended to see the creative person as an individual with a special talent for drawing inspiration and vision, not from the "self," but from the tribe's ancient traditions.

Since the West persists in the endemic notion that originality and only originality is the very essence of the creative process, it is not surprising that people gasp in indignation when an artist is accused of plagiarism. To the contemporary Western mind the infringing upon another person's art is the ultimate sign of a failure of originality. Contrarily, in the arts of primal people "plagiarism"—leaning heavily upon pre-existent art—is something of a virtue.

This contrasting way in which the West and primal peoples view originality is more significant as an expression of viewpoint than it is as a description of the actual working practices of Western artists, for on close examination it will be found that "quotation" is a commonplace among many of the very greatest artists of Europe and America.

So we must not lump the entire mentality of the West into just one moment of

history, for the Western mind possessed its own genesis and its own period of tribalism. Until very recently there did not exist in the West an awareness or an interest in the kind of idiosyncratic personality that conceives of originality as the ultimate source of art. Even the conception of authorship, as a demarcation of a person, was non-existent until the age of Pericles (300 B.C.). And as Herbert Read has pointed out in *Icon and Idea,* "even when in later historical times the artist was differentiated from other craftsmen, . . . even then there was the strongest impulse to achieve an ideal uniformity, and although distinct personalities (individualities) do emerge among the sculptors of classical Greece, it is very difficult to ascribe any personal accents to the work of a Myron or a Praxiteles." They may differ considerably in skill, in their fulfillment of the ideals of Greek aesthetic perfection, but they do not express, and were not expected to express, uniqueness or originality. Their artistic style was, in Read's words, "impersonal" to the point of bearing more resemblance to the creations of tribal artisans rather than to the fabled egocentric producers of Renaissance art.

When the Indian potter collects clay, she asks the consent of the riverbed and sings its praises for having made something as beautiful and useful as clay. When she fashions the clay into a form, she does so by evoking the shapes of sacred things in which power moves and life dwells. When she fires her pottery, to this day, she still offers prayers so the fire will not discolor or burst her wares. And, finally, when she paints her pottery, she imprints it with the images which give it life and power—because for a traditional American Indian, pottery is something *significant*—not simply a utility or a decorative artifact, but a "being" for which there is as much of a natural order as there is for persons or foxes or trees. It is through this transformation of clay into *being* that the potter asserts her individuality and makes art.

The art of American Indians, however, is not an "expressive" or personal form but a tribal activity that reflects the consciousness of a whole people. Such art possesses strong individuality—that is why we single out and admire the pottery of Lucy Lewis and Maria Martinez—but it does not reflect a conscious striving for originality. This contrast between individuality and originality is the most complex distinction between the way various twentieth century peoples look upon themselves and their artists.

The imagery of art grew very gradually out of the profound experiences of tribal histories. This process was universal—in Europe, Africa, Asia, Australia, and in the Americas. The iconography of art has such spontaneous and holistic relationships to a people's reality that it speaks to them silently, almost automatically, like the images of dreams. For primal people "art" is so central to existence that they rarely possess a word for it. It was only in the West that desensualization and dehumanization have resulted in the conception of art as an idiosyncratic product of one person's creative imagination . . . of one person's *originality.* In the West people with creative imagination do not only produce original things, but they also hold legal ownership to whatever it is they originate . . . like a patented product.

As soon as we begin to believe in art as predominantly the result of originality, then the relationship of the artist to people and the relationship of his or her art to tradition are obliterated both by copyright laws and by public consensus.

Originality is a conception that promotes elitism in art and denies the profound relationship of artists to societies.

This adoration of originality in the West is contradictory to all history, and especially to twentieth century history.

Many producers of great art were not even aware of the public obsession with origi-

nality. Or, if they were aware of it, they clearly ignored the mandate. Borrowing melodies from existing music was a commonplace throughout the Middle Ages. Of the 2,542 surviving works of the troubadours, at least 514, and perhaps another 70, have been reckoned to be imitations or borrowings with respect to their melodies. A fifth or more of this entire genre of music was clearly "unoriginal." Later Vivaldi borrowed from his predecessors, and then Bach borrowed whole compositions from Vivaldi. It was not a game or a deceit. Making music had very little to do with originating melodies. It was a process intent upon individualizing something out of a tradition—making it "new" through an expression that was individual.

Charles Ives is among the most important composers in North American musical history, and yet he is the least "original" at the same time that he is the most individual. He not only quoted Brahms and anybody else whose tunes interested him, he used a vast amount of folk materials with a passion. He played no favorites when it came to his borrowings. He must have also quoted himself in at least half of his compositions.

"Originality" is not the basis of our admiration of Charles Ives. We admire him because he had a special and personal way of interweaving all that he borrowed, a sense of form and style—and a startlingly liberal ear—which resulted in something which did not exist in any of the musical materials he appropriated.

Most early Americans in the arts were so inclined to lean on European examples that in the 1930's critics like George L. K. Morris urged them to borrow from Native Americans rather than copying the European masters. "American Indian art is the only true American art," he said. And American artists "should study Indian art in order to develop independent of European aesthetic values."

It was advice that sounded rather quaint until art historians began to notice the relationship of African art to the works of Derain, Picasso, Matisse, and Giacometti. John Ashberry, as well as many other critics, has noted again and again that Picasso's art was rather conservative until *Les Demoiselles d'Avignon* (1907), when the influences of African and early Iberian iconography made a sudden appearance in this painting.

As for the American Indian connection recommended by George L. K. Morris, it is easily found in the art of Rothko, Newman, Motherwell, Hartley, Pollock, Gottlieb and many other leaders of the first internationally acclaimed art movement of the United States. The Indian influence is not only visible in the work of these painters, it is also documented by their own statements. So is the impact of Indian rituals on the choreography of Martha Graham, and the artifacts of Central America (the Chac Mool sculptures) on the works of England's Henry Moore.

Originality is an illusion. Artists work within a tradition—frequently with materials that "belong" to someone even though they clearly do not belong to anyone except the heritage itself. I am not talking about petty theft. I am not talking about kids with empty heads and nothing to say who steal their term papers from textbooks. I'm talking about artists who have a great deal to say, who have a point of view, and a style and an individual talent.

The indignation which always surrounds accusations of plagiarism—the lack of originality—sounds a good deal like the Victorian animus toward adultery. Originality in the arts is the same kind of illusion as fidelity in human relations. To insist upon something that is illusionary or—at best—rare is not a matter of merely being unrealistic: what it finally comes down to is being immoral by insisting upon a morality that is meaningless.

The plagiarist is not the immoralist. It is those whose values place the artist in a position of indignity who are finally immoral.

A great, created work of art cannot be plagiaristic any more than it can be original. Edgar Allan Poe summed it up years ago: "All literary history demonstrates that for the most frequent and palpable plagiarisms we must search the works of the most eminent poets."

Maria Martinez of San Ildefonso Pueblo in New Mexico once said: "I do not create these pots. They are already here in the clay and in my people who speak through my hands."

19. Maria and Julian Martinez: *Plate, earthenware, 2" high, 12¾" diameter, circa 1940, San Ildefonso pueblo. Courtesy of Everson Museum of Art, Syracuse; gift of the Pueblo Indian Arts and Crafts Market, 1941.*

shards

Art has nothing to do with the fact of new invention, it resides in the quality of what has been invented; and whether the invention was made recently or not is irrevelant to the standing of the work of art. We do not burn our Rembrandts. Novelty can be exciting and delightful in art as in other affairs, but art exists in its own right, independently of novelty.

David Pye

Without copying there would be no crafts at all. We have all learned and copied from the past.

Shoji Hamada

20. Unknown Potter: *Bowl, earthenware, 5½" high, 13¼" diameter, 1941, pueblo unknown. Courtesy of Everson Museum of Art, Syracuse; gift of IBM Corporation, 1963.*

With Beauty May I Walk

Navajo Prayer
(Trans: Washington Matthews)

With beauty may I walk.
With beauty before me, may I walk.
With beauty behind me, may I walk.
With beauty above me, may I walk.
With beauty below me, may I walk.
With beauty all around me, may I walk.
In old age wandering on a trail of beauty,
 lively, may I walk.
In old age wandering on a trail of beauty,
 living again, may I walk.
It is finished in beauty.
It is finished in beauty.

In Defence of Tradition

. . . because of the heart, in spite of the head

Mike Dodd

Outside the mist hangs loosely, coolly caressing the
still and stately branches of the walnut. . . . And as the sun
rises drops of mist-water can be faintly heard as the young,
fragile buds quietly renew. Life is once again given form
different from last year; yet the same. Millenniums old, yet
new. New, yet old.

Imagine the "old" potters, with no knowledge of distant traditions and
quite possibly little knowlege of potters outside their own country, preparing, settling, drying
and throwing their clays; making wares which, in function, expressed the needs of their
communities. Imagine the destruction of such communities, and the consequent dissipation
of craftsmen during the migration of country people into the towns to supply the rapidly
enlarging industrial revolution, meaning that the crafts, as an expression of those needs, lost
their vitality, their self-integrity. Culture rose out of those needs. Their loss, therefore,
signified the loss of culture. When that root died, the living traditions were severed from
their roots. Originality decayed (origin . . . from the source). Tradition wilted and died also
or became totally unre*source*ful as e.g. in the modern Wedgewood and Delft factories, hardly
definable shadows of their former selves. The craftsman of those early communities had no
one to impress, no exhibitions to launch, no reputation to nurse. But he had his work, his
craft with which he could develop, unheeded, an inner relationship. Such a relationship was
between the Heart (the source) and the Hand. The very nature of the work at that time
would demand this relationship if the man was to remain content. Between himself and
the process of making lay the "development area" of the pre-industrial craftsman. The
deepening of his understanding of "the one on the wheel," of the subtleties of his materials,
where they were dug and how they were dug, the souring, the intricate sensations and
delicate movements learnt through long hours on the wheel, his feelings and insights. . . .
Intellectually, we now call the work of those men "unselfconscious." The identity of self, as
"I," was lost, since any self-assertion was subordinated in the heart/hand relationship. The
"I" bowed in the making of the pot, and not at its final acclamation! Such products were
naturally original, individual and free (individual in the proper sense of being undivided). We
are conscious of this, because of the head.

Twentieth century man, and the twentieth century craftsman in particular, has entered
life through quite a different door. He has been educated or conditioned to use his head at
the expense of his heart This imbalance of intellectual importance, the conceptual basis

of our understanding of life, gives us, in our relationship with our work a perceptual difference in vision, inner or outer. We are conscious of *why* we are doing what we are doing rather than doing it because it needs doing. We are, as someone said, intellectual revivalists. Instead of the relationship being between the craftsman's being and the process, . . . it is now between the process and the finished product. . . . The emphasis has shifted from the process of making and inner fulfilment, to the product and personal aggrandisement. . . . The shift is very evident in our work and attitudes Anything goes, the more "original and individual" the better—if only they were!—what we are really saying is that any *idea* goes. But what we fail to see, is that the pot can then only be as good as the idea and unjustly limited thereby. Contrast Leach's "The pot is the man" with "The pot is the idea." *Conceptual* art must be limited since concepts can only function within duality, and therein lies the gates of hell and the prison of the heart. Work made from this conceptual and highly self-conscious premise cannot be individual and free but, conversely, dividual and bound. Sadly the majority of art colleges fall within this trap, producing intellectual toys, negating the very humanity which gave them cause to be. This negation holds many pitfalls; resentment, envy, gimmicry, idiosyncracy, and supercilious pedantry on the ad nauseum argument of pottery v. sculpture v. painting etc., etc., etc. They are all languages of human expression, but it is not enough to learn the grammar. We must learn to know those who are eloquent and those who, rarer still, speak without speaking. . . . "There are no major and minor arts, only major and minor artists."

However having established that we have been brought up differently, have "come through another door" we cannot conscientiously rest if we bemoan the fact and wallow in an over-romanticised nostalgia, by slamming it in the face of reality. Perhaps the function of the modern-day potter is to try and strike a balance, a balance which in Japan is expressed as Jiriki, Tariki; Self-power, Other-power (something akin to Cardew's deliciously understated "the something other"). Being aware, we will have some sort of aesthetic, however nebulous, which in itself will have a greater or lesser degree of temperamental eclecticism. We will consciously choose from those countries and cultures, forms, textures and glazes which, because of their choosing, give us an indication of that which will express ourselves best. This is healthy, albeit easy to abuse. And yet at the same time as we extract what we will from these divergent traditions we hear talk that tradition is dead, old hat, the concern only of the "two-bit" functional potters! Tradition is the living and inexhaustible form of the Source. . . . It is interesting to note that in the modern tendency to reject the anthropocentric and irrational aspects of the traditions of the heart, we have evident, in compensation, conceptual creations of the "natural order" e.g. seashells, fungi, rocks etc. We should be careful here not to intellectually misinterpret Aristotle. "Art imitates nature" does not mean that art should imitate the *appearance* of nature, but the *nature* of nature. The heart is the centre of human experience and yet we must use the head to transcribe that which we feel. But the head must serve the heart; as Dag Hammersjöld aptly put it, "How humble the tool when praised for what the Hand has done."

Some years ago I was somewhat disturbed by something which Hamada is supposed to have uttered when asked if he would go to America to teach (he was then quite young). He declined and on being asked why, he replied "I wish to start a pottery in the country and lose my tail." And I wondered how he could lose something that evidently he hadn't got? Being now a little more versed in the eastern delight of paradox, perhaps he meant that he

wished to get rid of his "ego" or "self" which he knew existed only as a mental construct or "bind." This bind is only too real to most of us and yet it has no real existence. And when more recently Hamada said "a good pot is born not made" I realized that he was saying something to the effect that if we didn't lose our "tails," good pots would be out of our reach. Cezanne said something similar "I wish to paint this landscape while I'm not here." In other words, and in eastern terms, "a good pot is born and not made," means that it is *directly conceived* from that which is Unborn. One has lost one's tail sufficiently for the creative force to come into play without the hindrance of our self-opinionated, ideologically conditioned, little egos. This process of emptying, ful*fills* us.

21. Mike Dodd: *Bowl, stoneware, 5" diameter, 1980s. Courtesy of Mike Dodd.*

For me, pottery is unthinkable without very close attention to tradition. We cannot dismiss thousands of years of human love and expression by delineating an arbitrary line whereby tradition is no longer valid. True tradition is Vital, it is alive, it is life mirrored in an anthropocentric form. Why? In order that another anthropod may benefit thereby! Through this life we can give love, or indifference or hate, that is our choice, for it is not a concern of life itself, just as the sun, from its absolute point of vision knows nothing of shadows, and cares not, for "man stands in his *own* shadow and wonders why it is dark." A pot, a poem, a painting or a little piece of cloth, which speaks to us over the centuries, has shown us in its very form, the formless, the Unborn, the Heart, the Source. And we in our turn try to precipitate, give meaningful form to this formlessness whose language is written in the work of artisans from all countries at all times and whose vehicle is tradition. The success of this operation will depend on our ability to get out of the way, to allow the free play of the heart, that inexhaustible reservoir of growth. Old forms; yet new. New; yet old. . . . I hope we get more walnuts this year.

Shards

Change is the essence of tradition. Our declining civilisation has largely lost the conception of tradition as continuous change by small variations—as evolution, in other words—and can produce only fashions which, one after another, appear, live for a little while, and die without issue. At each death another deliberately different fashion is launched and promoted, as sterile as the one before.

David Pye

Tradition is the accumulated knowledge of the men that have worked and thought before you. It is the constant renewing of valid forms that have proven their importance and permanence to man throughout the centuries. Tradition as such and in itself is alive; it is only *convention* that brings it to a stop and to death. Tradition is alive for the very reason that every generation adds to it something in its own modern way, something that is only related to its time. In fact, it is just this element of actuality, or newness and youth that is infused in what may be an age-old subject, that makes it *tradition*, and that gives tradition its eternal value. Without, on one side, the accumulated permanence and the stability of what has proven to be of value, on the other side, the addition of this element of newness of its own time, there would be neither emotion, nor flame, nor vision.

Charles Augustin Sainte-Beuve

The lyf so short, the crafte so long to lerne.

Geoffrey Chaucer

The Need to Win

Chuang Tzu
(Trans: Thomas Merton)

When an archer is shooting for nothing
He has all his skill.
If he shoots for a brass buckle
He is already nervous.
If he shoots for a prize of gold
He goes blind
Or sees two targets–
He is out of his mind!

His skill has not changed. But the prize
Divides him. He cares.
He thinks more of winning
Than of shooting–

And the need to win
Drains him of power.

Pottery and the Person

Daniel Rhodes

Most discussions of pottery, or historical references to it, give it a kind of impersonal existence, as if pots sprang into being as a result of process, almost without the intervention of people. Pots of the past are described in detail, but their makers are seldom mentioned. This is partly because the pottery of the past was largely an anonymous art, and nothing much specifically is known of the actual potters.

As we learn to make pots, and as we deal with the sometimes difficult and intricate facets of the craft, our attention is directed to the *pot*, to the thing we are making. The fact that the pot is but a reflection of our inner being, of where we are at the time, is not intruding into our consciousness, and this is well, because any art or any craft requires full, directed attention, and self-consciousness, while it may be revealing or even fruitful, has no place in the moment of expressive action.

Looked at subjectively, however, pottery-making can be thought of not so much as an activity resulting in so many bowls, cups, or jars of some assumed function, value, or aesthetic merit but rather as the outcome of our urge to form and, in forming the clay, to find our own form. The changes and developments in the form of the clay which passes through our fingers can parallel, complement, signify, and support the changes and the evolution of our own inner consciousness. To form is to actualize, to bring into reality what was not there before, to create one's image, to expand and to develop this image. This impulse to form is basic to the human condition, existing among all of the tribes.

Today, the impulse to form, and the opportunity to deal directly with our own self as projected in tangible form in the outer sphere, is thwarted. Mechanization, industrialization, division of labor, commercialism, and standardization have wiped out most of the formerly abundant opportunities for the individual to function through craft. Great gains bring great losses, and men and women have been left with a feeling of being cut off from themselves with a loss of identity.

Craft, almost eliminated from the practical world and a seeming anachronism, has become a precious remnant. In it, we can sense the potential for full development of the person, for the restoration of wholeness. The artist and the craftsman, laboring outside of society's system of production-money-consumption, keep alive a different way of working and living. They work for the joy of working and they seek and find their identity in the work of their own hands rather than in commercialized images on screen or paper, images projected by promoters of a world which does not exist.

The way of the artist and the craftsman is difficult. Cut off from the main thrust of his

society, he must go it alone. The very traditions from which he seeks nourishment tend to wither, to become weakened and confused. There is the problem of finding bread. The artist working within the context of fine arts as they are defined in our culture, faces almost insuperable difficulties. He is cut off from any coherent tradition which might be shared with others in a supportive way. Alone, he struggles to assert his original and personal statement. By definition, his statement, since it must be starkly original and not based on the past, will be illegible except perhaps to a few. Obsolescence and neglect follow directly on success, a success which in any case is improbable in the extreme. The life of the dedicated artist can only be regarded as a heroic encounter, a struggle against impossible odds. It is significant that the work of children, folk artists, or the naive often has a freshness, vitality and charm lacking in "professional" art; these less sophisticated artists are still able to work without undue self-consciousness or concern about the ultimate meaning or acceptability of their work.

The potter works toward more modest goals than the sculptor or painter. He creates something of utility; aesthetic values are not its sole justification. With intelligence, skill, and practice he is reasonably assured of making something of value. Pottery exists within a framework or boundary—perhaps defined as constricting by some—but within this defined area some measure of security can be found. For the craftsman, function is a balance wheel. It is something to work with (or, in searching for the boundaries of one's expression, to work against). It is a fixed point of reference. To the question, "For whom is this work?" the "fine" artist can answer only that he hopes his work will eventually find an audience and move them as he has been moved. The potter can answer; "I present this pot, which embodies my skill, my insight, my respect for the material and process, my sincere search for form. It will be useful in the kitchen and on the table. It may bring a small touch of warmth and beauty to those who use it. Whatever exists in it which might be called 'art' will function through daily use, through touch, through intimate acquaintance."

Pottery-making then, is a shaping of material, a postulation of form, an actualization of dreams which can occur in a natural way without an undue challenge to the ego. It is not pretentious. Its commitments have to do with right making more than with exhibitionism. The potter can achieve a certain relaxation in his work, learn to be comfortable with it. Out of this natural relationship to work may grow a natural expression of self, an unforced, un-self-conscious, genuine flow of person to pot. However modest, the pot can be an authentic image of the potter.

To find reality in one's work, to project honestly into it, is to become *centered*. For better or worse, the pot becomes the projection of the potter, his image. In it are summed up the integration of his powers, his thoughts, his feelings, his action. Pottery form is an emblem of this integration, and we must avoid thinking about the form of pots as if it were something impersonal. Forms grow from the person. That is why it is impossible to assign any hierachy of value to pots or to impose standards aside from the equation *person = pots*.

As the development of personality is a slow process and a response to innumerable influences both external and internal, so the development of style in the work unfolds gradually. We are not making today what we made a year ago, and tomorrow we will be making something different, something not now imagined. The image grows, changes, fades or blurs at times, then sharpens, enlarges, becomes perhaps diffuse and then concentrated. These developments, like the changes in life, can bring joy, satisfaction, pain, or despair, but

they must be lived. The evolution of the clay under the hands cannot be forced. Time is required for each stage. Each fallow period must be endured; the seemingly negative factors in the work, after the passage of time and more work, may turn out to be faltering steps in the right direction. Failures can be defined as searches in the byways, and as such can be absorbed without damage to the self.

Pottery requires on one hand active effort, concentration, and tension, and on the other, relaxation. These two qualities, in fact, can be identified in many pots. Some pots, such as certain ones made in classical Greece or Etruria, are tense, sharply fashioned, with exaggerated curves and relationships between parts. Handles rise from the rims with sprightly vigor, and feet are made almost as separate forms. Some old Chinese pots are almost limp by comparison. Their proportions are modest, their parts closely integrated. The clay has not been asked to do that which is difficult for it. Of these two qualities, relaxation is the hardest for us to achieve. That is why the works of the contemporary Japanese potter Shoji Hamada are so impressive. Each of his pots, although usually modest in scale and in proportion, speaks of a sense of ease. The clay has not been pushed beyond a certain point. They are in the tradition of Zen-inspired arts—"No Fuss."

Pottery as meditation, as selfless concentration, requires the abandonment of anxiety and the perfection of skill to the point where it can be forgotten and one's consciousness becomes absorbed in the tactile sensations of process. In this state, the work will form itself, and the potter may feel presumptuous even to take credit for the happenings which emerge from his kiln. The question of originality will have been solved. Who asks whether their own pattern of speech and expression are original? No one, because we all achieve originality in speech by a lifetime of concentration on what is said rather than how it is said.

As in the growth of plants, the emergence of forms from the hands proceeds in small steps, gradual unfoldings. One must be satisfied with small gains, evolution rather than sudden revelation.

The potter approaches the clay with just his hands. There is no intervening superstructure, no frozen or mechanized system, no network of authority between him and his work. The forms he makes are his alone.

Shards

Fear is the greatest problem for us potters. Fear of failure, fear of success, fear of being accepted or rejected. If we can work without it, work for the joy of working, then we are free. Because then we are no longer working for money, for fame, or for mother but, for ourselves.

Having no fear leaves us free to take risks and thereby learn from our failures and successes. If we produce safe, calculated pots, then that joy of discovery is lost and our growth cut short. The way to continue growing is to risk the unknown. An old Chinese proverb says it best, "Fear came knocking, faith opened the door, but no one was there."

Jenny Lind

There are many marvelous stories of potters in ancient China. In one of them a noble is riding through town and he passes a potter at work. He admires the pots the man is making; their grace and a kind of rude strength in them. He dismounts from his horse and speaks with the potter. "How are you able to form these vessels so that they possess such convincing beauty?" "Oh," answers the potter, "you are looking at the mere outward shape. What I am forming lies within. I am interested only in what remains after the pot has been broken."

M. C. Richards

The Potmaker

John Green

Capturing quiet space
in wet vessels—
sits the potmaker
over his ticking wheel,
over the world,
over his clay,
in touch
in love
with what he feels—
the earth
spun into rugged pots
lined left away—in sunlit courts,
young eyes watch at wheel head height,
reflecting the turning days.

Stone pon stone
blocked doors go up,
alined with rising hope,
none but the potmaker
knows of the time,
of the energies,
he must conjure up
in this furious, furnatic climb
with rage that builds
to battle back all hell within his walls,
brushed and chopped ten thousand times
before his powdered glaze—will fall,
—then—
rest—with peace,
the crackle beast
becomes a loyal friend
that yields him rich in rugged pots,

to ease back a strength,
the potmaker needs
to help him capture quiet space,
in wet vessels—once again.

22. Daniel Rhodes: *Covered Jar, stoneware, 1970s. From* Pottery Form *by Daniel Rhodes,
1976, Chilton Book Company, Radnor, PA.*

An Historical Review of Art, Commerce and Craftsmanship

Harry Davis

It may be wondered why I, as a potter, have chosen a title which obviously has more to do with sociology than pottery. The reason is that the history of the relationship among these three explains the peculiar position of pottery today, and also explains the need which people seem to feel to differentiate between artists and craftsmen in the arbitrary way in which they do. This distinction has much more to do with prestige than with creative talent, and is very much bound up with social status. The history of this relationship also explains the peculiar fact that pottery has "made the grade"—that a generation ago potters managed to insinuate themselves into the world of Fine Art, while cabinet makers, musical instrument makers and blacksmiths, etc., did not.

Walter Gropius, the well-known architect and founder of the Bauhaus, spoke somewhere of the "fatal legacy from a generation which arbitrarily elevated some branches of art above the rest as Fine Art, and in so doing robbed all arts of their basic identity and common life." This strikes me as a wonderfully vivid and concise statement about a social malaise which lies at the back of the whole of Western culture. The generation to which Gropius is referring is of course the one which lived in the first half of the 16th century, and to which Leonardo Da Vinci and Michael Angelo belonged, as did also Giorgio Vasari the painter and author, whose writing had, I believe, a considerable influence on the growth of this legacy. In actual fact the arts and the crafts are parts of a continuous sequence, extending from spheres of activity where the imaginative is maximal and craftsmanship is subordinate, to those where craftsmanship is dominant and imagination has no place at all. In this context one must remember that a lathe worker machining parts for engines, or a pottery worker tending a jigger, are both craftsmen at the non-imaginative end of the sequence. Clearly one can have craftsmanship without what we call Art, but one cannot have art without craftsmanship. Somewhere in this sequence there is, one might say a frontier zone where art becomes a craft in the non-imaginative sense. It is unfortunate that this is thought of as a fixed line, arbitrarily located, instead of as a zone with room to manoeuvre. The creation of a work of art involves the artist in innumerable movements back and forth across this zone. He switches between the purely manual and the purely imaginative, and the two merge continuously. It is perhaps even more unfortunate that people find themselves, or so they think, located on one side or the other of this imaginary line. In consequence, you get people who in certain situations will proclaim indignantly, or even conceitedly, "I am an Artist," and thereby put paid to any further argument, and others who when brought into contact with what they think is art proclaim pathetically, "Of course I am no Artist," and

venture no comment. The probability is that in fact neither of them is uttering the truth. These arbitrary divisions are post-renaissance phenomena. One might say post-renaissance social irritants, because before the 15th century these distinctions were not made. Men and their occupations were distinguished on the basis of the physical tasks they performed. Painters made pictures. Image makers carved in stone and wood. Potters made pots. Although they made some exceedingly fine things—beautiful things—significant things—exciting things—whichever adjective happens to be fashionable—none of these people were called artists. The interesting thing is that their languages had no such word, and the thing we call art was liable to emerge in almost any artifact that craftsmen made. In consequence—and with an absence of bally-hoo—a cultural something, a human something, permeated the entire social environment. One should note that the question of the relationship between artist and craftsman did not arise as they were one and the same person. This spontaneous creativity in the human make-up is as old as the record of man's works. There is no escaping the extraordinary beauty of the tools and artifacts of Stone Age man, and the works of the Maoris and the Aborigines are full of fine examples. Graham Clark, the eminent archeologist, points out what an ancient characteristic of man this is. In a reference to hand-axes of the mid-Pleistocene, i.e. 300,000 years ago, he says: "It would be perverse to account for the finest hand-axes in terms of their function alone since they were better made than large numbers which must presumably have been adequate. The cult of excellence, the determination to make things perfect as they could be made, even if, at a purely utilitarian level, perfection might seem excessive, is something which began this early in the history of man." It is sobering to reflect on the magnificent things that have been done outside what we like to think of as civilisation, and to remember that the acme of barbarity can also be found within it.

I am stressing an aspect of social history because it also helps to explain the peculiar light in which potters tend to see themselves today. One might think that with all this interest in pottery and with numerous magazines apparently devoted solely to this subject, that the potter's vocation was an up-and-coming thing; that his self esteem and his social standing were at a high level. There is, however, something misleading about all this because, in the Anglo Saxon world as a whole, this new-found eminence is based on something else. For instance, when I was shown around the ceramics department of the University of Hawaii by Claud Horan, he showed me the work of his students and explained apologetically that none of his students wanted to make pots anymore. This was evident from the fact that all the work was what is called ceramic sculpture, and no hollow object was classifiable as a functional pot. Woven into all this is a preoccupation with status, and I want to record an experience of mine of some 30 years ago which illustrates this. When I was engaged by the Crown Agents for the Colonies to work at Achimota College in the Gold Coast, I thought I was being engaged as a potter. The officials in London flinched visibly at this but they recorded it so. Quite soon after my arrival in West Africa, it was explained that the title Ceramist would be more suitable—what they meant, of course, was more prestigious. I was duly referred to as the Ceramist, although many Europeans in the area admitted that they didn't know what such a one did for a crust. Being young and perhaps a little flattered by all this status-padding, I accepted it and made no protest. Five years later, when I resigned from the job, Michael Cardew accepted the position, and of course when negotiating with the Crown Agents in London, he encountered this terminol-

ogy. He too thought of himself as a potter and, being 15 years older than I was when I took on the job, he had the necessary self-confidence to make a public issue of it. I was present when Michael Cardew made it known to the assembled staff that he wasn't having any truck with this nonsense; he was a potter and that was what he expected to be called. I felt an awful worm because at that point it looked as though I had introduced the whole snobby idea. I had tolerated it and that was bad enough. Twenty-seven years later I see that this little bit of status-padding is still contributing to the irritation. I am sure this stems from the publisher straining every nerve to advertise his product, but there it is, explained on the dust cover of Cardew's recently published book, that he held the post of Ceramist to the Institute of Arts and Industrial and Social Sciences at Achimota. It is obvious from this impressive title what important tasks we were engaged in, and how necessary it must have seemed that we should appear as earnest ceramists and not just common potters. In North America, and in some quarters in New Zealand too, it is astonishing how much energy goes into splitting hairs over the classification of potters. Anything to avoid the simple title potter. This is all part of the "fatal legacy" as Gropius calls it and is mostly confined to those who think of themselves as the elite, and it is interesting that most European languages include these hair-splitting distinctions between straight potters and other potters. I have already referred to that fact that potters have managed to insinuate themselves into the world of Fine Art. We need to face the fact that they are holding their position in that world largely by not making pots—by not being potters. The Canadian potter Tam Irving once remarked aptly that "there is nothing wrong with making ceramic neck ties if people want them, but they do also want pots." He was saying of course that sculpture is a three-dimensional art-form just as valid in burnt clay as in wood or stone or metal. Pottery is another three-dimensional art-form which happens still to have links with the business of eating and drinking. The fact that sculpture has largely lost its social role as a means of commemorating heroes and saints is no reason for potters to abandon the social role which they still have. My plea is that pottery is a valid and viable art-form in its own right, and that potters should have the courage to be potters. The business of making useful pots does present several rather formidable hurdles, besides the one of giving expression to creative talent. One wonders how much the hurdle of acquiring skill, and the hurdle of mastering technological expertise, are the explanations for all this. It could also be explained by the fact that it is coming to be accepted that the time-cycle between the first lesson at night school and the first "One man show," as the phrase goes, should not exceed six months flat! Joking aside, this last can, of course, be accounted for in part by the extraordinary muliplication of commerical galleries. Some see this as a cultural blossoming, but one should remember the vested interest which lies behind such premature promotion of exhibitions and the pre-occupation with status which makes them so tempting.

There is an aspect of the growth of the English language which throws some interest-ing light on the distinctions made in Anglo-Saxon thinking with regard to the words Art and Craft. "Art" and "artist" derive from the Latin "Ars" meaning skill. "Craft" derives from the Teutonic, an old German and Norse word also meaning skill. Both words have had infinitive forms. It was possible at one time "to art" something, as it is now "to craft" it, which gives us the revolting phrase "hand crafter." Both words expose social shortcomings in the related words "artful" and "crafty." The word "craft" came into the language with the first Saxon and Danish invasions after the departure of the Romans. After the Norman

conquest, England, as is well known, was a land with two languages. The Normans, the ruling class, spoke French, and the Saxons, the ruled, spoke a Germanic dialect. There are many examples to show how, when the two languages merged, Saxon words remained attached to the menial aspects of life while the French was attached to the more privileged and dignified aspects. Take the classic example of the words "sheep" and "mouton," "sheep" being what the underpriviliged Saxon called the beast he tended, and "mouton" (mutton) being what the privileged Norman called it when he got it served up on the table. The point here is that 500 years before the Italian Renaissance, English was already equipped with explicit linguistic distinctions denoting what were to become the menial and what the dignified aspects of the visual arts. Remember that in 1066 there were still no "Artists."

The association of these two words with the idea of skill has another interesting lesson to offer. Art was interpreted as skill right up to the late 19th century and for many people this is still how it is used. An artist is an able draughtsman, and he who is not an able draughtsman is obviously no artist. It is astonishing how much relief and satisfaction people will often reveal when, after considering a modern painting in non-representational mode, they are able to point to some early drawing of a more conventional sort by the same artist. The reaction is to say, "You see he can draw," or, "It isn't that he can't draw." Few people seem to realise that the purpose of drawing in an artist's training is not only to develop skilled draughtsmanship, but more important to develop sensitivity to form and powers of perception. It is interesting that the *Oxford Dictionary* takes the interpretation of art as skill right up to Matthew Arnold. Quite apart from the discovery of primitive art, which began in this century, it had already become obvious that machines and cameras were getting altogether too clever, so that if we were to continue to pay homage to art, it became imperative to find something else in it besides skill. This is an example of the way value judgements swing violently from one extreme to another. We have jumped from Victorian prudery to the almost totally permissive in less than a century. Art has somersaulted in a similar way, until now signs of skill are sufficient grounds for derogatory comment, and nowhere more so than in the world of craft revivalism. If the craft in question happens to involve a function, it is difficult to dispense with skill altogether, but the status value of being associated with Art, rather than Craft, is so great that function is often gladly dispensed with.

I was very thrilled to read recently a statement by Gio Ponti, the well-known Italian architect, in which he records his gratitude to the organisers of certain museums in America. He was referring to the fact that in that country what he called conventional art (nice phrase) was exhibited alongside the work of primitive peoples and simple craftsmen, and he rejoiced in the fact that this presented the creative genius of man as a single whole. He pointed out that in Italy what he called conventional art would be found in an art gallery, and the rest in an ethnographical museum. This applies of course to museums and galleries in most parts of the world. I was excited to discover this passage because it reminded me of an experience of mine in 1935. I was in Paris, enlarging my knowledge of the visual arts, looking at the Louvre and the Luxembourg with an eye preconditioned by the conventional concepts of what is called Art. One saw there an overwhelming mass of material, some immensely moving and some equally depressing, and one felt relieved that one did not have to live with so much bombast created to flatter the egos of princes. Later while sight-seeing

in the vicinity of the Eiffel Tower, I came upon a building called the Trocadero (since pulled down). It was some sort of theatre built in the round and had immense circular galleries which contained a vast ethnographical museum. This, for me, was a discovery. Here was another side of man, displayed through a collection of works of primitive peoples, an uninhibited side uninfluenced by the egos of princes and patrons. Those familiar with that remarkable little carving called the *Willendorf Venus* will know that this was the work of an unknown Aurignacian who lived deep back in the last Ice Age, some 20,000 years ago. It is in a museum in Vienna, and it is a classic example of the sort of work of art which is normally classified as an ethnographical or archaeological exhibit. If one were to put the *Willendorf Venus* alongside a Henry Moore and an Alberto Giacometti, a pot or two from Neolithic China or contemporary West Africa, with perhaps a Van Gogh or a bronze from Benin and a few Stone Age implements, one would begin to see our heritage, as Gio Ponti does, in its true perspective. I must say I felt saddened and sorry for all those generations of young artists referred to by Sir Kenneth Clark in his recent lectures on civilisation. He was happy to think of them having, generation by generation, padded back and forth across the Pont des Arts, between the Ecole des Beaux Arts and The Louvre as they strove to equal the classic tradition enshrined in that gallery. It was sad to think that the ethnographical museum had not been on their itinerary. Thinking also of the universality of the arts of man, I felt there was something significant and very symbolic in the fact that the Ecole des Beaux Arts is situated at the extreme end of the Rue de l'Université. If one follows the Rue de l'Université to its other extreme, which is quite a long walk, one arrives at a point just opposite where that famous ethnographical museum used to be.

An event which first opened my eyes on the matter of what is Art and what is not Art, and of status in the arts, occurred when I was an art student, aged 17. I had taken a job as a decorator in a pottery. My parents were happy about this, as it meant that I was associated with something which they thought of as Art, though nothing could have been further from the truth, because (as I now see it), the pots were appalling. I was very intrigued with the whole potting process and pleased to be able to earn a living this way. I had also learnt to throw and it seemed I was fairly good at it. One day the owners asked me if I would like to leave the decorating and learn the throwing side properly from an old man who worked there. I was delighted and agreed, but when I told my parents about this, they were quite crestfallen. I had failed them on the academic front, and the vision of my plodding up the ladder in the local council offices to the eventual pension had been abandoned. Art seemed to them to be a presentable alternative, and, who knows, there was always the possibility that I might do something "original," but there I was, about to learn to be a thrower. To my mother this was a terrible come-down. She was reduced to tears, and I was perplexed and unable to understand the reason for this reaction. Many years were to elapse before I was able to see how events in social history could lead to such a distortion of values. There is a greater clarity today about the forces that influence value judgement, but I was recently reminded how much this kind of thinking about relative status still persists. This came about in the process of collecting data about the house we live in, and about its former occupants. The list included a retired gentleman, a builder, a vicar, etc., but one name had no occupation. In answer to our query about him we were told "Oh—he didn't do anything, he was only a labourer."

The dividing element which caused the Fine Arts to separate from the other arts was

of course money—money, the medium by which commerce has become the dominant and all pervading motivating force of society. With regard to the status obsessions, I won't say it was the cause, but it certainly was, and is, a prime factor in the fostering of false concepts of status. Someone had said very aptly that money is like manure. When you pile it up in a heap it stinks, but when you spread it out thinly it has a wonderfully stimulating, fertilising effect. The rise of commerce out of ages with, so to speak, no commerce at all, has twice had this stimulating effect in Europe. Gordon Childe has traced the fascinating story of the first of these in the late Bronze Age. The growth of the period known as the Middle Ages is the other example with which I am concerned here. This was preceded by the system of regional subsistence economies called feudalism which spread all over Europe after the fall of Rome. Then came the Crusades, provoked by the spread of Islam, which in turn brought into being the Order of Templars. This order began by assuming the role of pious protectors of pilgrims to the Holy Land, but soon it was involved in trading and money exchange as well. The Templars therefore became the founders of a primitive banking and credit organisation which extended all over Europe and which was accompanied by very considerable trading activity within Europe, and also between Europe and the Arab world. The result was the fantastic cultural stimulation of the Middle Ages and the birth of the great spate of cathedral building. It is not coincidence that the first Gothic cathedral was built in Paris when the Templars were at the height of their power with their banking headquarters also in Paris. By the year 1300 the Templars no longer dominated the banking scene. Banking in Paris was already a private merchant adventurer's field, and Florence already had its famous banking names. By the Renaissance the manure heap stage had been reached and the diffused culture of the common people began the long slow withering with which we are all familiar. Only in the vicinity of the manure heap of the great banker merchant princes did the arts flourish like giant over-nourished docks. To some this may seem a very irreverent way to speak about something which has been eulogised for 400 years as a pinnacle of Art and Culture. However, this is the point in history referred to by Walter Gropius as having left us that fatal legacy, as he calls it, and it isn't the only misshapen bit of inheritance it has left us. I think it behooves us to try and see all this in its true perspective. Remarkable as some aspects of this cultural peak undoubtedly were, one should not lose sight of the fact that it was also the point in history when two similarly remarkable civilisations were destroyed by Renaissance Europeans. The Inca and the Aztec civilisations were both wrecked at that time, and one should also remember that it was the same generation which revived the sale of slaves. Africans were first sold into slavery in the West Indies at that time. Ever since the fall of Rome, slavery had been slowly on the way out. Feudal Europe had its serfs, it is true, but at least the buying and selling of slaves had stopped, and freedom was on the increase everywhere in medieval Europe. The great wave of city charters is the evidence, and it was the free men of those cities who formed the guilds and built the cathedrals to which I have been referring.

The essayist Professor Lionel Trilling has commented adversely on the claim by Dr. Leavis that the basis of poetic genius is the "moral conscience" and says, "This gives nothing like adequate recognition to those aspects of Art which are gratuitous, and which arise from high spirits and the impulse to play." This vivid statement touches on very important and fundamental aspects of the arts, which are so much the antitheses of the spirit of commercialism, and at the same time almost the perfect complements to skill. The choice of the

word "gratuitous" is very apt. The dictionary gives for the word: "Freely bestowed, granted without claim, costing nothing to the recipient." These are not the terms of commerce. The human impulse to play is also a basic element in the creative process and very much a part of the artist's approach. The positive quality of the giving of one's powers and one's talents, which is so typical of the arts, particularly among primitives, is utterly in contrast to the egotism and greed of commerce as we know it. The greed of employers has provoked the trade union movement, and life is so steeped in the attitudes of these two that a positive approach, a generous approach, so essential to art, has almost become an offense in the world of trade and business. One hears the word "service" used in commercial contexts, but it is a fraud because it is strictly related to an ability to pay. I think it is important to appreciate that in more primitive communities these gratuitous and playful qualities could operate alongside trade and commerce because the two activities were widely separated in time and space. The two forms of motivation could be kept separate because of the infrequency of trading contacts. The seasonal movements of nomadic people, and the spacing of the medieval trade fairs are examples of this. Circumstances created a situation which permitted the motives of commerce and the motives of creativity to function independently. Such insulation of motives can also result from a state of mind, which I believe artists, even the apparently unscrupulous ones, have in common with primitives. It derives from a quasi-unconscious sense of dedication which prevents a confusion of motives.

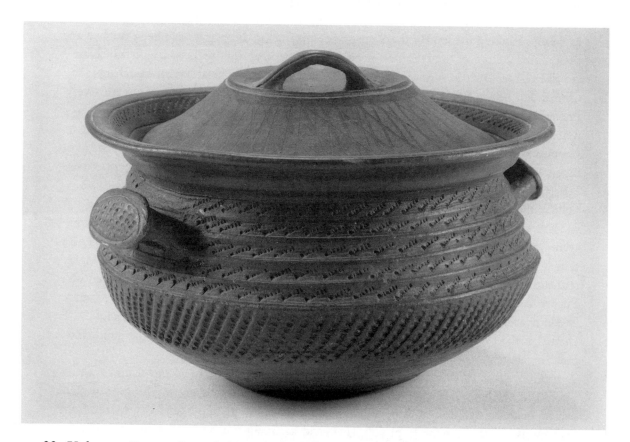

23. Unknown Potter: *Covered Casserole, earthenware, 6" high, 10¾" diameter, 1960s, Nigeria. Courtesy of the Royal Ontario Museum, Toronto.*

When Michael Cardew was in New Zealand, he showed us slides of Nigerian pots and remarked that the more primitive the tribe the more prone the people were to decorate their pots. Hearing this I was reminded of something which had greatly puzzled me when I was in West Africa 25 years ago. The peoples of those parts have for many centuries practiced that primitive form of agriculture which involves burning off the forest for their plantations and moving on when the soil is exhausted. This meant the continuous shifting of the sites of villages. I used to come upon such abandoned settlements which were always littered with pot sherds. The puzzling thing was that on these early sites the pots were mostly decorated, whereas the contemporary pots were mostly plain, not that the contemporary ones were decadent, they were not; but as I now see it, this was simply evidence that the more primitive communities were more prone to play creatively, and had less of an eye on the market.

I now want to take four widely separated periods in history and consider the prevailing attitudes to art and to commerce at these different times.

If one wants an example of art at its most vital, in full unself-conscious creative response to an environment, nothing could serve better than the cave paintings of France. Here one has a fine example of what Trilling calls "gratuitous high spirits and play" operating right outside the realm of commercial motivation. This is the work of Magdalenian Man who lived at the end of the last ice age, 12,000 years ago. These were real primitives who possibly had not even invented barter, let alone trade and commerce.

To move into the era of barter and commerce, I want to glance at the work of a nomadic people who lived in the Altai Mountains, 500 B.C. This was a branch of the Scythian family of peoples, whose frozen tombs were excavated by Russian archaeologists in recent years. Because of the altitude of the site and the peculiar construction of the tombs everything had been subjected to a sort of permafrost preservation. The result of this was that the contents, including the bodies, were found in an almost completely undamaged condition. The art of these people was astonishingly varied and vigorous, and it is also known that they were in trading contact with their neighbours, the Chinese and the Persians. Their trading activity was intermittent and obviously spaced out at irregular intervals, and in consequence their commercial motives were kept separate from their creative motives.

If we now take a look at a very different sort of society, which thrived 1500 years later, we see a rather anomalous situation. I am referring to the cathedral builders of northern Europe. Here we have a theocratic society, a settled economy, and the use of money, but nevertheless a tremendous artistic vitality. It is worth noting that anonymity is almost as complete here as in the caves of the Dordogne. One very interesting thing about this epoch was the loud and long opposition of the theocratic leadership to mammon in general and to usury in particular. As already noted, the system of banking and credit were operated by a very austere religious order. This was an actively anti-commercial leadership in a society which was however considerably involved in commerce. This was the period, incidentally, which produced one of the most vigorous periods of creative potting. I shall have occasion to refer to the English branch of this activity again later. In these three widely separated periods in our history there are two interesting things to note—both points that I have already touched on, but worth repeating. First is that fact that one can safely say that in none of these cultures would one have found languages that included a word for Art. They had

sculptors, painters, potters, metal founders, all with appropriate names no doubt, but no "Artists." The second thing is that the spirit of the thing we call commerce touched them very lightly.

If we now move on another 400 years (to use round figures) we come to the beginning of our own era of Renaissance Italy. This was a truly remarkable period—the period in which modern science was born. It was both forward looking and backward looking, and although it was in direct line of descent from the cathedral builders of the Middle Ages, the transition to the age of commerce was completed at this time. The backward glance was toward Rome, which was in itself very mercenary, but the general revival of interest in classical antiquity was stimulated by the fact that Italy had become a sort of refugee reception area for victims of the final overthrow of Byzantine Rome by the Turks. This was the period when the principles of modern banking and double entry bookkeeping were established. It also produced the first tycoons. The long struggle of the Church against usury was lost at this time. The Church was slow to give up this struggle, but the new commercial class had subtle techniques; lavish donation of works of art to the Church was one, care being taken to see that there should be no doubt about who donated what, the cash value of the gift being inscribed on the gift together with the name of the donor—a thing utterly in contrast to the mood of the cathedral builders of a few centuries earlier. There can be little doubt that the motive here was to soften the churchman's resolve in his censure of the links with mammon, and to acquire kudos and prestige at the same time. This was the beginning of the era of patronage, when the painters and sculptors began to come into the social orbit of the merchant princes. In their quest for kudos and prestige, it must have been obvious that this was best served by commissioning the most gifted and renowned sculptors and painters. In the process a very interesting and a very significant relationship came about: the sculptors and painters were drawn into an atmosphere of social intimacy with the ruling elite. The tycoons and the artists began to bask, as it were, in each other's glory, and both acquired kudos from the other's eminence. A familiar pattern.

In 1563 an event took place which has had its effect on the visual arts ever since. Cosimo Medici II sanctioned the founding of an academy which was to give distinction to his "artist" friends and absolve them from the obligations previously imposed on them by their guilds. Although this was no doubt justifiable on grounds of talent as well as for practical considerations, the prestige and distinction which it conferred set the chosen painters and sculptors—they were not yet called artists—in a class apart. This permanent separation from other craftsmen created a temptation to snobbery which was perhaps without equal and amounted to giving official sanction to an attitude among painters and sculptors which had been developing gradually over a considerable period. The element of snobbish exclusiveness which was thus confirmed in high places is traceable in the writings of Vasari who was a founder member and prime mover in the birth of this, the first of the academies of Art. An academy is precisely a fellowship of the elect and fits perfectly into André Maurois' classic definition of snobbery. He has expressed this with such telling alliteration, playing on the words of "Elus" and "Exclus," that I must quote the original. "Les exclus souhaitent devenir des elus; les elus defendent leurs privilèges et méprisent les exclus" (The outsiders long to become members of the elect; the elect—or elite—defend their privileges and despise the outsiders). One has to grasp that this transition was a long, slow process. The change to a society dominated by commerce took some 400 years. There

is a wealth of documentary material from which the stages of the change can be followed, and I am going to quote one or two which interest me very much as a potter. There is a famous document preserved in the files of a Genoese merchant banker which indicates a point when God and mammon were exerting forces of about equal strength. The man's name was Datini, and his account books are dedicated, "To the Glory of God and Profit." Lorenzo Ghiberti who was at his prime at the turn of the century in 1400 could see the way things were going. His much quoted remark to the effect that he had "chosen art in order to avoid the chase after money" ring a bell which many artists have heard toll in more recent centuries. By the year 1500 mammon was well and truly in the saddle, a more mercenary era there possibly never had been. Anything could be had for money—cardinals' hats and papal thrones included. Everything was for sale, so why boggle at the sale of slaves? A safe conduct to heaven, called an indulgence, could be had for a modest fee, and they were sold in their thousands to finance the building of St. Peter's and much else besides. This was the last straw which provoked Martin Luther to make his famous protest just 17 years later.

Guild records for the late 13th century in London show very interesting details regarding the ratio of master craftsmen to journeymen. The ratio was 1 to 1, so that allowing for apprentices, the numbers of which were also controlled on a strict ratio basis, this meant that the overall ratio of employees to employers was at a level highly conducive to creative effort. It is very interesting to note in this connection, that this is the period which produced the spate of "medieval pottery" which is such a remarkable tribute to the creative vitality of England at that time. The range, subtlety and individual character of the pots of that period never cease to amaze me, and what is so interesting about these pots is that they are all essentially functional, useful pots. Another record, this time from Paris for the year 1292, is a tax list from which the relative wealth of various citizens can be gauged. This is a very revealing document. Taxes were based on property and significantly enough the highest tax was paid by the banker merchants. These were Lombards, be it noted, and not the order of Templars. They topped the list with a tax of 114 livres a year. The next highest tax paid is a very interesting item of 19 livres paid by two potters. This might seem a big drop from the banker's 114, but it is astonishingly high when one comes to consider the rest of the list. A jeweller or dealer in precious stones paid 10 livres a year. Then come several trades paying between 5 livres and 10 livres. There is a painter at 6 livres and an image maker (sculptor) at 1 livre. Paris at this time was a much bigger city than London and it is clear from these records that commerce was developing at tempos relative to their size. The creative qualities of the work of the potters in the two cities seems to be an obvious reflection of this, and it is significant that the Guild Hall in London has a large collection of magnificent pots from medieval London, but the Cluny Museum in Paris has nothing comparable to offer. With the business prosperity of the potters in Paris standing second only to that of the bankers, it is perhaps not surprising that nothing very noteworthy survives.

Human institutions are prone, like many other things, to growth and flowering, fruition and decay. The Guild systems were no exception. They always had a monopolistic streak in their makeup, but at their best, they were very admirable institutions. In their prime, they were not only concerned to protect their privileges and monopolies; their ordinances also covered the craftsman's obligations to the consumer with regard to quality of work and embraced their obligations to each other. These obligations included help in times

of sickness and old age, and of course civic responsibility and elaborate ceremony. This, alas, did not last. The monopolistic element became the ascendant one. Commercial expansion, plus greed and nepotism within the guilds, finally changed the ratio of masters to journeymen and apprentices and transformed the role and habits of masters out of all recognition. They became employers pure and simple controlling large numbers of workers, and they were actively involved in politics. For example, in 16th century Florence anti-strike legislation soon became their concern and in this they were even able to call upon ecclesiastical backing in the form of threats of excommunication for restive workers. This was a pattern which at that time was confined to centres of commerce like Florence and the cities of the Netherlands but was to spread to the smallest provincial towns as the Industrial Revolution later came to augment it. The tremendous prestige and the extravagant exaltation of those who practised the "Fine Arts" was founded on wealth amassed by exploitation which entailed a loss of freedom and dignity among those who followed the "other arts."

It is very important to grasp that at the very point in history when Fine Art, that is to say painting and sculpture and architecture, was being used as a status symbol by the new class of wealthy bankers and merchants—and of course as a power symbol for princes and popes—those who followed the other arts, i.e., the craftsmen or artigiani, were losing their freedom and their dignity in the interests of commerce. Furthermore one must keep in mind the effect of repetition under orders from an employer, with the added circumstance of subdivision of tasks, which had inevitably a dire impact on the element of creative sparkle in work done. All this took root within the Renaissance period, and the painters and sculptors, having aligned themselves with the upper class, also began to voice their contempt for lesser mortals. This abitrary division between Fine Arts and other art has remained a feature of western society ever since.

The fashion in neo-classical ideas which began in this period was to determine taste in the arts for several centuries. It created an exaggerated respect for polish and outward refinement, and a contempt for primitive and elemental vitality which took a very long time to subside. This was of course a product of the split which I have described. Two hundred and fifty years later at the beginning of the Industrial Revolution, when Josiah Wedgewood came on the scene, this was still the case. One should remember that at this period there were in England a great many rural potters whose tradition and technique had come down in an unbroken line from the time of the cathedral builders, but the days of this tradition were numbered. I have already referred to the craftsman losing his freedom and his dignity as he was turned into a proletarian during the birth of capitalism in Renaissance Italy. There has been a lot written about Josiah Wedgewood. Those who have read William Cookworthy's *Diary* will know what an astute businessman he was. The name of Josiah Wedgewood still commands tremendous respect, and he is spoken of as the father of English potters, but he was not really a potter at all. He was an eminent industrialist—a manufacturer—and one of his most conspicuous achievements was perhaps his exploration of the idea of subdivision of labour. He developed the idea of the factory in the modern sense, and he was also responsible for some very impressive technological developments. Artistically speaking he merely reflected the neo-classical tastes of the upper classes, and perpetuated the Greek and Roman ideas which had percolated down from Florence. The success of these developments was the beginning of the end, in the pottery field, of that precious freedom among simple men to exercise the impulse to play creatively. No such play can take place

when the material advantages of subdivision of labour are being exploited. In accounts of the period the pre-industrial craftsmen are hardly mentioned and their work is seen as the "crude antecedent" of the new industrial pottery. From then on the independent craftsman was slowly eliminated, and his creative zest withered as his self-esteem declined. All this was accepted as the price of progress; Art as understood by the establishment still flourished in places called academies. It had the backing of royalty and was essentially something for gentlemen.

From the mid 18th century to the late 19th century the independent craftsman went steadily down hill. Then the craft revival movement, under the inspiration of William Morris, sought to recapture the creative scope which was once the birthright of any crafts-man and to allow him to regain his self-esteem and dignity. These were qualities once enjoyed by unself-conscious and illiterate men. The new craftsmen of the revivalist move-ment were middle class intellectuals, some were even university graduates and some were trained "artists." Some outstanding personalities brought the dignity and respect, which society already accorded them as graduates, to bear upon their new-found vocation, and did so in all humility and without false dignity. Others repeated the rather ignominious scramble for status vis-à-vis the "Fine Arts" which the painters and sculptors of the 16th century had indulged in with regard to the liberal arts and the social elite who enjoyed them.

As with all social maladies, diagnosis is easy. Remedy is another matter. The malady I have been stressing here is related to intrinsic values. The vital aspects of art are dependent on satisfactory value scales in relation to living and the world around us. A society almost totally dominated by monetary values—commercial values—is at an extreme disadvantage when it tries to accommodate other values in its thinking. It doesn't try, of course; individu-als in it try, but all they can do is to modify their personal behaviour in relation to their values. One looks to education for signs of hope, but it is committed to training young people to man the social order as it exists; and although it pays lip-service to the idea that things should be done for the right reasons, only its rebels seem in fact, to succeed in this respect. The truly simple and adequate reasons for making pots disappear from view when any gimmick is worth a try as an indication of originality and any publicity is worth chasing as a means to fame. To do something in order to appear to be original, to adopt mannerisms and play the eccentric in order to appear to be an artist; to pursue fame as a conscious objective are all symptoms of sickness and examples of actions taken for the wrong reasons. In saying that potters should have the courage to be potters, one is merely saying that they should have the courage to do things for the right reasons.

Shards

Life without industry is guilt, industry without art is brutality.

John Ruskin

Judge the art of a country, judge the fineness of its sensibilities, by its pottery; it is a sure touchstone.

Herbert Read

For a culture survives not only through its high-art embodiments; we study beauty less from paintings at the Metropolitan than from daily encounters with an honestly designed beer bottle.

Donald Hall

Art is *not* a matter of giving people a little pleasure in their time off. It is in the long run a matter of holding together a civilisation.

David Pye

All These Rely on Their Hands

Ecclesiasticus 38
(Trans: Edgar J. Goodspeed)

A scribe attains wisdom through the opportunities of leisure,
And the man who has little business to do can become wise.
How can the man who holds the plow become wise,
Who glories in handling the ox-goad?
Who drives oxen, and guides them at their work,
And whose discourse is with the sons of bulls?
He sets his mind on turning his furrows,
And his anxiety is about fodder for heifers.
It is so with every craftsman and builder,
Who keeps at work at night as well as by day.
Some cut carved seals,
And elaborate variety of design;
Another puts his mind on painting a likeness,
And is anxious to complete his work.
It is so with the smith sitting by his anvil,
And expert in working in iron;
The smoke of the fire reduces his flesh,
And he exerts himself in the heat of the furnace.
He bends his ear to the sound of the hammer,
And his eyes are on the pattern of the implement.
He puts his mind on completing his work,
And he is anxious to finish preparing it.
It is so with the potter, as he sits at his work,
And turns the wheel with his foot;
He is constantly careful about his work,
And all his manufacture is by measure;
He will shape the clay with his arm,
And bend its strength with his feet;
He puts his mind on finishing the glazing,
And he is anxious to make his furnace clean.

All these rely on their hands;
And each one is skillful in his own work;

Without them, no city can be inhabited,
And men will not live in one or go about in it.
But they are not sought for to advise the people,
And in the public assembly they do not excel.
They do not sit on the judge's seat,
And they do not think about the decision of lawsuits;
And they are not found using proverbs.
Yet they support the fabric of the world,
And their prayer is in the practice of their trade.

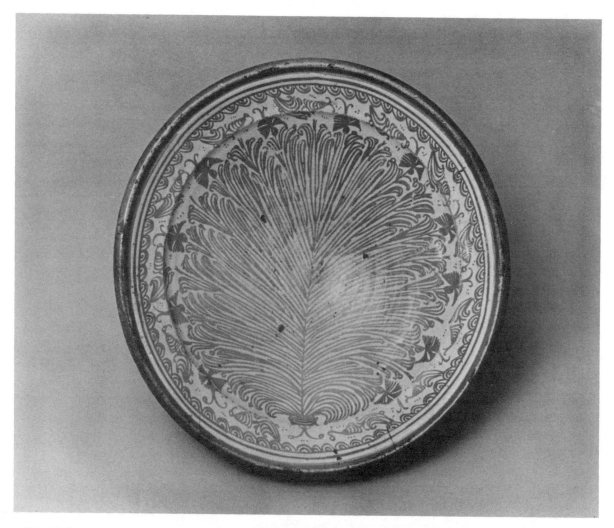

*24. **Unknown Potter:** Hispano-Moresque Bowl, earthenware, 4" high, 15½" diameter, 18th century. Courtesy of Everson Museum of Art, Syracuse; gift of Professional Women's League, in honor of Anna Witherhill Olmstead, 1975.*

Use and Contemplation

Octavio Paz
(Trans: Helen R. Lane)

Firmly planted. Not fallen from on high: sprung up from below. Ocher, the color of burnt honey. The color of a sun buried a thousand years ago and dug up only yesterday. Fresh green and orange stripes running across its still-warm body. Circles, Greek frets: scattered traces of a lost alphabet? The belly of a woman heavy with child, the neck of a bird. If you cover and uncover its mouth with the palm of your hand, it answers you with a deep murmur, the sound of bubbling water welling up from its depths; if you tap its sides with your knuckles, it gives a tinkling laugh of little silver coins falling on stones. It has many tongues: it speaks the language of clay and minerals, of air currents flowing between canyon walls, of washerwomen as they scrub, of angry skies, of rain. A vessel of baked clay: do not put it in a glass case alongside rare precious objects. It would look quite out of place. Its beauty is related to the liquid that it contains and to the thirst that it quenches. Its beauty is corporal: I see it, I touch it, I smell it, I hear it. If it is empty, it must be filled; if it is full; it must be emptied. I take it by the shaped handle as I would take a woman by the arm, I lift it up, I tip it over a pitcher into which I pour milk or pulque—lunar liquids that open and close the doors of dawn and dark, waking and sleeping. Not an object to contemplate: an object to use.

A glass jug, a wicker basket, a coarse muslin *huipil*, a wooden serving dish: beautiful objects, not despite their usefulness but because of it. Their beauty is simply an inherent part of them, like the perfume and the color of flowers. It is inseparable from their function: they are beautiful things because they are useful things. Handcrafts belong to a world antedating the separation of the useful and the beautiful. Such a separation is more recent than is generally supposed. Many of the artifacts that find their way into our museums and private collections once belonged to that world in which beauty was not an isolated and autonomous value. Society was divided into two great realms, the profane and the sacred. In both beauty was a subordinate quality: in the realm of the profane, it was dependent upon an object's usefulness, and in the realm of the sacred it was dependent upon an object's magic power. A utensil, a talisman, a symbol: beauty was the aura surrounding the object, the result—almost invariably an unintentional one—of the secret relation between its form and its meaning. Form: the way in which a thing is made; meaning: the purpose for which it is made.

Today all these objects, forcibly uprooted from their historical context, their specific

function, and their original meaning, standing there before us in their glass display cases, strike our eye as enigmatic divinities and command our adoration. Their transfer from the cathedral, the palace, the nomad's tent, the courtesan's boudoir, and the witch's cavern to the museum was a magico-religious transmutation. Objects became icons. This idolatry began in the Renaissance and from the seventeenth century onward has been one of the religions of the West (the other being politics). Long ago, at the height of the Baroque period, Sor Juana Ines de la Cruz coined a witty little phrase poking fun at aesthetics as superstitious awe: "A woman's hand is white and beautiful because it is made of flesh and bone, not of marble or silver; I esteem it not because it is a thing of splendor but because its grasp is firm."

The religion of art, like the religion of politics, sprang from the ruins of Christianity. Art inherited from the religion that had gone before the power of consecrating things and imparting a sort of eternity to them: museums are our places of worship and the objects exhibited in them are beyond history; politics—or to be more precise, Revolution— meanwhile co-opted the other function of religion: changing man and society. Art was a spiritual heroism; Revolution was the building of a universal church. The mission of the artist was to transmute the object; that of the revolutionary leader was to transform human nature. Picasso and Stalin. The process has been a twofold one: in the sphere of politics, ideas were converted into ideologies and ideologies into idolatries: art objects in turn were made idols, and these idols transformed into ideas. We gaze upon works of art with the same reverent awe—though with fewer spiritual rewards—with which the age of antiquity contemplated the starry sky above: like celestial bodies, these paintings and sculptures are pure ideas. The religion of art is a neo-Platonism that dares not confess its name—when it is not a holy war against heretics and infidels. The history of modern art may be divided into two currents: the contemplative and the combative. Such schools as Cubism and Abstract Expressionism belong to the former; movements such as Futurism, Dadaism, and Surrealism to the latter. Mystics and crusaders.

Before the aesthetic revolution the value of works of art pointed to another value. That value was the interconnection between beauty and meaning: art objects were things that were perceptual forms that in turn were signs. The meaning of a work was multiple, but all its meanings had to do with an ultimate signifier, in which meaning and being fused in an indissoluble central node: the godhead. The modern transposition: for us the artistic object is an autonomous, self-sufficient reality, and its ultimate meaning does not lie beyond the work but within it, in and of itself. It is a meaning beyond meaning: it refers to nothing whatsoever outside of itself. Like the Christian divinity, Jackson Pollock's paintings do not *mean*: they *are*.

In modern works of art meaning dissolves into the sheer emanation of being. The act of seeing is transformed into an intellectual process that is also a magic rite: to see is to understand, and to understand is to partake of the sacrament of communion. And along with the godhead and the true believers, the theologians: art critics. Their elaborate inter- pretations are no less abstruse than those of Medieval Scholastics and Byzantine scholars, though far less rigorously argued. The questions that Origen, Albertus Magnus, Abelard, and Saint Thomas Aquinas gravely pondered reappear in the quibbles of our art ciritcs, though tricked out this time in fancy masquerade costumes or reduced to mere platitudes. The parallel can be extended ever further: in the religion of art, we find not only divinities and

their attributes and theologians who explicate them, but martyrs as well. In the twentieth century we have seen the Soviet State persecute poets and artists as mercilessly as the Dominicans extirpated the Albigensian heresy in the thirteenth.

Not unexpectedly, the exaltation and sanctification of the work of art has led to periodic rebellions and profanations. Snatching the fetish from its niche, daubing it with paint, pinning a donkey's ears and tail on it and parading it through the streets, dragging it in the mud, pinching it and proving that it is stuffed with sawdust, that it is nothing and no one and has no meaning at all—and then placing it back on its throne. The Dadaist Richard Huelsenbeck once exclaimed in a moment of exasperation: "Art should get a sound thrashing." He was right—except that the welts left on the body of the Dadaist object by this scourging were like military decorations on the chests of generals: they simply enhanced its respectability. Our museums are full to bursting with anti-works of art and works of anti-art. The religion of art has been more astute than Rome: it has assimilated every schism that came along.

I do not deny that the contemplation of three sardines on a plate or of one triangle and one rectangle can enrich us spiritually; I merely maintain that the repetition of this act soon degenerates into a boring ritual. For that very reason the Futurists, confronted with the neo-Platonism of the Cubists, urged a return to art with a message. The Futurists' reaction was a healthy one, but at the same time an ingenuous one. Being more perspicacious, the Surrealists insisted that the work of art should say something. Since they realized that it would be foolish to reduce the work of art to its content or its message, they resorted to a notion that Freud had made common currency: that of *latent content*. What the work of art says is not be to found in its manifest content, but rather in what it says without actually saying it: what is behind the forms, the colors, the words. This was a way of loosening the theological knot binding being and meaning together without undoing it altogether, so as to preserve, to the maximum extent possible, the ambiguous relation between the two terms.

The most radical of the avant-gardists was Marcel Duchamp: the work of art passes by way of the senses but its real goal lies farther on. It is not a thing: it is a fan of signs that as it opens and closes alternately reveals its meaning to us and conceals it from us. The work of art is an intelligible signal beamed back and forth between meaning and non-meaning. The danger of this approach—a danger that Duchamp did not always manage to avoid—is that it may lead too far in the opposite direction, leaving the artist with the concept and without the object, with the *trouvaille* and without the *thing*. This is the fate that has befallen his imitators. It should also be said that frequently they are left both without the object and without the concept. It scarcely bears repeating that art is not a concept: art is a thing of the senses. Speculation centered on a pseudo-concept is even more boring than contemplation of a still-life. The modern religion of art continually circles back upon itself without ever finding the path to salvation: it keeps shifting back and forth from the negation of meaning for the sake of the object to the negation of the object for the sake of meaning.

The industrial revolution was the other side of the coin of the artistic revolution. The ever-increasing production of ever-more-perfect, identical objects was the precise counterpart of the consecration of the work of art as a unique object. As our museums became crowded with art objects, our houses became filled with ingenious gadgets. Precise, obedient, mute, anonymous instruments. But it would be wrong to call them ugly. In the early days of the industrial revolution aesthetic considerations scarcely played any role at all in the

production of useful objects. Or better put, these considerations produced results quite different from what manufacturers had expected. It is superimposition that is responsible for the ugliness of many objects dating from the prehistory of industrial design—an ugliness not without a certain charm: the "artistic" element, generally borrowed from the academic art of the period, is simply "added onto" the object properly speaking. The results were not always displeasing. Many of these objects—I am thinking in particular of those of the Victorian era and those in the so-called "Modern Style"—belong to the same family of mermaids and sphinxes. A family ruled by what might be called the aesthetics of incongruity. In general the evolution of the industrial object for everyday use followed that of artistic styles. It was almost always a borrowing—sometimes a caricature, sometimes a felicitous copy—from the most fashionable artistic trend of the moment. Industrial design consistently lagged behind the art of the period, and imitated artistic styles only after they had lost their initial freshness and were about to become aesthetic clichés.

Modern design has taken other paths—its own characteristic ones—in its search for a compromise between usefulness and aesthetics. At times it has achieved a successful compromise, but the result has been paradoxical. The aesthetic ideal of functional art is to increase the usefulness of the object in direct proportion to the amount by which its materiality can be decreased. The simplification of forms and the way in which they function becomes the formula: the maximum efficiency is to be achieved by the minimum of presence. An aesthetic mindful of the realm of mathematics, where the *elegance* of an equation is a function of the simplicity of its formulation and the inevitability of its solution. The ideal of modern design is invisibility: the less visible functional objects are the more beautiful they are. A curious transposition of fairy tales and Arabic legends to a world governed by science and the notions of usefulness and efficiency: the designer dreams of objects which, like *jinni*, are mute and intangible servants. The precise opposite of craftwork: a physical presence which enters us by way of the senses and in which the principle of maximum utility is continually violated in favor of tradition, imagination, and even sheer caprice. The beauty of industrial design is conceptual in nature; if it expresses anything at all, it is the precise accuracy of a formula. It is the sign of a function. Its rationality confines it to one and only one alternative: either an object will work or it won't. In the second case it must be thrown into the trash barrel. It is not simply its usefulness that makes the handcrafted object so captivating. It lives in intimate connivance with our senses and that is why it is so difficult to part company with it. It is like thowing an old friend out into the street.

There comes a moment, however, when the industrial object finally turns into a presence with an aesthetic value: when it becomes useless. It is then transformed into a symbol or an emblem. The locomotive that Whitman sings of is a machine that has stopped running and no longer propels trainloads of passengers or freight: it is a motionless monument to speed. Whitman's disciples—Valéry Larbaud and the Italian Futurists—were sent into ecstasies by the beauty of locomotives and railroad tracks at precisely the point in time when other means of transportation—the airplane, the automobile—were beginning to replace the train. The locomotives of these poets are the equivalent of the fake ruins of the eighteenth century: they complement the landscape. The cult of the mechanical is nature-worship turned topsy-turvy: usefulness that is becoming useless beauty, an organ without a function. Through ruins history again becomes an integral part of nature, whether we are contemplating the crumbled stone walls of Ninevah or a locomotive graveyard in Pennsylvania.

This affection of machines and contraptions that have fallen into disuse is not simply another proof of the incurable nostalgia that man feels for the past. It also reveals a blind spot in the modern sensibility: our inability to interrelate beauty and usefulness. Two things stand in our way: the religion of art forbids us to regard the useful as beautiful; the worship of usefulness leads us to conceive of beauty not as a presence but as a function. This may well be the reason for the extraordinary poverty of technology as a source of myths: aviation is the realization of an age-old dream that appears in every society, yet it has failed to create figures comparable to Icarus and Phaeton.

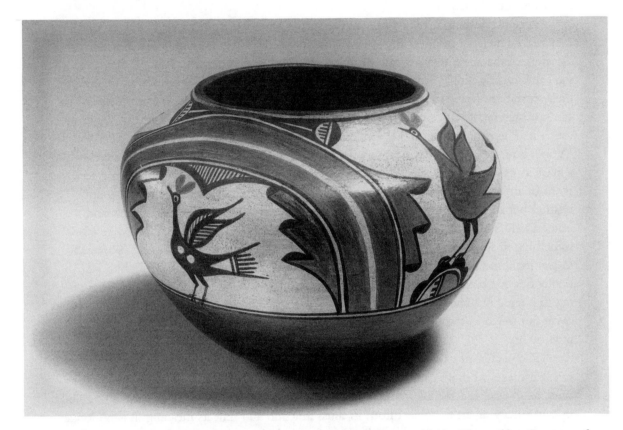

25. *Harviana Toribio*: *Jar, earthenware, 6" high, 8½" diameter, 1941, Zia pueblo. Courtesy of Everson Museum of Art, Syracuse; gift of the Pueblo Indian Arts and Crafts Market, 1941.*

The industrial object tends to disappear as a form and to become indistinguishable from its function. Its being is its meaning and its meaning is to be useful. It is the diametrical opposite of the work of art. Craftwork is a mediation between these two poles: its forms are not governed by the principle of efficiency but of pleasure, which is always wasteful, and for which no rules exist. The industrial object allows the superfluous no place; craftwork delights in decoration. Its predilection for ornamentation is a violation of the principle of efficiency. The decorative patterns of the handcrafted object generally have no function whatsoever; hence they are ruthlessly eliminated by the industrial designer. The persistence and the proliferation of purely decorative motifs in craftwork reveal to us an intermediate zone between usefulness and aesthetic contemplation. In the work of handcraftsmen there is

a constant shifting back and forth between usefulness and beauty. This continual interchange has a name: pleasure. Things are pleasing because they are useful *and* beautiful. This copulative conjunction defines craftwork, just as the disjunctive conjunction defines art and technology: usefulness *or* beauty. The handcrafted object satisfies a need no less imperative than hunger and thirst: the need to take delight in the things that we see and touch, whatever their everyday uses may be. This necessity is not reducible either to the mathematical ideal that acts as the norm for industrial design or to the strict rites of the religion of art. The pleasure that craftwork gives us is a twofold transgression: against the cult of usefulness and against the cult of art.

Since it is a thing made by human hands, the craft object preserves the fingerprints—be they real or metaphorical—of the artisan who fashioned it. These imprints are not the signature of the artist; they are not a name. Nor are they a trademark. Rather, they are a sign: the scarcely visible, faded scar commemorating the original brotherhood of men and their separation. Being made *by* human hands, the craft object is made *for* human hands: we can not only see it but caress it with our fingers. We look at the work of art but we do not touch it. The religious taboo that forbids us to touch the statues of saints on an altar— "You'll burn your hands if you touch the Holy Tabernacle," we were told as children—also applies to paintings and sculptures. Our relation to the industrial object is functional; to the work of art, semi-religious; to the handcrafted object, corporal. The latter in fact is not a relation but a contact. The trans-personal nature of craftwork is expressed, directly and immediately, in sensation: the body is participation. To feel is first of all to be aware of something or someone not ourselves. And above all else: to feel *with* someone. To be able to feel itself, the body searches for another body. We feel *through* others. The physical, bodily ties that bind us to others are no less strong than the legal, economic, and religious ties that unite us. The handmade object is a sign that expresses human society in a way all its own: not as work (technology), not as symbol (art, religion), but as a mutually shared physical life.

The pitcher of water or wine in the center of the table is a point of confluence, a little sun that makes all those gathered together one. But this pitcher that serves to quench the thirst of all of us can also be transformed into a flower vase by my wife. A personal sensibility and fantasy divert the object from its usual function and shift its meaning: it is no longer a vessel used for containing a liquid but one for displaying a carnation. A diversion and a shift that connect the object with another region of human sensibility: imagination. This imagination is social: the carnation in the pitcher is also a metaphorical sun shared with everyone. In fiestas and celebrations the social radiation of the object is even more intense and all-embracing. In the fiesta a collectivity partakes of communion with itself and this communion takes place by way of ritual objects that almost invariably are handcrafted objects. If the fiesta is shared participation in primordial time—the collectivity literally shares among its members, like bread that has been blessed, the date being commemorated— handcraftsmanship is a sort of fiesta of the object: it transforms the everyday utensil into a sign of participation.

In bygone days, the artist was eager to be like his masters, to be worthy of them through his careful imitation of them. The modern artist wants to be different, and his homage to tradition takes the form of denying it. If he seeks a tradition, he searches for one somewhere outside the West, in the art of primitive peoples or in that of other civilizations.

Because they are negations of the Western tradition, the archaic quality of primitive crafts-manship or the antiquity of the Sumerian or Mayan object are, paradoxically, forms of novelty. The aesthetic of constant change demands that each work be new and totally different from those that have preceded it; and at the same time novelty implies the negation of the tradition closest at hand. Tradition is thus converted into a series of sharp breaks. The frenetic search for change also governs industrial production, though for different reasons: each new object, the result of a new process, drives off the market the object that has immediately preceded it. The history of craftwork, however, is not a succession of new inventions or of unique (or supposedly unique) new objects. In point of fact, craftwork has no history, if we view history as an uninterrupted series of changes. There is no sharp break, but rather continuity, between its past and its present. The modern artist has set out to conquer eternity, and the designer to conquer the future; the craftman allows himself to be conquered by time. Traditional yet not historical, intimately linked to the past but not precisely datable, the handcrafted object refutes the mirages of history and the illusions of the future. The craftsman does not seek to win a victory over time, but to become one with its flow. By way of repetitions in the form of variations at once imperceptible and genuine, his works become part of an enduring tradition. And in so doing, they long outlive the up-to-date object that is the "latest thing."

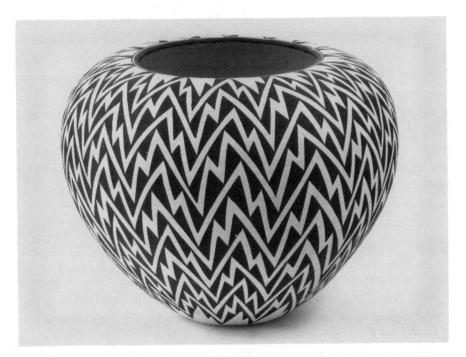

26. Lucy M. Lewis: *Jar, earthenware, 8½" high, 11¾" diameter, 1962, Acoma pueblo. Courtesy of U.S. Department of the Interior, Indian Arts and Crafts Board.*

Industrial design tends to be impersonal. It is subservient to the tyranny of function and its beauty lies in this subservience. But only in geometry is functional beauty completely realized, and only in this realm are truth and beauty one and the same thing; in the arts properly speaking, beauty is born of a necessary violation of norms. Beauty—or better put:

art—is a violation of functionality. The sum total of these transgressions constitutes what we call a style. If he followed his own logical principles to the limit, the designer's ideal would be the absence of any style whatsoever: forms reduced to their function, as the artist's style would be one that began and ended in each of his works. (Perhaps that is the goal that Mallarmé and Joyce set for themselves. The one difficulty is that no work of art is its own beginning and its own end. Each is a language at once personal and collective: a style, a manner. Styles are a reflection of communal experiences, and every true work of art is both a departure from and a confirmation of the style of its own time and place. By violating that style, the work realizes all the potentialities of the latter. Craftwork, once again, lies squarely between these two poles: like industrial design, it is anonymous; like the work of art, it is a style. By comparison with industrial designs, however, the handcrafted object is anonymous but not impersonal; by comparison with the work of art, it emphasizes the collective nature of style and demonstrates to us that the prideful *I* of the artist is a *we*.

Technology is international. Its achievements, its methods, and its products are the same in every corner of the globe. By suppressing national and regional particularities and peculiarities, it has impoverished the world. Having spread from one end of the earth to the other, technology has become the most powerful agent of historical entropy. Its negative consequences can be summed up in one succinct phrase: it imposes uniformity without furthering unity. It levels the differences between distinctive national cultures and styles, but it fails to eradicate the rivalries and hatreds between peoples and States. After turning rivals into identical twins, it purveys the very same weapons to both. What is more, the danger of technology lies not only in the death-dealing power of many of its inventions but in the fact that it constitutes a grave threat to the very essence of the historical process. By doing away with the diversity of societies and cultures it does away with history itself. The marvelous variety of different societies is the real creator of history: encounters and conjunctions of dissimilar groups and cultures with widely divergent techniques and ideas. The historical process is undoubtedly analogous to the twofold phenomenon that geneticists call *inbreeding* and *outbreeding*, and anthropologists *endogamy* and *exogamy*. The great world civilizations have been syntheses of different and diametrically opposed cultures. When a civilization has not been exposed to the threat and the stimulus of another civilization—as was the case with pre-Columbian America down to the sixteenth century—it is fated to mark time and wander round and round in circles. The experience of the *Other* is the secret of change. And of life as well.

Modern technology has brought about numerous and profound transformations. All of them, however, have had the same goal and the same import: the extirpation of the *Other*. By leaving the aggressive drives of humans intact and reducing all mankind to uniformity, it has strengthened the forces working toward the extinction of humanity. Craftwork, by contrast, is not even national: it is local. Indifferent to boundaries and systems of government, it has survived both republics and empires: the art of making the pottery, the woven baskets, and the musical instruments depicted in the frescoes of Bonampak has survived Mayan high priests, Aztec warriors, Spanish friars, and Mexican presidents. These arts will also survive Yankee tourists. Craftsmen have no fatherland: their real roots are in their native village—or even in just one quarter of it, or within their own families. Craftsmen defend us from the artificial uniformity of technology and its geometrical wastelands: by preserving differences, they preserve the fecundity of history.

The craftsman does not define himself either in terms of his nationality or of his religion. He is not faithful to an idea, nor yet to an image, but to a practical discipline: his craft. His workshop is a social microcosm governed by its own special laws. His workday is not rigidly laid out for him by a time clock, but by a rhythm that has more to do with the body and its sensitivities than with the abstract necessities of production. As he works, he can talk with others and may even burst into song. His boss is not an invisible executive, but a man advanced in years who is his revered master and almost always a relative, or at least a close neighbor. It is revealing to note that despite its markedly collectivist nature, the craftsman's workshop has never served as a model for any of the great utopias of the West. From Tommaso Campanella's *Civitas Solis* to Charles Fourier's phalansteries and on down to the Communist collectives of the industrial era, the prototypes of the perfect social man have never been craftsmen but priest-sages and gardener-philosophers and the universal worker in whom daily praxis and scientific knowledge are conjoined. I am naturally not maintaining that craftsmen's workshops are the very image of perfection. But I do believe that, precisely because of their imperfection, they can point to a way as to how we might humanize our society: their imperfection is that of men, not of systems. Because of its physical size and the number of people constituting it, a community of craftsmen favors democratic ways of living together; its organization is hierarchical but not authoritarian, being a hierarchy based not on power but on degrees of skill: masters, journeymen, apprentices; and finally, craftwork is labor that leaves room both for carefree diversion and for creativity. After having taught us a lesson in sensibility and the free play of the imagination, craftwork also teaches us a lesson in social organization.

Until only a few short years ago, it was generally thought that handcrafts were doomed to disappear and be replaced by industrial production. Today however, precisely the contrary is occurring: handmade artifacts are now playing an appreciable role in world trade. Handcrafted objects from Afghanistan and Sudan are being sold in the same department stores as the latest products from the design studios in Italian or Japanese factories. This rebirth is particularly noticeable in the highly industrialized countries, affecting producer and consumer alike. Where industrial concentration is heaviest—as in Massachusetts, for instance —we are witnessing the resurrection of such time-hallowed trades as pottery making, carpentry, glass blowing. Many young people of both sexes who are fed up with and disgusted by modern society have returned to craftwork. And even in the underdeveloped countries, possessed by the fanatical (and untimely) desire to become industrialized as rapidly as possible, handcraft traditions have undergone a great revival recently. In many of these countries, the government itself is actively encouraging handcraft production. This phenomenon is somewhat disturbing, since government support is usually inspired by commercial considerations. The artisans who today are the object of the paternalism of official state planners were yesterday threatened by the projects for "modernization" dreamed up by the same bureaucrats, intoxicated by economic theories they have picked up in Moscow, London, or New York. Bureaucracies are the natural enemy of the craftsman, and each time that they attempt to "guide" him, they corrupt his sensibility, mutilate his imagination, and debase his handiwork.

The return to handcraftsmanship in the United States and in Western Europe is one of the symptoms to the great change that is taking place in our contemporary sensibility. We are confronting in this case yet another expression of the rebellion against the abstract

religion of progress and the quantitative vision of man and nature. Admittedly, in order to feel disillusioned by progress, people must first have undergone the experience of progress. It is hardly likely that the underdeveloped countries have yet reached the point of sharing this disillusionment, even though the disastrous consequences of industrial super-productivity are becoming more and more evident. We learn only with our own thinking-caps, not other people's. Nonetheless, how can anyone fail to see where the faith in limitless progress has led? If every civilization ends in a heap of rubble—a jumble of broken statues, toppled columns, indecipherable graffiti—the ruins of industrial society are doubly impressive: because they are so enormous in scope and because they are so premature. Our ruins are beginning to overshadow our constructions, and are threatening to bury us alive. Hence the popularity of handcrafts is a sign of health—like the return to Thoreau and Blake, or the rediscovery of Fourier. Our senses, our instincts, our imagination always range far ahead of our reason. The critique of civilization began with the Romantic poets, just as the industrial era was dawning. The poetry of the twentieth century carried on the Romantic revolt and rooted it even more deeply, but only very recently has this spiritual rebellion penetrated the minds and hearts of the vast majority of people. Modern society is beginning to question the principles that served as its cornerstone two centuries ago, and is searching for other paths. We can only hope that is it not too late.

The destiny of the work of art is the air-conditioned eternity of the museum; the destiny of the industrial object is the trash barrel. The handcrafted object ordinarily escapes the museum and its glass display cases, and when it does happen to end up in one, it acquits itself honorably. It is not a unique object, merely a typical one. It is a captive example, not an idol. Handcrafted artifacts do not march in lockstep with time, nor do they attempt to overcome it. Experts periodically examine the inroads that death is making in works of art: cracks in paintings, fading outlines, changes in color, the leprosy eating away both the frescoes of Ajanta and Leonardo da Vinci's canvases. The work of art, as a material thing, is not eternal. And as an idea? Ideas too grow old and die. The work of art is not eternal. But artists often forget that their work is the possessor of the secret of the only real time: not an empty eternity but the sparkling instant, and the capacity to quicken the spirit and reappear, even if only as a negation, in the works that are its descendants. For the industrial object no resurrection is possible: it disappears as rapidly as it first appeared. If it left no trace at all, it would be truly perfect; unfortunately, it has a body and once that body has ceased to be useful, it becomes mere refuse that is difficult to dispose of. The obscene indestructibility of trash is no less pathetic than the false eternity of the museum.

The thing that is handmade has no desire to last for thousands upon thousands of years, nor is it possessed by a frantic drive to die an early death. It follows the appointed round of days, it drifts with us as the current carries us along together, it wears away little by little, it neither seeks death nor denies it: it accepts it. Between the timeless time of the museum and the speeded-up time of technology, craftsmanship is the heartbeat of human time. A thing that is handmade is a useful object but also one that is beautiful; an object that lasts a long time but also one that slowly ages away and is resigned to so doing; an object that is not unique like the work of art and can be replaced by another object that is similar but not identical. The craftsman's handiwork teaches us to die and hence teaches us to live.

Shards

Take, for instance, eating an apple. The primitives took it right off the tree and ate it, skin, seeds, and all. But today we seem to think that peeling it looks better, and then we cut it up and stew it and make a jam of it and prepare it in all kinds of ways. In preparing the apple, quite often we commit many errors on the way. But in just taking it off the tree and eating the whole thing, there are no mistakes to be made.

In a book about the Post-Impressionists, I came across the statement by Renoir, which said something like: "If half the would-be painters in France were transformed into craftsmen, it would benefit both painting and the crafts: the number of painters would be decreased, and the decorative arts would get able people." This statement gave me the courage to change my whole aim. It summarized my own thinking, and the fact that my ideas were endorsed by a great painter made a deep impression. Why not be a potter? Pots can be used, they have a function. Even a bad pot has some use, but with a bad painting, there is nothing you can do with it except throw it away.

Shoji Hamada

The Firing

for Les Blakebrough and the memory of John Chappell

Gary Snyder

Bitter blue fingers
Winter nineteen sixty-three A.D.
 showa thirty-eight
Over a low pine-covered splay of hills in Shiga
West-south-west of the outlet of Lake Biwa
Domura village set on sandy fans of the sweep
 and turn of a river
Draining the rotten-granite hills up Shigaraki
On a nineteen-fifty-seven Honda cycle model C
Rode with some Yamanashi wine "St. Neige"
Into the farmyard and the bellowing kiln.
Les & John
In ragged shirts and pants, dried slip
Stuck to with pineneedle, pitch,
 dust, hair, woodchips;
Sending the final slivers of yellowy pine
Through peephole white blast glow
No saggars tilting yet and segers bending
 neatly in a row—
Even their beards caked up with mud & soot
Firing for fourteen hours. How does she go.
Porcelain & stoneware: cheese dish. twenty cups.
Tokuri. vases. black chawan
Crosslegged rest on the dirt eye cockt to smoke—

The hands you layed on clay
Kickwheeld, curling,
 creamed to the lip of nothing,
And coaxt to a white dancing heat that day
Will linger centuries in these towns and loams
And speak to men or beasts
When Japanese and English
Are dead tongues.

A Journey Shared

Joe Spano

My wife, Joan Zerrien, is a potter.

I live with many of her pots. Some of them I handle every day. They illuminate my life in daily ways, quiet and unremarked pleasures. Others stop me in my tracks. They are the master's slap, the laugh of god. They tell me that it's wise to pay attention. I value both, as both have gifts to give if I'm in the receiving vein.

For example, I shave with a blade and, since Joan began to work in clay, I've had three pots to hold my shaving soap. Though I shave only when I must, I've probably spent more solitary time with them than any others.

The first, an earthenware pinch pot of cobalt blue, was also, possibly, the first Joan Zerrien pot. Built up of coils, it rested on another coil indented around with thumb marks. Another thumb mark on the handles showed where mine should rest in use. It was made for me. It was rough and crude and touched me as those objects can that show more love than skill. It was also an emblem of a time of change and risk for Joan and showed, to me, great courage. Through it I came to love the handmade pot because I saw in it what I now see in every pot that's made with love: the obvious, it has been *handled*. Physical decisions have been made over every inch of its surface. Countless split-second calculations, corrections, compromises, challenges, surrenders, and triumphs have led to the existence of this piece of earth in this exact form. So when I hold it, it interests me. It has something to say to me. Not intending to teach, it cannot help but do so.

Imagining it possessed the physical immortality suggested by such spiritual power, and loathe to be without it, I tossed the pinch pot in a dopp kit on a trip to Austin, Texas, and mashed that sucker flat.

The second was a luxurious stoneware tea bowl of Margo's Iron Red and Rutile, as sophisticated as my previous bowl was innocent. It was almost indecently delightful to the touch. It did not trouble; it soothed. Yet it inspired. It spoke of learning and of trust well-placed and well-rewarded. It was complex, but quiet, never insisting upon attention, yet never failing to reward attention paid. It was immaculate. To touch its surface was to think that all experience of it ended there; it was so smooth and still. Yet, past that, or below it, or inside, there was another world of melting color, crystals, and memory of fire.

I could see that it had faced the fire, had been surrendered. It had been tempered, tested, threatened with destruction. Other pots had perished. Why this one survived remained a mystery. The fire remained a mystery. I saw the piece burn with its own flame. I saw it burned but not destroyed. It had emerged, its form unchanged, but clothed in surfaces not hinted at before.

One morning, while in that state of less-than-wholeness in which I spend most of my life, I tried to grasp it as though it were not holy. It fell and shattered in a hundred pieces on the bathroom floor.

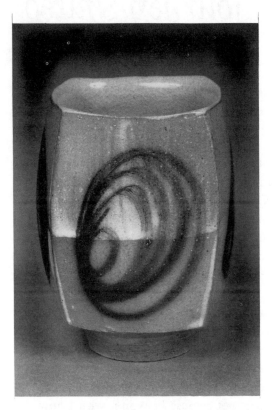

27. **Mark Shapiro:** *Tea Bowl, stoneware,*
4¼" high, 3¼" diameter, 1992.
Courtesy of Mark Shapiro.

These days, I use a little coffee cup. It's blue, a second, and not much treasured by myself or Joan. I smashed it on the water tap one morning, failed, for the moment, by my normally uncanny ability to distinguish between solids, liquids and gases. It only lost its handle, which Joan has super-glued back on. It's perfect for my use. To face them all: the mirror, shaving, and the possibilities of loss, so early in the morning is just too much.

And yet, only today, we spoke of choosing me another. One I would regret to have destroyed. Perhaps I have learned to look at things, and know, when I am touching them, to see them there as real as what is in my mind.

But I don't have to touch a pot to have it speak to me. Next to my bed there is a graceful pit-fired bowl which is disintegrating. I don't know why; nor do I care. It has long since lost its surface and as layer under layer is revealed, each too, begins to drift. I clean away a circle of dust around its foot and soon there is another, and another, like countless petticoats, as if some sweet and slow seduction were taking place in geologic time. Eventually, I assume, we will reach the bounds of modesty and enter the precinct of the metaphysical. The pot will simply disappear, telling me, "You see now, there is no thing but form. There is no space outside of that which serves to limit it." I cannot say what all this means, but only that the pot has made me think it.

Each day we eat and drink from dishes, bowls, and cups that Joan has made, and around the house are pieces from all phases of Joan's work with clay. Each pot is a record of a progress, a journey shared by earth and potter. But each is also a record of time we've shared and her work becomes the visible history of our life. My work [acting—*Ed.*], just now, is very visible and prone to celebration for that fact alone. But what I think I do is so remote from what it's celebrated for and so intangible, that, to be delighted constantly by the concrete products of Joan's life is to be balanced, and reminded that there is another world on which my world of make-believe is based, if it's to speak with any truth at all.

Shards

The challenge is to produce simple forms whose economy of expression extends beyond function to gesture and visual empathy. This empathy transfers everyday ware into objects of ritual esteem.

Byron Temple

All I'm trying to do is make what seems the relevant new version of things. In a way, the obvious aspects of the form are not really what is important. I'm not really interested in committing novelty upon the world, but only in making objects which have some hidden magic to them, which are good objects to use and therefore might make it better to drink coffee.

I like the idea that my work should function in people's lives. That is, it is very nice to have your pottery in collections—who could deny that?—but it is more rewarding when someone says, "I have this cup of yours and I drink my coffee from it every morning." That gives me a sense of having an effect, that my work should insinuate itself in that way into people's lives. It is not viewed in a purely aesthetic way, like when we go to the art gallery on a Thursday evening in order to look at art, but really enters into the ceremonies of people's lives. That's important.

John Reeve

What Is a Pot

Cynthia Bringle

What is a pot
a pot is not
just any gray
little bowl of clay
a pot is a pot
for daffodils
or a porridge pot
or a pot for pills
cruets and goblets
jars and jugs
platters and plates
and trays and mugs
shallow pots
or dark and deep
pots to give
and pots to keep
touch them, hold them,
pick them up
batter bowl
or saké cup
and feel the curve
of earth and sky
kitchen warm
or springtime shy
a pot is a mood
of many hues
but most of all
a pot is to use.

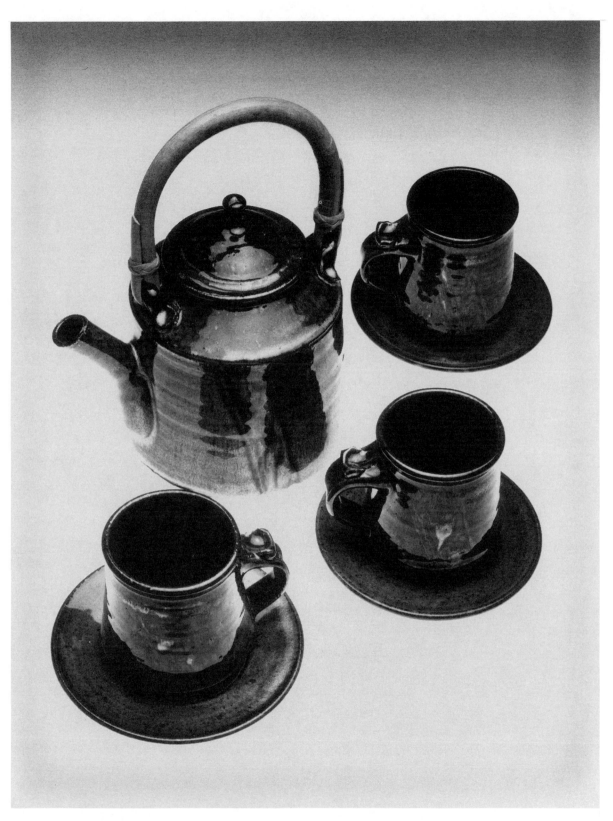

28. Richard Aerni: *Tea Pot, Cups, and Saucers; stoneware; tea pot 9" high, cups 3½" high; 1980. Courtesy of Richard Aerni.*

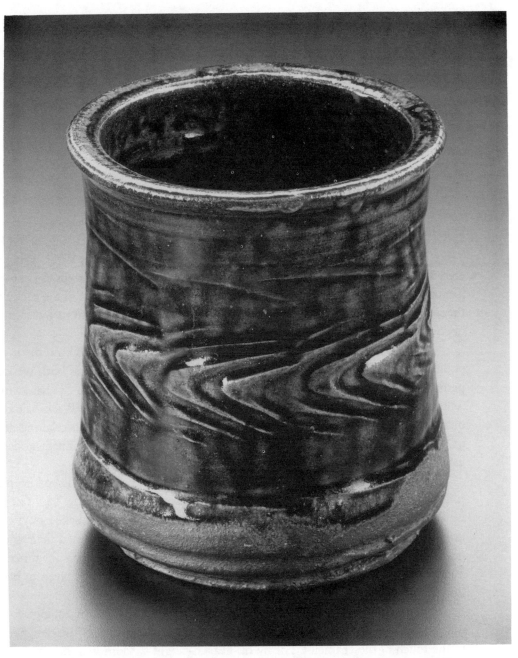

29. Shoji Hamada: *Paddled Jar, stoneware, 6¼" high, 6¼" diameter, 1952. Courtesy of Warren and Nancy MacKenzie.*

Tales & Fables

The Tale of the Porcelain-God

Lafcadio Hearn

Who first of men discovered the secret of the Ka-ling, of the Pe-tun-se —the bones and the flesh, the skeleton and the skin, of the beauteous Vase? Who first discovered the virtue of the curd-white clay? Who first prepared the ice-pure bricks of tun: the gathered-hoariness of mountains that have died for age; blanched dust of the rocky bones and the stony flesh of sun-seeking Giants that have ceased to be? Unto whom was it first given to discover the divine art of porcelain?

Unto Pu, once a man, now a god, before whose snowy statues bow the myriad populations enrolled in the guilds of the potteries. But the place of his birth we know not; perhaps the tradition of it may have been effaced from remembrance by that awful war which in our own day consumed the lives of twenty millions of the Black-haired Race, and obliterated from the face of the world even the wonderful City of Porcelain itself—the City of King-te-chin, that of old shone like a jewel of fire in the blue mountain-girdle of Feou-liang.

Before his time indeed the Spirit of the Furnace had being; had issued from the Infinite Vitality; had become manifest as an emanation of the Supreme Tao. For Hoang-ti, nearly five thousand years ago, taught men to make good vessels of baked clay; and in his time all potters had learned to know the God of Oven-fires, and turned their wheels to the murmuring of prayer. But Hoang-ti had been gathered unto his fathers for thrice ten hundred years before that man was born destined by the Master of Heaven to become the Porcelain-God.

And his divine ghost, ever hovering above the smoking and the toiling of the potteries, still gives power to the thought of the shaper, grace to the genius of the designer, luminosity to the touch of the enamelist. For by his heaven-taught wisdom was the art of porcelain created.

And though many a secret of that matchless art that Pu bequeathed unto men may indeed have been forgotten and lost forever, the story of the Porcelain-God is remembered; and I doubt not that any of the aged Jeou-yen-liao-kong, any one of the old blind men of the great potteries, who sit all day grinding colors in the sun, could tell you Pu was once a humble Chinese workman, who grew to be a great artist by dint of tireless study and patience and by the inspiration of Heaven. So famed he became that some deemed him an alchemist, who possessed the secret called "White-and-Yellow," by which stones might be turned into gold; and others thought him a magician, having the ghastly power of murdering men with horror of nightmare, by hiding charmed effigies of them under the

tiles of their own roofs; and others, again, averred that he was an astrologer who had discovered the mystery of those Five Hing which influence all things—those Powers that move even in the currents of the star-drift, in the milky Tien-ho, or River of the Sky. Thus, at least, the ignorant spoke of him; but even those who stood about the Son of Heaven, those whose hearts had been strengthened by the acquisition of wisdom, wildly praised the marvels of his handicraft, and asked each other if there might be any imaginable form of beauty which Pu could not evoke from that beauteous substance so docile to the touch of his cunning hand.

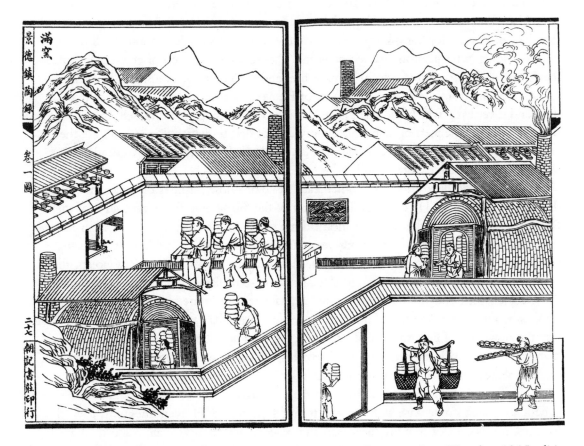

30. "Putting the Finished Ware into the Kiln," *from the* Ching-te-chen T'ao lu, *1815 edition.*

And one day it came to pass that Pu sent a priceless gift to the Celestial and August: a vase imitating the substance of ore-rock, all aflame with pyritic scintillation—a shape of glittering splendor with chameleons sprawling over it; chameleons of porcelain that shifted color as often as the beholder changed his position. And the Emperor, wondering exceedingly at the splendor of the work, questioned the princes and the mandarins concerning him that made it. And the princes and the mandarins answered that he was a workman named Pu, and that he was without equal among potters, knowing secrets that seemed to have been inspired either by gods or by demons. Whereupon the Son of Heaven sent his officers to Pu with a noble gift, and summoned him unto his presence.

So the humble artisan entered before the Emperor, and having performed the supreme prostration—thrice kneeling, and thrice nine times touching the ground with his forehead—awaited the command of the August.

And the Emperor spake to him, saying: "Son, thy gracious gift hath found high favor in our sight; and for the charm of that offering we have bestowed upon thee a reward of five thousand silver liang. But thrice that sum shall be awarded to thee so soon as thou shalt have fulfilled our behest. Hearken, therefore, O matchless artificer? It is now our will that thou make for us a vase having the tint and the aspect of living flesh, but—mark well our desire!—*of flesh made to creep by the utterance of such words as poets utter—flesh moved by an Idea, flesh horripilated by a Thought!* Obey, and answer not! We have spoken."

Now Pu was the most cunning of all the P'ei-se-kong, the men who marry colors together; of all the Hoa-yang-kong, who draw the shapes of vase-decoration; of all the Hoei-sse-kong, who paint in enamel; of all the T'ien-thsai-kong, who brighten color; of all the Chao-lou-kong, who watch the furnace fires and the porcelain ovens. But he went away sorrowing from the Palace of the Son of Heaven, notwithstanding the gift of five thousand silver liang which had been given to him. For he thought to himself: "Surely the mystery of the comeliness of flesh, and the mystery of that by which it is moved, are the secrets of the Supreme Tao. How shall man lend the aspect of sentient life to dead clay? Who save the Infinite can give soul?"

Now Pu had discovered those witchcrafts of color, those surprises of grace, that make the art of the ceramist. He had found the secret of the feng-hong, the wizard flush of the Rose; of the hoa-hong, the delicious incarnadine; of the mountain-green called chan-lou; of the pale soft yellow termed hiao-hoang-yeou; and of the hoang-kin, which is the blazing beauty of gold. He had found those eel tints, those serpent greens, those pansy violets, those furnace crimsons, those carminates and lilacs, subtle as spirit flame, which our enamelists of the Occident long sought without success to reproduce. But he trembled at the task assigned him, as he returned to the toil of his studio, saying: "How shall any miserable man render in clay the quivering of flesh to an Idea—the inexplicable horripilation of a Thought? Shall a man venture to mock the magic of that Eternal Moulder by whose infinite power a million suns are shapen more readily than one small jar might be rounded upon my wheel?"

Yet the command of the Celestial and August might never be disobeyed; and the patient workman strove with all his power to fulfill the Son of Heaven's desire. But vainly for days, for weeks, for months, for season after season, did he strive; vainly also he prayed unto the gods to aid him; vainly he besought the Spirit of the Furnace, crying: "O thou Spirit of Fire, hear me, heed me, help me! how shall I—a miserable man, unable to breathe into clay a living soul—how shall I render in this inanimate substance the aspect of flesh made to creep by the utterance of a Word, sentient to the horripilation of a Thought?"

For the Spirit of the Furnace made strange answer to him with whispering of fire: "Vast thy faith, weird thy prayer? Has Thought feet, that man may perceive the trace of its passing? Canst thou measure me the blast of the Wind?"

Nevertheless, with purpose unmoved, nine-and-forty times did Pu seek to fulfill the Emperor's command; nine-and-forty times he strove to obey the behest of the Son of Heaven. Vainly, alas! did he consume his substance; vainly did he expend his strength; vainly did he exhaust his knowledge: success smiled not upon him; and Evil visited his home, and Poverty sat in his dwelling, and Misery shivered at his hearth.

Sometimes, when the hour of trial came, it was found that the colors had become strangely transmuted in the firing, or had faded into ashen pallor, or had darkened into the fuliginous hue of forest mould. And Pu, beholding these misfortunes, made wail to the Spirit of the Furnace, praying: "O thou Spirit of Fire, how shall I render the likeness of lustrous flesh, the warm glow of living color, unless thou aid me?"

And the Spirit of the Furnace mysteriously answered him with murmuring of fire: "Canst thou learn the art of that Infinite Enameler who hath made beautiful the Arch of Heaven—whose brush is Light; whose paints are the Colors of the Evening?"

Sometimes, again, even when the tints had not changed, after the pricked and labored surface had seemed about to quicken in the heat, to assume the vibratility of living skin— even at the last hour all the labor of the workers proved to have been wasted; for the fickle substance rebelled against their efforts, producing only crinklings grotesque as those upon the rind of a withered fruit, or granulations like those upon the skin of a dead bird from which the feathers have been rudely plucked. And Pu wept, and cried out unto the Spirit of the Furnace: "O thou Spirit of Flame, how shall I be able to imitate the thrill of flesh touched by a Thought, unless thou wilt vouchsafe to lend me thine aid?"

And the Spirit of the Furnace mysteriously answered him with muttering of fire: "Canst thou give ghost unto a stone? Canst thou thrill with a Thought the entrails of the granite hills?"

Sometimes it was found that all the work indeed had not failed; for the color seemed good, and all faultless the matter of the vase appeared to be, having neither crack nor crinkling; but the pliant softness of warm skin did not meet the eye; the flesh-tinted surface offered only the harsh aspect and hard glimmer of metal. All their exquisite toil to mock the pulpiness of sentient substance had left no trace; had been brought to nought by the breath of the furnace. And Pu, in his despair, shrieked to the Spirit of the Furnace: "O thou merciless divinity! O thou most pitiless god!—thou whom I have worshiped with ten thousand sacrifices!—for what fault hast thou abandoned me?—for what error hast thou forsaken me? How may I, most wretched of men! ever render the aspect of flesh made to creep with the utterance of a Word, sentient to the titillation of a Thought, if thou wilt not aid me?"

And the Spirit of the Furnace made answer unto him with roaring of fire: "Canst thou divide a Soul? Nay! . . . Thy life for the life of thy work!—thy soul for the soul of thy Vase!"

And hearing these words Pu arose with a terrible resolve swelling at his heart, and made ready for the last and fiftieth time to fashion his work for the oven.

One hundred times did he sift the clay and the quartz, the kao-ling and the tun; one hundred times did he purify them in clearest water; one hundred times with tireless hands did he knead the creamy paste, mingling it at last with colors known only to himself. Then was the vase shapen and reshapen, and touched and retouched by the hands of Pu, until its blandness seemed to live, until it appeared to quiver and to palpitate, as with vitality from within, as with the quiver of rounded muscle undulating beneath the integument. For the hues of life were upon it and infiltrated throughout its innermost substance, imitating the carnation of blood-bright tissue, and the reticulated purple of the veins; and over all was laid the envelope of sun-colored Pe-kia-ho, the lucid and glossy enamel, half diaphanous, even like the substance that it counterfeited—the polished skin of a woman. Never since the making of the world had any work comparable to this been wrought by the skill of man.

Then Pu bade those who aided him that they should feed the furnace well with wood of tcha; but he told his resolve unto none. Yet after the oven began to glow, and he saw the work of his hands blossoming and blushing in the heat, he bowed himself before the Spirit of Flame, and murmured: "O thou Spirit and Master of Fire, I know the truth of thy words! I know that a Soul may never be divided! Therefore my life for the life of my work!—my soul for the soul of my Vase!"

And for nine days and for eight nights the furnaces were fed unceasingly with wood of tcha; for nine days and for eight nights men watched the wondrous vase crystallizing into being, rose-lighted by the breath of the flame. Now upon the coming of the ninth night, Pu bade all his weary comrades retire to rest, for that the work was well-nigh done, and the success assured. "If you find me not here at sunrise," he said, "fear not to take forth the vase; for I know that the task will have been accomplished according to the command of the August." So they departed.

But in that same ninth night Pu entered the flame, and yielded up his ghost in the embrace of the Spirit of the Furnace, giving his life for the life of his work—his soul for the soul of his Vase.

And when the workmen came upon the tenth morning to take forth the porcelain marvel, even the bones of Pu had ceased to be; but lo! the Vase lived as they looked upon it: seeming to be flesh moved by the utterance of a Word, creeping to the titillation of a Thought. And whenever tapped by the finger it uttered a voice and a name—the voice of its maker, the name of its creator: Pu.

And the Son of Heaven, hearing of these things, and viewing the miracle of the vase, said unto those about him: "Verily, the Impossible hath been wrought by the strength of faith, by the force of obedience! Yet never was it our desire that so cruel a sacrifice should have been; we sought only to know whether the skill of the matchless artificer came from the Divinities or from the Demons—from heaven or from hell. Now, indeed, we discern that Pu hath taken his place among the gods." And the Emperor mourned exceedingly for his faithful servant. But he ordained that godlike honors should be paid unto the spirit of the marvelous artist, and that his memory should be revered forevermore, and that fair statues of him should be set up in all the cities of the Celestial Empire, and above all the toiling of the potteries, that the multitude of workers might unceasingly call upon his name and invoke his benediction upon their labors.

Pale Pink Porcelain

Frank Owen

Tsang Kee Foo was an artist in porcelain. His house in Kingtehchen, the Porcelain Capital of China, was filled with exquisite specimens of porcelain art that no museum could surpass. The family of Tsang Kee Foo had all been potters dating back for almost a thousand years. Somewhere a book is written on the lineage of this renowned artist though trace of it has been lost. Perhaps some day it will be located and much data about this ancient family will be given to the world.

Tsang Kee Foo was tall and slim and round-shouldered from constantly stooping over his wheel. His face, colorless and bleached, looked as though it had been dried by the furnaces that baked his delicate porcelains. He was superbly well-educated, a profound linguist and efficient in all the supreme literatures of the world. One of his ambitions was to translate the musings of Long Chik, the poet, into pottery. For each quatrain a vase, an urn or a traced-bowl. He believed in the possibility of his desire since all arts are interchangeable. It was his knowledge of quaint tales and folklore that gave Tsang Kee Foo his charming personality. What mattered that he was cold and ruthless, that he could pass starving children on the streets without as much as a glance, or that he permitted his own sister to die of want simply because once in her youth she had criticized his handiwork? The face of Tsang Kee Foo was a mask, a smiling mask, and few there were who knew the mind that lived behind it.

He was successful, rich, an artist. It was enough.

Now as he sat at the door of his house he felt great contentment. He was snatching a moment's rest for his family from the ceaseless toil that had gone on for almost a thousand years. Listlessly he watched the coolies trotting past laden down with porcelainware which they were taking to the furnaces to be baked. Not many factories in Kingtehchen could boast furnaces, for most of the pottery was made in the homes of the people. Almost every house was a factory. And even tiny children were skilled in the ceramic art. But Tsang Kee Foo was rich. He had his own furnaces for baking. Life was very good.

In this he eclipsed Lu Chau, his greatest rival. Lu Chau was equally as skillful but he did not own his own furnace. Tsang Kee Foo hated Lu Chau though he always greeted him with a smile and welcomed him to his home. In cordiality he treated him as a brother. Yet deep within him was buried a burning hatred, a hatred that burned as surely as the pine-wood in his furnaces. For one thing Lu Chau was handsome. He was possessed of beauty that made all women his slaves. They looked up into his black almond eyes, into his face which was like a full moon, and listened to the flattery that dripped ever from his lips and at once they were lost in a surging sea of desire. Lu Chau's attraction for women was as

famous as his fine porcelains. In ordinary circumstances Tsang Kee Foo would not have cared for the talk which Lu Chau caused were it not that Lu Chau was infatuated with the lovely Mei-Mei, a China girl as gorgeous as any bit of porcelain.

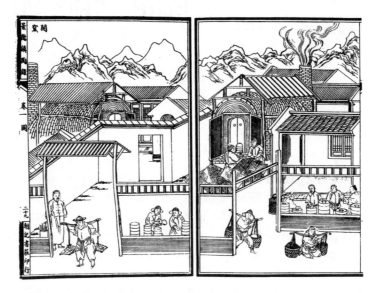

31. *"Opening the Kiln When the Porcelain Has Been Fired,"*
from the Ching-te-chen T'ao lu, *1815 edition.*

That poet of old must have been thinking of Mei-Mei when he wrote:

> *Her voice makes perfume when she speaks,*
> *Her breath is music faint and low.*

The lovely Mei-Mei was a product of porcelain even as were Tsang Kee Foo and Lu Chau. The very foundation of her family, of her house, was built on porcelain. But she paid no attention whatever to the modeling of cups and vases. Her concern was solely with the painting of them. Most of her vases were decorated with Yunnan blue and yellow, though other colors also were used upon occasion. Mei-Mei ground all her own colors from rock, crystals, arsenic, copper, lead and pewter. No colorist was ever more adept than she. Her creations were justly famous. It was said that she infused her personality into her creations. Each bit of pottery reflected her mood. When she was melancholy, so was the jar. When love, desire or laughter enveloped her it found reflection in her work. Whether all the quaint tales that were recounted about her were true or not they served to emphasize her popularity. If all the great artists of China were put down, the name of Mei-Mei would have to be among them.

With all her colors she was satisfied, with the sole exception of pink. The pale pink color which she desired was hard to locate. There were many types of red but not the elusive pink for which she had sought in vain for years.

Lu Chau wooed her with vast enthusiasm. He was always smiling.

"Forever I will stand guard over you," he declared, "like an old gingko tree if you will but pause to listen to my voice. Marry me and I will fashion wondrous pottery for you to paint."

Tsang Kee Foo was equally as vehement in his wooing. He quoted to her all the love songs of the poets. He brought flowers to her of rare elegance.

"When we are wed," he declared, "life thereafter will be but one superb poem of loveliness. Greater than Kutani-ware is the porcelain of Mei-Mei and greater than the love of any other is my love for you. It is like an endless lyric poem, or a brook that flows on forever through the ages. When the sun ceases to rise yellow over China then only will fade my devotion."

Mei-Mei smiled. She sang softly to herself as she worked at her art. She was decorating a vase with ivory-white and mirror-black. Close beside her was one of great beauty in celadon.

"Who first brings to me the secret of the pale pink color that I crave," she murmured, "to him will I surrender and to none other. Marriage at best is a subjection of womanhood and I can only submit to it if my reward does justify. Love is a poem but poems can be repeated to many people. My love is a color, pale pink like the blush of the morning, pink like the cheek of a happy woman, pink like the sky when day is dying. Your reward will be great if you win me; mine must be great by proportion."

Tsang Kee Foo returned to his house. He locked himself in his workroom for days seeking the secret of that wondrous color. His enthusiasm was great but no greater than that of Lu Chau even though Lu Chau was not so adept at concentration. While pining for the wondrous Mei-Mei he was not blind to the charms of other women. He studied profoundly but his amours were in like proportion.

Frequently he stopped at the home of Tsang Kee Foo. He was extremely polite, but the essence of politeness he affected did not dull the edge of his cynicism. He angered Tsang Kee Foo to an acute degree by assuming that in the end he himself would win the prize. All women were as flowers that bent to every breeze and the love of Lu Chau was as subtle as wind sighing through willows.

He walked about the rooms of Tsang Kee Foo, fingering his porcelains, eulogizing their perfection and beauty. Occasionally he drew attention to a slight defect in one. At other times he was loud in his praise. But the porcelains he praised were always the ones Tsang Kee Foo had not wrought, while those in which he detected defects were always the works of his friend.

This goaded Tsang Kee Foo to great fury, but there was nothing in his bland expression that reflected his inward turbulence. He knew that he was a far better artist than Lu Chau, except in one thing—the frailties of women.

"Women," reflected Lu Chau, "are much like porcelain; a single flaw and they are worthless."

He was perfectly complacent. He was handsome and he knew it. China girls loved to gaze upon his moon-like face. His kisses were valued. In love, he was supreme. The ceramic art was only secondary. Every other art was subordinate to love. Some day he would marry Mei-Mei. The future was pleasant to contemplate. Not for a moment did he question his ultimate success. Lu Chau did not fail in love.

It enervated his spirits to talk to Tsang Kee Foo. He was a rival to be derided, not to be feared. What woman could fail to choose Lu Chau, given the choice between them?

He handled the cups, the bowls and the vases carefully. Tsang Kee Foo was an artist, a ceramic-artist, not a love-artist. He was eloquent, his words were honeyed, but his face was like a bleached dried lime.

Meanwhile Tsang Kee Foo sat and gazed up toward the lantern above his head. He made no rejoinder to Lu Chau's witticisms except an occasional grunt. He reclined seemingly at ease upon a divan. But there was no rest in his mind. He could be patient. Ultimately his time would come.

The baking furnaces of Tsang Kee Foo were in a separate house at the foot of his garden. There all the splendid potteries that had brought renown to him were baked. It was one of the few private furnaces in Kingtehchen. Even Lu Chau with all his swagger had no furnace. He was forced to send his wares through the crowded streets with all the other throngs of potters. Lu Chau was handsome, successful with women, but he had no bake ovens. He was simply one of the common herd. Tsang Kee Foo smiled. There was more provocation for mirth in the thought than in any of the witticisms of Lu Chau.

"Now we are rivals," mused Tsang Kee Foo. "Perhaps one of us will attain to the hand of Mei-Mei. And because I wish to put no obstacle in your way I offer to you the privilege of using my bake-ovens for your experiments. Let us be rivals but not enemies. If it comes to pass that you discover the pale pink color before I do, then will I bow my head and pray to the spirits and the dragons to bestow happiness upon you and to guard your footsteps well."

Lu Chau was surprised. He arched his eyebrows. "You speak in a manner befitting a great artist," he commented, "and I will accept your kind offer. It would indeed be a crime to refuse a suggestion coming from a heart so overflowing with bounty. Let me then be less than the least coolie in your household. If I offend by being in your shop too often have me cast from your door."

Tsang Kee Foo smiled. He blinked his eyes as though the light were strong, the light, perhaps, of his own benevolence.

"And now," he said, "I will take you to the rear of my garden to inspect my furnaces. They are not perfect, but they are adequate. Such as they are, I offer them to you."

Together they strolled out into the garden.

The air struck their faces delightfully cool. The sun was a yellow maze. It poured down in golden splendor on the lilacs and peonies, on the pink oleanders and lotuses that sweetened the air. About the walks were stately trees, Chinese ash and scented pine. The air was as fragrant as the spice-laden air of Cambodia. Beneath the trees several stone benches beckoned one to loiter. It made incongruous the fact that at the foot of the garden were the furnaces of intense heat in which pottery was baked. The pine fires were never out. They continued onward as surely as the moon. In this same spot the family of Tsang Kee Foo had flourished for a thousand years, had clung tenaciously to life through famine and flood, through pestilence and death. There was something admirable about it, something superb.

Tsang Kee Foo opened the door of his shop and bade Lu Chau enter. He was very polite, very formal. No race can match the Chinese in courtesy, no Chinaman could eclipse Tsang Kee Foo, poet and potter and lover of Mei-Mei.

At one end of the shop was the great door that led to the bake ovens. Lu Chau walked close to it. His interest was sincere. Cupidity lighted up his eyes. He was to receive the use of these ovens free.

Tsang Kee Foo opened the great door. The blast that came from the oven was like that of a swirling volcano.

"I have a dozen vases baking within at the present time," he said, "but there is room for very many more. Stand closer so that you can appreciate its capacity."

Lu Chau stepped forward that he might peer with greater intensity. As he did so Tsang Kee Foo caught him about the waist and pushed him into the oven. The shriek which Lu Chau emitted was drowned as the great iron door swung shut.

Without haste or trepidation Tsang Kee Foo returned to his garden. The air was fragrant with lotuses. He plucked a carnation from a bush and touched it to his nostrils. Never, he thought, had the wistaria blossoms appeared to greater advantage. He seated himself upon a bench near a willow tree. His soul was filled with poetry. Quatrains like jewels were chasing themselves through his consciousness. He thought of the lovely Mei-Mei. When they were wed it would be an excellent triumph for the art of ceramics. What wondrous vases they would be able to create together. He listlessly picked up a ripe pomegranate that had fallen to the ground. Love was as delicious as the seeds of that luscious fruit, sweeter than honey and almonds or sandalwood and myrrh.

Now Lu Chau would bother him no more. No longer would he be forced to bear the bite of his sarcasms, of his boastings, nor to listen to the quaint tales he told of amorous Chinese maidens who could not resist his allure. The future had taken on a rosy hue, somewhat akin to that pale pink color of Chinese porcelain for which Mei-Mei yearned. Until the moon rose that night he remained in his garden, until the soft flush of sunset had blended into the purpling folds of night. The scent of lotuses sweetened, the breeze intensified, the stars bloomed out like wondrous lanterns hanging in the sky. The world was suffused in a riot of beauty. Tsang Kee Foo rose to his feet. He sang wildly in his ecstasy. He crooned love songs to the moon.

Even unto dawn he remained in his garden. For his eyes there was no sleep. He wished simply to breathe in that perfume of joy forever. He refreshed his face by crushing it into a large wild rose on which the cool night dew was heavy.

When the hour of noon approached he went to the studio of Mei-Mei. He bowed low as he entered, arrayed in the costliest of his satin costumes.

"Surely," he cried, "I must be permanently protected from hardship and danger by a Spirit Screen. Beloved am I of the gods, for in all this universe I am the one appointed to gain the love of Mei-Mei."

As he spoke he drew from his cloak a vase, exquisite in workmanship and of a soft pale pink color that surpassed in splendor the glory of dawn or the cheek of a lovely woman. Mei-Mei uttered a little cry as she seized the vase and fell upon her knees to more easily study its elusive color. Her eyes were of dazzling brightness and her heart beat with supreme excitement. It was that immortal hour for which she had waited years.

Tsang Kee Foo stood beside her, as majestic as a gingko tree. He did not tell her that Lu Chau existed no longer, that his blood had colored the vase. He could not explain how the miracle had come to pass, nor did he try to. It was sufficient that the vase was pink. He had offered Lu Chau the use of his ovens. Lu Chau had rewarded him for his generosity.

At last Mei-Mei rose to her feet. "It is the color," she whispered; "nowhere else have I beheld it except in the necklace of peculiar workmanship which Lu Chau always wore about his neck. When he returns, I will marry you, even as my word was given. But I cannot do so until Lu Chau admits that I have kept faith. Lu Chau is a cultured gentleman. I know that he will accept defeat gracefully."

The Potters of Firsk

Jack Vance

The Yellow Bowl on Thomm's desk stood about a foot high, flaring out from a width of eight inches at the base to a foot across the rim. The profile showed a simple curve, clean and sharp, with a full sense of completion; the body was thin without fragility; the whole piece gave an impression of ringing well-arched strength.

The craftsmanship of the body was matched by the beauty of the glaze—a glorious transparent yellow, luminescent like a hot summer afterglow. It was the essence of marigolds, a watery wavering saffron, a yellow as of transparent gold, a yellow glass that seemed to fabricate curtains of light within itself and fling them off, a yellow brilliant but mild, tart as lemon, sweet as quince jelly, soothing as sunlight.

Keselsky had been furtively eying the bowl during his interview with Thomm, personnel chief for the Department of Planetary Affairs. Now, with the interview over, he could not help but bend forward to examine the bowl more closely. He said with obvious sincerity: "This is the most beautiful piece I've ever seen."

Thomm, a man of early middle-age with a brisk gray mustache, a sharp but tolerant eye, leaned back in his chair. "It's a souvenir. Souvenir's as good a name for it as anything else. I got it many years ago, when I was your age." He glanced at his desk clock. "Lunchtime."

Keselsky looked up, hastily reached for his brief case. "Excuse me, I had no idea—"
Thomm raised his hand. "Not so fast. I'd like you to have lunch with me."
Keselsky muttered embarrassed excuses, but Thomm insisted.
"Sit down, by all means." A menu appeared on the screen. "Now—look that over."
Without further urging Keselsky made a selection, and Thomm spoke into the mesh. The wall opened, a table slid out with their lunch.

Even while eating Keselsky fondled the bowl with his eyes. Over coffee, Thomm handed it across the table. Keselsky hefted it, stroked the surface, looked deep into the glaze.

"Where on earth did you find such a marvelous piece?" He examined the bottom, frowned at the marks scratched in the clay.

"Not on Earth," said Thomm. "On the planet Firsk." He sat back. "There's a story connected with that bowl." He paused inquiringly.

Keselsky hurriedly swore that nothing could please him more than to listen while Thomm spoke of all things under the sun. Thomm smiled faintly. After all, this was Keselsky's first job.

"As I've mentioned, I was about your age," said Thomm. "Perhaps a year or two

older, but then I'd been out on the Channel Planet for nineteen months. When my transfer to Firsk came I was naturally very pleased, because Channel, as perhaps you know, is a bleak planet, full of ice and frost-fleas and the dullest aborigines in space—"

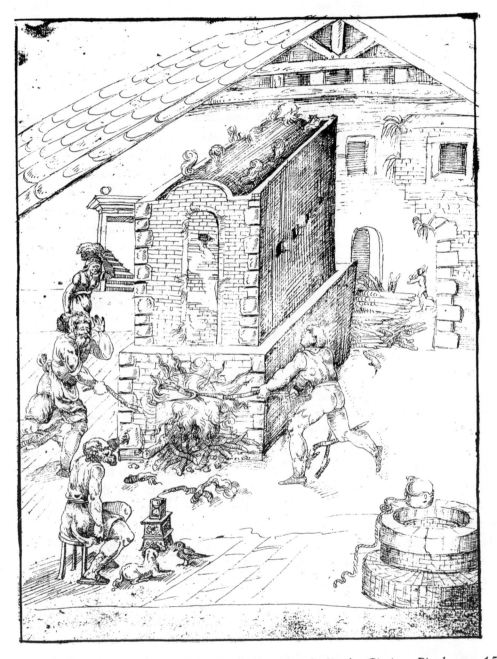

32. "The Kiln," from The Three Books of the Potter's Art *by Cipriano Piccolpasso, 1557.*

Thomm was entranced with Firsk. It was everything the Channel Planet had not been: warm, fragrant, the home of the Mi-Tuun, a graceful people of a rich, quaint and ancient culture. Firsk was by no means a large planet, though its gravity approached that of Earth. The land surface was small—a single equatorial continent in the shape of a dumbbell.

The Planetary Affairs Bureau was located at Penolpan, a few miles in from the South Sea, a city of fable and charm. The tinkle of music was always to be heard somewhere in the distance; the air was mellow with incense and a thousand flower scents. The low houses of reed, parchment and dark wood were arranged negligently, three-quarters hidden under the foliage of trees and vines. Canals of green water laced the city, arched over by wooden bridges trailing ivy and orange flowers, and here swam boats each decorated in an intricate many-colored pattern.

The inhabitants of Penolpan, the amber-skinned Mi-Tuun, were a mild people devoted to the pleasures of life, sensuous without excess, relaxed and gay, guiding their lives by ritual. They fished in the South Sea, cultivated cereals and fruit, manufactured articles of wood, resin and paper. Metal was scarce on Firsk, and was replaced in many instances by tools and utensils of earthenware, fabricated so cleverly that the lack was never felt.

Thomm found his work at the Penolpan Bureau pleasant in the extreme, marred only by the personality of his superior. This was George Covill, a short ruddy man with prominent blue eyes, heavy wrinkled eyelids, sparse sandy hair. He had a habit, when he was displeased—which was often—of cocking his head sidewise and staring for a brittle five seconds. Then, if the offense was great, he exploded in wrath; if not, he stalked away.

On Penolpan, Covill's duties were more of a technical than sociological nature, and even so, in line with the Bureau's policy of leaving well-balanced cultures undisturbed, there was little to occupy him. He imported silica yarn to replace the root fiber from which the Mi-Tuun wove their nets; he built a small cracking plant and converted the fish oil they burned in their lamps into a lighter cleaner fluid. The varnished paper of Penolpan's houses had a tendency to absorb moisture and split after a few months of service. Covill brought in a plastic varnish which protected them indefinitely. Aside from these minor innovations Covill did little. The Bureau's policy was to improve the native standard of living within the framework of its own culture, introducing Earth methods, ideas, philosophy very gradually and only when the natives themselves felt the need.

Before long, however, Thomm came to feel that Covill paid only lip-service to the Bureau philosophy. Some of his actions seemed dense and arbitary to the well-indoctrinated Thomm. He built an Earth-style office on Penolpan's main canal, and the concrete and glass made an inexcusable jar against Penolpan's mellow ivories and browns. He kept strict office hours and on a dozen occasions a delegation of Mi-Tuun, arriving in ceremonial regalia, had to be turned away with stammered excuses by Thomm, when in truth Covill, disliking the crispness of his linen suit, had stripped to the waist and was slumped in a wicker chair with a cigar, a quart of beer, watching girl-shows on his telescreen.

Thomm was assigned to Pest Control, a duty Covill considered beneath his dignity. On one of his rounds Thomm first heard mentioned the Potters of Firsk.

Laden with insect spray, with rat-poison cartridges dangling from his belt, he had wandered into the poorest outskirts of Penolpan, where the trees ended and the dry plain stretched out to the Kukmank Mountains. In this relatively drab location he came upon a long open shed, a pottery bazaar. Shelves and tables held ware of every description, from stoneware crocks for pickling fish to tiny vases thin as paper, lucent as milk. Here were plates large and small, bowls of every size and shape, no two alike, ewers, tureens, demijohns, tankards. One rack held earthenware knives, the clay vitrified till it rang like iron, the

cutting edge chipped cleanly, sharper than any razor, from a thick dripping of glaze.

Thomm was astounded by the colors. Rare rich ruby, the green of flowing river water, turquoise ten times deeper than the sky. He saw metallic purples, browns shot with blond light, pinks, violets, grays, dappled russets, blues of copper and cobalt, the odd streaks and flows of rutilated glass. Certain glazes bloomed with crystals like snowflakes, others held floating within them tiny spangles of metal.

Thomm was delighted with his find. Here was beauty of form, of material, of craftsmanship. The sound body, sturdy with natural earthy strength given to wood and clay, the melts of colored glass, the quick restless curves of the vases, the capacity of the bowls, the expanse of the plates—they produced a tremendous enthusiasm in Thomm. And yet—there were puzzling aspects to the bazaar. First—he looked up and down the shelves—something was lacking. In the many-colored display he missed—yellow. There were no yellow glazes of any sort. A cream, a straw, an amber—but no full-bodied glowing yellow.

Perhaps the potters avoided the color through superstition, Thomm speculated, or perhaps because of identification with royalty, like the ancient Chinese of Earth, or perhaps because of association with death or disease—The train of thought led to the second puzzle. Who were the potters? There were no kilns in Penolpan to fire ware such as this.

He approached the clerk, a girl just short of maturity, who had been given an exquisite loveliness. She wore the *pareu* of the Mi-Tuun, a flowered sash about the waist, and reed sandals. Her skin glowed like one of the amber glazes at her back, she was slender, quiet, friendly.

"This is all very beautiful," said Thomm. "For instance, what is the price of this?" He touched a tall flagon glazed a light green, streaked and shot with silver threads.

The price she mentioned, in spite of the beauty of the piece, was higher than what he had expected. Observing his surprise, the girl said, "They are our ancestors, and to sell them as cheaply as wood or glass would be irreverent."

Thomm raised his eyebrows, and decided to ignore what he considered a ceremonial personification.

"Where's the pottery made?" he asked. "In Penolpan?"

The girl hesitated and Thomm felt a sudden shade of restraint. She turned her head, looked out toward the Kukmank Range. "Back in the hills are the kilns; out there our ancestors go, and the pots are brought back. Aside from this I know nothing."

Thomm said carefully, "Do you prefer not to talk of it?"

She shrugged. "Indeed, there's no reason why I should. Except that we Mi-Tuun fear the Potters, and the thought of them oppresses us."

"But why is that?"

She grimaced. "No one knows what lies beyond the first hill. Sometimes we see the glow of furnaces, and then sometimes when there are no dead for the Potters they take the living."

Thomm thought that if so, here was a case for the interference of the Bureau, even to the extent of armed force.

"Who are these Potters?"

"There," she said, and pointed. "There is a Potter."

Following her finger, he saw a man riding out along the plain. He was taller, heavier than the Mi-Tuun. Thomm could not see him distinctly, wrapped as he was in a long gray

burnoose, but he appeared to have a pale skin and reddish-brown hair. He noted the bulging panniers on the pack-beast. "What's he taking with him now?"

"Fish, paper, cloth, oil—goods he traded his pottery for."

Thomm picked up his pest-killing equipment. "I think I'll visit the Potters one of these days."

"No —" said the girl.

"Why not?"

"It's very dangerous. They're fierce, secretive —"

Thomm smiled. "I'll be careful."

Back at the Bureau he found Covill stretched out on a wicker chaise lounge, half-asleep. At the sight of Thomm he roused himself, sat up.

"Where the devil have you been? I told you to get the estimates on that power plant ready today."

"I put them on your desk," replied Thomm politely. "If you've been out front at all, you couldn't have missed them."

Covill eyed him belligerently, but for once found himself at a loss for words. He subsided in his chair with a grunt. As a general rule Thomm paid little heed to Covill's sharpness, recognizing it as resentment against the main office. Covill felt his abilities deserved greater scope, a more important post.

Thomm sat down; helped himself to a glass of Covill's beer. "Do you know anything about the potteries back in the mountains?"

Covill grunted: "A tribe of bandits, something of the sort." He hunched forward, reached for the beer.

"I looked into the pottery bazaar today," said Thomm. "A clerk called the pots 'ancestors.' Seemed rather strange."

"The longer you knock around the planets," Covill stated, "the stranger things you see. Nothing could surprise me any more—except maybe a transfer to the Main Office." He snorted bitterly, gulped at his beer. Refreshed, he went on in a less truculent voice, "I've heard odds and ends about these Potters, nothing definite, and I've never had time to look into 'em. I suppose it's religious ceremonial, rites of death. They take away the dead bodies, bury 'em for a fee or trade goods."

"The clerk said that when they don't get the dead, sometimes they take the living."

"Eh? What's that?" Covills' hard blue eyes stared bright from his red face. Thomm repeated his statement.

Covill scratched his chin, presently hoisted himself to his feet. "Let's fly out, just for the devilment of it, and see what these Potters are up to. Been wanting to go out a long time."

Thomm brought the copter out of the hangar, set down in front of the office, and Covill gingerly climbed in. Covill's sudden energy mystified Thomm, especially since it included a ride in the copter. Covill had an intense dislike of flying, and usually refused to set foot in an aircraft.

The blades sang, grabbed the air, the copter wafted high. Penoplan became a checkerboard of brown roofs and foliage. Thirty miles distant, across a dry sandy plain, rose the Kukmank Range—barren shoulders and thrusts of gray rock. At first sight locating a settlement among the tumble appeared a task of futility.

Covill peering down into the wastes grumbled something to this effect; Thomm, however, pointed toward a column of smoke. "Potters need kilns. Kilns need heat—"

As they approached the smoke, they saw that it issued not from brick stacks but from a fissure at the peak of a conical dome.

"Volcano," said Covill, with an air of vindication. "Let's try out there along that ridge—then if there's nothing we'll go back."

Thomm had been peering intently below. "I think we've found them right here. Look close, you can see buildings."

He dropped the copter, and the rows of stone houses became plain.

"Should we land?" Thomm asked dubiously. "They're supposed to be fairly rough."

"Certainly, set down," snapped Covill. "We're official representatives of the System."

The fact might mean little to a tribe of mountaineers, reflected Thomm; nevertheless he let the copter drop onto a stony flat place in the center of the village.

The copter, if it had not alarmed the Potters, at least had made them cautious. For several minutes there was no sign of life. The stone cabins stood bleak and vacant as cairns.

Covill alighted, and Thomm, assuring himself that his gamma-gun was in easy reach, followed. Covill stood by the copter, looking up and down the line of houses. "Cagey set of beggars," he growled. "Well . . . we better stay here till someone makes a move."

To this plan Thomm agreed heartily, so they waited in the shadow of the copter. It was clearly the village of the Potters. Shards lay everywhere—brilliant bits of glazed ware glinting like lost jewels. Down the slope rose a heap of broken bisque, evidently meant for later use, and beyond was a long tile-roofed shed. Thomm sought in vain for a kiln. A fissure into the side of the mountain caught his eye, a fissure with a well-worn path leading into it. An intriguing hypothesis formed in his mind—but now three men had appeared, tall and erect in gray burnooses. The hoods were flung back, and they looked like monks of medieval Earth, except that instead of monkish tonsure, fuzzy red hair rose in a peaked mound above their heads.

The leader approached with a determined step, and Thomm stiffened, prepared for anything. Not so Covill; he appeared contemptuously at ease, a lord among serfs.

Ten feet away the leader halted—a man taller than Thomm with a hook nose, hard intelligent eyes like gray pebbles. He waited an instant but Covill only watched him. At last the Potter spoke in a courteous tone.

"What brings strangers to the village of the Potters?"

"I'm Covill, of the Planetary Affairs Bureau in Penolpan, official representative of the System. This is merely a routine visit, to see how thing are going with you."

"We make no complaints." replied the chief.

"I've heard reports of you Potters kidnapping Mi-Tuun," said Covill. "Is there any truth in that?"

"Kidnapping?" mused the chief. "What is that?"

Covill explained. The chief rubbed his chin, staring at Covill with eyes black as water.

"There is an ancient agreement," said the chief at last. "The Potters are granted the bodies of the dead; and occasionally when the need is great, we do anticipate nature by a year or two. But what matter? The soul lives forever in the pot it beautifies."

Covill brought out his pipe, and Thomm held his breath. Loading the pipe was

sometimes a preliminary to the cold sidelong stares which occasionally ended in an explosion of wrath. For the moment however Covill held himself in check.

"Just what do you do with the corpses?"

The leader raised his eyebrows in surprise. "Is it not obvious? No? But then you are no potter—Our glazes require lead, sand, clay, alkali, spar, and lime. All but the lime is at our hand, and this we extract from the bones of the dead."

Covill lit his pipe, puffed. Thomm relaxed. For the moment the danger was past.

"I see," said Covill. "Well, we don't want to interfere in any native customs, rites or practices, so long as the peace isn't disturbed. You'll have to understand there can't be any more kidnapping. The corpses—that's between you and whoever's responsible for the body, but lives are more important than pots. If you need lime, I can get you tons of it. There must be limestone beds somewhere on the planet. One of these days I'll send Thomm out prospecting and you'll have more lime than you'll know what to do with."

The chief shook his head, half amused. "Natural lime is a poor substitute for the fresh live lime of bones. There are certain other salts which act as fluxes, and then, of course, the spirit of the person is in the bones and this passes into the glaze and gives it an inner fire otherwise unobtainable."

Covill puffed, puffed, puffed, watching the chief with his hard blue eyes. "I don't care what you use," he said, "as long as there's no kidnapping, no murder. If you need lime, I'll help you find it; that's what I'm here for, to help you, and raise your standard of living; but I'm also here to protect the Mi-Tuun from raiding. I can do both—one about as good as the other."

The corners of the chief's mouth drew back. Thomm interposed a question before he spat out an angry reply. "Tell me, where are your kilns?"

The chief turned him a cool glance. "Our firing is done by the Great Monthly Burn. We stack our ware in the caves, and then, in the twenty-second day, the scorch rises from below. One entire day the heat roars up white and glowing, and two weeks later the caves have cooled for us to go after our ware."

"That sounds interesting," said Covill. "I'd like to look around your works. Where's your pottery, down there in that shed?"

The chief moved not a muscle. "No man may look inside that shed," he said slowly, "unless he is a Potter—and then only after he has proved his mastery of the clay."

"How does he go about that?" Covill asked lightly.

"At the age of fourteen he goes forth from his home with a hammer, a mortar, a pound of bone lime. He must mine clay, lead, sand, spar. He must find iron for brown, malachite for green, cobalt earth for blue, and he must grind a glaze in his mortar, shape and decorate a tile, and set it in the Mouth of the Great Burn. If the tile is successful, the body whole, the glaze good, then he is permitted to enter the long pottery and know the secrets of the craft."

Covill pulled the pipe from his mouth, asked quizzically, "And if the tile's no good?"

"We need no poor Potters," said the chief. "We always need bone-lime."

Thomm had been glancing along the shards of colored pottery. "Why don't you use yellow glaze?"

The chief flung out his arms. "Yellow glaze? It is unknown, a secret no Potter has penetrated. Iron gives a dingy tan, silver a gray-yellow, and antimony burns out in the heat

of the Great Burn. The pure rich yellow, the color of the sun . . . ah, that is a dream."

Covill was uninterested. "Well, we'll be flying back, since you don't care to show us around. Remember, if there's any technical help you want, I can get it for you. I might even find how to make you your precious yellow—"

"Impossible," said the chief. "Have not we, the Potters of the Universe, sought for thousands of years?"

". . . But there must be no more taking of lives. If necessary, I'll put a stop to the potting altogether."

The chief's eyes blazed. "Your words are not friendly!"

"If you don't think I can do it, you're mistaken," said Covill. "I'll drop a bomb down the throat of your volcano and cave in the entire mountain. The System protects every man-jack everywhere, and that means the Mi-Tuun from a tribe of Potters who wants their bones."

Thomm plucked him nervously by the sleeve. "Get back in the copter," he whispered. "They're getting ugly. In another minute they'll jump us."

Covill turned his back on the lowering chief, deliberately climbed into the copter. Thomm followed more warily. In his eyes the chief was teetering on the verge of attack, and Thomm had no inclination for fighting.

He flung in the clutch; the blades chewed at the air; the copter rose, leaving a knot of gray-burnoosed Potters silent below.

Covill settled back with an air of satisfaction. "There's only one way to handle people like that, and that is, get the upper hand on 'em; that's the only way they'll respect you. You act just a little uncertain, they sense it, sure as fate, and then you're a goner."

Thomm said nothing. Covill's methods might produce immediate results, but in the long run they seemed short-sighted, intolerant, unsympathetic. In Covill's place he would have stressed the Bureau's ability to provide substitutes for the bone-lime, and possibly assist with any technical difficulties—though indeed, they seemed to be masters of their craft, completely sure of their ability. Yellow glaze, of course, still was lacking them. That evening he inserted a strip from the Bureau library into his portable viewer. The subject was pottery, and Thomm absorbed as much of the lore as he was able.

Covill's pet project—a small atomic power plant to electrify Penolpan—kept him busy the next few days, even though he worked reluctantly. Penolpan, with its canals softly lit by yellow lanterns, the gardens glowing to candles and rich with the fragrance of night blossoms, was a city from fairyland; electricity, motors, fluorescents, water pumps would surely dim the charm—Covill, however, was insistent that the world would benefit by a gradual integration into the tremendous industrial complex of the System.

Twice Thomm passed by the pottery bazaar and twice he turned in, both to marvel at the glistening ware and to speak with the girl who tended the shelves. She had a fascinating beauty, grace and charm, breathed into her soul by a lifetime in Penolpan; she was interested in everything Thomm had to tell her of the outside universe, and Thomm, young, softhearted and lonely, looked forward to his visits with increasing anticipation.

For a period Covill kept him furiously busy. Reports were due at the home office, and Covill assigned the task to Thomm, while he either dozed in his wicker chair or rode the canals of Penolpan in his special red and black boat.

At last, late one afternoon, Thomm threw aside his journals and set off down the street, under the shade of great kaotang trees. He crossed through the central market, where the shopkeepers were busy with late trade, turned down a path beside a turf-banked canal and presently came to the pottery bazaar.

But he looked in vain for the girl. A thin man in a black jacket stood quietly to the side, waiting his pleasure. At last Thomm turned to him. "Where's Su-then?"

The man hesitated, Thomm grew impatient.

"Well, where is she? Sick? Has she given up working here?"

"She has gone."

"Gone where?"

"Gone to her ancestors."

Thomm's skin froze to stiffness. *"What?"*

The clerk lowered his head.

"Is she dead?"

"Yes, she is dead."

"But—how? She was healthy a day or so ago."

The man of the Mi-Tuun hesitated once more. "There are many ways of dying, Earthman."

Thomm became angry. "Tell me now—what happened to her?"

Rather startled by Thomm's vehemence the man blurted, "The Potters have called her to the hills; she is gone, but soon she will live forever, her spirit wrapped in glorious glass—"

"Let me get this straight," said Thomm. "The Potters took her—alive?"

"Yes—alive."

"And any others?"

"Three others."

"All alive?"

"All alive."

Thomm ran back to the Bureau.

Covill, by chance, was in the front office checking Thomm's work. Thomm blurted, "The Potters have been raiding again—they took four Mi-Tuun in the last day or so."

Covill thrust his chin forward, cursed fluently. Thomm understood that his anger was not so much for the act itself, but for the fact that the Potters had defied him, disobeyed his orders. Covill personally had been insulted; now there would be action.

"Get the copter out," said Covill shortly. "Bring it around in front."

When Thomm set the copter down Covill was waiting with one of the three atom bombs in the Bureau armory—a long cylinder attached to a parachute. Covill snapped it in place on the copter, then stood back. "Take this over that blasted volcano," he said harshly. "Drop it down the crater. I'll teach those murdering devils a lesson they won't forget. Next time it'll be on their village."

Thomm, aware of Covill's dislike of flying, was not surprised by the assignment. Without further words he took off, rose above Penolpan, flew out toward the Kukmank Range.

His anger cooled. The Potters, caught in the rut of their customs, were unaware of

evil. Covill's orders seemed ill-advised—headstrong, vindictive, over-hasty. Suppose the Mi-Tuun were yet alive? Would it not be better to negotiate for their release? Instead of hovering over the volcano, he dropped his copter into the gray village, and assuring himself of his gamma-gun, he jumped out onto the dismal stony square.

This time he had only a moment to wait. The chief came striding up from the village, burnoose flapping back from powerful limbs, a grim smile on his face.

"So—it is the insolent lordling again. Good—we are in need of bone-lime, and yours will suit us admirably. Prepare your soul for the Great Burn, and your next life will be the eternal glory of a perfect glaze."

Thomm felt fear, but he also felt a kind of desperate recklessness. He touched his gun. "I'll kill a lot of Potters, and you'll be the first," he said in a voice that sounded strange to him. "I've come for the four Mi-Tuun that you took from Penolpan. These raids have got to stop. You don't seem to understand that we can punish you."

The chief put his hands behind his back, apparently unimpressed. "You may fly like the birds, but birds can do no more than defile those below."

Thomm pulled out his gamma-gun, pointed to a boulder a quarter-mile away. "Watch that rock." And he blasted the granite to gravel with an explosive pellet.

The chief drew back, eyebrows raised. "In truth, you wield more sting than I believed. But "—he gestured to the ring of burnoosed Potters around Thomm—"we can kill you before you can do much damage. We Potters do not fear death, which is merely eternal meditation from the glass."

"Listen to me," said Thomm earnestly. "I came not to threaten, but to bargain. My superior, Covill, gave me orders to destroy the mountain, blast away your caves—and I can do it as easily as I blasted that rock."

A mutter arose from the Potters.

"If I'm harmed, be sure that you'll suffer. But, as I say, I've come down here, against my superior's orders, to make a bargain with you."

"What sort of bargain can interest us?" said the Chief Potter disdainfully. "We care for nothing but our craft." He gave a sign and, before Thomm could twitch, two burly Potters had gripped him, wrested the gun from his hand.

"I can give you the secret of the true yellow glaze," shouted Thomm desperately. "The royal fluorescent yellow that will stand the fire of your kiln!"

"Empty words," said the chief. Mockingly he asked: "And what do you want for your secret?"

"The return of the four Mi-Tunn you've just stolen from Penolpan, and your word never to raid again."

The chief listened intently, pondered a moment. "How then would we formulate our glaze?" He spoke with a patient air, like a man explaining a practical truth to a child. "Bone-lime is one of our most necessary fluxes."

"As Covill told you, we can give you unlimited quantities of lime, with any properties you ask for. On Earth we have made pottery for thousands of years and we know a great deal of such things."

The chief Potter tossed his head. "That is evidently untrue. Look"—he kicked Thomm's gamma-gun—"the substance of this is dull opaque metal. A people knowing clay and transparent glass would never use material of that sort."

"Perhaps it would be wise to let me demonstrate," suggested Thomm. "If I show you the yellow glaze, then will you bargain with me?"

The Chief Potter scrutinized Thomm almost a full minute. Grudgingly: "What sort of yellow can you make?"

Thomm said wryly: "I'm not a potter, and I can't predict exactly—but the formula I have in mind can produce any shade from light luminous yellow to vivid orange."

The chief made a signal. "Release him. We will make him eat his words."

Thomm stretched his muscles, cramped under the grip of the Potters. He reached to the ground, picked up his gamma-gun, holstered it, under the sardonic eyes of the Chief Potter.

"Our bargain is this," said Thomm, "I show you how to make yellow glaze, and guarantee you a plentiful supply of lime. You will release the Mi-Tuun to me and undertake never to raid Penolpan for live men and women."

"The bargain is conditional on the yellow glaze," said the Chief Potter. "We ourselves can produce dingy yellows as often as we wish. If your yellow comes clear and true from the fire, I agree to your bargain. If not, we potters hold you a charlatan and your spirit will be lodged forever in the basest sort of utensil."

Thomm went to the copter, unsnapped the atom bomb from the frame, discarded the parachute. Shouldering the long cylinder, he said: "Take me to your pottery. I'll see what I can do."

Without a word the Chief Potter took him down the slope to the long shed, and they entered through an arched stone doorway. To the right stood bins of clay, a row of wheels, twenty or thirty lined against one wall, and in the center a rack crowded with drying ware. To the left stood vats, further shelves and tables. From a doorway came a harsh grinding sound, evidently a mill of some sort. The chief Potter led Thomm to the left, past the glazing tables and to the end of the shed. Here were shelves lined with various crocks, tubs and sacks, these marked in symbols strange to Thomm. And through a doorway nearby, apparently unguarded, Thomm glimpsed the Mi-Tuun, seated despondently, passively, on benches. The girl Su-then looked up, saw him, and her mouth fell open. She jumped to her feet, hesitated in the doorway, deterred by the stern form of the Chief Potter.

Thomm said to her: "You're a free woman—with a little luck." Then turning to the Chief Potter: "What kind of acid do you have?"

The chief pointed to a row of stoneware flagons. "The acid of salt, the acid of vinegar, the acid of fluor spar, the acid of saltpeter, the acid of sulphur."

Thomm nodded, and laying the bomb on a table, opened the hinged door, withdrew one of the uranium slugs. Into five porcelain bowls he carved slivers of uranium with his pocket knife, and into each bowl he poured a quantity of acid, a different acid into each. Bubbles of gas fumed up from the metal.

The Chief Potter watched with folded arms. "What are you trying to do?"

Thomm stood back, studied his fuming beakers. "I want to precipitate a uranium salt. Get me soda and lye."

Finally a yellow powder settled in one of his beakers; this he seized upon and washed triumphantly.

"Now," he told the Chief Potter, "bring me clear glaze."

He poured out six trays of glaze and mixed into each a varying amount of his yellow salt.

With tired and slumped shoulders he stood back, gestured. "There's your glaze. Test it."

The chief gave an order; a Potter came up with a trayful of tiles. The chief strode to the table, scrawled a number on the first bowl, dipped a tile into the glaze, numbered the tile correspondingly. This he did for each of the batches.

He stood back, and one of the Potters loaded the tiles in a small brick oven, closed the door, kindled a fire below.

"Now," said the Chief Potter, "you have twenty hours to question whether the burn will bring you life or death. You may as well spend the time in the company of your friends. You cannot leave, you will be well guarded." He turned abruptly, strode off down the central aisle.

Thomm turned to the nearby room, where Su-then stood in the doorway. She fell into his arms naturally, gladly.

The hours passed. Flame roared up past the oven and the bricks glowed red-hot—yellow-hot—yellow-white, and the fire was gradually drawn. Now the tiles lay cooling and behind the bricked-up door the colors were already set, and Thomm fought the impulse to tear open the brick. Darkness came; he fell into a fitful doze with Su-then's head resting on his shoulder.

Heavy footsteps aroused him; he went to the doorway. The Chief Potter was drawing aside the bricked-up door. Thomm approached, stood staring. It was dark inside; only the white gleam of the tiles could be seen, the sheen of colored glass on top. The chief Potter reached into the kiln, pulled out the first tile. A muddy mustard-colored blotch encrusted the top. Thomm swallowed hard. The chief smiled at him sardonically. He reached for another. This was a mass of brownish blisters. The chief smiled again, reached in once more. A pad of mud.

The chief's smile was broad. "Lordling, your glazes are worse than the feeblest attempts of our children."

He reached in again. A burst of brilliant yellow, and it seemed the whole room shone.

The Chief Potter gasped, the other Potters leaned forward, and Thomm sank back against the wall. "Yellow—"

When Thomm at last returned to the Bureau he found Covill in a fury. "Where in thunder have you been? I sent you out on business which should take you two hours and you stay two days."

Thomm said: "I got the four Mi-Tuun back and made a contract with the Potters. No more raiding."

Covill's mouth slackened. "You *what?*"

Thomm repeated his information.

"You didn't follow my instructions?"

"No," said Thomm. "I thought I had a better idea, and the way it turned out, I had."

Covill's eyes were hard blue fires. "Thomm, you're through here, through with Planetary Affairs. If a man can't be trusted to carry out his superior's orders, he's not worth a cent to the Bureau. Get your gear together, and leave on the next packet out."

"Just as you wish," said Thomm, turning away.

"You're on company time till four o'clock tonight," said Covill coldly. "Until then you'll obey my orders. Take the copter to the hangar, and bring the bomb back to the armory."

"You haven't any more bomb," said Thomm. "I gave the uranium to the Potters. That was one of the prices of the contract."

"What?" bellowed Covill, pop-eyed. *"What?"*

"You heard me," said Thomm. "And if you think you could have used it better by blasting away their livelihood, you're crazy."

"Thomm, you get in that copter, you go out and get that uranium. Don't come back without it. Why, you abysmal blasted imbecile, with that uranium, those Potters could tear Penolpan clean off the face of the planet."

"If you want that uranium," said Thomm, "you go out and get it. I'm fired. I'm through."

Covill stared, swelling like a toad in his rage. Words came thickly from his mouth.

Thomm said: "If I were you, I'd let sleeping dogs lie. I think it would be dangerous business trying to get that uranium back."

Covill turned, buckled a pair of gamma-guns about his waist, stalked out the door. Thomm heard the whirr of copter blades.

"There goes a brave man," Thomm said to himself. "And there goes a fool."

Three weeks later Su-then excitedly announced visitors, and Thomm, looking up, was astounded to see the Chief Potter, with two other Potters behind—stern, forbidding in their gray burnooses.

Thomm greeted them with courtesy, offered them seats, but they remained standing.

"I came down to the city," said the Chief Potter, "to inquire if the contract we made was still bound and good."

"So far as I am concerned," said Thomm.

"A madman came to the village of the Potters," said the Chief Potter. "He said that you had no authority, that our agreement was good enough, but he couldn't allow the Potters to keep the heavy metal that makes glass like the sunset."

Thomm said: "Then what happened?"

"There was violence," said the Chief Potter without accent. "He killed six good wheel-men. But that is no matter. I come to find whether our contract is good."

"Yes," said Thomm. "It is bound by my word and by the word of my great chief back on Earth. I have spoken to him and he says the contract is good."

The Chief Potter nodded. "In that case, I bring you a present." He gestured, and one of his men laid a large bowl on Thomm's desk, a bowl of marvelous yellow radiance.

"The madman is a lucky man indeed," said the chief Potter, "for his spirit dwells in the brightest glass ever to come from the Great Burn."

Thomm's eyebrows shot up. "You mean that Covill's bones—"

"The fiery soul of the madman has given luster to an already glorious glaze," said the Chief Potter. "He lives forever in the entrancing shimmer—"

Time Shards

Gregory Benford

It had all gone very well, Brooks told himself. Very well indeed. He hurried along the side corridor, his black dress shoes clicking hollowly on the old tiles. This was one of the oldest and most rundown of the Smithsonian's buildings; too bad they didn't have the money to knock it down. Funding. Everything was a matter of funding.

He pushed open the door of the barnlike workroom and called out, "John? How did you like the ceremony?"

John Hart appeared from behind a vast rack that was filled with fluted pottery. His thin face was twisted in a scowl and he was puffing on a cigarette. "Didn't go."

"John? That's not permitted." Brooks waved at the cigarette. "You of all people should be careful about contamination of —"

"Hell with it." He took a final puff, belched blue, and ground out the cigarette on the floor.

"You really should've watched the dedication of the Vault, you know," Brooks began, adopting a bantering tone. You had to keep a light touch with these research types. "The President was there—she made a very nice speech—"

"I was busy."

"Oh?" Something in Hart's tone put Brooks off his conversational stride. "Well. You'll be glad to hear that I had a little conference with the Board, just before the dedication. They've agreed to continue supporting your work here."

"Um."

"You must admit, they're being very fair." As he talked Brooks threaded amid the rows of pottery, each in a plastic sleeve. This room always made him nervous. There was priceless Chinese porcelain here, Assyrian stoneware, buff-blue Roman glazes, Egyptian earthenware—and Brooks lived in mortal fear that he would trip, fall, and smash some piece of history into shards. "After all, you *did* miss your deadline. You got nothing out of all this"—a sweep of the hand, narrowly missing a green Persian tankard—"for the Vault."

Hart, who was studying a small brownish water jug, looked up abruptly. "What about the wheel recording?"

"Well, there was that, but—"

"The best in the world, dammit!"

"They heard it some time ago. They were very interested."

"You told them what they were hearing?" Hart asked intensely.

"Of course, I—"

"You could hear the hoofbeats of cattle, clear as day."

"They heard. Several commented on it."

"Good." Hart seemed satisfied, but still strangely depressed.

"But you must admit, that isn't what you promised."

Hart said sourly, "Research can't be done to a schedule."

Brooks had been pacing up and down the lanes of pottery. He stopped suddenly, pivoted on one foot, and pointed a finger at Hart. "You said you'd have a *voice*. That was the promise. Back in '98 you said you would have something for the BiMillennium celebration, and—"

"Okay, okay." Hart waved away the other man's words.

"Look—" Brooks strode to a window and jerked up the blinds. From this high up in the Arts and Industries Building the BiMillennial Vault was a flat concrete slab sunk in the Washington mud; it had rained the day before. Now bulldozers scraped piles of gravel and mud into the hole, packing it in before the final encasing shield was to be laid. The Vault itself was already sheathed in sleeves of concrete, shock-resistant and immune to decay. The radio beacons inside were now set. Their radioactive power supply would automatically stir to life exactly a thousand years from now. Periodic bursts of radio waves would announce to the world of the TriMillennium that a message from the distant past awaited whoever dug down to find it. Inside the Vault were artifacts, recordings, everything the Board of Regents of the Smithsonian thought important about their age. The coup of the entire Vault was to have been a message from the First Millennium, the year 1000 A.D. Hart had promised them something far better than a mere written document from that time. He had said he could capture a living voice.

"See that?" Brooks said with sudden energy. "That Vault will outlast everything we know—all those best-selling novels and funny plays and amazing scientific discoveries. They'll all be *dust*, when the Vault's opened."

"Yeah," Hart said.

"Yeah? That's all you can say?"

" Well, sure, I—"

"The Vault was *important*. And I was stupid enough" —he rounded on Hart abruptly, anger flashing across his face— "to chew up some of the only money we had for the Vault to support *you*."

Hart took an involuntary step backward. "You knew it was a gamble."

"I knew," Brooks nodded ruefully. "And we waited, and waited—"

"Well, your waiting is over," Hart said, something hardening in him.

"What?"

"I've got it. A voice."

"You have?" In the stunned silence that followed Hart bent over casually and picked up a dun-colored water jug from the racks. An elaborate, impossibly large-winged orange bird was painted on its side. Hart turned the jug in his hands, hefting its weight.

"Why . . . it's too late for the Vault, of course, but still . . . " Brooks shuffled his feet. "I'm glad the idea paid off. That's great."

"Yeah. Great." Hart smiled sourly. "And you know what it's worth? Just about *this* much—"

He took the jug in one hand and threw it. It struck the far wall with a splintering crash. Shards flew like a covey of frightened birds that scattered through the long ranks of pottery. Each landed with a ceramic tinkling.

"What are you *doing*—" Brooks began, dropping to his knees without thinking to retrieve a fragment of the jug. "That jug was worth—"

"Nothing," Hart said. "It was a fake. Almost everything the Egyptians sent was bogus."

"But why are you . . . you said you succeeded . . ." Brooks was shaken out of his normal role of Undersecretary to the Smithsonian.

"I did. For what it's worth."

"Well . . . show me."

Hart shrugged and beckoned Brooks to follow him. He threaded his way through the inventory of glazed pottery, ignoring the extravagant polished shapes that flared and twisted in elaborate, artful designs, the fruit of millennia of artisans. Glazes of feldspath, lead, tin, ruby, salt. Jasperware, soft-paste porcelain, albarelloa festooned with ivy and laurel, flaring lips and serene curved handles. A galaxy of the work of the First Millennium and after assembled for Hart's search.

"It's on the wheel," Hart said, gesturing.

Brooks walked around the spindle fixed at the center of a horizontal disk. Hart called it a potter's wheel but it was a turntable, really, firmly buffered against the slightest tremor from external sources. A carefully arranged family of absorbers isolated the table from everything but the variable motor seated beneath it. On the turntable was an earthenware pot. It looked unremarkable to Brooks—just a dark red oxidized finish, a thick lip, and a rather crude handle, obviously molded on by a lesser artisan.

"What's its origin?" Brooks said, mostly to break the silence that lay between them.

"Southern England." Hart was logging instructions into the computer terminal nearby. Lights rippled on the staging board.

"How close to the First Mil?"

"Around 1280 A.D. apparently."

"Not really close, then. But interesting."

"Yeah."

Brooks stooped forward. When he peered closer he could see the smooth finish was an illusion. A thin thread ran around the pot, so fine the eye could scarcely make it out. The line wound in a tight helix. In the center of each delicate line was a fine hint of blue. The jug had been incised with a precise point. Good; that was exactly what Hart had said he sought. It was an ancient, common mode of decoration—incise a seemingly infinite series of rings, as the pot turned beneath the cutting tool. The cutting tip revealed a differently colored dye underneath, a technique called sgraffito, the scratched.

It could never have occurred to the Islamic potters who invented sgraffito that they were, in fact, devising the first phonograph records.

Hart pressed a switch and the turntable began to spin. He watched it for a moment, squinting with concentration. Then he reached down to the side of the turntable housing and swung up the stylus manifold. It came up smoothly and Hart locked it in just above the spinning red surface of the pot.

"Not a particularly striking item, is it?" Brooks said conversationally.

"No."

"Who made it?"

"Near as I can determine, somebody in a co-operative of villages, barely Christian. Still used lots of pagan decorations. Got them scrambled up with the cross motif a lot."

"You've gotten . . . words?"

"Oh, sure. In early English, even."

"I'm surprised crude craftsmen could do such delicate work."

"Luck, some of it. They probably used a pointed wire, a new technique that'd been imported around that time from Saxony."

The computer board hooted a readiness call. Hart walked over to it, thumbed in instructions, and turned to watch the stylus whir in a millimeter closer to the spinning jug. "Damn," Hart said, glancing at the board. "Correlator's giving hash again."

Hart stopped the stylus and worked at the board. Brooks turned nervously and paced, unsure of what his attitude should be toward Hart. Apparently the man had discovered something, but did that excuse his surliness? Brooks glanced out the window, where the last crowds were drifting away from the Vault dedication and strolling down the Mall. There was a reception for the Board of Regents in Georgetown in an hour. Brooks would have to be there early, to see that matters were in order—

"If you'd given me enough money, I could've had a Hewlett-Packard. Wouldn't have to fool with this piece of . . ." Hart's voice trailed off.

Brooks had to keep reminding himself that this foul-tempered, scrawny man was reputed to be a genius. If Hart had not come with the highest of recommendations, Brooks would never have risked valuable Vault funding. Apparently Hart's new method for finding correlations in a noisy signal was a genuine achievement.

The basic idea was quite old, of course. In the 1960's a scientist at the American Museum of Natural History in New York had applied a stylus to a rotating urn and played the signal through an audio pickup. Out came the *wreeee* sound of the original potter's wheel where the urn was made. It had been a Roman urn, made in the era when hand-turned wheels were the best available. The Natural History "recording" was crude, but even that long ago they could pick out a moment when the potter's hand slipped and the rhythm of the *wreeee* faltered.

Hart had read about that urn and seen the possibilities. He developed his new multiple-correlation analysis—a feat of programming, if nothing else—and began searching for pottery that might have acoustic detail in its surface. The sgraffito technique was the natural choice. Potters sometimes used fine wires to incise their wares. Conceivably, any-thing that moved the incising wire—passing footfalls, even the tiny acoustic push of sound waves—could leave its trace on the surface of the finished pot. Buried among imperfections and noise, eroded by the random bruises of history . . .

"Got it," Hart said, fatigue creeping into his voice.

"Good. Good."

"Yeah. Listen."

The stylus whirred forward. It gently nudged into the jug, near the lip. Hart flipped a switch and studied the rippling, dancing yellow lines on the board oscilloscope. Electronic archaeology. "There."

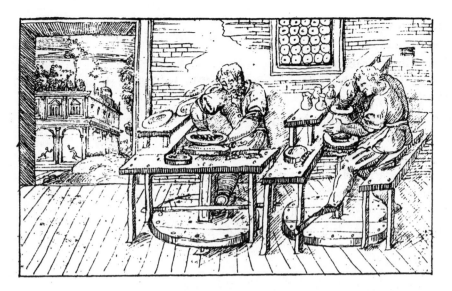

33. *"Throwing,"* *from* The Three Books of the Potter's Art
by Cipriano Piccolpasso, 1557.

A high-pitched whining came from the speaker, punctuated by hollow, deep bass thumps.

"Hear that? He's using a foot pump."

"A kick wheel?"

"Right."

"I thought they came later."

"No, the Arabs had them."

There came a *clop clop clop*, getting louder. It sounded oddly disembodied in the silence of the long room.

"What . . .?"

"Horse. I detected this two weeks ago. Checked it with the equestrian people. They say the horse is unshod, assuming we're listening to it walk on dirt. Farm animal, probably. Plow puller."

"Ah."

The hoofbeats faded. The whine of the kick wheel sang on.

"Here it comes," Hart whispered.

Brooks shuffled slightly. The ranks upon ranks of ancient pottery behind him made him nervous, as though a vast unmoving audience were in the room with them.

Thin, distant: "Alf?"

"Aye." A gruff reply.

"It slumps, sure."

"I be oct, man." A rasping, impatient voice.

"T'art—"

"*Busy*-mark?"

"Ah ha' wearied o' their laws," the thin voice persisted.

"Aye—so all. What mark it?" Restrained impatience.

"Their Christ. He werkes vengement an the alt spirits."

"Hie yer tongue."

"They'll ne hear."

"Wi'er Christ 'er're everywhere."

A pause. Then faintly, as though a whisper: "We ha' lodged th' alt spirits."

"Ah? You? Th' rash gazer?"

"I spy stormwrack. A hue an' grie rises by this somer se'sun."

"Fer we?"

"Aye, unless we spake th' *Ave maris stella* 'a theirs."

"Elat. Lat fer that. Hie, I'll do it. Me knees still buckle whon they must."

"I kenned that. So shall I."

"Aye. So shall we all. But wh' of the spirits?"

"They suffer pangs, dark werkes. They are lodged."

"Ah, Where?"

"S'tart."

"'Ere? In me clay?"

"In yer vessels."

"Nay!"

"I chanted 'em in 'fore sunbreak."

"Nay! I fain wad ye not."

whir whir whir

The kick wheel thumps came rhythmically.

"They sigh'd thruu in-t'wixt yer clay. 'S done."

"Fer *what*?"

"These pots—they bear a fineness, aye?"

"Aye."

A rumbling "—will hie home 'er. Live in yer pots."

"An?"

"Whon time werkes a'thwart 'e Christers, yon spirits of leaf an' bough will, I say, hie an' grie to yer sons, man. To yer *sons* sons, man."

"Me pots? Carry our kenne?"

"Aye. I investe' thy clay wi' ern'st spirit, so when's ye causes it ta dance, our law say . . ."

whir

A hollow rattle.

"Even this 'ere, as I spin it?"

"Aye. Th' spirits innit. Speak as *ye* form. The dance, t'will carry yer schop word t' yer sons, yer *sons* sons sons."

"While it's spinning'?"

Brooks felt his pulse thumping in his throat.

"Aye."

"Than't—"

"Speak inta it. To yer sons."

"Ah . . ." Suddenly the voice came louder. "Aye, aye? There! If ye hear me, sons? I be from yer past! The ancient dayes!"

"Tell them wha' ye must."

"Aye. Sons! Blood a' mine? Mark ye! Hie not ta strags in th' house of Lutes. They carry the red pox! An' . . . an', beware th' Kinseps—tey bugger all they rule! An', whilst pot-charrin', mix th' fair smelt wi' greeno erst, 'ere ye'll flux it fair speedy. Ne'er leave sheep near a lean-house, ne, 'ey'll snuck down 'an it—"

whir whir thump whir

"What—what happened?" Brooks gasped.

"He must have brushed the incising wire a bit. The cut continues, but the fine touch was lost. Vibrations as subtle as a voice couldn't register."

Brooks looked around, dazed, for a place to sit. "In . . . incredible."

"I suppose."

Hart seemed haggard, worn.

"They were about to convert to Christianity, weren't they?"

Hart nodded.

"They thought they could seal up the—what? wood spirits?—they worshiped. Pack them away by blessing the clay or something like that. And that the clay would carry a message—to the future!"

"So it did."

"To their sons sons sons . . ." Brooks paused. "Why are you so depressed, Hart? This is a great success."

Abruptly Hart laughed. "I'm not really. Just, well, manic, I guess. We're so funny. So absurd. Think about it, Brooks. All that hooey the potter shouted into his damned pot. What did you make of it?"

"Well . . . gossip, mostly. I can't get over what a long shot this is—that we'd get to hear it."

"Maybe it was a common belief back then. Maybe many tried it—and maybe now I'll find more pots, with just ordinary conversation on them. Who knows?" He laughed again, a slow warm chuckle. "We're all so absurd. Maybe Henry Ford was right—history *is* bunk."

"I don't see why you're carrying on this way, Hart. Granted, the message was . . . obscure. That unintelligible information about making pottery, and—"

"Tips on keeping sheep."

"Yes, and—"

"Useless, right?"

"Well, probably. To us, anyway. The conversation before that was much more interesting."

"Uh huh. Here's a man who is talking to the ages. Sending what he thinks is most important. And he prattles out a lot of garbage."

"Well true . . ."

"And *it* was important—to him."

"Yes."

Hart walked stiffly to the window. Earthmovers crawled like eyeless insects beneath the wan yellow lamps. Dusk had fallen. Their great awkward scoops pushed mounds of mud into the square hole where the Vault rested.

"Look at that." Hart gestured. "The Vault. Our own monument to our age. Passing on the legacy. You, me, the others—we've spent years on it. Years, and a fortune." He chuckled dryly. "What makes you think we've done any better?"

The Greeks Had No Word For It

Geoffrey Household

"May I say ten pounds?" the auctioneer asked. "Five? Thank you, madam. . . . Six . . . Six, ten . . . Seven . . . Seven, ten . . . At seven pounds ten? Going at seven pounds ten. An ancient Greek drinking bowl of the best period? Going at . . ."

Sergeant Torbin had at last wandered into the auction because there was nothing else to do. It was early closing day at Falkstead, and the shops were shut. There was nowhere to sit but the edge of the quay, and nothing to watch but the brown tide beginning to race down to the North Sea between grey mud-banks. The only sign of animation in the little town was around the open front door of a small box-like eighteenth-century house, the contents of which were being sold.

"Eight!" said the sergeant nervously, and immediately realized that nothing could give a man such a sense of inferiority as a foreign auction.

But the atmosphere was quiet and decorous. The auctioneer acknowledged Bill Torbin's bid with a smile which managed to express both surprise and appreciation at seeing the United States Air Force uniform in so rural a setting. He might have been welcoming him to the local Church Hall.

"May I say eight, ten?"

A military-looking man, overwhelming in size and manner, nodded sharply.

Bill could hardly hope that the bowl was genuine. He liked it for itself. Angular black figures chased one another round the red terracotta curve. He recognized Perseus, holding up that final and appalling weapon, the Gorgon's head. Very appropriate. A benevolent goddess, who reminded Bill of his tall, straight mother, looked on approvingly.

He ran the bowl up to ten pounds. When the auctioneer's hammer was already in the air, he heard someone say: "Guinness!"

There was a snap of triumph in the word, a suggestion that the whole sale had now come to a full stop. It was the military man again. To Sergeant Torbin he was the most terrifying type of native—a bulky chunk of brown tweed suit, with a pattern of orange and grey as pronounced as the Union Jack, and a red face and ginger moustache on top of it.

"It's against you, sir," the auctioneer told him hopefully.

Bill knew that much already. But the mysterious word "Guinness" sounded as if it had raised the ante to the moon. He panicked. He decided that he had no business in auctions. After all, he had only been in England a week and had come to Falkstead on his first free afternoon because it looked such a quiet little heaven from the train.

"Going at ten guineas . . . At ten guineas . . . Sold at ten guineas!"

Hell, he ought to have guessed that? But who would think that guineas would pop up at auctions when they belonged in the time of George III? Bill Torbin walked out and sat on the low wall which separated the garden from the road, conducting a furious auction with himself while he waited for the 6:30 train back to his bleak East Anglian airfield.

He had just reached the magnificent and imaginary bid of One Hundred Goddam Guineas when the tweed suit rolled down the garden path with the drinking bowl under its arm.

"Nice work, colonel!" Bill said, for at last he had an excuse to talk to somebody.

"Oh, it's you, is it? I say, you didn't want it, did you?"

The sergeant thought that was the damn silliest question he had ever heard. He realized, however, that it was meant as a kind of apology.

"British Museum stiff with 'em!"

Again he got the sense the Englishman was disclaiming any special value for his purchase. Bill asked if the bowl were genuine.

"Good Lord, yes? A fifth-century Athenian cylix! The old vicar had it vetted. His father picked it up in Istanbul during the Crimean War. That was the late vicar's late niece's stuff they were selling. Have a look for yourself!"

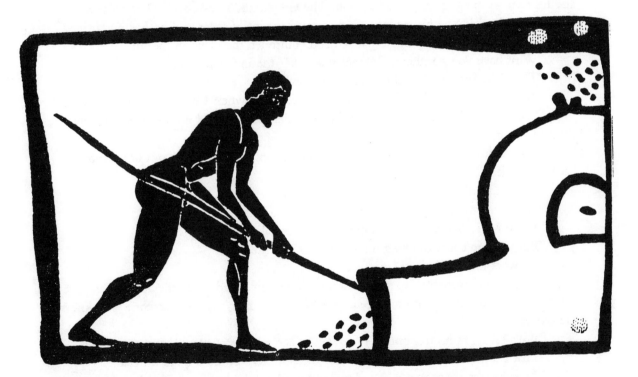

34. "Raking the Coals from the Firemouth of the Kiln," *scene depicted on an ancient Corinthian pot.*

Sergeant Torbin took the bowl in his hands with reverent precautions. Round the bottom, which he had not seen before, two winged horses pulled a chariot. He wondered what on earth he would ever have dared to do with so exquisite a piece if he had bought it. He might have presented it to the squadron but, like himself, the squadron had no safe place to keep it.

"How the devil did you know I was a colonel?"

Bill did not like to say that he couldn't possibly be anything else unless it were a general, but he was saved by the bell. The church clock struck six.

"Ah, they'll be opening now," said the colonel with satisfaction. "How about a drink?"

Bill Torbin murmured doubtfully that his train left at 6:30. The colonel announced that Falkstead station was only two minutes from the pub, and that he himself had often done it in eighty seconds flat. Considering the noble expanse of checked waistcoat, Bill thought it unlikely. But you never knew with these tough old Englishmen. Half of the weight might be muscle.

The colonel led the way to The Greyhound. It was a handsome little pub, built of white weather-boarding with green shutters, but Torbin had no eyes for it. He was watching the precious cylix which was being swung by one of its handles as carelessly as it it had been a cheap ash-tray. The sergeant decided that the British had no reverence for any antiquities but their own.

In the bar were four cheerful citizens of Falkstead drinking whisky, two boat-builders drinking beer with the foreman of the yard and at a table near the window, the auctioneer and his clerk keeping up respectability with The Greyhound's best sherry. The colonel disconcertingly changing his manner again, greeted the lot of them as if he had just arrived from crossing the North Sea single-handed and enthroned the cylix on the bar.

"What have you got there, Colonel Wagstaff?" the innkeeper asked.

"That, Mr. Watson, is a Greek drinking bowl."

"Never saw 'em used," Mr. Watson answered, "not when I was a corporal out there."

Wagstaff explained that it was an old one, which possibly had not been used for two thousand years.

"Two thousand four hundred," said the auctioneer taking his pipe out of his mouth, "at the very least."

"Time it was!" Mr. Watson exclaimed heartily.

"What are you going to put in it?" the colonel asked.

"Who? Me?" Watson said, not expecting to be taken literally.

"But you can't start drinking out of it!" Bill protested.

"It's what it is for, isn't it?"

"And an unforgettable experience for our American friend," said the auctioneer patronizingly, "to drink from the same cup as Socrates—or at any rate someone who knew the old boy."

"Well, seeing as it's this once," Mr. Watson agreed, "what would you say, colonel."

"That Burgundy which you bought for the summer visitors is quite drinkable."

The cylix was about two inches deep, and just held the bottle which Mr. Watson emptied into it. The terracotta flushed under the wine. The figures blossomed.

"See?" said Colonel Wagstaff. "Like rain in a dry garden!"

The company gathered round the bar. Wagstaff raised the bowl in both hands and took a hearty pull.

"Tastes a bit odd," he remarked, passing it on to Torbin. "Still you can't have everything."

The loving cup went round the eleven of them and Mr. Watson.

"Fill her up again," said the auctioneer.

The next round was the colonel's and after that there was a queue for the fascinating honour.

"If you take the 7:45 bus to Chesterford," Colonel Wagstaff suggested, "there's sure to be a train from there."

Bill was beginning to feel for the first time that England had human beings in it. But it was not the facile good-fellowship which persuaded him to wait for the bus. The bowl had become a local possession, and The Greyhound a club in which he was welcome to drink but might not pay. He was jealous. He could not bring himself to leave his goddess skittering along the bar in pools of Burgundy without his own hands ready to catch her.

The auctioneer said a fatherly good-bye to all, trod upon his bowler hat and left. Bill was astonished at the dignity with which he ignored his oversight and knocked out the dent. He looked at the clock. He felt bound to mention that it was 7:40.

"By Jove, so it is!" said the colonel, taking his moustache out of the bowl.

Till 7:45 he addressed them shortly on the value of punctuality in the military life, and then they all piled out into the street, led by Colonel Wagstaff, the bowl and Sergeant Torbin, and cantered through the village to the yard of the Drill Hall where the Chesterford bus was waiting.

It was a typical, dead, East Anglian bus stop on the edge of the North Sea marshes. The bus was not lit up, and there was no sign of the driver. The colonel swore it was a disgrace and that Sergeant Torbin would never catch his train at Chesterford.

"What time does it go?" Bill asked.

"I don't know. But you might very easily miss it. It's a damned shame! Here's a gallant ally trusting conscientously to the Chesterford Corporaton to get him to camp before midnight, and he lands in the guardroom because their bloody buses can't run to time! I've a good mind to teach them a lesson. Anyone want to go to Chesterford?"

About half a dozen of them agreed that it would be a reasonable act of protest to run the bus themselves, whether they wanted to go to Chesterford or not.

Wagstaff opened the driver's door and switched on all the lights. Bill was fresh from a lecture in which he had been told to behave in England with the formality of the English. He decided that he had better be American and hire a car. But the colonel had tossed the bowl onto the driving seat and was just about to sit on it. Bill rescued it with a quarter of an inch to spare, and found himself on the way to Chesterford.

The colonel was roaring along between the hedges when the auctioneer's clerk leaned forward and tapped Bill on the shoulder.

"Sergeant," he said. "It is 8:45 the bus starts, not 7:45. You had better go back and catch it."

Wagstaff jumped on the brake, and Sergeant Torbin just managed to save the bowl from violent contact with the dashboard. Several of the passengers slid on to the floor, where they continued to sing 'Down Mexico Way' half a bar behind the rest.

"So it is," the colonel exclaimed. "Changed it last week! Well, I'll teach 'em to monkey with the timetable." And he let in the clutch, cursed the gears, found top and put his foot down.

Bill was still wondering whether the auctioneer's clerk was sober or whether his liquor just made him more clerkly, when the man leaned forward again and tapped the colonel.

"Has it occurred to you, sir," he suggested precisely, "that it might be thought you had stolen a corporation bus?"

"We'll get out here, chaps," the colonel said, pulling up so close to the hedge that they couldn't and had to get out by the driver's door—all except the boat-builder's foreman who broke the glass over the emergency exit and managed to make it work. "The Bull is just up the road."

The Bull was a small riverside pub, empty except for two farm hands and a ferryman. It fulfilled, far better than The Greyhound, all Bill's expectations of the quiet English inn.

"Mr. Baker and gentlemen," Wagstaff announced from the head of the procession, "we are celebrating the acquisition of a Greek drinking bowl. Could we allow it to go to America? Never!"

"Say, why not?" Bill asked.

"Because they don't drink wine in America. They drink gin."

Bill was about to say that it was not true, and that works of art were appreciated a darn sight more than . . . but he was too late.

"What's wrong with filling her up with gin?" asked the boat-builder's foreman.

"Neat?" protested Mr. Baker.

"It is indeed long," said the colonel, "since she was accustomed to those heights of felicity where you, Mr. Baker, would be legally bound to refuse to serve us. So slowly, slowly. Gin and tonic. Half and half. Old Greek custom. Always put water with it. Not the men we are today." And he began to sing 'Land of Our Fathers' at the top of his voice.

Mr. Baker had just filled the bowl when Torbin's ear, trained by conversation in the presence of jet engines, heard the bus draw up outside. He shouted the news at Wagstaff.

The colonel sprang into action. "Right, Bill! Our fault! Won't get you mixed up in it!"

He pushed the sergeant on to the window-seat, made him lie down and covered his uniform with a couple of overcoats. When the bus driver, accompanied by a full load of cops from a police car, crashed through the door, he was kneeling at Bill's side and bathing his forehead with gin and tonic out of the bowl.

"Now which of you gentlemen—" a policeman began.

The colonel kept his handkerchief firmly over Bill's mouth and explained in a voice which was the very perfection of quiet respectability that he had bought a priceless Athenian cylix at the late vicar's late niece's auction, and that an American art dealer had endeavoured to steal it from him outside The Greyhound.

Foiled by these gallant citizens and especially by this poor fellow—he tenderly mopped Bill's forehead with gin—the art dealer had made his escape in a corporation bus. They followed, some on foot, some clinging to the vehicle. The bus stopped suddenly just down the road, and the fellow bolted into the darkness before they could get hold of him.

"There was a tall, dark American sergeant in Falkstead this afternoon," said another cop.

They all swore that it wasn't the sergeant. No, a civilian. A little, fairish chap.

"And six of you couldn't stop him?"

"He had a gun," said the boat-builder's foreman, and choked into his handkerchief.

The bus driver, having no official duty to believe unanimous witnesses, went straight to the point which interested him.

"Which of you blokes broke the window above the emergency door?"

"I did" answered the colonel magnificently. "It was an emergency."

Mr. Baker polished glasses and said nothing. The ferryman and two farm hands waited patiently for free drinks. After telephoning a description of the art dealer to county headquarters, the police escorted the bus back to Falkstead.

"Now, Bill," said the colonel, "be reasonable! Whatever is the use of having allies if one can't put the blame on them?"

"Hell!" Bill replied, and accidentally kicked over the bowl which was on the floor at his feet. He picked it up and glared protectively at the lot of them.

"Bill, you have upset these gentlemen's liquor."

Sergeant Torbin was in honour bound to have her filled up again. He discovered that he was delighted to do so, and reminded his conscience that the Athenian potter must have designed his wares to stand up to an evening's amusement.

What with one of them pointing out that the horses at the bottom seemed to trot whenever the tonic water fizzed on to the gin, and another swearing it was possible to hold a full bowl by one handle without spilling any—which it wasn't—the strength of the cylix was certainly astonishing. Mr. Baker put the auctioneer's clerk to bed upstairs—explaining that he didn't want his house to get a bad name by turning him loose on the road—and that left Bill aware that he was the only member of the party with any worry at all in the back of his mind. Not that he hadn't been drinking his share. But in early days at The Greyhound, when the rest of them had been laying a foundation of Burgundy as if it were beer, he was too overcome by his respect for the bowl to commit more than a reverent sip whenever it came round to him.

At 9:30 he suggested that he ought to telephone for a taxi.

"Don't you bother!" the colonel said. "We'll cross the ferry here, and then it's only half a mile to the junction. He'll get a train from there won't he, Mr. Baker?"

Mr. Baker consulted a sheet behind the bar, and said pointedly that if he hurried, he would.

They all piled out on to the landing-stage, and Mr. Baker locked up the bar though there was half an hour to go before closing-time. The ferryman unchained his punt, and twice took Bill and the colonel nearly over to the other side. The first time he turned round in midstream without noticing it, and the second time he had to put back because the boatbuilder's foreman had fallen off the jetty while waving good-bye.

Bill and Colonel Wagstaff landed and set off along the creek-side path in single file—until, that is, Bill noticed that Wagstaff had left the bowl behind in the punt.

"Now, see here, colonel," Bill recommended when they had recovered it, "you let me carry that!"

"OK," said the colonel. "Catch!"

After a quarter of a mile, Wagstaff who was leading, sat down on a tussock of grass and began to laugh. "Bill—Guineas!"

Bill grunted. He had reached the sentimental stage of liquor, and his eyes were dramatically wet as soon as he was reminded that for a dollar and a half and a little courage he could have saved a priceless possession from the inevitable smash.

"Not fair! I knew guineas would fox you. Unsporting to take advantage of an ally. Funny at the time, yes! Bill, I present you with the bowl."

"No colonel, I won't take her."

"Got to take her."

"Say, we've had a lot to drink, and—

"Boy, I was military attaché in Moscow."

"Well, that sure makes a difference, colonel, but—"

It did. By the standards of his experience, Bill could not describe the colonel as drunk. He was merely incalculable.

"Also," said Wagstaff repentantly, "I have used it as a common utensil."

"Not yet," Bill answered. "I guess you would if I wasn't carrying it."

"But from now on it is yours."

"Then you let me pay for it," said Bill, handing the bowl to the colonel and feeling for his wallet.

"Not allowed to pay for it. That's an order from a superior officer. Even in retirement, sergeant, certain privileges attach themselves to—"

"Order my foot!"

"If you won't take it, I'll pitch the bloody thing in the river."

"Go on! You pitch it!"

The colonel did, with a neat back-handed action of the wrist. The cylix flew like a discus into the darkness and landed with a plop on the tidal mud.

Bill Torbin, after one horrified stare at the personified obstinacy of the English, drunk or sober, plunged after it. He squelched out toward the water, while the smell of primeval slime rose from the pits where his legs had been.

The sounds of progress became less violent. There was silence, except for the shunting of a distant train.

"Colonel, I'm stuck," Bill said.

"Nothing to bother about, boy! We're used to it round these parts. Lie on your stomach!"

"I can't. I'm up to my chest."

"Hard under foot?"

"I wouldn't be talking to you if it wasn't."

"Then I'll come and pull you out."

The colonel advanced over his knees and took off his coat. Keeping hold of one sleeve, he swung the other over to Bill. Between cuff and cuff were a good eight feet.

"I think I see her," Bill said. "You pull me clear and then I'll sort of swim."

Wagstaff pulled. The sergeant emerged as far as the thighs, and flung himself forward down the slope. The object was an old white-enamelled basin with a hole in it.

Bill managed to turn, and floundered back like a stranded porpoise until the choice between sinking head first or feet first became urgent. The colonel took a step forward and flung the coat again. He, too, went in up to his chest.

"I guess this mud is covered at high water," Bill said after a pause.

"Float a battleship!" Wagstaff agreed cheerfully. "But there's an hour in the ebb still. Nothing to worry about. Round here everybody knows where everybody is."

"Well, if you say so, colonel."

"If I'm not home when the pubs shut," Wagstaff explained, "my housekeeper will telephone The Greyhound because she was expecting me home to dinner. Mr. Watson will

telephone Mr. Baker. Mr. Baker will telephone the junction. The stationmaster will say we never arrived, and somebody will come and look for us. You'll see. Cold, this mud isn't it?"

The comment struck Sergeant Torbin's mixed drinks as excessively funny. He began to hoot with laughter. The colonel, after two or three staccato explosions like an ancient truck protesting against the starting handle, warmed up and joined the racket at an octave lower.

"But you shouldn't . . . you shouldn't . . ." yelled Torbin, trying to control himself, "you shouldn't have drunk out of her."

"Only pity for her, Bill. Only pity for her. How would you like to spend sev-seventy years on the vicar's mantelpiece remembering Alci-bibi-biades?"

Bill pulled himself together, mourning perfection farther out in the mud. "She was safer there," he said solemnly.

"At the mercy of any passing housemaid. Euphemia, she was called I knew her well. But out of this nettle, safety, we pluck—"

"You've got it wrong."

"Shakespeare, Bill."

"Common heritage, Colonel."

"What I mean to say is that when we pick it up it's yours."

"Can't get at ten guineas. Under the mud."

"Then that's settled. Do you know any songs to pass the time, Bill?"

"If I had my ukulele—"

"I'll do that bit," said the colonel, "if you don't mind it being a banjo."

Bill's repertoire was good for an hour and a half.

"I could do with a drink," Wagstaff said, giving a final plunk to his imaginary strings.

"That search party is sure taking a long time, colonel."

"Must have slipped up somewhere. You'd have thought they would have heard us."

"Your turn now."

"I was considering that question in the intervals," Wagstaff said. "The trouble is, Bill, that the only songs I can ever remember were acquired during the sheltered life of school and university, and are of such monstrous indecency that even sergeants' sing-songs have been closed to me."

After an hour of the colonel, Bill agreed that the sergeants might be right, and added that he thought the tide was rising.

"Eight hours down, and four hours up," said Wagstaff.

"Not six?"

"Four."

"Hadn't we better try to get out?"

"You can try, Bill."

After ten minutes Bill said: "I guess I'll learn some of those songs of yours, colonel, when I've got my breath back."

"Repeat the words after me, Bill, facing the land."

In competition with each other, they so concentrated upon the job in hand that neither heard the approaching craft until she was three hundred yards away. With the fast tide under her, she was abreast of them before their yells for help met with any response.

"'Old on!" shouted the bridge, "it ain't easy yer know!"

The engine-room telegraph rang. The wash from the propeller slid up the mudbank, as the ship was held steady in the tide. A beam of light glared into their faces.

The captain certainly knew his channel well. Going gently astern, he edged into the bank until the bows towered above them. Prettily riding the crest of a wavelet, right under the forefoot of the ship, was the bowl.

"Look out," Bill shouted. "You'll run her down."

"Never saw there was another of you!" bawled the captain.

The telegraph rang violently. White water swirled at the stern. Their rescuer withdrew, edging out a little into the current, and the tide promptly swung the ship in a quarter circle with the bows as centre. The captain went ahead in a desperate effort to regain steerage way, and there she was, aground fore and aft across the channel.

"Knew that would 'appen," said the captain, addressing them conversationally from the forecastle. "Now where's the lady?"

"No lady," the colonel replied. "She walked home."

"What? And left you there?"

"Must have forgotten."

"Cor! What I'd 'ave said if I'd known there was no lady! Well, catch 'old!"

The rope fell by Wagstaff. The captain, the mate and the one deckhand dragged him, wallowing, through the mud and up the side of the ship.

Sergeant Torbin followed, but left the rope in order to plunge sideways and recover the bowl. By the time the mate had recoiled the line and flung it back, very little sergeant was visible beyond his cap and an outstretched arm.

"What d'yer do that for?" asked the captain, when Bill too was safe on board. "Balmy?"

"It's two thousand years old," Bill explained.

"Like me frying pan," said the mate. "Went up to me waist for that one, I did, fifty-year-old it might be, and they don't make 'em like that no more."

The captain led the way to a small saloon under the bridge. It reeked of fug and decayed vegetables but was gloriously warm.

"You take them things off, and Bert will 'ang 'em in the engine-room," he said.

"Any old clothes will do," the colonel invited, dropping coat and trousers in a solid lump on the floor.

"Ain't got none. Don't keep a change on board, not none of us."

"Blanket will do."

"Don't sleep on board neither."

"What are you?" the colonel asked.

"Chesterford garbage scow. Takes it from the trucks and dumps it overboard at forty fathom, see? Never out at night, we aren't unless we misses a tide like we done yesterday. Bert, give 'em a couple of towels and shovel up them clothes!"

Bill managed to make the towel meet round his waist. The colonel found his wholly inadequate.

"I'll try this," said Wagstaff cheerfully, lifting the bowl from the cabin table and removing the tablecloth. "Show you how they wear 'em in India!"

The cloth had once been red plush, but the pile was smooth with age and grease-stains. The colonel folded it diagonally, passed two corners through his legs, knotted the tassels and beamed on the captain.

"Well, I suppose" said the captain grudgingly, "that you'd both better 'ave a drop of rum, though it don't look to me as if it was so long since the last one." He unlocked a first aid cabinet and produced a bottle.

"I admit with pride that we have been celebrating the acquisition of a priceless antique," the colonel answered.

"This 'ere?"

"That there."

"Sort of basin, like?"

"An old Greek drinking bowl, captain."

"How's it used."

"It was *not* used," the sergeant shouted. "They kept it to look at. On the mantelpiece."

"Nonsense, Bill! They didn't have mantelpieces. I'll show you, captain. A slave took the jug, so!"—the colonel seized the bottle of rum—"and emptied it into the bowl, so!"

"Hey!" the skipper protested.

"And then it went round like a loving cup."

Wagstaff took a sip and with both hands passed the bowl courteously to the captain, who could only drink and pass it on to Bill. Bill despairingly lowered the level by a quarter of an inch, gasped and passed it to the mate—the mate to Bert.

"Good navy rum, that!" said the colonel, starting the bowl on its round again.

"Got to stay where we are for the time being," the mate agreed. "Bert, you take them clothes away like the skipper ordered, and then you can 'ave a lie-down."

With the memory of the rising tide safely behind him, Bill felt that there was some excuse for the theory that an object should be used as its maker intended. Half an hour later, inspired by his towel, he was showing them a dance he had learned in the South Pacific when he began to think the saloon was going around.

It was. The stern of the garbage scow, gently lifted from the mud, swung across river with increasing speed and thudded into the opposite bank. Bill made a dive for the bowl as it slid across the table and landed in the captain's lap.

"Knew it would 'appen!" the skipper yelled. "That's the last time I picks a Yank out of the mud!"

He jammed in the doorway with the mate. The bows came off the mud and described the same semi-circle as the stern. The engine-room telegraph rang like a fire engine. Wagstaff, flung off the settee on to the floor, sat there cross-legged shaking with laughter. Bill cradled the bowl grimly on his knees.

"Allies, Bill, allies! What did I tell you? It's all your fault, and your towel has come off!"

"Colonel," said Bill, reknotting it round his waist, "how come all the guys that tried to shoot you missed?" He dropped his head on the table, and instantly fell asleep.

They were awakened by Bert, flinging down two still soggy bundles of clothes. "Skipper say 'e don't want no more to do with either of you," he announced, "and if you ain't off this scow as soon as we ties up he'll send for the police."

It was light. Up the reach the town, the castle and the municipal rubbish dump of Chesterford were in sight. The clock on the church tower made the time eight-thirty.

"Bill," said Wagstaff, breaking the silence, "that piece of linen in which you have wrapped the bowl was once my shirt."

"Say colonel, I'm sorry. I wasn't thinking."

"Not a word. It will dry there. And I can do up my coat collar. Thank heaven I am known in Chesterford!"

Bill took the remark on trust, through it seemed to him when he was escorted by the mate through the corrugated iron door of the garbage wharf, before breakfast and looking as if he had been dug out of the tip, that personally he would prefer a town where he was not known.

Striding up the main street of Chesterford, however, alongside the colonel, he understood. Wagstaff's air was guiltless, so full indeed of a casual manliness as he greeted an occasional acquaintance that only one of them thought it proper to comment on his appearance.

"Showing our friend here some sport," said the colonel. "Mallard right. Teal left. Got 'em both. Lost me balance. And this gallant fellow hauled me out."

As they resumed their squelching progress up the High Street, Bill remarked that he sounded exactly like a British colonel on the movies.

"A very useful accomplishment," Wagstaff agreed, "which has enabled me before now to rescue allies from well deserved court martial. Later in the day which is now upon us, Bill, or even tomorrow or whenever that damned bowl permits us both a reasonably sober countenance, I shall accompany you to your commanding officer and obtain for you a mention in your home town paper and probably a medal from the Royal Humane Society."

"What's that?"

"It gives medals. Did you not leap into mud of unknown bottom to rescue me?"

"Don't mention it, colonel. It was the least I could do," said Bill, and paused. "Say, wasn't it the bowl?"

"The values are quite irrelevant, Bill. Me or the bowl? The bowl or me? We will now go into the Red Lion here for a bath and breakfast."

"Will the bar be open yet, colonel?"

"Oh, that'll be all right. They know me there."

"Then I'm not going in with this bowl," Bill said firmly. "Not to the Red Lion or any other of your animal friends."

"Fresh herrings, Bill. I can smell 'em. And bacon and eggs to follow."

"We can have breakfast at a tea shop."

"Too respectable. They wouldn't let us in."

Sergeant Torbin, desperately searching the market square for safety, was inspired by the opening of the double doors of the Chesterford Museum. He ran, vaulted the turnstile in the vestibule where the doorkeeper was just changing into his uniform coat, and charged down an alley of Roman tombstones into a collection of stuffed foxes and weasels marked "Natural History." Hesitating wildly between "Neolithic," "Iron Age" and "Gentlemen," he saw a door to his left with CURATOR on it. He leaped through it, and found himself facing a desk where a very tall wisp of a man in his seventies was quietly cataloguing.

"You take this," he said. "Lock it up in your safe quick!"

Before the Curator could get over the shock of an American sergeant, covered with mud from head to foot and offering with out-stretched arms an unknown object wrapped in dirty linen, Wagstaff also was upon him.

"Is it—is it a baby?" the curator asked.

"It is, sir, a fifth-century Attic cylix," the colonel replied with dignity.

The curator, tremblingly extracted the bowl, and at the sight of it instantly recovered an almost ecclesiastical self-possession.

"But this is an article of great value," he intoned.

"I know it is. You've no idea of the trouble I've had preserving it from destruction."

"This-um-er-has dispossessed you of it?"

"Lord, no! It's his."

"Colonel, it is yours," said Bill with what he hoped was finality.

The colonel took the bowl with both hands, pledged an imaginary draught to the gods and held it high above the stone floor of the curator's office.

"I've nowhere to keep it," Bill screamed.

"Oh, that's all that is bothering you, is it?" the colonel exclaimed. "Well, what's that damned owl doing?"

A stuffed barn owl in a Victorian show case stood on the curator's work-bench. Wagstaff lifted the glass dome from the ebony base, and removed the owl which immediately disintegrated into dust and feathers.

"Mouldy," said the colonel. "Disgrace to the museum. That reminds me, I believe I'm on the committee. Give you a new one and stuff it myself."

"I was indeed considering—" the curator began.

"Of course you were. Quite right! Mind if I sit down at your desk a minute?"

The colonel printed a neat card:

LENT TO THE MUSEUM BY COURTESY OF
SERGEANT WILLIAM TORBIN, USAF

He laid the bowl upon the ebony stand and propped the card up against it.

"That will keep *you* quiet," he said, replacing the glass dome, "until Bill has a mantel-piece for you again. The sergeant has only to write to you to get it, I suppose?" he added fiercely to the curator.

"Yes, yes, but—"

"Any objection to the Red Lion now, Bill? It will be a pleasant change to drink out of glasses once more."

Legends of Ahimsa

Daniel Rhodes

In the foothills above Lake Pancil, and a few minutes' walk from the village of Karuna, was the pottery known as Ahimsa.

The pottery had been there as long as anyone could remember. Its workshop, kiln, shed, dwelling and storage buildings were nestled under the trees and almost invisible until one approached closely. When the kiln was firing, the steady rise of white smoke could be seen from the village.

The master potter, a quiet man with broad shoulders and a kindly face, was seen from time to time in the village trading his pots for goods at the market. He was a respected member of the community, but his retiring manner and the rather distant relationship between Ahimsa and the rest of the village gave rise to much gossip. The two apprentices, Joco and Boso, were looked upon with some suspicion.

"Those two are so dirty! Their trousers are always caked with clay."

"They say that the apprentices do all the work and that the master never goes near the wheel himself."

"They say he imitates the potters at Lamasa, and never originated any forms or colors himself."

"Why do they fire the kiln at night?"

"Someone who was over there recently said the clay smells like rotting cabbages."

"They say his pots are famous and fetch very high prices in the city."

"Impossible! We are using two of his pieces for pickling jars."

The Master worked nearly every day at his wheel, and the apprentices became used to the steady flow of strong, full shapes which at the end of the day stood in impressive rows on the rack. But one day, the pots seemed stronger and more beautiful than usual. The apprentices stopped their work and watched him in awe.

"Master, is that some special new clay you are using? It is a different color than our regular clay."

"Yes, I got this clay from my friend at Lamasa. It is a discarded batch—pots made from it crack in the fire."

The Master returned from the city where he had gone to sell his pots. The sale had been a great success. In fact, all but one of the pots were sold. The Master tossed the unsold pot carelessly under the table without comment.

But the next morning the apprentices were surprised to see the left over pot placed on the shelf above the wheels where special pieces were kept for study and emulation.

"Look," said the Master. "Look well at this pot. Study the subtlety of its surface and the energy of its form. Penetrate its mystery. It is our new standard."

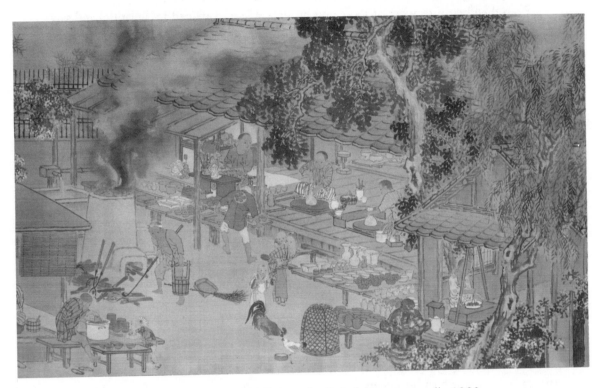

35. "The Pottery Yard," from the Rokubei pottery scroll, 1882.

The pottery received a large order from an important client. Everyone knew that the reputation of Ahimsa was dependent on the successful completion of this group of pots. The Master and his two apprentices went to work with great energy and determination. They wedged up the oldest clay, greased the wheels. All day long and for several days they threw and trimmed. The Master worked on the more important forms and he directed, criticized, and cajoled the others as they worked. At last all was finished and ready for the fire.

But the next day when the apprentices entered the shop they were astonished to see that there were no pots on the racks. At first they thought the Master had set the kiln during the night, but it was empty. Then in the slaking pit they saw their efforts melting into the slime; every pot had been discarded. Some lids and handles could still be seen above the wet surface.

The Master entered the shop rubbing his hands. He put on his apron.

"The warm up is finished," he said. "Now we begin."

Of the two apprentices, Boso was the most skilled, the most expert thrower. His pots were always straight, symmetrical, and perfectly formed. He had received much praise and

encouragement from the Master. But gradually the favorable comments become more infrequent.

One day, the Master stopped at Boso's wheel.

"Your pots are too straight and perfect," he said.

"How can I change them?" asked Boso.

"Stop trying so hard! Relax! Let the clay do what it wants to do."

Boso then began to work at loosening his style. He encouraged irregularities and saw to it that each piece had something a little out-of-round or off center. He was sure that he was making progress, but for a long time there was no comment from the Master. But finally the Master stopped again at Boso's wheel.

"Your pots are too crooked, too eccentric," he said.

"But how shall I change them now?" asked Boso.

"Stop trying so hard! Relax! Let the clay do what it wants to do."

The apprentice Joco was of a philosophical turn of mind. He had pondered on a problem for a long time, and finally mentioned it to the Master.

"Master, how can the two characteristics of clay be reconciled in a pot? Clay when plastic is soft, slippery, and easily manipulated. But when fired it is hard, brittle, and rock-like."

The Master answered, "A state of unity must be obtained by doing away with the two polar and contradictory states. Remember that *saja* is always realized by transcending the dualities. One must realize a synthesis between notions of formal existence and the unformed. *Yoni* and *lingam* must become as one."

"I don't understand," said Joco.

"Get back to your wheel! Stop mulling!"

Joco was making saggers. Such tiresome work; the shape was just a cylinder, and the clay was so coarse it hurt his fingers.

The Master usually reserved criticism until the end of the day, but today he kept interrupting.

"Make them a little higher. Thicken up the edge. Clean up that sloppy bottom! Don't let the form belly out! Too thin! How can we set pots on that rough bottom? Watch the texture!"

Joco became really exasperated. These were only saggers!

He burst out, "Why are you so particular about the shape of these saggers? We don't sell them, and no one ever sees them!"

"That's just it," said the Master. "The pots are sold and gotten rid of. But these saggers—we have to handle them, look at them, and live with them for months or even years."

The Master seldom reminisced, but one day Boso asked him how he had acquired the ability to make pots so filled with energy and life. He replied by telling a story.

"When I was a young apprentice, I struggled at the wheel, like everyone else. I made good progress, but I was always dissatisfied, and sometimes discouraged. My pots seemed good to me while they were still on the wheel, moist, soft, and glistening. But later, when they began to dry—awful! And after the fire, worse still!

"My master, knowing that I was discouraged, offered suggestions, advice, and encouragement, but nothing seemed to help.

"Finally, to my surprise, he ordered me to stand on the wheel head. He then began coiling thick ropes of clay around my feet. Then he coiled around my ankles, my legs, and then my body and my neck. I was covered with coils of clay! I stood on the wheel transformed. I was the space within the pot! Then he took a paddle, and as the wheel slowly turned he beat the coils against my legs and body, shouting, 'foot, foot (smack), belly! belly! (smack) shoulder! shoulder! (smack) neck! neck!'

"After that day, my pots changed."

The Master had apparently gone mad. He was glazing pots for the kiln, but instead of the usually orderly process of stirring, dipping, decorating, chaos took over. The Master mixed different glazes together, coated pots over twice or three times, scraped off parts of the glazed surface, dribbled and splashed glazes, swiped at pots with the studio broom instead of the brush, dusted on clay and sweepings over the glazes, hurled ashes from the kiln into the buckets of glaze, sprinkled salt on the shoulders of jars.

The more he worked, the more bizarre were his methods. But at last, all the pots were glazed and the kiln was set.

"This will be a disaster," said Boso as they sat that night slowly feeding the fire. "We are wasting our time, because the Master has ruined all of these pots with his mad glazing."

But the next day, the Master insisted on a meticulously correct firing, and the kiln advanced to white heat just as usual. After the stoking ceased, the glowing rows of pots could be seen through the spy holes.

When the kiln was opened, the worst fears of the apprentices were confirmed. Pots were stuck to the shelves. Glazes were crawled and cracked. Colors were muddy. Surfaces were crusty and dry, or runny and glassy. It seemed that each pot which was brought out was worse than the last one. The Master threw them one by one onto the dump, where each made that special crashing noise which signifies the death of a pot.

But as they delved deeper into the setting, they reached one large jar, standing at the back of the kiln. A masterpiece! Its color, a mysterious grey green, was luminous and deep. Around the shoulder a band of deeper color encircled the pot, and near the lip the glaze was flecked with minute pinpoints of gold!

The Master studied the pot a long time as it lay on the ground at the kiln door. He took the paper from the prayer stick and put it in his pocket, then carried the pot toward the shop.

"Good firing!" he said.

Joco asked, "Why do we never sign our pots with Ahimsa, the name of the pottery?"

The Master replied, "Those who value our pots recognize them instantly without the aid of a mark. Those who do not value them would not be impressed with a mere signature. Furthermore, those who would imitate us cannot do it by forging a mark. They would have to breathe the same fire into their work as we do, which is impossible."

The Master's former apprentice Soba was visiting. He said, "Master, would it be too much to ask if you would give me the recipe for that green glaze?"

"Of course not," said the Master, and wrote it out for him.

Later, Soba came back. "You remember that green glaze? It looks entirely different when I use it."

"When I gave you the glaze, it became yours. Why do you now complain because it looks like your green glaze instead of mine?"

One day while Boso was out of the shop, the Master slipped one of his own pitchers onto the board holding Boso's morning production of pitchers. Boso returned and began to put handles on the pitchers. But when he came to the pitcher the Master had made, something went wrong. He made several handles, but none of them worked, and each time he cut them off.

"Master," said Boso, "I can't make a handle which looks right on this piece. What is the matter?"

"Throw it into the scrap," said the Master. "There is a least one bad pot in every batch."

Joco was restless, and thought that his skills had reached the point where the Master would grant approval for him to leave and to establish himself as a master potter. But the Master was silent.

Finally Joco broached the subject.

"Do you not think that my training should be coming to an end?" he asked. "I can do each job in the shop perfectly. And my pots fit perfectly into the production here. Some of them have even been mistaken for yours."

"Be patient," said the Master. "Your training is not complete. It may be nearing completion when you are no longer able to make pots which fit perfectly into our production here."

Joco's day did arrive. The Master, with a twinkle in his eye, drew Joco aside and said, "Time for you to leave! I caught myself imitating one of your pots!"

The New Disciple

Janwillem van de Wetering

Master Tofu lives on the eastern slope of Mount Hyee, a little west of the fishing village, Sakamoto, at Lake Biwa, in a cabin at the end of a winding path. The emperor appointed Tofu as a Living National Treasure. That title is given only to true artists who have reached their goals. There's a painter on the northern island of Oshima who's a Living Treasure. He only draws cormorants, on flat stones that he finds on the beach. The emperor acknowledges that the painter understands the essence of the cormorant.

Master Tofu makes vases and teabowls. He uses the local clay and burns twigs under his oven. His tools consist of a few blunt knives and a wheel. He built his cabin himself, and his disciple lives near him in an even smaller cabin. Master and disciple spend months turning pots and then place them in the oven. When the oven is full, the master goes for a walk. He sits on the rocks and watches the blue shine of the large lake down below. He sits in the sunshine or in the cold light of the moon and mumbles or hums. The wild animals pass close by, birds chirp near his ears, a butterfly rests on his hand. Then the master will become quiet himself, and once nothing disturbs him and his soul is as pure as empty space, he will return to the oven and light the fire. The flames roar up and lick at the closely fitted bricks, and the master sits on a stool and waits. When the fire dies and the ashes stop glowing, Tofu will pry open the oven to check whether his vases and bowls have withstood the ordeal. Most of the pots he will break up, but usually a few remain.

Every item that carries his seal is worth a fortune, and Master Tofu will go to the art dealers in town and exchange his creations for bank notes. He looks like a kind old man. His clear eyes glitter between the wrinkles of his funny apple face. He doesn't walk easily and supports his spare little frame on a gnarled stick. When he has collected his money—he twists the notes in tight rolls that he secures with elastic bands—he will walk to the pleasure quarter and start the evening with a bowl of tofu soup. Tofu is a jelly made out of soybeans. It's supposed to be healthy, has little taste, can be bought everywhere, and isn't expensive. Rumor has it that the master was born in a noble family, but he lives like a poor hermit and gave himself that silly name. Perhaps he wants to show his modesty in that way. Except for tofu soup, he usually eats only fruits and the roots of plants that grow around his cabin, but when he's in town, he'll drink rice wine and then wander about the streets where the prostitutes hang out. After a couple of days and nights of partying Tofu goes back to baking pots, walking, and sitting quietly.

Some ten years ago the experts requested the emperor to appoint Tofu as a Living

National Treasure, because the master's art is so pure and simple and contains a touch of ungraspable refinement. The true artist tries to break through the frontiers of human restriction, and Master Tofu must have been successful, for his pots cannot be caught within definitions. It goes without saying that young potters like to learn from him. It seems, however, that Tofu does not want to teach, and hides whenever someone shows up. Only Turu has managed to penetrate Master Tofu's defenses, but he had to camp for weeks near the master's property and wait patiently until the old man finally deigned to show himself.

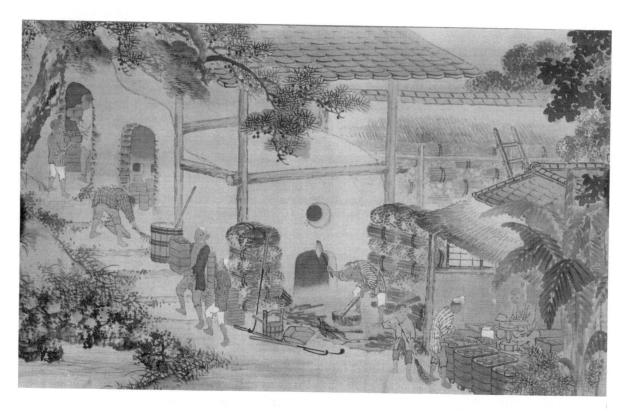

36. "The Kiln," from the Rokubei pottery scroll, 1882.

"What can I teach you?" asked Master Tofu. "Making good pots is ridiculously easy. You take some clay, form a vase or a bowl, put it in the oven, and wait until the fire is done. That's all there is to my simple craft. Don't think; make your hands surround the emptiness. Empty within, empty without. What else is a pot but a line in space? Do you have to bother me to hear what you know already?"

Turu stayed. "You have to pass on your skill so that your knowledge can be shared by whomever comes after you."

"I don't have to do anything," said Tofu, "but if you think that I'm wrong, I'll order you to weed my garden."

Turu did everything the master told him to do. He collected twigs for the oven, did the laundry, swept the floor, carried clay, cooked potfuls of tofu, and tried to imitate the master's ways. Turu also made vases and bowls and put them in the oven. At times his pots looked a little better than at other times, but they never in any way resembled what Tofu was doing.

"No, no," Tofu said. "You've got to quit thinking. Allow the shape to come out by itself."

"Yes, but," Turu said.

"Yes, but," Tofu said, and broke all Turu's vases and bowls with his stick.

Turu bowed angrily and walked to the city, but came back the next day. He tugged on the master's sleeve. "What now?" asked Tofu.

"We've got to leave here," said Turu.

Master Tofu sighed.

"I do know," Turu said, "that you never have to do anything at all, but this time the obligation will save your own existence. If our very lives are threatened, do you think we should defend ourselves?"

"Are our lives being threatened?" Master Tofu asked.

Turu lit a cigarette and bent his head to the side. "Yes. Don't you know that we now have neighbors?"

"I do," Tofu said. "Two strapping young fellows. They built a cabin on the other side of the brook."

"I met them," Turu said. "Just now, on the path. I know who they are. They are no good."

"Who is good?" Tofu asked.

"Not me," Turu said. "That's what you're always saying. I do everything wrong, in the wrong way. But our new neighbors do everything wrong in just the right way. They're terrorists from the capital."

Master Tofu kept quiet.

"Listen," said Turu. "You have no idea of what goes on in the world. They're against the existing order and want to destroy civilization, so that a new society can arise from the ruins. They blow up trains and kill ministers of state. They're afraid of nobody and nothing. There are all sorts of terrorists, and the most terrible are disciplined intellectuals. I think that these two belong to the worst kind."

"Exceptional people?" asked Master Tofu. "I hope you're right. Muddlers I know aplenty. I believe I'm a terrorist myself, of the very worst kind, but unfortunately, I have neither time nor inclination to cause any trouble."

Turu closed his eyes and shook his head. "These fellows are werewolves who'll do all the evil they can envision. We've got to leave at once. I'm not even sure that it's not too late already. Their photographs are on the front page of the *Kyoto Times*. I recognized them at once, and I'm sure they noticed."

"So what?" asked Tofu.

Turu began to sweat. "Have you gone crazy, Master Tofu? Am I really addressing a senile old codger? They asked me whether you happened to be the famous Living National Treasure. Everybody knows that you're stashing a fair supply of cash. Please think of a plan so that we can escape. We're almost out of time."

"Bah," said Master Tofu, and lit a cigarette, too. He blew the smoke into Turu's face. "Turu," said Master Tofu, "you behave like a fool. I can't teach you anything. For years you've been scurrying around my feet, but your head is filled with clay, and I can't get it out for you. Maybe you learned something here, but you won't notice until you've broken away from me. You have to understand your own wisdom, which is no different from my own. You've got to go."

"Where can I go?" asked Turu. "They'll wait for me and cut me down. They have binoculars and are watching us right now."

"I'll distract their attention," said Master Tofu. "In the meantime, you'll sneak out of the rear window and crawl through the bushes, climb the mountain, and make your escape down the western slope."

"Yes, but," said Turu.

Master Tofu picked up his stick.

"What difference does it make," asked Turu, "whether I'm murdered on the eastern path or break my neck falling off the western cliffs?"

"If you stay here, I'll crack your skull," said Master Tofu.

Turu grabbed an axe. "Don't try to fight me, old fool." He trembled with fear and rage.

"Choose," Master Tofu said. "My stick is deadly."

Turu attacked the master. Master Tofu sat on his stool. Turu's axe flashed. The metal protector at the end of Tofu's stick kept warding off the axe's blade. Every flash of the axe coincided with a weep of the stick. The fight went on until Turu came to the end of his strength.

"Well?" asked Tofu.

"I'll go," Turu said.

Tofu went outside and danced on the field outside his cabin. He sang and waved his arms. While Tofu danced, Turu slid through the rear window and crawled through the bush. He reached the forest and sat on a rock. "I have to make a choice," Turu thought. "I can climb the mountain and try to get away via the steep cliffs on the other side, but then I'm almost sure to fall to my death. If I go down this side, the terrorists will see me and cut me off. They're tall and strong, and one is armed with bow and arrows, and the other with a sword. If I go back, Tofu will go for me with his stick. It's time to face the truth. Tofu is no master at all. The terrorists want to rob him. What is that to me? I'll offer them my services, and get a third of the loot."

The more Turu thought about his plan, the better he liked it. Wasn't it true that he had given up everything to become a master's disciple, and had gotten nowhere after years of strenuous labor? Wasn't it equally true that he owed nothing to a society foolish enough to appoint unspectacular potters to the rank of Living National Treasure? "The ignorant people," Turu thought, "have supplied Tofu with a lot of money because they thought that he was a great man. I'll take some of that cash myself, so that I'll be equipped to make a proper beginning."

The two men now living on the land west of Tofu's were called Sakai and Yasudo. They were both honor students of Tokyo University's Department of Philosophy. Sakai had practiced sword-fighting for some ten years, and Yasudo was a formidable exponent of the art of archery. They had become close friends because they both believed in the "opposite direction." "Only Nothing is of value," they were always saying to each other, "and therefore we have to reach that Nothing." Sakai had graduated with an exhaustive study of "The Essence of Duality," and Yasudo was approved by the university's authorities because of his brilliant comments on "The Untruth of Good." The professors who only practiced theory were much surprised when the two young doctors claimed credit for a devastating fire in

downtown Tokyo, the disastrous derailing of one of Japan's famous "bullet trains," and the subsequent brutal murder of a minister of state.

Sakai and Yasudo were now resting on Mount Hyee, the holy mountain that protects the temple city of Kyoto, Japan's spiritual heart. Hyee is also known as the Mountain of Rumination, and its landscape resembles those of ancient paintings—impenetrable forests reach up to razor-sharp cliffs shrouded in lofty mists. There the human spirit sheds all that holds it down and floats over fields covered with fragrant herbs. The thinker learns to listen, like the clever fox whose ears turn around to catch the slightest rustle, in secret meditations that reach for and connect with the empty base of all.

Sakai lowered his field glasses. "Amazing. That old man limps somewhat, but his dance is impressive. One would think that he might try to compensate for his useless leg, but he exaggerates its lameness, so that the defect becomes the theme of what he's trying to express. What do you think he knows?"

"My guess'll be as bad as yours," said Yasudo, "but we're having a visitor, the fellow who scared so easily when we met him on the path today. There he is, under the gnarled pine tree." He picked up an arrow and lifted his bow.

Sakai touched his friend's arm. "Wait a little; maybe his information is of some value."

Sakai concentrated again on Master Tofu, who had just finished his imitation of a wounded rabbit and now became a heron, standing silently on one leg, staring into clear water, beak withdrawn shyly, ready to spear a fish. "Quite an amusing fellow," Sakai said softly. "Now why was it, again, we wanted to kill him?"

"In order to combine the necessary with the pleasurable," Yasudo said. "A Living National Treasure represents the best of our present society. When we do away with him, we'll advertise our effort, and Tofu's stash will enable us to continue our performance."

Turu approached and bowed.

"Hello," said Yasudo. "Formulate as clearly and succinctly as you can what brings you here."

Turu told his tale.

"Right," Sakai said, "from the frying pan into the fire. Tofu tried to teach you the mystery of form, and obviously you failed to grasp his teaching. With us you're worse off, for we teach the art of how to do away with form."

Turu laughed. "I've been well trained in that particular field. Whatever I made was broken by Tofu's stick. I'm ready for revenge."

"Good," Yasudo said. "You say Tofu managed to collect some solid capital? You know him well, and the arrangement at his house must be familiar to you. Go down and make him give up his money, then return and give it all to us."

"That doesn't sound so good," Turu said. "I'll be of use to you, and you'd better be of use to me. Nothing is for free."

"Nothing is for free, indeed," Sakai said. "Wait until dark and then complete your mission. Don't try to get away, for it'll be easy for us to hunt you down."

Yasudo smiled. "Why do you hesitate? Your choices are already made. By coming here, you surrender to our power. Maybe we'll accept you in time, as our comrade, but first you'll have to prove yourself."

"Good evening," Turu said.

Master Tofu woke up.

"Listen," Turu said. "I'm no longer your property, for I've broken my chain. Your stick may have parried an axe, but I'm now carrying a sword. See this magnificent weapon? My new masters stole it from Tokyo's Imperial Museum. It once belonged to Prince Yozo, and was forged by Tokoro. Whoever holds this sword is invincible. If you use your stick, I'll cut off your head."

"My stick is in the corner," Tofu said. "I don't need a stick when I'm asleep."

"Stop chatting," Turu said. "I've come for your money. If you give it to me, I may save your life."

"You don't mind if I don't get up?" Tofu asked. "My money is in that vase."

"I hope you're not joking now," Turu said as he squatted and put the vase on the floor. His right hand held on to the sword as his left hand approached the vase's neck, which was wide at the top.

"Just a mintue now," Tofu said. "I know you're all-powerful since you've become the friend of great spirits, and your sword, which once conquered the country and was made by a master forger, does frighten me a lot. Even so, I do think I should advise you. Are you sure you want to put your hand into the vase? I made it when I was still struggling with my own demons, and it could be that one of them sneaked into it. It's night now, and even demons have to rest. Perhaps he'll be upset when you disturb his sleep."

"For years you have used me as a slave," Turu snarled. "I thought that I could learn from you, without ever realizing that I was being abused. Now shut your trap, for when I lose my temper, you'll surely lose your head."

Turu put his hand in the vase and then pulled it out, yelling with fear and pain. A writhing viper dropped to the floor.

"Simpleton," said Tofu. "Did you really learn that little about forms and shapes? The money was at the bottom of the vase, and because its neck is too narrow below to admit your hand, you should have smashed the vase."

Turu rolled about on the floor. The snake's poisonous teeth had bitten deeply, and Turu's arm was swelling already.

"Help me," begged Turu.

"The poison is fast," Tofu said, "and in your blood, on its way to your heart. The viper is the demon that is born from greed. Each spot on its skin is a golden coin."

"I'm dying," yelled Turu.

"Take a deep breath," said Tofu, "and relax your muscles. It'll stop your fear. To die is an interesting experience, but fearfulness will spoil it for you."

Turu beat the floor with his fists and began to whimper. His eyes bulged, his face turned purple, his jaws cramped open, and spittle dribbled down his chin.

"The clouds keep passing the moon," Yasudo said, "and I can't see what's happening out there, but I do believe that Master Tofu is preparing a burning pile. And now he's dragging a body. He's lifting it onto the branches and lighting the fire. I'm afraid our new disciple has left us already."

"Would *you* like to go now?" Sakai asked.

"Now what?" Master Tofu asked. "If you're after the money, I keep it in that vase. I don't mind if I'm to lose my life, but I detest being woken up all the time."

Yasudo studied the vase. He thought aloud. "The money is in the vase, but if one reaches for it, something unpleasant evidently results. Besides, the vase's neck is too narrow below. In order to get at the money, I'll have to break the vase."

"Splendid," Master Tofu said. "Your logic is impeccable, but my teacher used to say that a little straight thinking does no more than produce a little answer."

"Was your teacher right?" Yasudo asked, while he fitted an arrow to his bow.

"Well," Master Tofu said, "right or wrong, who'll make the ultimate decisions? A little of both, it all depends on how you look at the problem."

"Get up," Yasudo said, "find a hammer, and smash that vase."

"May I warn you?" Tofu asked.

"Please do," Yasudo said. "Although I really never care for advice."

"Go away," Master Tofu said. "That vase contains only money. A lot of it, I do admit, and free to you, but you're still a young man, and it may be better if you make your own."

Yasudo aimed his arrow at Master Tofu's heart. "You're not telling me that I shouldn't steal, I hope. What is possession? What difference can there be between what's yours and mine? I'm ordering you to break that vase."

"As you like," grumbled Master Tofu. "All I'm trying to do is catch some sleep, and everyone barges in as if my humble abode were the Central Railway Station. Why should you involve me in your mistaken routine?"

"Our paths cross each other," Yasudo said, "and we'll both have to accept the consequences of this meeting. Are you about to do as I say, or do I have to release this deadly arrow?"

Master Tofu got up, grabbed a hammer, and smashed the vase. The viper fell out and so did the money. Yasudo tried to watch the viper and Master Tofu at the same time. The viper slid toward Tofu, and Tofu bowed his head. The snake turned in a flash and went for Yasudo. The arrow hit the spot where the viper's head had been half a second ago.

"Ouch," Yasudo said.

"I'm sorry to see that you're now dying," said Master Tofu.

"I didn't pay sufficient attention," Yasudo said. He stretched out on the floorboards, and crossed his hands on his chest. He took a deep breath and closed his eyes. The viper had bitten him on the leg, and the poison rushed up toward his heart. Now look at that, Sakai thought. The performance is about to repeat itself. Master Tofu has plenty of firewood. I'm sure he'll leave enough to dispose of my body when the time comes. Isn't Yasudo burning brightly? Now how could he have lost that unequal battle? He's the best bowman I've ever met. He recognizes the danger of a situation long before a crisis occurs, and there I see his body, consumed by hellish flames.

"Once more?" Master Tofu asked. "Three is a strange number indeed. I have often been successful at the third try. What can I do for you?"

"I'm unarmed," Sakai said. "Your former disciple brought you my sword, but I'm physically stronger than you and excel at karate."

"Are you threatening me?" Tofu asked from his bed.

"I'm not sure yet," Sakai said. "Frankly, I'm not even sure of the purpose of this visit. I've been watching you today. First you danced, then you burned the corpses of your own

disciple and my friend. It seemed to me that you were quite contained in the midst of all activity, even when you were prancing about, showing me some of the aspects of your being."

"You like to chat," Tofu said. "But I prefer to sleep at this time. How about coming to see me in the morning?"

"There's some money on the floor," Sakai said.

Tofu groaned and sat up. "It's all yours, provided you leave my home. That money has been causing trouble all night. I should never have kept it. You know, when I make money, I always get drunk, and once I'm drunk I like to play with the ladies, but there's always more of the stuff than I can possibly spend."

"And there's a snake, too," Sakai said. "He looks unhappy."

"That's because he lived in a vase," Tofu said, "and I smashed his home."

"Why do you call yourself Tofu?" Sakai asked. "Hermits go for fancy names. Master Cranebird, for instance, or Master Unicorn. Tofu is a colorless jelly that never hardens, it just becomes somewhat spongy. Are you colorless and spongy?"

"Yes," Tofu said. "Would you please take the money and leave me alone?"

Sakai shook his head. He got up, found a vase, and inserted the money. He put the vase in front of the viper. The viper slid into its neck. Sakai placed the vase on a shelf, found a broom, and swept the shards into a neat little heap.

"Will you be leaving now?" Tofu asked.

"No," said Sakai. "Will you take me as your disciple?"

Tofu kept quiet. Sakai continued sweeping.

"You walked the wrong way," Tofu said, "but never mind; it hardly matters how we define what has been brought about. The suffering that you caused will have to be put right sometime, however."

"As you say," Sakai said.

"And there's nothing I can teach you; all that the mind needs to grasp is already present within the mind."

"That I haven't grasped yet," Sakai said.

Tofu sighed. "You'll find some bedding in that cupboard over there. Let's go to sleep. Tomorrow you have to weed the vegetable garden."

Sohni and Mahinwal: A Gujrati Potter's Legend

Owen S. Rye and Ahmed Din

The potters of Gujrat make a fine *piala*, drinking bowl, in the same style as has been made for many hundreds of years. It is known as "Sohni's bowl," after Sohni of the old legend of Sohni and Mahinwal. Sohni was thin and fragile, like the bowl, and beautiful. Her father was a potter, and he was the first man to make bowls like this. He must have been a very good potter because today only the very best potters can make these bowls.

Mirza Izad Beg was a prince, who was related to the royal Mughal family of Delhi. Like the other Mughals, he used to holiday in Kashmir in summer because the hills of Kashmir were cooler than the plains of Delhi. From Kashmir one summer he decided to return to Delhi by way of Lahore. On the way to Lahore he stopped at Gujrat, where he heard of the very fine bowls made by one of the Gujrati potters. He decided to buy some of these bowls to take with him.

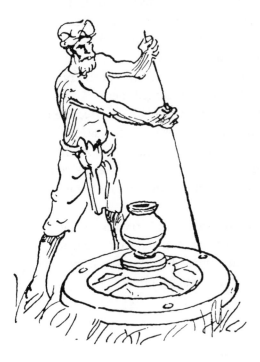

37. "Indian Wheel," *from* A Potter's Book *by Bernard Leach, 1940.*

When he went to the potter's shop to buy the bowls he saw Sohni, who used to sit in the potter's shop. He was so awed by her that he wanted to see her again, so he bought some bowls and went away to plan how he could speak to her. No one knew his true identity, so his plan was simple. The next day he went back to the potter's shop, and said that he was so impressed by the fine bowls that he wanted to learn how to make them and to become an apprentice to the potter. The potter had no idea that his visitor was a prince. The previous day his clothes had been dusty from travel, and this day he wore peasant's clothing. So the potter listened sympathetically; but he was jealous of his skills and would not teach them to anyone. Instead, he offered the visitor a job as a cowboy, tending the potter's buffalos. The prince accepted, but before he left the shop he made it clear to Sohni that she, and not the work, was the reason for his visit.

The prince became a tender of buffalos, a *mahinwal*. His plan had worked, because Sohni had been sufficiently intrigued that she wanted to meet the stranger. This seemed impossible becasue the buffalo were kept on the other side of the Chenab River, which flowed much closer to Gujrat than it does now. She devised a plan of her own. One night she waited until after dark and took a large pot out of the shop. She carried it down to the river and, by turning it upside down, she was able to use it as a float and cross the river. This way she had her first meeting with Mahinwal, and in the same way they met many more times.

Inevitably, the potter found that they had been meeting, and forbade Mahinwal to see her again, and told him that his job was finished. But as the potter had not discovered how or where they met, Sohni was occasionally able to cross the river in secrecy. Eventually the potter heard that they were still meeting and was furious; even more so when he learned that Sohni had not only been meeting Mahinwal but had been taking food from the potter's own house to keep Mahinwal alive. The potter went out and arranged a marriage for Sohni, and very soon she was married to another man.

This was not enough to stop her meeting with Mahinwal. She still went out at night, when she could, and crossed the river using the pot which she had hidden behind a bush near the river.

Finally the family of Sohni's husband became suspicious at her behavior and decided to watch her at all times. One night the husband's sister saw Sohni leaving the house, followed her to the river, and learned the secret of the river crossing. The sister determined to revenge her brother for Sohni's behavior. When Sohni was busy at work the sister went to the potter's shop and took an unfired water pot from a pile that had been left out to dry. She took it to the river, to where the other pot was hidden, and exchanged them.

That night Sohni again left the house and went to the river in the darkness. Because of her haste and the darkness she did not realize that the pot had been changed. She waded into the Chenab, turned the pot upside down, and began to float and swim across. As the pot became soaked with water the unfired clay disintegrated in her hands. Because she could not swim without the pot she screamed; and because she could not swim without the pot she drowned.

Mahinwal, waiting on the other side of the river, heard her scream. Heedless of the fact that he could not swim himself he dived into the river to save her; and so it was that both lovers drowned in the waters of the Chenab. Thus, in Gujrat today, the best potters make the fine bowls in memory of the beautiful Sohni and her Mughal prince.

The Potter's Hands

George Demetrios

That co-ordination between hands, feet, and desire, so vital to a potter, was acquired by Spanos since childhood.

His father had also been a potter; in fact, from time immemorial his folks must have been potters. No one changed much his trade in the villages; a baker's son was automatically a baker, a farmer's, a farmer.

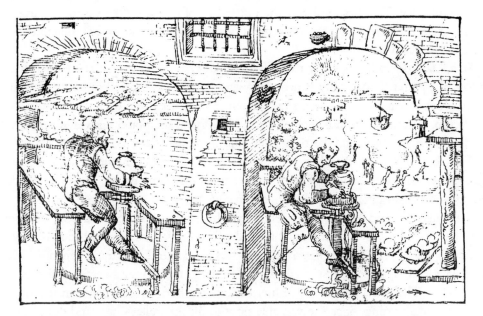

38. "Trimming," from The Three Books of the Potter's Art
by Cipriano Piccolpasso, 1557.

Spanos, the potter, got his name and surname from generations of not very hairy men—the word "Spanos" meaning hairless.

His pottery and kiln were near a brook and mill, where the miller, Demos, between two large round stones, ground the wheat, barley, corn, and oats of his villagers.

They were inseparable friends. The miller would stand by the hour watching the potter's hands on the wheel. Spanos would turn pots for drinking water, jars for jam, plates, cups, and saucers. . . .

Now and then the miller was thrilled by some shapes like vases that the potter created, considered very queer, useless, and unorthodox by their villagers. The miller knew instinctively when these shapes would appear. The potter, during these rare moments, would invariably be silent, with a far-off look in his eyes and a menacing concentration. Then suddenly an animation and a great élan would seize his friend. He would slam a round lump of clay on top and centre of his potter's wheel, his right foot kicking below. With hands wet with slip and eyes closed, he would shape from this common clay a cylindrical cone, and from this cone, a shape that enraptured the miller's soul.

The potter, however, was never satisfied, claiming to his friend that he had not as yet mastered the necessary articulation to convey to these forms the divine inspirations he felt.

At the insistence of the miller, a few of these nontraditional shapes were fired, glazed, and divided between the two.

The miller would try his luck now and then with the pottery wheel. His hands, being large and clumsy from lifting those heavy bags when he dumped the wheat or corn in the chute above his millstones, would press the clay too hard, his foot could never co-ordinate with his calloused hands, and he could never mount the clay on a balanced cone, which is the source and beginning of any pot. His cone would just tumble over.

He admired inwardly the potter's hands, the delicate, tapering, long fingers that caressed the wet clay. That beautiful way the potter had of letting go the tips of his fingers, just at the right moment, to let the movement of the wheel partake and complete the circular, cylindrical vases.

"Ah," said the miller one day to his friend, "lucky is the girl that marries such hands, such touch, a potter. Look at my hands—they are just paws compared to yours, they are made to lift. You can press and feel. I just lift and dump. If I could only be a potter. I am tired of corn, wheat, barley, oats, flour—flour." His friend the potter answered him that without flour everyone would die of hunger, but the miller was sad.

They both got married and, being very poor and such good friends, had their weddings together, the same Sunday. The priest was there, the same people came for the double wedding, and the dreadful expenses were cut in two.

The miller married the teacher, a delicate girl he had loved since childhood. The potter married a very husky, rosy farmer's daughter, taller than himself, one he had adored for years.

About ten years after their marriage there was an extraordinary transformation. The potter's wife, although still robust, walked very tenderly, spoke very sweetly, and dressed in dainty clothes. The miller's wife, the former delicate teacher, was rosy, was on the fat side, and was decidedly strong, since she was able now to lift the miller's bags and dump them in the chute above the round millstones.

This transformation was brought to the miller's notice one evening after dinner, at the potter's house, when his wife jokingly lifted him way up, to demonstrate her strength. The miller was amazed. The potter looked in astonishment and admiration, also, and unconsciously he gave a scrutinizing look in the direction of his wife.

For the first time, it seems, they had both remarked how their wives had changed, for the potter's wife seemed so delicate now, and the miller's so strong and rosy.

All laughed and joked about it except the miller, who was pensive and silent. He finally said to the three in a very sad voice, "Lucky is the girl who marries a potter. I know, it was the hands."

From the Journal of a Leper

John Updike

Oct. 31. I have long been a potter, a bachelor, and a leper. Leprosy is not exactly what I have, but what in the Bible is called leprosy (see Leviticus 13, Exodus 4:6, Luke 5:12-13) was probably this thing, which has a twisty Greek name it pains me to write. The form of the disease is as follows: spots, plaques, and avalanches of excess skin, manufactured by the dermis through some trifling but persistent error in its metabolic instructions, expand and slowly migrate across the body like lichen on a tombstone. I am silvery, scaly. Puddles of flakes form wherever I rest my flesh. Each morning, I vacuum my bed. My torture is skin deep: there is no pain, not even itching; we lepers live a long time, and are ironically healthy in other respects. Lusty, though we are loathsome to love. Keen-sighted, though we hate to look upon ourselves. The name of the disease, spiritually speaking, is Humiliation.

I have come back from Copley Square, to this basement where I pot. Himmelfahrer was here this morning, and praised my work, touching the glazes and rims in a bliss erotic and financial both. He is my retailer, my link with the world, my nurturing umbilicus. Thanks to him I can crouch unseen in clayey, kiln-lit dimness. His shop is on Newbury Street. Everything there is beautiful, expensive, blemishless; but nothing more so than my ceramics. If the merest pimple of a captured dust mote reveal itself to my caress, I smash the bowl. The vaguest wobble in the banding, and damnation and destruction ensue. He calls me a genius. I call myself a leper. I should have been smashed at birth.

Tomorrow begins my cure. I ventured out for lunch to celebrate this, and to deposit Himmelfahrer's mammoth check. Boston was impeccable in the cold October sunlight, glazed and hardened by summer. The blue skin of the proud new Hancock folly rose sheer and unfractured into a sky of the same blue, mirrored. For a time, the building had shed windows as I shed scales, and with more legal reverberation, but it has been cured, they say. I look toward it still, hoping to see some panes missing, its perfection still vulnerable. The strange yellow insect that cleans its windows is at work. In its lower surfaces Trinity Church, a Venetian fantasy composed of two tones of tawny stones, admires itself, undulating. The Square itself, a cruel slab laid upon Back Bay's hearts, is speckled with survivors—the season's last bongo drummer, the last shell-necklace seller, the last saffron frond of Hare Krishna chanters. They glance at me and glance away, pained. My hand and my face mark me. In a month I can wear gloves, but even then my face will shout of disgrace: the livid spots beside my nose, the crumbs in my eyelashes, the scurvy patch skipping along my left cheek, the silver cupped in my ears. A bleary rummy in a flapping overcoat comes up to me

and halts his beggar's snarl, gazing at my visage amazed. I give him a handful of coin none-theless. Light beats on my face mercilessly.

In the shadows of Ken's, I order matzo-ball soup and find it tepid. Still, it is delicious to be out. The waitress is glorious, her arms pure kaolin, her chiselled pout as she scribbles my order a masterpiece of *Sèvres biscuit*. When she bends over, setting my pastrami sandwich before me, I want to hide forever between her cool, perfect, yet flexible breasts. She glances at me and does not know I am a leper. If I bared my arms and chest she would run scream-ing. A few integuments of wool and synthetic fibre save me from her horror; my enroll-ment in humanity is so perilous. No wonder I despise and adore my fellow-men—adore them for their normal human plainness, despise them for not detecting and destroying me. My hands would act as betrayers, but while eating I move them constantly, to blur them. Picking the sandwich up, my right hand freezes; I had forgotten how hideous it was. Usually, when I look down, it is covered with clay. It has two garish spots, one large and one small, and in the same relation to one another as Australia and Tasmania. The woman next to me at the counter, a hag in pancake makeup and mink, glances down with me. Involuntarily, she starts. Her fork clatters to the floor. Deftly I pick it up and place it on the Formica between us, so she does not have to touch me. Even so, she asks for another.

Nov. 1. The doctor whistles when I take off my clothes. "Quite a case." But he is sure I will respond. "We have this type of light now." He is from Australia, oddly, but does not linger over the spots on my hand. "First, a few photographs." The floor of his office, I notice, is sprinkled with flakes. There are other lepers. At last, I am not alone. He squints and squats and clicks and clucks. "Good seventy per cent I would say." He has me turn around, and whistles again, more softly. "Then some blood tests, *pro forma*." He explains the treatment. Internal medication straight from the ancient Egyptians will open me like a flower to lengthening doses of artificial light. His own skin bears the dusty-rose ebb of a summer's tan. His scalp is flawlessly bald and dreamily smooth. I wonder what perversity drove him into dermatology. "When you clear," he says casually, toward the end. When I clear? The concept is staggering. I want to swoon, I want to embrace him, as one embraces, in primitive societies, a madman. On his desk there is a tawdry flesh-pink mug with a tea bag in it, and I inwardly vow to make him a perfect teacup if he makes good his promise. "Nasty turn in the weather today," he offers, buttoning up his camera; but it is a lame and somehow bestial business, polite conversation between two men of whom one is dressed and the other is naked. As I drag my clothes on, a shower of silver falls to the floor. He calls it, professionally, "scales." I call it, inwardly, filth.

I told Carlotta tonight of his casual promise to make me "clear." She says she loves me the way I am. "How *can* you!" I blurt. She shrugs. She was late this evening, having been hours at devotions. It is All Saints' Day. We make love. Stroking her buttocks, I think of the doctor's skull.

Nov. 8. First treatment. The "light box" has six sides lined with vertical tubes. A hexagonal prism, as the Hancock Tower is a rhomboidal prism and a Toblerone chocolate bar is a triangular one. A roaring when it switches on, so one has astronautical sensations; also sensations of absurdity, standing nude as in a "daring" play where the stage lights have consumed the audience. The attendant, a tremulous young man with a diabolically pointed

beard, gave me goggles to protect my retinas; I look down. I am on fire! In this kiln my feet, my legs, my arms, wherever there are scales, glow with a violet-white intensity like nothing but certain moments of film as it develops in a darkroom pan. To make sure the legs are mine, I do a little dance. The Dance of Shiva, his body smeared with ashes, his hair matted and foul. My legs, chalky as logs about to fall into embers, vibrate and swing in the cleansing fire. The dance is short-lived; the first dose is but a minute. The box has a nasty, rebuking snort when it shuts off.

Dressed, stepping out from behind the curtain, I make future arrangements with the attendant and wonder what has led him into work of this sort. Dealing with people like me is a foul business, I am certain.

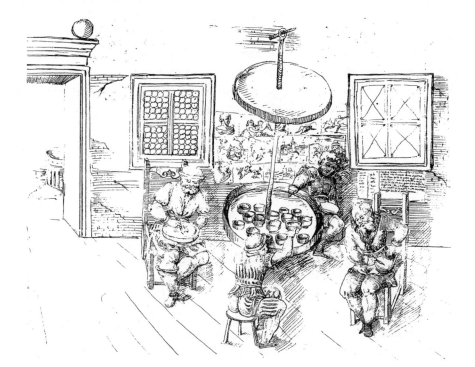

39. "Decorating," *from* The Three Books of the Potter's Art
by Cipriano Piccolpasso, 1557.

Nov. 12. No perceptible change. Carlotta tells me to relax. Dr. Aus (his real name keeps escaping me) says two weeks pass before the first noticeable effects. Himmelfahrer tells me Christmas is coming. I work past midnight on an epic course of vases, rimmed and banded with a very thin slip tinctured with cobalt oxide. The decoration should not strike the appraiser at first glance; he should think first "vase," and then "blue," and then "blue and not-blue." The Chinese knew how to imbue this mystery, this blush in the glaze, this plenitude of nothingness. I scorn incision, sgraffito, wax resist, relief. Smoothness is the essence, the fingers must not be perturbed. The wheel turns. My hand vanishes up past the wrist into the orifice of whistling, whispering clay, confiding the slither of its womb-wall to me, while the previous vase dries.

My dose was two minutes today.

The disease is frightened. Its surface feigns indifference, but deeper it itches with subtle rage, so that I cannot sleep. It has spread across my shoulders, to the insides of my arms, to my fingernails, whitening and warping them with ridges that grow out from beneath the cuticle like buried terrors coming to light.

Nov. 13. I have been taken off the treatment!

A leper among lepers, doubly untouchable.

Aus says my antibody count is sinisterly high. "A few more tests, to be on the safe side." Tells me stories of other lepers—cardiac patients, claustrophobes, arthritics—who had to be excluded. "Don't want to cure the disease and kill the patient." Please do, I beg him. He tut-tuts, his Commonwealth sanity recoiling from our dark American streak. Tells me that like all lepers I have very natually "fallen in love with the lights."

I cannot work, I cannot smile.

I know now the box *exists*, that is the torture. It is there, out there, a magical prism in this city of dungeons and coffins and telephone booths. Boston, that honeycomb of hospitals, has a single hexagon of divine nectar, a decompression chamber admitting me to Paradise, and it is locked. I marvel at, in the long history of trapped mankind, the inability of our thoughts to transport bodies, to remove them cell by cell from the burning attic, the sunk submarine. Mine is the ancient prayer, *Deliver me.* Carlotta says that all her prayers are that I be granted the strength and grace to bear my disappointments. A vapid petition, I narrowly refrain from telling her. Confessionals, lavatories, one-room apartments, tellers' booths—they rattle through my mind like dud machine-gun cartridges. I want to be in my light box.

Nov. 15. Blood tests all morning. The nurse drawing the samples from my veins looms comely as the dawn, solid-muscled as a young puma. She handles my horrible arm without comment. I glance down and imagine that the leprosy on its underside shines less brightly. She chatters over my head to a sister nurse of childish things, of downtown movies and horny interns and TV talk shows, her slender jaw ruminating on a wad of chewing gum. In her forgetfulness of me, as I fill vial after vial, her breasts drift in their starched carapace inches from my nose. I want to suck them, to counteract the outward flow of my blood. Yin and Yang, mutually feeding.

Carlotta, coming tonight to console me, finds me almost excessively manly.

Nov. 18. Last night's dreams. I am skiing on a white slope, beneath a white sky. I look down at my feet and they are also white, and my skis are engulfed by the powder. I am exhilarated. Then the dream transfers me to an interior, a ski hut where the white walls merge into the domed ceiling indistinguishably. There is an Eskimo maiden, muscular, brown, naked. I am dressed like a doctor, but more stiffly, in large white cards. I awaken, immensely ashamed.

In the negative print of this dream, I am sitting on a white bowl and my excrement overflows, unstoppably, unwipable, engulfing my feet, my thighs in patches I try to scrape. I awaken and am relieved to be in bed, between clean sheets. Then I look at my arms in the half-light of dawn and an ineluctable horror sweeps over me. This is real. This skin is me, I can't get out.

Himmelfahrer adores my new vases. He fairly danced with anticipation of his profit,

stroked their surface—matte white and finely crackled à la early T'ang ware—as if touching something holy. I feel his visits indignantly, as invasions of my cave of dimness. I wear gloves at all times now, save when molding the clay. If I could only wear a mask—ski, African, Halloween—my costume would be impregnable.

3 A.M. I was in a dark room. A narrow crack of light marked a doorway. I tiptoed near, seeking escape, and there is no door to open; the light is a long fluorescent tube. I grip it and it is my own phallus.

Nov. 22. Miracle!

Aus called before nine and said the tests appear normal; the first must have been a label error. It showed, he confessed, that I was fatally ill with lupus, and that ultraviolet light was pure poison to me. I am reinstated. Come Thursday and *resume.*

Carlotta brings champagne this evening to celebrate, and I am secretly offended. She does not love me the way I am, apparently. She shyly asks if I want to give thanks and I coldly reply, "To whom?"

Nov. 25. The attendant welcomed me back without enthusiasm or acknowledgment of my hiatus. His face pale as candle tallow above the wispy inverted flame of his beard. I scan the remnant of his face left beardless and detect no trace of leprosy. Also, my fellow-lepers, piled like so many overcoats in the tiny anteroom, waiting for their minutes of light, have perfect skin to my eyes. Most are men: squat, swarthy, ostentatiously dapper types—rug or insurance salesmen, their out-of-season tans bespeaking connections in Florida. There is a youngish woman, too. Her skin is so deeply brown her lips look pale by contrast. She sits primly, as before confession. Her plump throat, her tapered fingers, and round wrists betray a sumptuous body—the brown vision of my Eskimo maiden, adipose to withstand the embrace of ice. I follow her in with my eyes, see her feet step out of their shoes beneath the white curtain, and then be disengaged by a naked hand from the silken tangle of fallen tights. Desire fills me. I take my own turn, in an adjacent box, with some impatience, as something my due, like breathing, like walking on unbroken legs. My time is two minutes—where I left off. It seems longer. I fall to counting the tubes, and notice that one is burnt out. I discover, touching it to effect a repair, that all the tubes are touchable, they are not the skin of the sun. I tell the attendant of the malfunctioning tube, and he nods bleakly.

And walking home, through the twilight that comes earlier and earlier, I look up and see that a pane has fallen from my beloved, vexed Hancock Tower. It wasn't in the newspapers.

And Himmelfahrer, his rather abrasive voice close to tears, calls to cry that two of the vases have turned up cracked in his storeroom. In the mood of benevolence that the renewal of my treatment has imbued me with, I volunteer that the flaw may have been in my firing, and we agree to share the loss. He is grateful.

Dec. 7. I am up to eight minutes. Carlotta says that my skin feels different. She confesses that my bumps had become a pattern in her mind, that my shoulders had felt as dry and ragged to her fingers as unplaned lumber, that she had had to steel herself to touch me ardently, fearful that I would hurt. It had startled her, she says, to wake up in the morning and find herself dusted with my flakes. She confides all this lightly, uncomplainingly, but her tone of relaxation implies that a trial for her is past. I had dared

dream that I was beautiful, if not in her eyes and to her touch, then in her heart, in the glowing heart of her love. But even there, I see now, I was a leper, loved in one of those acts of inner surmounting that are the pride and the insufferable vanity of the female race. Drunk on wine; I had an urge to pollute her, and I glazed her breasts with an *engobe* of honey, peanut butter, and California Chablis.

In the mirror I see little visible change—just a grudging sort of darkening in those isthmuses of normal skin between the continental daubs of silver and scarlet. The cure is quackery. I am a slave of quackery and crockery. And lechery. I long to see again the lovely female leper, whose ankles, as I remember my glimpse beneath the curtain, bore a feathery hint of scaliness. Papagena. We are all dreadful, but how worse to be a woman, when men have so little capacity for inner surmounting. Yet how correspondingly grateful and ardent to be touched. Yet Papagena is never at the clinic. If there is any pattern in their appointments, it is that no leper see another more than once.

In the corridors, though, we see cripples and comatose postoperatics being wheeled from the elevator, the dwarfed and the maimed, the drugged and the baffled, the sick and the relatives of the sick, bearing flowers and complaints. The visitors bring into the halls chill whiffs of the city, and a snuffly air of having been wronged, they merge indistinguishable with the sick, and altogether these crowds, lifted by the random hand of misfortune from the streets, make in these overburdened halls a metropolis of their own. A strange, medieval effect of *thronging*. Of Judgment Day and of humanity posing for the panoramic camera disaster carries. Monstrous moving clumps of faces—granular, asymmetrical, earthen.

Dec. 12. Small bowls on the little wheel all week, and some commissioned eggshell cups and saucers. The handles no thicker than a grape tendril. Stacking the kiln a tricky, teetery business. The bisque firing on Tuesday, and then the glaze; feldspar and kaolin for body, frits and colemanite for flux, seven-per-cent zircopax for semiopacity, a touch of nickel oxide for the aloof, timeless gray I visualize. Kiln up to 2250°, Cone No. 6 doffed its tip in the peephole, Cone 5 melted on its side, Cone 7 up-right, an impervious soldier at attention in Hell. Turned kiln off at midnight. Eyes smarting, dots dancing. Nicest time to sleep, while kiln cools, the stoneware tucked safe into its fixed extremity of hardness.

In the morning, the gray a touch more urgent, less aloof than I had hoped. Two rims crystallized. Smashed these, then five more of the twenty, favoring the palest. Held the eighth in my mind, remembering my impulse to give a teacup to Dr. Aus. He has kept his promise. The mirror notices a difference, so does Carlotta. I find something crass lately in her needs, her bestowals, her observations. She says my tan is exciting, on my bottom as well, like a man in a blue movie. We used to go to blue movies, the darkest theatres, to hide me; I would marvel at all the unleprous skin.

A strange recurring fantasy: when we spend the night together her skin and mine will melt together, like the glazes of two pots set too close together in the kiln.

Dec. 13. St. Lucy's Day. The saint of dim-sightedness, of the winter dark, Carlotta tells me. My stomach feels queasy—perhaps the mystical Pharaonic pills that compel my skin to interact with the light. Couldn't get going all day. My brain feels soft.

Dec. 16. Aus whistles when I take off my clothes. "Quite an improvement." Yet he

scarcely examines me, smiles dismissively when I try to show him the recalcitrant spots, the uneven topography of the healing. "You've forgotten the shape you were in, my friend." It is true. My life up to now has been unreal, a nightmare. He offers to show me the "snaps" he took. I say no. He takes new photographs. I elaborate my sensation that the leprosy, chased from my skin, is fleeing to deeper tissue, and will wait there to be reborn, in more loathsome and devilish form. He scorns this notion. "All you lepers get greedy." A clinical stage, evidently, like anger in the dying. I am *good enough*, his manner states. He accepts the teacup indifferently, with a grazing glance. "My wife'll adore it." My stomach turns. I should have saved out two. It never occurred to me he was married. Did he choose her, I wonder, for her pelt? One of the wonders of our world; the love life of gynecologists, etc.

Dec. 17. When I asked Himmelfahrer how our Beacon Hill patroness liked the cups, he replies she was rapturous. But his manner of relating this is not rapturous. He seems dull, I feel dull. Instead of working the afternoon through, I leave a few pieces to air-dry and walk in the city, parading my passable face, my fair hands. I tend to underdress these days. I have caught cold. I never catch colds.

Dec. 21. The nadir of the year. The faces in Copley Square are winter-thinned and opaque. I miss the thronging, gaudy effect of the hospital halls. Here, on the pavements, the faces drift like newspapers of two days ago, printed in a language we will never take the trouble to learn. Their death masks settle upon their features, the curve toward disintegration implicit in the present fit. I used to love people; they seemed lordly, in permitting me to walk among them, a spy from the scabrous surface of another planet. Now I am aware of loving only the Hancock Tower, which has had its missing pane restored and is again perfect, unoccupied, changeably blue, taking upon itself the insubstantial shapes of clouds, their porcelain gauze, their adamant dreaming. I reflect that all art, all beauty, is reflection. The faces on Boylston Street appear to me sodden, spongy, drenched with time, self-absorbed. The waitress at Ken's, whom I once thought exquisite, seems sullen and doughy. The matzo-ball soup is so tepid I push it away, into the arm of the man next to me at the counter. I wait for him to apologize, and he does. Afterwards, picking the pastrami from between my teeth, I cross Copley Square and look at myself in the Hancock panes. There I am, distorted so that parts of me seem a yard broad and others as narrow as the waist of an hourglass. I look up and the foreshortened height of the structure, along its acute angle, looms like the lifted prow of a ship. I wait for it to topple, and it doesn't.

Carlotta tells me I am less passionate. It is morning. She has just left, leaving behind her a musky afterscent of dissatisfaction.

Dec 25. I am beautiful. I keep unwrapping myself to be sure. Even on my shins leprosy has vanished, leaving a fine crackle of dry skin, à la T'ang ware, that bath oil will ease. On my thighs, a faint pink shadow such as a whiff of copper oxide produces in a reduction atmosphere. The skin looks babyish, startled, disarmed: the well-known blankness of health. I feel between my self and my epiderm a gap, a thin space where a wedge of spiritual dissociation could be set. I have a thin headache, from last eve's boozy spat with Carlotta. And a tooth that is shrinking away from its porcelain filling seems to be dying; at least there is a neuralgic soft spot under my cheekbone. Perhaps, too, it hurts me to be

alone. The light box is closed for the holiday. Carlotta is spending Christmas in religious retreat with an order of Episcopalian nuns on Louisburg Square.

Notes for a new line of stoneware: bigger, rougher, rude, with granulations and leonine stains of iron oxide.

Dec. 29. Caressing Carlotta, my fingertips discovered a pimple at the nape of her neck. Taking her to the window, I saw that the skin of her upper chest, stretched taut across the clavicles, was marred by a hundred imperfections—freckles, inflamed follicles, a mole with a hair like a clot of earth supporting the stem of a single dead flower, the red indentations left by the chain of her crucifix, the whitish trace of an old wound or boil, indescribably fine curdlings and mottlings. My hand in contrast bore nothing of the kind; even the ghostly shadow of my Australia-shaped lesion has been smoothed away. We discovered, Carlotta and I, that while examining her shoulders I had lost my readiness for love; nothing we did could will it back. I had wilted like a No. 5 cone. An incident unprecedented in our relationship. She seized the opportunity to exercise her womanly capacity for forgiveness, but I was not gulled, knowing who, at bottom, was to blame. Her spots danced on the insides of my lids.

Jan. 6. Dr. Aus has pronounced me "clear." He, by the way, is going home for a month, during which time I am to be given, like a new car, "maintenance checks." He takes my photographs for his collection, and looks forward to being away. It will be high summer Down Under. "We live on the beaches." I picture him suspended upside down in a parallelepiped of intense white sun, and feel abandoned.

Jan. 11. Carlotta says we should cool it. She has been seeing another man, a lay priest. I have been impotent with her twice since the initial fiasco, but she says that is not it. She will always love me, it is just that a woman needs to be needed, if I can understand. I pretend that I do. A worse blow falls when Himmelfahrer visits. He surveys my new work, pyramids of it, some of it still warm from the kiln, which I have enlarged. He appears disconsolate. He agrees to take only half, and that on consignment. He says it is the slow season. He touches a gargoylish pitcher (the spout a snout, the handle a tail) and observes there has been a change. I say the design is a joke, a fancy. He says he is speaking not of intent but of texture. He says these are good pots but not fanatic, that in today's highly competitive world you got to be fanatic to be even good. He is a heavy gray man, who moves with many leaden sighs. I feel a pang of guilt, knowing that I spend fewer hours than formerly in my studio, preferring to walk out into the city, clad as lightly as the cold allows, immersing myself in mankind and in the snow, which has been falling abundantly. There is a contagion of bliss in a city, in its miasma of digested disaster—the sirens wailing from the rooftops, the unexplained volume of smoke down the block, the blotchy-faced drunk shrieking at phantoms and hawking into the war-memorial urn.

Himmelfahrer apologizes for his own disappointment, and relents. He offers to take this new batch on our former terms if I will revert to my former small scale and muted tone and exquisite finish. I spurn him, of course. I see the plot. He and Carlotta are trying to make me again their own, their toy within the gilded cage of my disease. No more. I am free, as other men. I am whole.

The Potter's Visitors

A. L. Solon

Madame, Daughter and Aunt Mary alight from their speckless motor and carefully pick their way to the entrance of the Potter's Shop.

The Potter, with thirty seconds in which to prepare for distinguished strangers, wipes his sludgey hands upon the once clean towel, opens the door and grins a welcome.

"Do you allow visitors to your studio?" inquires Madame. "We have heard so much about your wonderful work and just had to come."

They enter with many exclamations of enchantment and proceed to admire everything with rapturous enthusiasm.

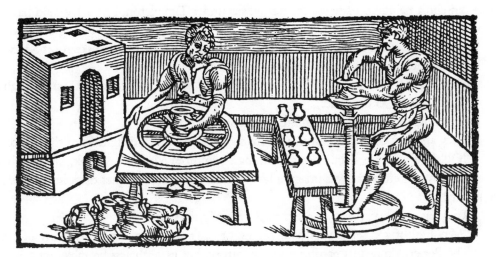

40. "The Pottery," from The Pirotechnia *by Vannoccio Biringuccio, 1540.*

"Oh Mother! Isn't this the cutest thing you ever saw?" exclaims Daughter, seizing a perforated bowl with one hand.

"Oh dear, this piece came off in my hand as soon as I touched it. I'm dreadfully sorry; I'm afraid I've broken it!"

"Never mind, dear," consoles Madame, "accidents like that happen all the time in pottery. Isn't it all perfectly fascinating? And to think that all these beautiful things are made from just common earth? Do you get your clay from nearby?"

The Potter explains that his "body" is composed of several ingredients, some coming from a great distance.

"We've got lots of clay on our ranch. You remember, Mary, that hole under the horse trough where we used to play when we were children? I'll send you a little and let you test it. I'm sure it must be very valuable."

The Potter thanks Madame for her kindness, and the party passes through to the throwing room.

"Oh look!" exclaims Daughter, "here's a potter's wheel—the same as we've been reading about in Persian poetry."

The Potter wedges up a piece of clay and proceeds to perform the grand Miracle.

The ball is centered, and very slowly, vases and bowls, in rapid succession, are produced from between his fingers.

"Oh, how perfectly wonderful!" gasps Daughter. "I would give anything to be able to do that. I suppose it requires lots of skill, though, and you've got to have the proper temperament to become expert."

"I suppose it's like swimming," explains Madame. "It seems so difficult at first, but after you have tried a few times and learned the strokes you wonder how you ever could have been so foolish as not to have been able to swim in the first place. That's so, isn't it?"

The potter agrees with Madame that, once a person has learned to throw, throwing is easy.

The last shape is cut from the wheel and they visit the kiln shed.

"This is the kiln, isn't it?" inquires Madame. "You see, I know all about it, because I once did china painting. I studied for ten weeks under Templeton Terps. I would have studied longer, only he stopped giving lessons. He went into the piano tuning business."

"You lose quite a lot of pieces during the burning, do you not?" asks Aunt Mary.

"Yes, quite a lot," agrees the potter.

"And do you have to stay by the kiln all the time the fires are burning?" asks Daughter.

"Pretty nearly all the time."

"Then why don't you take them out before they break?"

They arrive at the warerooms, with many exclamations of delight from the visitors.

"Oh, how many perfectly beautiful things!" enthuses Madame. "Look, Jane, at that big green one over there. Can you imagine how wonderful a big bouquet of poinsettias would look in it?"

They pick up everything and examine carefully for flaws.

"May I ask if you sell any of your pieces, or can't you bear to part with any of them?"

The Potter admits that parting is sweet sorrow, but nevertheless bearable, especially toward the end of the month.

"You see," adds Madame, "we have a very dear friend who is getting married. We think the world of her and want to get something really nice. Which do you think would be suitable, Mary?"

"I think that big oval bowl with the wonderful colors on the inside is very lovely indeed, don't you?"

"Yes, I think it's very lovely, Aunt Mary," says Daughter, "but it wouldn't be safe to give that: those colors might clash with her carpet, and besides, Miss Smith, our art teacher, says all shiny pottery is vulgar and should be avoided."

"That's true, of course," agrees Madame. "I suppose we ought to get something in green—green goes with everything. How much is that green vase over by the window?"

"That one is five dollars."

"Five dollars!" exclaims Madame, with arching eyebrows. "How very expensive. Haven't you something about the same size, only cheaper?"

"This one is slightly defective. You may have it for two and a half dollars."

"Do you think it would be safe to give that one, Mary? I don't think it's advisable, dear. Remember, Mr. Smith is in the hardware business and he might notice the blemishes."

"How much is this small one?" asks Madame, pointing to a Mirror Black.

"That is twenty-five dollars."

"Really? I wonder what it is that makes pottery so expensive? Hammered brass is so reasonable."

After going through everything on the shelves and hunting through the seconds they come to the conclusion there is nothing quite suitable.

"My! It's nearly five o'clock," exclaims Madame, glancing at her platium wrist watch. "We must hurry home. Well good-bye. We have enjoyed our visit so much. I'm going to tell my friends to call. It's been so good of you to give us so much of your time. Good-bye."

The Potter throws the remains of the broken perforated bowl into the scrapbox, perhaps recalling the old couplet:

> *The Potter's art, my friend, is without par;*
> *Us Potters make our pots of what us Potters are.*

The Clay War

Barry Targan

> —all things fall and are built again
> and those that build them again are gay
>
> **William Butler Yeats**

In a small alcove, or perhaps it is merely a niche, on the west side of the New York Metropolitan Museum of Art, behind the rooms of dusty colored Egyptian vases and urns and amphora-type vessels standing quietly as doom and as forlorn, behind all those rooms to which few come and in which no one lingers long, there is a smallish glass display case, about three feet high by five feet wide, which is sometimes lighted and sometimes not. It is as if the case were there by accident; unlike the Egyptian pottery and the more popular halls of French Impressionists and Titians and Tintorettos and the great fake Etruscan Warrior threatening forever, high up in the ether of the museum, which get lighted by an automated and computerized central control panel in the museum's deeps, the small glass display case is illuminated only when a guard, accidentally passing by it, notices that it is darkened and stops to attend to it.

The guard flicks the ordinary light switch on the side of the case and the three fluorescent bulbs stutter on slowly. They are old bulbs with antique starters. Not an art historian, he is yet familiar enough through his years of peripheral rounds to see that these objects are different from the Egyptians nearby or from the Greeks beyond.

In the glass case is a teapot with six cups surrounding it, a low bowl about twenty inches wide at the rim, a pitcher about twelve inches high, and then, taking up almost a third of the case, a great glowing metallic red bubble of a lidded porcelain bottle as wide as it is high. It looks as if, freed from the case, it would float pulsingly upward. All the other pieces are muted, earthy, and matted like stone, glistening like stones after a rain has dampened them. The tones of the pieces shift about on the surfaces, mottled hue blending into hue so that each inch is different, although one can never tell when they become different. The pieces are like fire itself, definable but amorphous, present and gone in the same instant. The guard reaches out his hand to touch the pieces and bumps his hand against the glass. Do not touch. Do not lean on the glass. But his hand is on the glass and he thinks that if the glass were not there, he would touch the pieces regardless, that he would daringly pick them up and try them, and if, unimaginably, he could, he would eat and drink from them.

The glass case is sealed, locked by a concealed lock in the base to which the key is misplaced or unrecorded. Someday the bulbs in the case will burn out, one by one. Perhaps then the case will be dismantled and relit or even repositioned in the museum. Or perhaps the case will come to be accepted that way, finally to be lighted only for a few hours each

day from the reflected light of the Egyptian Room as the sun passes over the glassed, transepted roof, the vessels in the case quietly hidden in the New York Metropolitan Museum of Art like a solemn and honorable promise of silence, though with no grandeur lost in the keeping of it nor beauty dimmed.

Ephron Gherst came from Poland to this country in 1878 when he was twenty-three years old. He came with a wife his own age whom he insisted on calling, in this country,

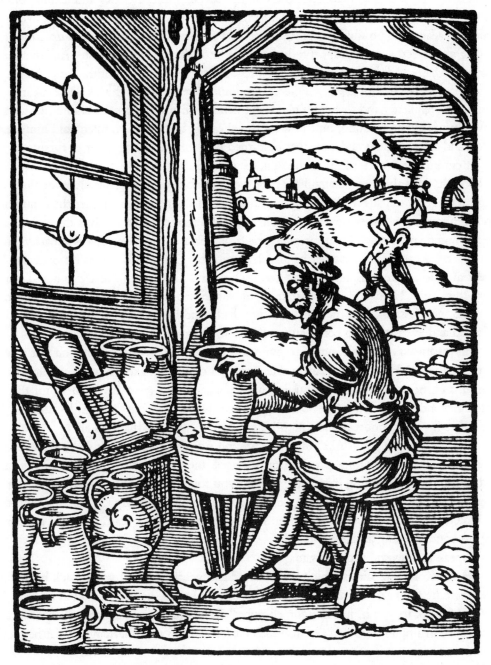

41. "The Potter," *from* The Book of Trades *by Jost Amman and Hans Sachs, 1568.*

Fanny (in Poland it had been Fanaela), for he determined that that was the American style and he would, now that he was here, practice it. English, he declared, was all they would speak as soon as they learned it. He came too, with a son, Aerrie, age five. And he came with a skill. He was a potter. Besides one hundred dollars after the passage, that was all he came with: strong youth, responsibility, a craft. But what more was there? And this was America, so what more did he need?

He put in his greenhorn year in New York City. It wasn't bad. The leap from the weeping muddy hovel of his birth and rearing, with its slow realities of seasons and its relentless poverty and mad danger, into the sharp, paved, artificial clatter and angular brightness of the quick and growing city, was just right for Ephron Gherst just then. He was a learner, an adapter to possibilities, more concerned to eat whatever life served up rather than to judge and select, a man of appetite before taste, though not without taste. An adventurer, perhaps. Perhaps, too, he was enchanted, either victim or source—or both—of a fine and potent magic. Had he not already done the impossible, learned a highly skilled craft in a country that explicitly and threateningly prohibited him from doing so? Had he not married on nothing, less than nothing, on the wage the cheating bastard in Fremlen paid him for the platters and baking dishes and cups that he turned out, for the killing labor of mixing the clay, of cutting the wood, of firing the kiln, of walking the ten miles to the work?

So what was there to be afraid of? Not the pale, collapsed timorous elders of the village who despaired at his labor, that he should work with his hands rather than mumbling into toothlessness with them over the scrolls, and who feared for themselves through him, that he should enrage the Governor or, worse, the rabble of Fremlen, by his audacity. And not the leering bastard shop owner in Fremlen who sold Ephron's work as his own and held the threat of exposure at Ephron's butt like a white-hot drawing iron ready to brand him before the world. He had learned despite them all and had married Fanny when he needed her. (And what a crying out there had been at that!) And he made a son and had earned and saved and even stolen to come away to here to form and pursue his dream.

His dream was simple enough: to live without fear and to live by what he was able and pleased to do. He was a craftsman. He wanted a place to make his wares, a kiln to fire them in, a chance to sell them, a house to live in, a garden to grow his potatoes for the winter. Beyond that, what? More sons? A gold piece or two to bury against hard times? For once a fine dress and boots of the softest leather for Fanny? And that was all.

"All," Kollowitz said. "All?" He came around from the heavy desk in his tumbled, strewn office and sat down next to Ephron and took the glass of half-drunk tea out of his hand. "Aren't you forgetting something? Aren't you forgetting the fancy brownstone on Twenty-third Street, the one with the servants? Aren't you forgetting the carriage with the two matched horses? And what about the summer house by the ocean? Tell me, Ephron, why are you forgetting all these things?"

"Speak in English," Ephron said.

"Aiii," Kollowitz said, slapping his forehead and getting up and going back behind the desk where he felt safer. "You don't know English, Ephron Gherst," he said in English, "so how can I speak to you in it? All right, all right," Kollowitz raised his hands. What he had to say, even in English, wouldn't be too difficult for Ephron to understand. What he had to say was *no*.

Kollowitz was a cousin to Ephron Gherst, so distant that it was impossible for either of

them to establish or deny the connection. In the puddle of a village, less than a crossroads, in which Ephron had spent most of his life, Kollowitz was the one thread-thin bond that any of them had to the New World. Not *this* Kollowitz, who was not much older than Ephron, but to a grandfather or perhaps even a great-grandfather. When the village would speak of America, it meant not a place but a single declarative statement: Kollowitz went there. It was all they had to say about so arcane a subject as America, until the expression came to mean nothing at all. When some stray breeze over the marshes brought with it America, someone would say, "Kollowitz went there," and that would be that.

There were many Kollowitzes in New York, and it took Ephron two months of daily searching to find the only Kollowitz who remembered Fremlen, if only vague and muffled mentions of it. But that had been enough. Kollowitz liked Ephron, admired his odd history, his rare skill, his easy courage, and accepted the obligation to help. He got Ephron a job at once in a small leather-goods factory at the river end of Canal Street, sweeping up, moving material, and slowly learning a little about cutting the hides into straps and belts. There were no potteries in New York for him to work in.

And Kollowitz reestablished Ephron's family in a tenement better than the one they had been led to that first day off of the boat, by the landlord agents who came to feed on their helplessness like gulls hovering in a ship's wake. And although Kollowitz could not see the Ghersts socially—he was too well established for that—yet he visited them each month, laden with food and clothing and a toy for Aerrie. Then they would sit for a few hours over glasses of strong orange-colored tea and tell each other about what each lacked, Kollowitz his Polish past, Ephron his American future.

But this that Ephron asked for now—*wanted*—was impossible.

Since the early spring, since April, Ephron had been going by himself into New Jersey, to the capital, Trenton, on the train, and then from Trenton, by wagon when he could beg a ride but mostly by foot, into the edges of the pine woods which was most of the state. He had heard about this New Jersey and its endless and mysterious stretches of pine at about the same time that he had learned that Trenton was the pottery center of the East, of probably all of America. At once, even before he knew anything, he imagined this to be his place. Effortlessly available quantities of wood to fire his kilns, and pine wood at that, the long and quick flame of pine so perfect for *his* kind of pottery. The clays that he would find and buy from the Trenton mills. The closeness to cities where he could someday sell—Philadelphia, Trenton, New York, and more. It was everything. And surely, if there was a pottery industry already, it was a sufficient sign that the conditions were right for a one-man operation. His trips to the region confirmed him. His mind made up, he walked about in that countryside to find his place on earth.

It took most of the summer. First only using the long Sunday, leaving New York in the dark on the rattling milk train and arriving at Trenton still in the dark. Then he would steal a Saturday from work, then more and more of them, until he was warned by his boss at the leather factory. But by then he had found it: a shack for a house, a shallow well, and acres of scrubby pine. In two creek beds nearby he had found some promising clay deposits, rough fire-clay that he could use to build the kiln and some good earthenware clay which might get him started with some low-fire things until he got settled enough to move on. Best, he found the owner, and learned that the property could be bought: two hundred dollars.

"Ephron. Friend. How can I give you five hundred dollars?"

"Lend," Ephron corrected him. "Two hundred for the property, the rest for nails, wood, tools, things, food for the winter."

"Lend, give, is not the point. I'm talking about the risk. To start this was . . ." Kollowitz shook his head back and forth, weighty with his knowledge of business ways and the world, a pendulum swinging from doubt to doubt. "What I'm saying is you would be taking on all the problems at once—the making, the selling, the building, the . . . the . . . everything. If anything went wrong anywhere along the line . . . buuum." Kollowitz threw his arms wide, leveling Ephron's life. "Go a step at a time. Get a job in the factories in Trenton. Then get the land. Then build. Get the feel of the market. You see what I mean? Aiii," he slapped at his forehead again, seeing from Ephron's face that he had indeed considered steps but had already decided on leaping. Then he would have to be tougher.

"Five hundred I can't lend you, Ephron, so that is that." He settled back. He glanced at his watch. He was a busy man and Ephron had had enough of his time. Clients were waiting in the outer room.

"Four hundred then," was what Ephron said.

"Four hundred? If you needed absolutely five, so now how come suddenly you can do it on four?"

"I can't," Ephron laughed, roared, "But I will,"

They settled finally at three hundred. With a weary shrug Kollowitz had given in, but not without hope. For when he asked, with a businessman's reflex to a troubled agreement, but in softening humor, what Ephron had to offer for collateral, after first explaining what collateral meant, Ephron held up his two hands to him and said, "These."

It was better than Kollowitz had gotten from many another.

By the time the first snows of early December came, Ephron, Fanny, and the boy were home. Ephron had sawed, hammered, and patched against time and had won. Each fresh and sound timber replacing a rotted one shored up his life, each nail driven into each firm, shaven board sang to him the descant more ancient than man of home, of place. Door jambs, headers, shingles, shelves, post, two rafters, three joists, and an entire sill on one side of the building. Pushing in a bellying wall, twisting straight a canted corner of the building, he beat his shack into a house and comfort in eighteen-hour hosannas, in flower bursts of energy like the sudden autumn asters all about him. The weather stayed good. It kissed him and he kissed it back. Besides his potter's craft, this was the first of anything he had ever owned. Already it was superior to all he had left in the mud ten miles from Fremlen.

Fanny gathered herbs and late berries and fruits and then mushrooms, scouring the fields and nearby roads with a thoroughness the already abundant Americans could not comprehend. And established chickens. And acquired a goat, the start of a flock of geese, a cat. She sewed and mended and arranged. Nothing ended but that it began. To Aerrie the work was play. So when the snow was higher than they could fight through out to the clogged road, they were ready. Wood, food, Aerrie, the preparations for spring—the garden, the kiln, the workshop—all, all of it a sustaining gaiety, a reliable pledge that life had its reasons and its ways.

Only once, in October, before the earth froze up, Ephron had paused for a week to

dig clay from the nearby creek beds and to go the difficult twenty miles to Trenton to seek out additional clays and other supplies. He had returned late at night in a rented wagon with what clay he needed, but with a worry too. Or the shadow of a worry perhaps. It was hard to tell, as it is hard to tell if we hear or if we think we hear a twig snap behind us in the tangled woods we sometimes plunge through in dreams.

He had gotten most of what he needed in Trenton, and if it had been hard bodily work, yet it hadn't been too difficult to transact. The large potteries were not very interested in selling raw materials, certainly not in the small amounts that Ephron wanted and could afford, or could carry away. Still, a precious dollar here and here and there and there and a yard man at one mill and the chief mixer at another could be persuaded to look elsewhere for ten minutes or so. But what worked best for Ephron was the absurdity.

When asked what he wanted the clay for, he would say, to make pottery.

And the head man in the yard would laugh above the clamor of the efficient mill, the dry loads of clays, broken and unrefined mountains or powdered and sifted, shifting from mound and building to tanks and bins, the muffled roaring of the continuous fires in the building-high kilns and the monuments of steaming smokestacks a hundred feet high, the creak and screech of the compressors blending and mixing and extruding the clays, the slap and skitter of the leather belts on the rods and gears and pawls arranged as power take-offs for the wheels before which inconceivable rows of whitened men sat in hunched and productive array. The head man in the yard would open the black hole of his mouth in the clay-cloaked body and laugh and wave about like a lord to whatever Ephron wanted. It was worth the good joke. Anything to help a competitor, the ghostly yard man had said.

By three o'clock the steepsided wagon was full, but Ephron had not found one clay, one kind of clay, the ball clays from places called Tennessee and Kentucky, that he wanted to learn about, to explore, to use in time. In his year in America, Ephron had heard of new materials unknown to Fremlen, the wondrous kaolins from Georgia and Florida, strong stoneware clay from Ohio, refractory flints, dense feldspars, smooth fire-clays from Pennsylvania and even New Jersey, self-glazing clays from Albany in New York State. But particularly he had heard of the silky and plastic purity of the white ball clays from those places, Kentucky and Tennessee. Even in America they were just coming into use. So Ephron lugged out to the one mill he had been told might have this clay, flouring the road with sprinkles of his commoner clay through the cracks of the wagon sides at every jounce, the horses unhappy and a long way yet to go.

At the Mercer Clay Works, Ephron made his inquiries. The language of craftsmen, any crafts, are simple, basic, and direct, like the actions themselves. Few words are necessary to describe the nuances that the fingers achieve; to talk at length about the cleanness with which a well-formed pitcher lip cut off the fluid stream that poured over it was a waste of breath. Could describing the condition of clay accomplish the same thing as the feel of the clay in the hand of the man who would use it? Could fire be measured by equipment instead of by its color and the shimmering hold with which it grasped the ware in the kiln? So Ephron had little difficulty with language during the day, for it wasn't cracked English he spoke as much as it was the fundamental knowledges themselves, the immediate and intuitive current of truth to truth. By the time he was talking to the people at the Mercer Clay Works on the Bordentown side of Trenton, New Jersey, Ephron had come to know at the

ending of this day that he had knowledges that none of the others had, that a man who knew about this didn't know as much about that. Was he the only potter in Trenton who fired the clay he himself shaped from the clay he himself mixed?

The Mercer Clay Works had the Tennessee ball clay, and it was safely stored, secured from weather and thieves, and unobtainable by any means. So Ephron begged.

"This much," he pleaded, making a bushel with his arms. Nothing. "A hatful," he implored, pulling off his hat and sinking to his knees. He laughed, to make his urgency acceptable. They gave him a hatful of the clay after he explained how he would test it. He told them about a type of shrinkage test for certain clays that they had never heard of, that he had developed himself. A hatful of clay for his useful discovery. A trade. The barter of craftsmen, uneven now, but the only trade in town.

At the special Tennessee ball clay storage shed, the men working there were quiet. They were shovelers, the lowest workers, the inept extra sons who knew nothing of craft, destined only for early disability and then death as their lungs calcified from the inescapable fume of clay they lived in.

As the Trenton potteries established and enlarged through the century, whole Irish villages were brought to America to be taught to work them, whole families and then generations stayed to live and die in them, scourged by silicosis, the potter's disease, too inevitable to be dreaded any longer, only one more penance they were taught to accept as a payment on the policy of the life to come, where they, with God, would breathe in the icy cool blue air and all would eat and drink from gold and silver plate and not off of the cursed clay.

So when one of the young shovelers upon receiving orders handed a hatful of the Tennessee dust to Ephron, he could hear nothing of Ephron's tremble of excitement, the flutter of imagining. He could hear only the strangeness of Ephron's accent, see only the difference of his clothing, the assurance of his walk, the hugging of his hat and the little dance of joy like it was gems he held. All he could see was this dark, straight, strong man, no older than himself, claiming his terrific rights to walk away by the side of his wagon to . . . But he could go no further, shape no more of his hate than that, just as with clay he could do no more than fling it dryly about. He spat whitely upon the ground and remembered.

Passing out through the gates to the Mercer Clay Works, Ephron felt Fremlen at his back, the cold, harrying wind that would blow him from the city to his hovel. In a spasm of panic he thought he was waking from a dream, that all that had been wonderful this year— the new city, and Kollowitz and the home a-building in the woods and the plans and the future riding in the wagon he led and even the exquisite joy of his dirt-full hat—that all of it was dissolving into a murky, numbing morning, that he was waking up to his ordinary journey from his father's hut to Fremlen, and that all the rest had not been. He struck out at the horse to hurry it, to outrun the terror. And then the panic was gone. He sighed and laughed and patted the horse to soothe it. All that was good was still good. Trenton was not Fremlen.

Through the winter he prepared. In the lean-to of peeled logs that he had attached to the house, he dried and cleaned and mixed the clays he had dug himself in the nearby creeks. In a wooden mold he shaped the thousand special bricks he would fire in the spring

and from which he would build his mighty kiln, already planned and drawn to the finest detail. Into other molds he pounded his densest mixture of clays to make the shelves for the kiln. Small amounts of the clays he had gotten from Trenton he mixed to special proportions and then rolled out into small rectangular slabs that he would thoroughly dry and fire and test to find all he would need to know about them.

He recorded his formulae and recipes and later his results like an alchemist possessed by the visions of what this and that clay body could achieve if they worked out to be what he struggled for in his imagination: the strength and the vitreous density and the color that the fired clay itself would bloom into and lend to whatever glaze he would devise, and to guess at whatever good accidents might spring out of the fire because he had prepared for them. It was all a glory of artistry to Ephron then, the freedom to work in the holy realm of his vision and his skill, to work only within the boundary of creation itself where there is no failure ever, for there even if the test tiles, carefully marked and numbered, should melt or crumble or burst or warp or die in all the ways that they can in the fire that must try them, so that the philosopher's stone or the great elixir eluded him this time, still they would not have gotten very far away.

What a glorious distance from Fremlen now, where he had been jesseled to his perch like a tame crow to do over and over again all of the old things, including the foolish errors and the tradition-bound faults, as though there was nothing more to know, or nothing further for a jug or a jar to be. Twice he had offered his improvements to his boss, each time to be rejected with scoffing and imprecations, so that he learned and found and imagined quietly and stored it up till his time would come—as it had now.

Why did he know all that he did? What was in him that he could rub a clay in his fingers or smell it or taste a little of it and comprehend how the clay would work, how it would likely fire and glaze? Perhaps it was in Ephron's will; perhaps it was the shapes in his head that called forth a clay body that would keep a daring curve or a clay that would sustain in the fire the arching handle Ephron's hands had stripped it into; perhaps his knowledge came out of the intimacy that love brings.

George Barton was the first person to befriend Ephron here. George Barton was the blacksmith for the Hightstown area. He lived three miles further in toward Hightstown than did Ephron but on the same coarse road. He was seventy-five years old, white-haired but as straight as he had ever been, all that was strong about him still strong, his skin thick and darkened like the crust on slow-baked bread by the decades of his forge's fire. Fire was what he and Ephron had first in common, the catalytic element both worked with, and thereby knew and cherished. They touched each other through it and discovered more.

Early Ephron had sought out the nearest blacksmith and had found George Barton. He would have need of certain special fabrications difficult to make. Ephron showed him sketches of the framing he would need for his kiln and of the rods he would need as he constructed his potter's wheel. And there would be other things too. Yes, George Barton could do all that. And then they talked, Ephron as best he could about his plans to build, to make, to sell, to live here.

George Barton listened, his great clubs of forearms twitching with their own memories of sixty years ago when he had come with his father from the middle of England to where they were now, this very place and land and smithy. The forge here was the forge he had

built with his father, stone upon stone. He told Ephron that there wasn't a barn for miles about that didn't swing its doors on Barton hinges.

In the winter, when the snows of a storm had packed themselves down or been driven into opening canyons in the road, Ephron would bundle down to the smithy. Then the two men would sit for a time by the constant fires and drink tea together and George Barton would tell Ephron Gherst about this new country and his own old dreams and what it was all coming to anyway. And Ephron would come back full to his brim like one of his own bottles to pour out all of George Barton's history to Fanny and Aerrie.

To Ephron it was all a wonder that this land should be here now or that it had been as George Barton had found it. And George Barton was glad to speak to such a listener, for Ephron accepted impressions as quickly and perfectly as the clay he worked. George Barton had been silent too long with the scattering of his children, the death of his wife, the quickening all about that had sealed over him. It was good for him to find an Ephron, loud with life, boisterous with plans. And of course there was the fire and the clay and the iron, there was all of that to talk about.

Sometime before the spring George Barton dragged out of an unused stable stall a chest that only he could have moved alone, and opened it to Ephron. It was full of delicacies of drawn wire and tapered spikes, splatters and bursts of metal.

"Sometimes the iron would run so," George Barton touched a splayed teardrop of the dark cold metal. "Or here it would splatter or break in . . . a way. I used to have them. I couldn't melt them back. I took to throwing them into here. I even made some on purpose for a time. A long time ago." He dropped the lid to the chest and shoved it back again into the past. He didn't know what to think of it all, his doing that then or even his showing it to Ephron now, only that it didn't need to be explained. Iron or clay lived in fire. It took strong men to drive them and sometimes nothing at all could. Those were the moments George Barton had once saved and once even dared to imitate, to reach out to capture the fundamental dignity of elements when they spume and flare as in memorial of their own birth eonic distances ago.

"Yes," Ephron had said to George Barton, to himself. "Like throwing the clay into the air and firing it that way. To be able to do that."

"Yes," George Barton had said. He had gone back to horseshoes and scrollwork and iron banding and weathervanes, as Ephron Gherst prepared to go on to plates and jugs and bean pots. But Ephron thought that he would capture the flung clay yet.

Spring came quick and easily, the misty air not as soft as the winter-cleaned sunlight promised it would be, but soft enough for Ephron and Fanny and the boy to dance about in it. Ephron cut trees for a week, felling the thin pines, trimming the branches, and then, with no horse to do it, hauling the logs out in small trailing bundles, he and Fanny haltered together, giggling and stumbling through the damp needled matting of the forest floor.

He stacked the bricks of clay he had molded for the kiln through the winter and fired them like a brickmaker for three days. And when they were cool, or almost cool, he built his kiln like no kiln before it had ever been built, with intricate measurements for the flue placement and fireboxes and ash pits, bag walls, spy holes. As he mounted the bricks in interlocking patterns to eliminate all heat-losing chinks, mortaring them together only with wet clay, he shouted out to Fanny what he was doing, why this would do that, why it

would work better than any kiln ever had, fire higher temperatures more evenly through-out, be precisely controllable, why it would do his will.

Fifty feet away Fanny dug in the loamy and sandy soil and laughed to herself to hear him. She would stop her work and grasp hands of the soil to watch it break apart softly and easily, to watch the rain sift down through it quickly, to kiss it for its goodness.

Ephron came back to her from the doorway; he was halfway through and sat down beside her and took her hands in his. "Listen," he said, "nothing bad can happen here." He raised her hands to his face. "Do you think I would let it?" Then he got up and went back to work.

The kiln fired as well as he had expected it to, demanded it would. The simple, low-fire wares—flowerpots, dishes, mugs—were excellent. And in Trenton they were more than acceptable, finely made and not expensive. He returned with money and some orders. It had all begun at last. The garden and his business grew. From his test tiles he selected the clay body that most suited him and mixed determined quantities of it, stoneware now, even some porcelains: high-firing, nearly translucent, bold. And in the midst of all his business he contrived with more formulae, blending and testing the precious Tennessee ball clay into amalgams fit to hold the arabesques and pavanes of shapes that pushed through him until he could not breathe with the pressure of them and until he would shout out the building joy of thinking that he would make what he would someday make.

He tramped about in nearby streams to discover pebbles that had trapped flickers of oxides, and then he would pulverize and grind them down in a machine that George Barton had devised for him. He hoarded these exotic colorants in small leather sacks like other men had held the gold dust they broke out of the rock of another coast.

By September his life had begun to seat itself, diligence wearing away the obstructions, asserting the patterns, deepening the grooves that round and control our days. The orders for what he was making—the low-fire earthenware—were increasing steadily and were almost enough to sustain them, and even his blazing high-fire stoneware was, if not selling yet, at least being curiously appraised, people attracted by it but unnerved, uncertain as people always are before wonders.

Ephron Gherst, the potter from Hightstown, was beginning to be noticed, so much so that he had had to formalize his methods of procuring materials. To get his supplies now he had to go through the front office. And pay.

At the Mercer Clay Works it was not so easy. John Clough, the working owner, had heard about the successful advent of Ephron Gherst and took no competition, large or small, for granted. It was not, however, the daily low-fire production ware that John Clough was thinking about when he refused to sell the Tennessee ball clay to Ephron at any price; it was the special, occasional pieces of his that he had seen and that he had heard spoken of that bedeviled him. Those pieces were like nothing produced in any of the local factories or that could be produced there. John Clough understood that, but the pieces were not like anything produced by any of the other small native potters either, from any place or from any time that John Clough knew of. Ephron's special pieces were fired to as ringing a strength and density as the best bone china produced by the Mercer Clay Works, but the pieces looked like the fire, like the fire had been frozen, all the impurities of the clay burned into beauty. And the size of some of these pieces, and the balance and certainty of all of

them were beyond anything the jigging and extruding and casting machines of the factories could match.

John Clough had no fear that these fine pieces of this Ephron Gherst would establish a competing style or would challenge the main production lines as determined by him and the larger pottery manufacturers of Trenton or of Europe, but he saw no good reason to abet or to encourage the kind of skill and knowledge that Ephron's work represented. He would not sell Ephron Gherst the Tennessee ball clay: there was too much more that he might make out of it. But John Clough offered him a job. A good one. Which Ephron politely and absolutely refused. And that was to be the last he ever had to do with the Mercer Clay Works. At least officially.

On the way out of the office he passed by the shovelers he had seen the year before, or perhaps these were others. Who could tell beneath their shroud of clay dust? Only one, the one who spoke now. Ephron remembered him, remembered the terrible desperate glass-blue tinted eyes forever wet with a rage he could not comprehend.

"Hey, *yankle*," the blue-eyed man shouted at Ephron as he passed by the group of cloudy men. Even sitting inactive they created a stratus of clay, a climate, a dry white weather of oblivion. "Hey, *yankle*," was all he shouted. Or could even think to shout.

But it was enough. Ephron shuddered from history. Fremlen was following him after all.

Ephron got his Tennessee ball clay at last. He had to buy it directly from the Tennessee fields through a shipper in Philadelphia, and by the time it lay in burlap-bagged piles in the storehouse which he had added to the workshed, it had cost two hundred dollars, a breaking sum nearly thrice what it would have cost had he been able to buy it in larger loads or to have bought it locally. Still, he had plans for it that would make it worth emeralds.

He had gotten some of the money from Kollowitz, whom he had visited late in the summer. They had written frequently over the year, Ephron full of his bursting days, his inches of success, his ounces of gain, Kollowitz full of his encouragement and cautions. And of his pride in Ephron.

"Mad," Kollowitz said as they sat together in his summer-hot office. "What is it? The trip up here did this to you? The heat? Overwork?" Ephron had just explained to him his need. "You are getting on your feet, you are just about ready to meet your bills *and* your old debts, and now you are talking about a loan, about *new* debts? What's wrong with what you are doing? Making a living isn't enough?" But it was Kollowitz and not Ephron who was sweating. Ephron was used to heat and to living in the only day before him. Disasters were in the future; dreams were now. Ephron listened and smiled as Kollowitz dizzied himself in the tightening swirls of his practical fears, doubts evoking doubts. He was particularly upset by the foreboding refusal of John Clough. "Why?" he said at last, exhausted by the heavy black chimeras he had lifted up for Ephron to see. "What do you need this clay for? What more do you need to do than you've done?" He meant with Ephron's life, but he and Ephron defined that differently.

Ephron opened the box he had carried with him on the train up from Trenton and took out of it a large bottle, as round as it is possible to imagine roundness to be. At the precise top pole of it a neck and rim rose like an exquisite but defiant pronouncement, smaller than fingers could have formed but yet asserting that fingers had. Ephron put the bottle on the desk in front of Kollowitz. Kollowitz could only smile to see it, though it

made him feel much more, the blood in his hot body lurch, the skin at his temples tighten.

"I made two of these," Ephron said. "Without the right amount of the ball clay I couldn't have done it. With the ball clay I can make more, and bigger. So that's why." But the bottle was sufficient argument for itself. Kollowitz looked upon it and relented.

The other bottle was for George Barton, who had lent Ephron fifty dollars toward the clay. He also built Ephron a pug mill for mixing his clays. Building it got George Barton back into some steelwork too, back into the elegant days when the finest axes and cutlery in this country were made by men like him and his father out of precious bar steel imported from England. George Barton remembered what it was to hunger at night for substances fit to compel. He found now that he had lost nothing of his skill, only the urgency to use it, and Ephron Gherst had given him some of that from his own great store. For two months George Barton welded and blazed, tempering and annealing through days and nights, and on the fifteenth of November, when the sandy road between them was frozen tight, the two strong men drew the heavy machine to Ephron's on a stoneboat behind a pair of borrowed drays. They skidded the mill into place and Ephron poured the dry mix and water into the hopper. Then, as he turned the heavy gearing that George Barton had made to mesh like a watch, all the substances binded together and emerged at the gate as workable clay. George Barton and Ephron and Fanny and the child, Aerrie, all took a turn. Then they drank strong tea and Fanny's dandelion wine. A ceremony.

The winter was again mild, and so there were days, even in February, when Ephron, with Fanny and Aerrie helping, could carefully stack the great kiln with the fragile ware. The child was old enough to learn useful things and to be truly helpful, and what needed to be done in the house or pottery was now finished, so Ephron fired the kiln more often and sold all he fired, and when the thinly crusted creeks that threaded the vast pine barrens broke back into spring water, he had a dollar more in his hand than he needed, although still much less than he owed. But better than money, the small store of oxides and pigments and colorants that he had ground out of the pebbles and rocks and dirt had accumulated to a usable amount. Soon he would stain and glaze and draw upon his pottery with earthly crystals none had ever seen before. For even he, even after his most recent tests, could not predict exactly what would happen in the kiln. But Ephron Gherst knew enough to accept mystery as a gift and not a challenge.

"Look at that," George Barton said showing him the handbill. "September the first to the fifth. A State Fair."

"What is a State Fair?" Ephron asked.

"Well, it's like a county fair, only bigger I guess. Like the fair we had last year in Allentown, remember, only this is for the whole state. The first New Jersey State Fair."

"Good," Ephron said. "We must go." The county fair had been a delight. He turned back to his work.

"But look," George Barton drew him back. "Look." He pointed to the small tightly packed lines filling the paper beneath the large blocky type. It was the usual list of exhibitions to be judged. But after livestock, foods, and quilts, and between tin-smithing and

harness work, was pottery. There had been nothing like that at the county fair. Ephron took the paper and read on. At the bottom were the directions for submitting: all you had to do was show up at least a day before the fair was to open. And there were prizes too, ribbons blue and red and white.

"What about you?" Ephron asked. He pointed out to George Barton the blacksmithing.

"Sure," he said. "I'm going to work now," and left the shed, complications of weathervanes already turning in him.

One of Ephron's wheels was arranged so he could pull it outside to work in the air in the good summer months. That was where the wheel was now, the second of the wheels he had built here, a refinement upon a refinement. The central shaft was machined steel, a bar that George Barton had ordered turned on a lathe. For the first time in his life Ephron had used true bearings instead of a simple tight hole drilled through a thick oak block. And when George Barton had welded to the shaft the flat round head upon which Ephron worked, he had leveled it to tolerances as fine as feathers, as certain as spider threads. There was no potter's wheel like it anywhere else. When Ephron sat upon it and spurred the great balanced flywheel up to its fullest thrumming speed, he rode it like an ancient charger, mounted, a bold knight after his grail.

Through the afternoon he worked out leisurely pieces that he would fire and from which he would select for exhibition. And there would be many more pieces. He had a month to go.

The month went quickly. Besides mixing quantities of the clay he would use for this performance, and aging it by quick devices he knew and others he invented, there was the wood that always had to be cut to dry a little to replace the wood that already waited to be burned. And there was the forming of the pots themselves. And when these were completely dried out in the sapping August heat, the bisque firing was loaded and completed. He and Fanny and Aerrie removed the still-warm bisque and spread out the rough, pinkish-white porous pieces in rows in the workyard.

"I leave them out overnight so the dew can coat them," he explained to the boy. "Then the pieces won't soak up too much glaze like a sponge. They'll be a little wet already." He taught the boy all that he could. It was all that Ephron would be able to give him.

They left the bisqued pots. Tomorrow Ephron would glaze all morning and dry the pieces in the afternoon sun, and in the evening they would stack for the glaze firing, and early in the morning after that Ephron would kindle the first soft flames in the kiln. But now, this day's work done, they walked off to George Barton's.

They returned home in the last of the August light. All of the bisqued pieces in the workyard were smashed, methodically and exactly, every one of them crushed where they had been placed as though an enormous claw had descended upon them through the unprotesting trees.

Fanny threw up her hands and covered her face. The boy whimpered.

"No," Ephron Gherst commanded them quickly. "No." Fanny lowered her hands to his voice. Aerrie stopped like a quivering, uncertain blade between them, and then he and his mother ran after Ephron as he strode heedless through the broken yard. He pulled a

shovel away from the wall of the shed and dragged after him a clattering flatbed cart as he went. All that was left was now, and that was what he would work with. What hadn't failed him in the past shouldn't fail him here. At the perimeter of the cleared land around the house, just at the end where the pines thickened into an unbroken wave of forest across the state to the sea, he uncovered the pit in which he had buried a great mound of his thoroughly mixed prized clay.

"I was saving this for you," he explained to the boy, "preparing it. In ten years it would have aged like . . ." He shrugged. Who could imagine a clay body so pure? "So we'll make more another time, yes?" He jumped down into the pit and began to shovel the fermenting clay up to the surface. "But now we will need it." He inhaled the clay like a soft cheese and nodded in approval.

"Ephron?" Fanny asked, pleaded. "Ephron, *what*?"

But he dug down. It would be easier to show her than to explain.

All night and into the morning the great wheel in the yard spun. Fanny wedging the clay, pushing and kneading it like bread as Ephron had shown her; the boy, until he sagged down to sleep, carrying the clay loaves to his father, riding, riding.

Everything that clay could be made into, Ephron Gherst made that night, not simply the kinds of things but the *limits* of them, so that the merest unmeasurable fraction further and the high-bellying pitcher or bottle would collapse upon itself or the cantilevering lip of an incredibly wide platter would slump and crack at the impossibility of maintaining the mathematically perfect curve necessary for its strength. Freed by catastrophe, what could he not attempt or dare? Having already lost, what risky endeavors could threaten him? All the night long he flung the clay up into the sky and held it there.

The day was good, dry but not too hot. The vessels moved quickly into the leather hardness they had to have to be trimmed. Fanny slept for two hours but the boy woke up and moved pots into and out of the sun according to his father's explanations. "When the rims look dry, like nearly white, move them under the trees. When the bottom of the bowls lift off at the edges, bring them to me right away." He told the boy everything, singing out like it was a song, a canticle. As he finished trimming each pot—a casserole, perhaps, or a sugar bowl or a platter—he would sign his name sweepingly across the bottom—GHERST—large, biting into the leathery clay. What would they say when they saw that, his signature on a soup bowl as if it was a painting or a statue? He whooped at the thought. Fanny woke up to his laughter.

By that evening it was done. All of the broken bisque was gone, swept away into memory. In its place a new and grander kiln-full of greenware waited.

"But there isn't time," Fanny said at the supper. And then she said what had been with her all along, what couldn't be swept out like the broken bisqueware. "And they may come back."

"I have a way," Ephron told them both, teaching the boy. "You can glaze and fire greenware all the way through to the glaze in one firing, but it is full of problems. It is very hard to glaze the unbisqued pieces, hard to stack them in the kiln, hard to handle them at all. One little nick and a piece is ruined. And the firing? Aaaaah. It takes forever. Slow? Feeeeh." He sighed out and shook his head at the weariness he could imagine from such a firing, at the hours, at the days. But that is the way that it would have to be.

About the other thing, those, or whatever it was, that might come back? What could he say? All he could do was what he could do, which was right now to glaze and stack and fire the most difficult kilnware in his life. That would have to be enough.

"Enough?" Fanny said. "But what is it?"

"It's all I've got," he said, getting up from the table and going into the workshed to modify his glazes so that they would adhere to the greenware instead of the bisque.

"Aerrie," he shouted out from the attached room after a while. "Come. I'll show you a trick with glazes." The boy looked up at his mother. Floating now with her, he moved in her current, in her tired, sad ebb, and hesitated.

But "Go," she said to him sharply. "Go. Quickly."

Ephron slept through the little of the night that was finally left for him after he had finished modifying the glazes. By early morning he was at the careful work of glazing the fragile greenware, first the driest smaller pieces and then, as the afternoon dried them out, he worked on the larger ones. At last the stacking, like a ballet, the pots held from destruction against the kiln walls or other pieces by gesture and discipline. Piece after piece he offered up like a votary.

After midnight Ephron began the first small fire in one firebox. It burned that way, not much larger than a campfire, for a day and a night, the three of them taking turns that the barely smoldering fire should not go out or grow but only stay. On the second day the fire was enlarged and a second fire started at the diagonal firebox, and after twelve hours of that, with Ephron hovering from port to port, adjusting the damper, checking at spy-holes high up or low in the kiln walls, fires were started in the remaining two fireboxes. And at the beginning of the third day the kiln began to glow into visible internal life, the heaviest orange. And now the fire began, the upward drive for curing heat, the long drenching heat as the fire hourly clenched the now glassily swimming particles further and further into each other and into perdurable form. Now, when the kiln was unbearable to look into, when the flame roiled and licked about for air, Ephron drew yet one more test ring from a port.

"Soon," he said to Fanny. "Two hours, maybe three." He put his arm over her shoulder. What days had gone by! How they and the boy, like the ware in the kiln, had been tempered! "Soon," he said.

But in less than an hour he saw that what was left of the wood would not be enough. The huge store from which he had fired the bisque he had not had time to replenish. And now this endlessly long firing had outlasted his calculations and supply. He looked now at what was left of the former mountain and watched it dwindle even as he watched. At this point in the firing a four-inch-thick round of wood would break and twist into coals in less than a minute after it was thrown into a firebox. And there were four fireboxes circling the kiln from corner to corner to corner. He adjusted the damper one way and then another or pushed more heat through different fireboxes trying to drive the kiln more quickly. He drew more test rings and read them like auguries. Fire, they said. But there was nearly no more fire to feed them. He had come close. He had wagered and lost.

"Ephron," Fanny whispered, even through the rumble of the kiln, and looked to the edge of the barely lit circle of light glowing about them.

They had come back. Drawn at last by the two days of billowing smoke from his stack, amazed, perhaps, or furious, or merely come like creatures to carrion, whatever, they had come back. Ephron could not see how many. He did not know them. Only once he

caught a remembered maddened blue glint of eyes in the flickering mantle between the kiln glow and forest dark.

"Go to the boy," he said to Fanny, and she was gone.

He circled the kiln, stuffing its four mouths with the endings to the diminishing heap of pine logs. And then he circled it again and fed it again. He was a potter. By circumstance or destiny he didn't walk away from that. And what else was there to go to anyway? He circled and fed and the mantle flickered.

"Ephron," George Barton said. "I heard them come along the road and followed them," he explained. He pointed to them with a long staff, light and swift in his great arching arm like it was a staff of cleanly trimmed larch to walk with through the woods, but it was not a larch stick, it was an iron rod and he pointed it widely, roundly at them all.

Ephron told him about the wood. Already the kiln roared and bellowed.

"We could cut wood," George Barton said.

"Not fast enough, I think," Ephron said. "And not with them." He pointed with a toss of the head, the circle of grief undulated like an expectation. Soon.

But maybe not.

"Come," Ephron Gherst said, pulling George Barton to the storage shed. "Here." He took George Barton's iron bar and smashed it into the corner of the building and a slab of wood pulled out an inch. He gave the bar back and George Barton understood and rose up and hammered the slight shed apart and down, crushing it with learned strength as he had hammered at the harder iron all his long life. It was a nothing, siding, posts, and beams exploding into fuel in the late night.

Fanny ran out of the house at the noise and shrieked at the spectacle, the white-haired kiln-lit ancient giant flailing the shed to splinters. Ephron ran to the kiln with them. He motioned to her and she did the same.

In an hour they needed another hour. George Barton shouldered down the lean-to of peeled pine logs where the potter's wheels were kept, butting it flat and prying the logs apart with his hands. And now they were laughing, already triumphant beyond objects, safely beyond dread, as if they had drawn a sorcerer's circle in the sand about their wise making that nothing outside of itself could assail.

Some shelving, a few pieces of heavy furniture, the stairs to the upper loft in the house and part of the south wall, and it was done. At every spy hole the sun-bright trembling dazzle of the kiln pierced the last of the night evenly. Up and down, the kiln was equal. All the draw rings were eloquent.

Sometime toward dawn, unnoticed, they were gone, broken apart by what they had seen, if not forever, at least for now. Fremlens come and go.

In the brightening dew of morning Ephron and Fanny and George Barton and the boy, who could not tell if he had slept to dreams or had woken to dreams, tired, smoke-stained, pine-pitched as they had never been, sat and ate, ebullient as the spangling day coming quickly. Catbirds mewed in the trees. Brown thrashers sang back, doubling their cries.

It would take two days for that seething kiln to cool, just time enough to pack up for the first New Jersey State Fair. Ephron looked around. He would have to do a lot of rebuilding, but then, he had the rest of his life for that.

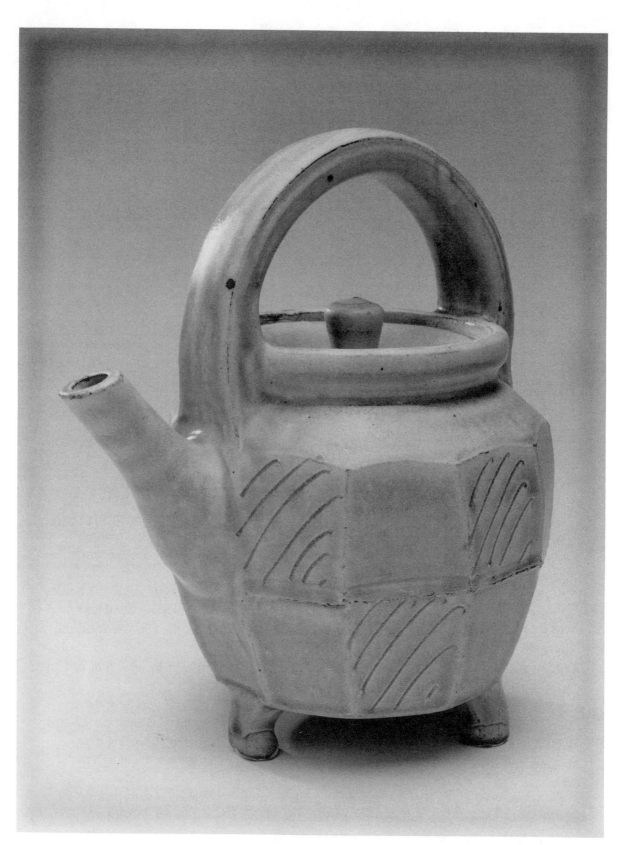

42. Mike Dodd: *Tea Pot, stoneware, 8½" high, 1988. Courtesy of Mike Dodd.*

Index

Numbers in bold italics indicate illustrations.

43. *Unknown Potter:* *Kizaemon Ido Tea Bowl, stoneware, 3½" high, 6½" diameter, 16th century, Yi dynasty, Korea. From* The Unknown Craftsman *by Soetsu Yanagi, 1989, Kodansha International, New York.*